Skyscraper Primitives

SKYSCRAPER

by DICKRAN TASHJIAN

PRIMITIVES

Dada AND THE AMERICAN AVANT-GARDE

1910-1925

Middletown, Connecticut

·WESLEYAN UNIVERSITY PRESS

Copyright © 1975 by Dickran Tashjian

Acknowledgement is gratefully made to the following libraries
for permission to quote from various unpublished documents in their
collections: The Beinecke Library of Yale University for
materials from the Stieglitz Archives; The Newbury Library
of Chicago for materials from the Malcolm Cowley Papers;
The Special Collections of Princeton University Library
for materials from the Harold Loeb Papers.

The publisher gratefully acknowledges the support of the publication
of this book by The Andrew W. Mellon Foundation.

Library of Congress Cataloging in Publication Data

Tashjian, Dickran, 1940–
 Skyscraper primitives.

 Bibliography: p.

 1. Arts, American. 2. Arts, Modern — 20th century
— United States. 3. Dadaism — Influence. I. Title.
NX504.T37 709'.73 74-21925
ISBN 0-8195-4081-1

Manufactured in the United States of America
First edition

Contents

Illustrations appear in two sections, one after page 90 and another after page 164.

Acknowledgements

This study would not have been possible without the help and encouragement of many people. First and foremost among them is William H. Jordy, whose generous criticism shaped my ideas during the early stages of research and writing. To George Monteiro, whose support is always difficult to measure; to Sidney Simon, who first introduced me to Dada and its possibilities; to Mary C. Turpie, for her kindness; to Sherman Paul, whose reading of the manuscript was invaluable; to my colleagues in The Department of Comparative Culture, particularly James J. Flink, Dickson D. Bruce, Jr., and Peter Clecak; to Malcolm Cowley and Matthew Josephson, who shared their pasts; to Michael Jones, for his photography; to Susanne Paulson and Edna Mejia, who patiently typed various versions of the manuscript; to Susan McCarthy, for essential proof-reading; to Harold Snedcof, Richard Wilson, Robert Grinchuk, James Corlett, Philip Johnson, Richard Slotkin, Travis Hedrick, and Dolores Brien: my thanks.

I also want to thank the librarians who simply went about their business of providing inestimable services. I especially appreciate the dedication and assistance of the late Christine Hathaway, who directed the Harris Collection of Brown University, and of her staff, particularly Mary Russo.

I should also like to acknowledge the many museums, galleries, and collectors for providing illustrations. I am particularly indebted to Anne d'Harnoncourt, Kynaston McShine, Richard Tooke, Maurice Tuchman, Robert Schoelkopf, Bernard Rabin, Elizabeth Asher, Mrs. Terry Dintenfass, Roxana Barry, James Mayor, Dorothy Norman, Ben Wolf, Mrs. Michael Blankfort, Kitty Dixon, Anselmo Carini, Mrs. Robin Jones, William H. Lane, Denise D'Avella, Peter Dzwonkoski, Peter Bunnell, Arturo Schwarz, Elizabeth Horter, Barney Burstein, Geoffrey Clements, Timothy Baum, and Sir Roland Penrose, all of whom graciously responded to my queries and requests.

And finally, Ann and Lootfi.

DICKRAN TASHJIAN
Irvine, California
January 1, 1975

Preface

> "We are in the childhood of a new age, we are, by the chronological ac-
> cident of our birth, chosen to create the simple forms, the folk-tales and
> folk-music, the preliminary art that our descendants may utilize in the
> vast struggle to put positive and glowing spiritual content into Machin-
> ery." Gorham Munson, *Waldo Frank: A Study.*

To describe Hart Crane, Man Ray, or Charles Demuth as "primitives"
may appear to be the bizarre workings of a Dadaist mentality. With a
stretch of the imagination, these artists can be conceived as provin-
cial — at least in the initial stages of their careers — but hardly primitive
in the complex and sophisticated renderings of their experiences as
Americans early in the twentieth century. Yet there were others, like
Arthur Cravan and Robert Coady, perhaps even William Carlos Wil-
liams, who appeared barbaric, almost crude, in their violently ener-
getic appeals for a new American art. Only Marcel Duchamp, at the
center of New York Dada, moved easily among the crucial tensions of
his work, sustaining the complex subtleties of the *Large Glass* against
the direct shocks of his readymades. By way of these paradoxes, Du-
champ came to represent the range of American participants in Dada.

 In 1924 Gorham Munson first identified "Skyscraper Primitives"
as those American painters and poets who were affected by Dada's
fascination with the machine and who in turn celebrated modern
American technology. He was referring to Matthew Josephson's views
expressed in the pages of *Broom* and other little magazines. Although
Munson wanted to evoke a narrow sectarianism, Josephson and his
group had important antecedents that extended back to the 1913
Armory Show. Part of this study traces the history of at least one seg-
ment of an emerging avant-garde in New York during this decade.

 The term "primitive," as I would emphasize it, has little or noth-

ing to do with crudity or even simplicity. Such meanings are vestiges of the ethnocentrism coloring early anthropological studies in the nineteenth century. However, the American artists involved with Dada were indeed primitives in being among the first in this century to direct their full attention to the rapidly accelerating technology of their environment. Some of them glorified a cultural primitivism, stripping away traditional values in order to accept the vitality of contemporary life, as both Munson and Josephson did when they came to advocate, among other things, a childlike spontaneity in the arts, cultivating the naïveté and the unself-consciousness of folk expression.

Theirs, however, was but one response, which must be seen within the larger context. Throughout the history of modernism there has been a recurrent quest for the primitive in a flight from a presumably corrupt civilization. The circumstances of the War in Europe brought Dada to New York, but since America has always represented the exotic to Europeans, particularly the French, one dimension of the Dada imagination had preceded the arrival of Duchamp and Picabia. Thus, in awakening American artists to their exciting machine environment, Dada fostered a unique primitivism that sought not the tropics but what we have come to perceive as our own concrete jungle. This new primitivism was paradoxically urban in locus and sensibility.

Some of the ensuing tensions were endemic to modernist primitivism: how one might remain naïve in a sophisticated milieu was a problem recognized at the time, but how advertising and other mass media were expressions of the urban "folk" — or if there is indeed such a phenomenon as an urban "folk" — is an issue that folklorists themselves have yet to resolve. This was but one issue among the many facing artists who lacked an available tradition in acknowledging the machine. In other words, the perceived cultural changes wrought by technology necessitated a reevaluation of basic questions about art and culture — even by those who rejected primitivistic solutions. And just as we are slowly discovering that supposedly inferior "savages" actually possess a complex cultural life, so too should we be aware that the responses of American artists to Dada were anything but simplistic.

The study of Dada in relation to American art takes shape, in its largest contours, as cultural history. Culture is, of course, a construct of symbols, conveying the values, attitudes, and ideas of a given group

and informing its behavior. Artistic activity, however it may be defined by various cultures, is located on the axes of abstract meaning and concrete manifestation, or, if you will, symbol and artifact. Within this frame of reference, art can be studied in order to understand the culture that produced it, just as knowledge of cultural values can illuminate a work of art. Yet I am wary of the first approach, and not simply because studies of that sort risk simplifying the art under consideration. Even if one treats a work of art in its complexity, exploring both form and content, an artifact that should at some point and in one sense be recognized as an end in itself is reduced to a means of understanding something else. Indeed, the reduction of art in such circumstances is always disturbing to me. Yet the autonomy of art also has its limitations. How much do we gain when we become aware of the cultural context of a particular work, and how often have we misunderstood a work because of our ignorance of its milieu and history?

Classic tensions between the universal and the particular raise crucial problems for the cultural historian. To what extent, and indeed in what sense, can an individual work of art be said to represent its culture—especially a diverse culture such as our own? To talk about *American* culture is simply to identify a very large category that dissipates readily unless rigorously specified. Although in the final analysis we are referring to a particular national group, we must yet recognize the cultural pluralism of the United States. In the context of American *cultures*—engaged in both external and internal conflicts—the avant-garde has been a significant force in American life.

By designating the New York avant-garde a subculture, the problem of representation is mitigated. The extremely limited audience of this group at its outset clearly precludes the necessity of demonstrating that large numbers of Americans actually subscribed to the values of a particular work of art. Yet a work need not have a mass audience to be representative. A poem or a painting in itself inevitably reveals cultural values, although these may belong only to a very small group—often only to a single member of the group. But the very concept of a subculture suggests that its members also share some values of the dominant culture. In fact, an individual would have to be alienated or isolated in the extreme not to have some commonly shared values, and even then, the degree of his estrangement can be measured by the values he has rejected.

The avant-garde, moreover, is a special instance of a subculture.[1] The term suggests that its participants deliberately set out in advance of their fellows, exploring new territory, as it were, and their ultimate task is to guide those left behind into previously uncharted realms. Separation and reunion thus mark the rhythms of the relationship between the avant-garde and society. And this was often enough the case with the early New York avant-garde. Though ridiculed and alienated by culturally sanctioned conservative artists and critics, the group in touch with European Dada had nonetheless an intense desire to create what it conceived to be an indigenous American art, central to the contemporary life from which it was derived. The present study traces the group's hazardous course between Europe and America.

In order to determine the cultural patterns that informed the avant-garde, I have examined the traditional sources of diaries, memoirs, and correspondence of individual artists within the historical framework of little magazines published during the period. Besides art itself, the most significant form of communication for the avant-garde has been the little magazine, which provides a wealth of material lending insight to its editors, contributors, and readership. In their diversity the littles range between a public and a private voice, often proclaiming the views of a particular faction through a series of manifestoes and just as often propounding the idiosyncracies of a single editor. And because these magazines are published over a period of time, they chart the course of change within the avant-garde. Most important, interspersed among the editorials and essays are short stories, plays, poems, paintings, photographs, and sculpture which, as part of the context of the little magazine, reveal a panoply of values that comprise the cultural locus of the American avant-garde.[2]

A critic of the Armory Show once referred to Duchamp's *Nude Descending a Staircase* as "an explosion in a shingle factory": the same might be said of Dada. It was neither a school nor a movement but rather an essentially chaotic phenomenon that cut across art forms and national boundaries. Likewise, none of the American poets and few of the painters involved came together in anything so formal as a school. Nor was there the obvious coherence or concerted direction that a metaphor such as "movement" suggests. Nevertheless, in collaborating on little magazines, in subscribing and contributing to them, Americans in the avant-garde formed a volatile but significant nexus of associations that crucially addressed itself to Dada.

Because Dada does not conform to the model suggested by the concept of movement, with all its underlying assumptions, a cultural analysis of the phenomenon is all the more essential. Within the realm of art history, movements are often assumed to be self-contained, unfolding one after another, as art comments on art. Dada, however, made a decisive break with art in an attempt to capture life itself. Consequently, viewing Dada artifacts solely as "art," irrespective of intent and context, would be restrictive. Likewise, though the central figures involved can be identified, the center of Dada shifts constantly from individual to individual. For a resolution of these problems, only the concept of culture embraces a sufficiently broad range of human behavior commensurate with the diffuse nature of Dada, as it moved among the aesthetic, social, and psychological areas of human experience. Moreover, cultural analysis reveals the intrinsic incoherence of Dada by pointing up the essential tensions and contradictions of its structure. New York Dada, like its European counterparts, vigorously attacked prevailing cultural definitions of art. Of course, the virulent existence of anti-art feeds upon defiance and opposition, for art and anti-art are symbiotic aspects of the creative process, as innovation works against tradition and convention. And it is because of such paradoxes that the nonsense of Dada has retained its integrity.

Skyscraper Primitives

"Art and science are to be blended in a most interesting manner provided an unique theory just advanced by James F. Kerr, General Manager of the First Radio World's Fair, stands the acid test to which it is now being subjected by a special committee of radio engineers.

"It is barely possible that the far-famed bronze statue, 'Diana,' which surmounts the tower of Madison Square Garden and *which is universally claimed as one of the finest pieces of sculpture in existence,* may soon adopt a more useful profession than that of a beautiful weather vane. In other words, Saint-Gaudens' masterpiece may go into the radio business and establish herself as the world's most exquisite antenna.

"When 'Diana' does make her radio debut I am going to arrange to open the first program transmitted through her with a eulogy of her creator, Augustus Saint-Gaudens, by *George Grey Bernard or some other famous American sculptor.* This, if I am not mistaken, will cause 'Diana' to vibrate with her own praises. Later on, perhaps, we will be able to arrange for the lady to communicate direct with some equally celebrated European statue."

<div align="right">Reported in The Little Review 10 (1924).</div>

Introduction

Anarchic, protean, subversive, international—however accurately characterized—Dada remains elusive. Its mercurial nature was accelerated and fragmented by the rampant individualism of the various Dadaists. Marcel Duchamp, Hugo Ball, Tristan Tzara, or Kurt Schwitters, to single out only a few from among the many participants, resist attempts at a composite portrayal. Then, too, the broad range of contradictory attitudes that this phenomenon assumed appears to preclude any valid generalizations. Foreseeing such obstacles, the Roumanian Dadaist Marcel Janco offered a cryptic warning. "Do not trust anything that calls itself 'dada history,'" he declared, "however much may be true of dada, the historian qualified to write about it does not yet exist. Dada is by no means a school and certainly not a brotherhood, nor is it a perfume. It is not a philosophy either."[1] Janco implies that the qualified historian would spit on the ashes of Dada and laugh, lest he risk writing absurd scholarship in pursuing scholarship of the absurd.

In this regard, Dada's American ashes have apparently scattered without a trace. Dada, it is commonly agreed, began in Zurich, Switzerland, during the First World War and spread rapidly throughout Europe, but not to America (except, possibly, for the gratuitous presence of Marcel Duchamp and Francis Picabia in New York). Countless critics have offered reassurances that such a decadent, nihilistic movement could not have sullied our pristine shores. No foreign anarchy for our innocent American artist! To borrow a phrase from Duchamp, such critics once again applied the Monroe Doctrine, this time, however, to American art.[2]

But suspicions arise. Duchamp and Picabia, two leading Dadaists even before the term was invented in 1916, were in New York intermittently for several years beginning in 1913. Surely, as Michel Sanouillet, an intrepid historian of Paris Dada, has remarked, they did not create their work in a cultural vacuum. There was clearly some

discourse between the two Europeans and American artists, who were eager at the very least to learn about French modernism. After the War, moreover, any number of young Americans went abroad to become "expatriates." Many spent their time in bars and cafés, but what better places could be found to overhear the exciting talk of all the Dadaists congregated in Paris, and possibly to join in their discussions?[3] Or is it possible that these Americans were deaf to the scandal and noise raised by the Dadaists and an outraged public alike?

Dada itself has been increasingly viewed as the significant phenomenon it indeed was during that period. To a great extent, this discovery was made retrospectively, particularly after the renaissance of Dada attitudes among American artists of the past decade. From this perspective has come the recognition that Dada had struck if not the first, then certainly the most crucial blow at those distinctions once possible between fine art and popular art. The magnetic fields of technology and the avant-garde have generated new polarities to replace those that were probably arbitrary and without much validity. Yet the new currents do not bear totally positive charges, and their poles constantly shift in value and identity. The ambiguities of our present situation are difficult to assess. For example, it is perhaps too soon to tell whether or not Marshall McLuhan's Mechanical Bride is another Blondie to the avant-garde's Bumstead. Even McLuhan himself has been reluctant to offer a definitive judgment—possibly for reasons that have little to do with the courtship's ongoing nature.[4] It has become increasingly clear, however, that we can no longer ignore this phenomenon, which was engendered in large measure by Dada. In order to move, therefore, toward an understanding of our contemporary culture—even to decide that an ambiguous suspension of judgment may be salutary—it is imperative to return to the earlier relationship between Dada and American art. Except in a few instances, however, scholars have overlooked this episode in American art, which has been historically important in its implications, particularly given the rapid growth of technology in our environment.[5]

Since the impact of Dada on American arts during World War I and shortly thereafter is little known, a preliminary outline of their cross-cultural relationship is necessary. In its broadest terms, Dada in America and Europe made a substantial impression upon a varied group of American artists, both visual and literary, from about 1915 to 1925. Many major American artists of the time—Alfred Stieglitz, Arthur

G. Dove, Charles Sheeler, Man Ray, Charles Demuth, Joseph Stella, and Stuart Davis—were affected by Dada, though of course not in the same measure. Only Man Ray became a full-fledged Dadaist, whereas some were vehemently opposed, and still others remained highly ambivalent in their attitudes. Nevertheless, they all did respond by exploring the art/anti-art possibilities spawned by Dada. Thus the history of American modernism during the decade after the Armory Show remains incomplete without a consideration of Dada in its relationship to American art.[6]

Among the many American writers who were deeply involved in the avant-garde activities in New York during that period were E. E. Cummings, Hart Crane, and William Carlos Williams, whose poetry developed out of their response to Dada. As with most of the painters, it would be inaccurate to label any one of them Dadaists, yet Cummings' "modernism," for example, becomes most meaningful in as much as it assumes specific contours in a Dada context, just as his traditionalism makes sense primarily in its relationship to his rightful predecessors, Emerson and Whitman. In like fashion, although Dada was not the sole influence on Hart Crane, it does serve to measure his sense of experimentation with language, his response to American popular culture, and even his mysticism. And it certainly motivated his critical attraction to technology. Williams was perhaps the most vocal in his opposition to Dada; yet his earliest preoccupation with the creation of a purely American art makes sense primarily in terms of his reaction to European Dada and establishes the basis for his later work.

In tune with these writers and painters were the little magazines and an enthusiastic corps of contributors in the ranks of the avant-garde who have been overshadowed by the more reknowned figures of the twenties, among whom T. S. Eliot was perhaps the most prominent. In both the literary and visual arts, then, discourse with Dada suggests that the American avant-garde was not monolithic, for its factions were united mainly by their estrangement from the public. A view from within contributes to an accurate history, not merely by providing colorful episodes but by revealing the internal dynamic of American avant-gardism as well.

True to its nature abroad, Dada thrived upon opposition and controversy in America. Its breeding ground were the little magazines of the period—their history revealing the subterranean course of Dada in America. The narrative of this study is structured according to the his-

tory of the little magazines closely identified with Dada. *Camera Work*, edited by Alfred Stieglitz, set the stage for Dada during the years of the Armory Show. In 1915 Stieglitz' group published a review called *291*, which introduced Dada to America's avant-garde upon the infectious arrival of Picabia. Appearing soon after, Duchamp plunged into, and indeed, precipitated, local avant-garde controversy, which was reflected in the three reviews he published: *The Blind Man* and *Rongwrong* (1917), and *New York Dada* (1921). All three were essentially single-issue magazines, but their significance for the American avant-garde far outweighed their ephemeral nature.

A year after the demise of *291*, Robert Coady, a New York art dealer, published *The Soil*, a magazine which introduced in its pages the athletic Arthur Cravan, an almost legendary boxer and poet from France with proto-Dada attitudes. Although *The Soil* (1917) was brought out for only five issues, William Carlos Williams continued its lively skirmish for an American art in the sporadic issues of *Contact*, which he helped to launch in 1920. The following year, *Broom*, under the direction first of Harold Loeb and then of Matthew Josephson, carried on the plea of its predecessors through its controversies over Dada, and henceforth pitted itself against all comers, including its symbiotic counterpart, *Secession*. Close to exhaustion, Dada shenanigans in America flared up one last time, in *Aesthete 1925*.

As in Europe, American squabbles occasionally expended energy over nothing. But European Dada had a profoundly serious undercurrent, directed as it was against what many felt to be the bankruptcy of Western culture. Given Dada's interaction with American art, it was inevitable that an American response engender some nihilistic feelings. But rather than engage in public gestures of significant nonsense, American artists based their controversies on the ambiguities of art and anti-art. This does not imply variations on the rather tedious theme of American innocence—that is, on the assumption that American artists would not venture into the brothels of European Dada. Rather, the degree of nihilism that permeated Dada depended upon the specific cultural situation of the Dada group in question. For example, the outburst of Dada in Zurich was matched in intensity and indeed in a heightened degree of political nihilism in post-War Germany. In France, where conditions were different for young Parisian artists, Dada did not develop to the same pitch. As for New York, the presence of Picabia and Duchamp—the latter so cool and detached, despite the in-

tensity of his many paradoxes—intellectually shaped the anti-art tendencies of the local avant-garde.

Not that American artists were passively waiting for the impact of Dada to fall upon them. Many were in the process of breaking away from academic values to embrace new sensibilities, techniques, and assumptions about art. Gaining their impetus from abroad, they discovered an exhilarating twentieth century already a decade spent. Not only did they belatedly have to adopt new art forms, but they were also forced to create their own identity as artists in a world they were just beginning to chart. Thus Dada encouraged American writers and painters to find their own identity. Indeed, out of the implicit tensions and contradictions of an American culture that was generally opposed to modern art, Dada awakened American artists to new possibilities of creation and self-awareness.

At the same time, however, an exposure to Dada would have meant little or nothing to American artists if they had not been predisposed to the anti-art values that Dada proclaimed. Their attraction was conditioned by a traditional American preoccupation with supposedly immutable fact, free from the changes of history, and hence implicitly free from culture and art. While a few of them seized upon the formal experimentation of Dada, the majority discovered the freedom of new subject matter, particularly the machine and its industrial-urban environment, construed by Dadaist and American alike to be peculiarly American, by eminent domain so to speak, because of America's rising leadership in the industrial revolution. The machine, "a female born without a mother," as Picabia described it, was not subject to time; it was supposedly an American fact that could be treated directly, without the fetters of art. And so, another machine, the camera, became crucial in the dissemination of anti-art attitudes and values through Stieglitz's advocacy of straight photography. American artists also extended their purview beyond the machine alone to its technological effects upon culture; that is to say, they acknowledged and assessed the presence of mass media, the film, advertising, popular music—in short, all the new and widely available communicative materials of culture made possible by an accelerating technology that was to have a profound effect upon the creative process itself.

In order to delineate the configurations of Dada in America it is necessary to take the measure, however tentatively, of Dada in Eu-

rope; even though Picabia and Duchamp expressed proto-Dada at-
titudes in New York as early as 1915 (in fact, even earlier in the case
of Duchamp), and both were subsequently accepted by Dada groups
in Europe when communication was established. Because these two
helped to shape the American avant-garde during the second decade
of this century, they rightfully belong in the forthcoming narrative.
Dada in Europe, on the other hand, most explicitly revealed itself in
the manifestos that assaulted the public. And the development of Dada
in Paris, transmitted by Tristan Tzara from Zurich, was crucial to those
young American expatriates in search of their own country.

As Hans Richter, a participant and recently a chronicler, has right-
fully indicated, Dada originated specifically in Zurich, where con-
ditions early in 1916 provided the catalyst for a climate that was still
inchoate in other countries. According to Richter, "The peculiarly
claustrophobic and tense atmosphere of neutral Switzerland in the
middle of the Great War supplied an appropriate background." "It
was here," he wrote, "in the peaceful dead-centre of the war, that a
number of very different personalities formed a 'constellation' which
later became a 'movement.' Only in this highly concentrated atmos-
phere could such totally different people join in a common activity.
It seemed that the very incompatibility of character, origins and at-
titudes which existed among the Dadaists created the tension which
gave, to this fortuitous conjunction of people from all points of the
compass, its unified dynamic force."[7] Out of this pressure cooker
emerged Dada, whose environment reflected its many paradoxes. It
arose in a haven of peace, surrounded on all sides by a senseless war.
And it immediately cast itself in opposition to the prevailing absurd-
ities with its own absurdity, thereby kindling a different type of war,
conducted against the structural underpinnings of culture itself.

The mystery surrounding its birth is no less revealing. Soon after
the German poet Hugo Ball and Emmy Hennings opened the Cabaret
Voltaire in January 1916 as a gathering place for refugee artists to
exhibit their paintings, recite their poetry, and stage skits, Dada was
born. Appropriately enough, controversy soon raged as to who origi-
nated the term and as to what it meant. Hans Arp asserted, "I hereby
declare that Tzara invented the word Dada on 6th February 1916,
at 6 p.m. I was there with my 12 children when Tzara first uttered the
word . . . it happened in the Café de la Terrace in Zurich, and I was
wearing a brioche in my left nostril." But if one is to believe Richard
Huelsenbeck, "The word Dada was accidently discovered by Ball and

myself in a German-French dictionary when we were looking for a stage-name for Madame Le Roy, the singer in our cabaret." This historical enigma suggests the futility of seeking a logical sequence in Dada. Most significantly, Tzara's cryptic admission, "A word was born, no one knows how," elevated the origin of Dada to the level of myth, a characteristic recognized by Hugo Ball in his discovery of "the evangelical concept of the 'word' (logos) as a magical complex of images."[8] In assuming the role of gods who conjure the logos, these men developed the dominant trend of Dada into a dynamics of creation.

The concept of the logos as the rational principle of the universe was, however, inverted by the Dadaists, since the term "Dada" has no meaning. According to Richter, "In Rumanian *dada* means 'yes, yes,' in French a rockinghorse or a hobby horse. To Germans it is an indication of idiot naivety and of a preoccupation with procreation and the baby-carriage." These various denotations are in fact misplaced in the context of Dadaism, for they are germane only insofar as they all point to nonsense under the misleading guise of rationality. Tzara bluntly mocked those who sought to give the term meaning. "DADA MEANS NOTHING," he roared. "The first thought that comes to these people is bacteriological in character: to find its etymological, or at least its historical or psychological origin."[9] Since Dada was deliberately created as a nonsense word, it has neither denotative nor connotative meaning in terms of logical discourse. Hence logical definition is impossible. No set of essential characteristics defines Dada, as nonsense explodes the logos.

Given the horrific backdrop of the War, the attitude of negation was inextricably associated with this nonsense. The manifestos of Tzara, whom Richter views as one of the most nihilistic of Dadaists, made this relationship clear when, under the rubric of "Dadaist disgust" in his manifesto of 1918, he proclaimed:

Every product of disgust capable of becoming a negation of the family is Dada; a protest with the fists of its whole being engaged in destructive actions: *Dada; knowledge of all the means rejected up until now by the shamefaced sex of comfortable compromise and good manners: Dada; abolition of logic, which is the dance of those impotent to create: Dada; of every social hierarchy and equation set up for the sake of values by our valets: Dada; every object, all objects, sentiments, obscurities, apparitions and the precise clash of parallel lines are weapons for the*

fight: Dada; abolition of memory: Dada; abolition of archeology: Dada; abolition of prophets: Dada; abolition of the future.

In practice, this destructive sweep of Dada entailed the empty gesture of impotent rage designed to enrage. "Call your family on the telephone," Tzara advised, "and piss in the hole reserved for musical gastronomic and sacred stupidities." As a demonic force whose incantatory evocation brought destruction, Dada also contained within itself the powers of self-destruction. Hence Tzara observed, "The true dadas are against Dada." With this self-opposition as an internal necessity came the inevitable cry: "Dada is dead."[10]

Yet in this death ritual Dada held the germ of affirmation. Tzara, the archangel of destruction, could envision an aftermath. "We must sweep and clean. Affirm the cleanliness of the individual after the state of madness, aggressive complete madness of a world abandoned to the hands of bandits, who rend one another and destroy the centuries. Without aim or design, without organization: indomitable madness, decomposition. Those who are strong in words or force will survive, for they are quick in defense, the agility of limbs and sentiments flames on their faceted flanks." Amid Nietzschean echoes, Tzara's individual would emerge from this devastation purified and strengthened, his desire for nothing less than absolute freedom affirming life in all its configurations. "Freedom: Dada Dada Dada, a roaring of tense colors, and interlacing of opposites and of all contradictions, grotesques, inconsistencies: LIFE," cried Tzara.[11] The very syntax of the passage suggests that freedom and life are held in a balanced suspension by the magical incantations of Dada zeroing in on absurdity.

The achievement of freedom required the destruction of all modes of expression considered restrictive, particularly logic, which was for Tzara "an enormous centipede stifling independence." These negations were best served by the strategy of contradiction, dramatized by the Dada manifesto itself. Tzara observed that ordinarily, "To put out a manifesto you must want: ABC to fulminate against 1, 2, 3." While conventional manifestoes are presumably based on logic, Dada's were based upon nonsense, with contradiction as the goal. "I write a manifesto and I want nothing," Tzara asserted, "yet I say certain things, and in principle I am against manifestos, as I am also against principles. . . . I write this manifesto to show that people can perform contrary actions together while taking one fresh gulp of air."[12] As a result, Dada manifestos were deliberately illogical and contradictory, and replete with

explosive typography so as to suggest the chaos and disorder of life itself.

No less than logic, art was viewed as an obstacle to creation. Occasionally, Tzara agreed with Huelsenbeck that "art . . . is a large-scale swindle." But more often, a doctrinaire condemnation was dislocated by Tzara's fundamental ambivalence: "Dada remains within the European frame of weaknesses it's shit after all but from now on we mean to shit in assorted colors and bedeck the artistic zoo with the flags of every consulate. We are circus directors whistling amid the winds of carnivals convents bawdy houses theatres realities sentiments restaurants HoHiHoHo Bang."[13] Art, then, was "shit," but this "shit-art" came "in assorted colors," anticipating the wide range and vitality of creativity released by Dada. Furthermore, national boundaries were to be transcended as the Dadaists "bedeck the artistic zoo with the flags of every consulate." The bars of the "artistic zoo" would be broken by Dada, for art in the service of a bankrupt nationalism had to be destroyed. This image in turn suggests that the role of the artist would be that of a "circus director" (an art-role closely allied with life, "carnivals convents bawdy houses theatres realities sentiments restaurants").

Anti-art was to free creativity from the bonds of ideal beauty, a meaningless criterion employed by art critics. "A work of art should not be beauty in itself, for beauty is dead," declared Tzara. "A work of art is never beautiful by decree, objectively and for all. Hence criticism is useless, it exists only subjectively, for each man separately, without the slightest character of universality." With beauty dead, and a world floundering in the chaos of absurdity, creativity gained a new power to illuminate the human situation, "the sad fable of mankind." Tzara, however, did not set up his own rigid criteria to replace a sterile art serving a dead beauty. Quite the contrary, he felt that "art was a game of trinkets children collected words with a tinkling on the end then they went and shouted stanzas and they put little doll's shoes on the stanza and the stanza turned into a queen to die a little and the queen turned into a wolverine and the children ran till they all turned green."[14] Tzara's rhetoric in this passage suggests that art, once stripped of its false sanctity, would be free to assume multiple transmutations.

This summary of Tzara's manifestos indicates that he was neither a doctrinaire nor a programmatic nihilist. His negation redounded to affirmation; his destructive sweep released the individual from mori-

bund restrictions to explore new realms of expression. While Dada was disruptive, it disrupted to make new creation possible. Dada was a metamorphic "state of mind," released by nonsense and absurdity. Its attitudes, informed by nihilism, irrationality, and freedom, were directed against a wide range of targets, but never more devastatingly than against art, which, in its complicity with the standing order, committed the greatest betrayal of human values.[15] Picabia's Rorschach-like illustration in his magazine 391 suggests this kind of artistic negation. Sacrilegious in itself, *Sainte-Vierge* not only blots out all previous works of art depicting the Madonna but also destroys the concept of art itself, since the image in combination with its subject matter negates any and all aesthetic values. But more often, the Dadaists took a negative stand against art in order to be positive about creation. Negation and affirmation worked a mutual leverage on the fulcrum of nonsense.

The Dadaists expressed their anti-art attitudes through the appropriation of life itself. As Tzara maintained, "Dada is a quantity of life undergoing a transparent transformation both effortless and giratory [*sic*]." But while the Dadaists could afford to select from a broad range of experience, they tended to turn to those aspects which reflected not only their anti-art values but also their desolate sensibilities enervated by the War and a civilization they viewed as bankrupt. Consequently, the iconography of their work often emphasized the cheap artifacts of popular culture, modern technology, and the experiences of dreams and nightmares, all of which were invested with perverse elements of chance and a primitivistic vitality to affirm the rawness of life against the obscene veneer of civilization.[16]

With the rapid spread of Dada from Zurich to Berlin in 1917 (then throughout Germany) and to Paris in 1919, the Dadaists mounted an assault of diverse expression. The Dada event, a phenomenon borrowed from the Futurists and perfected by subsequent confrontations, ranged from soirées to film showings, painting exhibitions to poetry readings, scandalous public demonstrations to internecine rivalries of little sense. The violence, the informality, and the strenuous activity of these events were deliberately cultivated in order to bridge the gap between art and life, if not to destroy art altogether. During this period, manifestos, broadsides, reviews, and little magazines were published incessantly—throwaway ephemera symbolizing the evanescence of Dada itself. In literature automatic writing competed with simultaneous, abstract, and chance poetry. The visual arts exploded in multiple media: painting and the readymade; collage, photomon-

tage, and assemblage; film, photography, and the Rayograph. As Richard Huelsenbeck accurately observed, "Dada is not limited to any art."[17] Neither was Dada restricted to any style, as George Ribemont-Dessaignes maintained.[18] Some individuals opposed Cubism, others espoused only abstract art, and still others condemned modernism generally. In sum, Dada swept the field, leaving it free for individual decisions in the arts.

Since the key to an understanding of anti-art attitudes lies in the recognition of the particular cultural context of such manifestations, the historical situation of the individual Dadaist or his group must be taken into consideration. Otherwise, since what shocked the bourgeoisie (as well as communists and intellectuals) yesterday will not today, the furor of Dada must needs remain enigmatic. Ultimately, however, the vitality of historical Dada points to the dynamics of art/anti-art ambiguities that are essentially a-historical in their implications. The uninhibited freedom afforded by anti-art cleared new ground for creativity. In the opinion of Richter, "Our real motive force was not rowdiness for its own sake, or contradiction and revolt in themselves, but the question (basic then, as it is now), 'where next?'"[19] In this sense, anti-art became the means by which Dada took as its province not merely new art forms but the entire creative process with all its anarchic ramifications. In its a-historical dimension, Dada ultimately subsumed the internal dynamics that create avant-gardism, with the paradoxical result that Dada is dead, but at the same time, Dada lives.

In contrast to Cubism, Futurism, and Surrealism, Dada was a deliberately incoherent phenomenon that went beyond such contemporaneous movements to appropriate the entire realm of creation as its concern.[20] Cubism, at its best, fostered a revolutionary way of seeing the world; at the very least, it created a new style of painting. As for the Italian Futurists, though they had anticipated many Dada attitudes and gestures, they diverged from Dada by severely limiting themselves to a mere celebration of technology. Moreover, their underlying admiration of its power eventually led them to the glorification of war and the espousal of fascism. By way of contrast, Dada's ambiguity about the machine, combined with an intense idealism, opened a new order of creativity that was necessarily denied the Futurists.

The question of Surrealism in its relation to Dada is more complex. Michel Sanouillet's conclusion that Dada took the form of Sur-

realism in France perhaps illuminates the contours of Paris Dada.[21] Certainly he avoids the difficult problem of plotting the subtle and mercurial transformation of Dada into Surrealism. Yet Surrealism as a movement took its cue and distinct identity from André Breton's leadership, publicly declared in his Manifesto of 1924. To be sure, Breton summarized much of what had already occurred as early as 1919, but his emphasis upon psychic automatism in 1924 was most significant in the development of what had been only one element of Dada. And his distillation of Surrealism from the unconscious was consummated with a curious if not paradoxical cerebral quality. Breton's deeply meditative character was in stark contrast to the Berlin Dadaists, whom Jane Heap, the co-editor of *The Little Review*, rightfully perceived as "closer to madness than the French."[22] And with good reason, given the breakdown of post-War Germany in contrast to the relative stability of France, which turned the dissent and destruction of Dada inward, upon the group itself. During that period, as suicide or boredom became inevitable in a Paris capable of rapidly absorbing avant-garde gestures and reducing them to mere postures, Breton moved along the tangent of the psyche in order to chart new realms for the avant-garde.

The historical necessities of Surrealism only serve to underscore the distinct complexity of Dada in its dispersal in all directions from an essential matrix of nonsense. While its major coloration was destructive and anarchic, its nihilism was paradoxically affirmative. The explosively absurd nature of Dada, taking on multiple guises, gyrated through all the arts and ultimately encompassed the creative process. Moreover, Dada was able to cut across national boundaries in its many transmutations. It was to be expected, then, that the configuration of Dada in America would be different from the various forms it took in Europe. Nevertheless, it had the same over-all effects in America: "Dada awakened senses and sensibilities to the immense multiple collision of values, forms, and effects among which we live, and to the dialectic of creation and destruction, affirmation and negation by which life and art progress."[23] Dada raised profound problems that still strike at the heart of American culture. While Waldo Frank's despair that America *is* Dada[24] may have been exaggerated, the chaos of Dada illumines America's essential conflict with tradition and may even lend intelligibility, if not significance, to our contemporary chaos in the arts.

1 | *Camera Work* and the Anti-Art of Photography

On January 14, 1913, Francis Picabia, soon to be hailed by *The New York Times* as "the leading spirit in the New Movement . . . the latest 'Thing' in modern French art," arrived in New York City, just before the opening of the Armory Show.[1] About a month later he met Alfred Stieglitz, who championed the cause of photography and modern art in his magazine *Camera Work* and at his gallery at 291 Fifth Avenue. What Picabia's arrival would mean to the newly emerging American avant-garde had already been anticipated in part by the experimentation of Stieglitz and his followers, both painters and photographers, in the Photo-Secession. Although *Camera Work* never overtly embraced Dada, the magazine framed its excursions into the nature of photography in terms of art and anti-art, challenging the academic hegemony of representational values in painting. The ensuing polemics were visualized in dramatic fashion by the Armory Show, which called into question academic assumptions about the nature of art. As a representative of the new European art, the ebullient Picabia joined in the arguments over photography, painting, and technology. Although his views, consonant with those expressed in *Camera Work*, belonged more in the camp of Futurism than of Dada at the time, they served as the basis from which his Dada attitudes would later emerge in 1915.[2] Like the Futurists, many Dadaists were fascinated by the machine, although their attitudes were colored not by optimism but rather by an ironic skepticism or despair. In 1913, however, a tendency to rationalism and positivism dominated the arguments of Picabia and his American friends.

Whatever the eventual depths of Stieglitz' despair over the state of American art,[3] *Camera Work* did not assume Dada's guise of nihilism and nonsense. Though the magazine contained an occasional hoax, it was the essays of the critic-poet Benjamin De Casseres that

reflected the romantic nineteenth-century origins of Dada; but above all, it was the work of Marius De Zayas, the Mexican caricaturist, who established the intellectual substructure of the Dada spirit by summarizing the anti-art attitudes toward photography and painting that had hitherto been scattered throughout the magazine. Moved to that brink of recognition which was necessary for the leap into Dada, De Zayas' positivism nevertheless restrained the total anarchy that Dada alone would provoke. Consequently, *Camera Work* remained an eclectic anthology, though setting the stage for Picabia's Dada stance in 1915, and raising in the process a number of crucial problems about art that the two European expatriates would drive to their extreme resolution with a merciless logic of their own in the years after 1915.

That *Camera Work* was able to perform this important function was a result of its course of development over the years prior to 1915. Published from 1903 to 1917, the magazine concerned itself with broad trends in the visual arts and discussed not only the particular views of the Stieglitz circle but divergent ideas as well. It also pointed out the inertia of American critics in their failure to understand the new modes of expression. Conceived as a constructive response to such needs, the magazine became a forum whose purpose was to explore avant-garde activity for the edification of both the American artist and his public. Never restricted to the discussion of photo-techniques alone, *Camera Work* transcended what might otherwise have become a narrow approach to photography by adopting an editorial policy of deliberate eclecticism.[4]

Almost inevitably, then, *Camera Work* came to explore the implications of modern painting for the photographer. In this broadened perspective, photography itself did not diminish in importance, for discussions generally dwelt upon the interplay between the two media. Moreover, the problems considered by the magazine dealt primarily with aesthetics, not criticism,[5] since before critical tools could be formulated, it was clearly necessary to establish the aesthetic values of the new work being done in the visual arts.

Photography alone posed many serious questions. Although the camera was already used widely both in America and abroad, its aesthetic significance had not yet been determined. In an article published in 1905 Roland Rood, one of the early contributors to *Camera Work*, suggested that a mysterious chaos informed photography as an art. "The position of pictorial photography from the philosophical

standpoint is intensely interesting," he remarked. "One might say it has entered the art-world as has radium the physical world; there is something decidedly uncanny about it, and we really don't know where we stand."[6] Earlier on, the historian Henry Adams had been equally struck by the same forces of a universe newly discovered in the gallery of dynamos at the Paris Exposition of 1900. But whereas Adams remained pessimistic, Rood was not. Here was the camera, he seemed to be saying, an instrument perhaps capable of visualizing a world we scarcely knew existed.

By the late nineteenth century this mystery surrounding photography had assumed controversial proportions, and in the twentieth, *Camera Work* began to probe its depths. Since the essential question concerned the viability of photography as an art form, the magazine published numerous articles presenting diverse views on the question. At the center of the controversy was the issue of straight as opposed to pictorial photography. In straight or "pure" photography, the photographer meddled neither with his subject nor with any of the intermediate processes that led to the final print, whereas in pictorial or "art" photography, he felt justified to intervene in any way he saw fit in order to produce a print that would be considered "artistic," that is to say, one that most closely approximated a painting in appearance: an image soft in tone, "impressionistic," so to speak, and preferably depicting a genteel scene.

The majority of writers in *Camera Work*, its professed tolerance notwithstanding, favored straight photography, deploring the pretensions of the pictorial mode (Charles Fitzgerald, critic for the New York *Evening Sun*, going so far as to call it a "mongrel art"), against which they upheld the inherent vitality of straight photography and even the artless efforts of the amateur in his snapshots. A major strategy of these contributors was to assert the autonomy of photography from the fine arts and thus to maintain its scientific integrity. In 1909 the art critic Charles H. Caffin claimed, for example, that "photography is itself a scientific process, lending itself at every turn to the acquisition and dissemination of knowledge. That it is scientific is at once the significance and the measure of its value."[7] In other words, an insistence upon the scientific nature of photography was meant to underscore its uniqueness and thus free the medium from the stigma of inferiority tacitly conceded by those pictorial photographers who sought to imitate painting.

Some critics believed that the mechanical nature of photography was favorable to capturing the primitive quality of a raw American landscape transformed by an expanding technology. Rood, for example, argued that straight photography required the development of our primitive sensibilities so that "you may even succeed in the almost impossible feat of combining your thought with railroad-yards, locomotives, and skyscrapers." The British photographer Alvin Langdon Coburn agreed. Photography, at home in the speed and up-tempo of modern life, could portray contemporary actuality. For Coburn, the camera was most particularly adapted to the new age as a mechanical instrument. By virtue of its skyscraper technology, America would understandably be most congenial to photography and lead in its development. Coburn went on to praise the efforts of Stieglitz in this direction and approved of the anti-art quality of his photographs. "If you call it a 'glorified snapshot,'" he advised, "you must remember that life itself has much of this same quality."[8] A preference for the primitive had to pervade the medium that was to capture life itself. And the association of primitivism and technology, seen as a peculiarly American development, foreshadowed the enthusiasms of the French Dadaists for American culture.

If the concept of straight photography moved out from under the traditional criteria applied to painting, painting itself was in turn liberated by photography. In the special number of *Camera Work* (June 1913) Gabrielle Buffet, Picabia's wife, published "Modern Art and the Public," an article in which she attempted to define the new pictorial language of modernism. As a final argument against the need for visual representation in painting, she turned to the technological advances of the camera. Its facility of mechanical reproduction outmoded painting that was based on the model of Renaissance perspective or trompe-l'œil values.[9]

Stieglitz had anticipated her position in the previous issue, exposing his readers to the ideas of John Marin, whose exhibition of watercolors at "291" during the spring of 1913 reflected the artist's relationship to the new urban environment. For Marin the city was alive. "Shall we consider the life of a great city as confined simply to the people and animals on its streets and in its buildings? Are the buildings themselves dead?" he asked rhetorically. "We have been told somewhere that a work of art is a thing alive. You cannot create a work of art unless the things you behold respond to something with-

in you. Therefore if these buildings move me they too must have life. Thus the whole city is alive; buildings, people, all are alive; and the more they move me the more I feel them to be alive." That feeling of vitality, with "great forces at work," led Marin "to express graphically what a great city is doing." In his works, nonrepresentation became necessary for self-expression: "How am I to express what I feel so that its expression will bring me back under [its] spells? Shall I copy facts photographically?"[10] Like Gabrielle Buffet, Marin sensed the need to eliminate photographic representation from his painting.

The rhetorical quality of Marin's questions pointed to Stieglitz' endorsement of straight photography. At the same time as the Armory Show and Marin's exhibition, Stieglitz displayed his own photographs, taken over the course of twenty-one years. As the "Notes on '291'" suggested, "A comparison between Marin's rendition of New York and Stieglitz's photographs of the same subject afforded the very best opportunity to the student and public, for a clearer understanding of the place and purpose of the two media." Since Stieglitz' efforts "represent[ed] the straightest kind of straight photography,"[11] the two exhibitions were meant to show the differences between idea and fact, self-expression and naturalistic representation; indeed, implicitly, the difference between pictorial photography and the work of two men who retained the integrity of their media.

"Notes on '291'" also included Picabia's "Preface" to his exhibition at Stieglitz' gallery from March 17 to April 5. His ideas, paralleling those of his wife, are noteworthy because they indicate his distance from Dada at the time. By refusing to be entrapped in a labyrinth of subjectivity, he manifested his faith in artistic communication. Nor had he yet lost hope in the public, for there still could be a link between creator and viewer. In order to facilitate understanding of his work, he offered an analogy between music and painting.[12] Unlike the anarchical absurdity of *391*, his review which appeared only four years later, Picabia's analogy to music presupposed rational and harmonious laws (albeit ill-defined) in the creative process itself so as to facilitate an understanding of modern art.

Not yet hailed as the anti-painter of Zurich's Dada community, Picabia was still committed to painting as an art form. In an interview granted to *The New York Times*, he gave little indication that he would soon become a Dadaist. Indeed, his enthusiasm about America made any such prediction appear untenable. The interviewer asked Picabia,

"What do you expect to achieve – what is your object in coming to America?" His answer reflected an optimism that was based upon the stereotypes of the Old and New Worlds:

> France is almost outplayed. It is in America that I believe that the theories of The New Art will hold most tenaciously. I have come here to appeal to the American people to accept the New Movement in Art in the same spirit with which they have accepted political movements to which they at first have felt antagonistic, but which, in their firm love of liberty of expression in speech, in almost any field, they have always dealt with with an open mind. When my paintings are exhibited in this coming exhibition [the Armory Show], if they arouse the same adverse and the same antagonistic criticism that they have aroused in France, I shall have a basis on which to appeal to the American love of free expression in all fields of activity.[13]

However, Picabia's confidence, based upon American rhetoric about its political institutions, was probably shattered by the generally negative reception of New York critics to the Armory Show.

At this point, however, Picabia's outlook shared more with Futurism than with Dada. Whereas later on he would refer to Cubism as "une cathédrale de merde," here in this interview he merely shrugged Cubism aside as a form of realism, inadequate to express sensibilities shaped by the new technological environment. From his inveterate love of automobiles, he drew an example that clearly demonstrated his Futurist attitudes toward the machine:

> I paint a picture of an automobile race. Do you see the cars rushing madly ahead in my picture of that race: No! You see but a mass of color, of objects that, to you, are strange, maybe weird. But if you are used to, if you are capable of, accepting impressions, from my pictures of an automobile race you will be able to achieve the same suggestions of wild desire for speed, the excitement of that hundred mile an hour rapidity, that the driver himself feels. I can throw colors, the idea of movement on a canvas that will make you feel and appreciate that.[14]

Consequently, Picabia and Marin found they had much in common during 1913, with their romantically optimistic feelings toward the machine and their skyscraper environment of New York City. Picabia, as the nominated leader of the new art, was apparently safely esconced in Futurist attitudes, heading toward a purification of painting consonant with its urban surroundings.

His new trend in painting, despite the alarm of conservative American critics, remained within the bounds of art. Iconoclastic and

chaotic on the surface—at least to those viewers unaccustomed to European modernism—Picabia's work was based upon a rationale and an order that was intelligible to anyone with an open mind. Moreover, his arguments, couched in moderate language, possibly in order to appeal to a conservative public, could hardly be called inflammatory. But there were hints in the pages of *Camera Work* that modern art might embark upon other roads, leading to the creative disorder and nonsense of Dada.

In the Special Number also appeared an article from the French journal *Les Hommes du Jour*, entitled "Vers L'Amorphisme," and which forecast new directions in art with apocalyptic undertones. To elucidate its position, the article offered a brief account of the development of modern painting, beginning with Monet's Impressionism, from which Cubism eventually evolved. The writer expounded a logical culmination of the ensuing avant-garde factions in a manifesto of "Amorphism":

> Guerre à la Forme!
> La Forme, violà l'ennemi!
> Tel est notre programme
> C'est de Picasso qu'on a dit qu'il étudiait un objet comme un chirugien dissèque un cadavre.
> De ses cadavres génants que sont les objets, nous ne voulons plus.[15]

While art here is not killed outright, the "Amorphist" manifesto obviously wanted to deal a mortal blow to its essential formal nature.

After explaining that light absorbs the form of all objects, the manifesto offered an example of "Amorphist" painting: "Prenons l'œuvre géniale de Popaule Picador: *Femme au Bain*." Illustrated beneath the invitation was a blank rectangle followed by this commentary:

> Cherchez la femme, dira-t-on. Quelle erreur!
> Par l'opposition des teintes et la diffusion de la lumière, la femme n'est-elle pas visible à l'œil nu, et quels barbares pouraient réclamer sérieusement que la peinture s'exerce inutilement à esquisser un visage, des seins et des jambes?[16]

By this time, the reader realizes that he has been tricked. What began in an apparently serious tone gives way to mockery—of the reader as well as of the new art and its practitioners (Popaul Picador: Pablo Picasso? Francis Picabia?). And yet, even as a spoof, this article had an element of seriousness.[17] Unlike Dada, which lashed out at every-

thing, including itself, this manifesto thrust in a single direction, against the new tendencies in art. Saved by a sense of humor, the article was nonetheless a jeremiad, clinging to the conservative in art. But even so, it foreshadowed Dada in its tone, occasionally revealing a destructive mockery that Picabia and Duchamp would soon employ against all art and art movements. Ironically, too, the Amorphist hoax anticipated the eventual silence of Duchamp in the blankness of its suggested "canvas," which was indeed the logical culmination of the gestures of Dada.

While the brief flash of "Amorphism" implied Dadaism in its own, rather limited way, there were other, more sustained developments in *Camera Work* that also forecast Dada. For example, the writings of Benjamin De Casseres, who first appeared in the pages of *Camera Work* in 1908, fell within this realm. Hardly a Dadaist, Casseres was a *fin de siècle*, rather genteel, romantic. But even from this perspective, his statements, stripped of their oftentimes sentimental nature, point to nineteenth-century undercurrents that Dada was to mobilize in its quest for a destructive renewal of the creative process.

Casseres was a blunt critic of American culture in matters pertaining to art. In an article entitled "The Art 'Puffer,'" he harshly attacked American critics: "Today, art criticism is the art of the stool-pigeon, the go-between between the advertising staff of many of the great metropolitan dailies and the art dealers, who pay, pay, pay." Even though the animus clearly existed, his rhetoric defined the limits of his criticism. Unlike the Dadaists, Casseres did not hold an absurd mirror up to his society. Although he sensed its bankruptcy — "this age of shreds and pasteboard, of superficialities and stupidities, of inanities and material prosperity" — he stopped short of aping in word or deed the vicious nonsense of the time with his own nonsense.[18] Casseres could wag his finger in admonition, but he restrained himself from thumbing his nose in derision.

Nevertheless, he foresaw elements in art that would lead to its destruction at the hands of the Dadaists. For example, as early as 1911, he envisioned the artist as "a tool in the hands of the Unconscious," and he celebrated the imagination as "the realm of the gorgeous, monstrous hallucinations of the Unconscious." And although, as might have been expected, he extolled the irrational as "the apotheosis of the Intuitive," he also went so far as to assert that "The Intellect is bankrupt. It is only a park pond. The Mississippi and the Amazon flow

through the heart. All ends are myths. Life itself explains life. Chance, danger and the irrational constitute the new Trinity."[19] The outlook approximated that of a Tristan Tzara or a Hans Arp, who, only a few years later, would dance to a similar tune.

Casseres' observations in "The Ironical in Art" were even more closely related to Dada. Surveying his times, he maintained that "There is a revaluation going on in the art of the world to-day. There is a healthy mockery, a healthy anarchic spirit abroad. Some men are spitting on themselves and their work; and that is healthy too." As he concluded, "it is a glorious age and a glorious anarchic world of color, motion, vibration and scintillating creative-destructiveness!" Here Casseres had arrived at the central contradictions that would explode as Dada, and offered a summary benediction of attitudes that Dada would adopt: "We should mock existence at each moment, mock ourselves, mock others, mock everything by the perpetual creation of fantastic and grotesque attitudes, gestures, and attributes."[20]

Although the central attitudes in his essays were proto-Dada, Casseres never went the whole way. He stood at the threshold of Dadaism's anarchy and nihilism, but never entered in. His significance lay in the articulation of values that Dada was soon to appropriate for its own ends. For Casseres, however, those values were rooted in the nineteenth century. Partly because he was sentimental and somewhat prone to preciosity, but most particularly because he could not free himself from the past, he was unable to participate in future developments.

A more sustained discourse of proto-Dada attitudes can be found in the writings of the caricaturist Marius De Zayas, whom Sadakichi Hartmann portrayed as "a natural iconoclast" who "beats against the iron doors of tradition." Indeed, for Hartmann, a caricaturist flirts with anarchy, for he is "the thrower of mental bombs of contempt and despair." But even if Hartmann's somewhat inflated description were accurate, there was another side to De Zayas, who, in answer to Stieglitz' question, "What is '291'?" offered the following self-characterization: "I belong, or at least I believe I belong, to that class that Carlyle describes as 'cause-and-effect speculators', a class for whom no wonder remains wonderful, but all things in Heaven and Earth must be computed and 'accounted for'."[21] In the course of developing his attitudes toward art, De Zayas' impulse to explicate and analyze his experiences dominated his iconoclastic bent as a caricaturist. Con-

sequently, he rationalized many attitudes central to Dada. Like Casseres, he did not translate his feelings into Dada gestures, and thus remained on the periphery of Dada until his collaboration with Picabia and his machine portraits for *291* in 1915. De Zayas' ideas, expounded in the pages of *Camera Work*, reveal not only his increasing predilection for the Dada values that Picabia would fully enunciate in 1915, but also the anti-art complexities underlying straight photography and its implications for painting and American culture.

In 1911 De Zayas described his reaction to "The New Art in Paris." In the belief that America suffered a paucity of modern art, and that, despite the efforts of "291" New York afforded only isolated glimpses of the exciting work being done in Europe, De Zayas eagerly went to the Salon d'Automne. "I wanted first to get an idea of ensemble, and afterwards to study the details, which is a system as good as any other. But I could not understand anything. I looked, but did not see: it seemed to me as if I were in the Tower of Babel of painting, in which all the languages of technique, color, and subjects, were spoken in an incoherent and absurd manner." As though following the course of Henry James' archetypal American, De Zayas was inflicted with Christopher Newman's "aesthetic headache," and confused by the paintings, he sought relief: "Wearily I sat down on a bench, and closed my eyes. It seemed to me I was the victim of an atrocious nightmare."[22]

But De Zayas soon recovered, however, and arrived at some conclusions that were to form the basis for his later views. He interpreted the apparent chaos of the Salon as a sign of artistic freedom, out of which new trends of art would develop, and indeed he detected a return to primitivism in the radical work of the exhibitors. So impressed by what he had seen, De Zayas celebrated Paris as the ideal urban center for the artist, free to create in a liberal environment for a tolerant public.[23] Although more apparent than real, the openness of the Paris art world was nevertheless to serve as a yardstick for De Zayas to measure the American public's unwillingness to accept the new art.

In the same issue of *Camera Work* De Zayas wrote an article on Picasso that gave a preliminary statement concerning criticism in which he asserted the subjectivity of judgment and the need for tolerance. Although possibly aroused by the intransigence of particular American critics, De Zayas most likely based his criticism of the crit-

ics upon a recognition of his own impulses. "Every critic is the priest of his dogma, of a system; and condemns implacably what he finds to be out of his faith, a faith not reasoned but imposed," he claimed. On the other hand, his condemnation was buttressed by the assumption that the artist should possess freedom of expression.[24] This point of view was later to be proclaimed by Dada, which desired complete freedom in the arts. But De Zayas vacillated between that desire and the critic within himself. Ultimately, the assimilation of these divergent attitudes resulted in a hybrid version of anti-art that was to abstain from the anarchy of Dada.

One year later in 1912, De Zayas wrote an article entitled "The Sun Has Set"—a departure from his previous two essays, which had already prepared the new direction he was to take. Here he dramatically proclaimed that "art is dead": "Its present movements are not at all indications of vitality; they are the mechanical reflex action of a corpse subjected to a galvanic force." With his penchant for systemizing, De Zayas offered a programmatic explanation of the causes for the supposed death of art. A religious world-view had been replaced by a "positivistic spirit" which nurtured capitalism and industrialism. Consequently, "art, which is a striving toward the Ideal, has succumbed to Industry, which is a striving for the Real." Art, had been driven from the center to the periphery of cultural concerns and "reduced to a diversion for the idle intellectual people."[25]

In turning to modern art, De Zayas perceived a welter of contradictory and invalid impulses at work. Primitivism, an element that he had probably extrapolated from Picasso's interest in African sculpture, was supposedly predicated upon unconscious creation, whereas in contrast "the modern artist is the prototype of consciousness. He works premeditatedly, he dislocates, disharmonizes, exaggerates premeditatedly." Created out of a fatal self-deception, what passed for vital, "new" art actually imitated the age, which was "chaotic, neurotic, inconsequent, and out of equilibrium."[26] De Zayas' insights focused upon one of the dilemmas of experimentation: how could the modern artist achieve, out of his acute self-awareness, a genuine spontaneity in his radical efforts to return to the essentials of creativity?

Since for De Zayas there was no viable alternative, he proclaimed the death of art. But given his cyclical view of the development of art, he was able to conclude on the optimistic note "that death is not absolute but relative, and that every end is but the beginning of a

new and a fresh manifestation."[27] Like the Dadaists, De Zayas saw the processes of destruction and creation inextricably woven together, and could criticize and condemn what he saw as a moribund formalism in the new art. But in this particular essay he did not attack the concept of art itself, as many Dadaists would. Instead, he limited himself to criticizing only a particular manifestation of an art which imitated primitive form.

Rather than settle within the framework of art, however, De Zayas went on to explore new avenues of creativity in his next essay entitled "Photography." "The Human Intellect has completed the circle of Art," he maintained. "Those whose obstinacy makes them go in search of the new in Art, only follow the line of the circumference, following the footsteps of those who traced the closed curve. But photography escapes through the *tangent* of the circle, showing a new way to progress in the comprehension of form." Photography could break from the circle because, he claimed, "photography is not Art. It is not even an art. Art is the expression of the conception of an idea. Photography is the plastic verification of a fact."[28] De Zayas based the dichotomy of art and photography in part upon the tenuous premise that the latter required only mechanical manipulation, whereas art necessarily involved human values and ideals in its realization. His argument, however, led to some interesting possibilities for a camera aesthetic in asserting that photography, not art, could achieve true form:

> In order fully and correctly to appreciate the reality of Form, it is necessary to get into a state of perfect consciousness. The reality of Form can only be transcribed through a mechanical process, in which the craftsmanship of man does not enter as a principal factor. There is no other process to accomplish this than photography. The photographer—the true photographer—is he who has become able, through a state of perfect consciousness, to possess a clear view of things as to enable him to understand and feel the beauty of the reality of Form.[29]

Like others before him, De Zayas also conceived the mechanical function of photography as consonant with the times: a fact-oriented culture demanded a fact-producing means of representation.

De Zayas believed that technique was of minimum importance to photography, which he viewed as an essentially mechanical and non-human process. The photographer was passive; beauty, inherent in the "reality of Form," could be achieved through the machine without human interference. As he wrote in a letter to Stieglitz, this passivity was indeed desirable, since "photography can be made not to

be art if only the non-sensitive camera is left to be efficient and show results."[30] In the final analysis, art betrayed form:

> The more we consider photography, the more convinced we are that it has come to draw away the veil of mystery with which Art enveloped the represented Form. Art made us believe that without the symbolism inspired by the hallucination of faith, or without the conventionalism inspired by philosophical auto-intoxications, the realization of the psychology of Form was impossible; that is to say, that without the intervention of the imaginative faculties, Form could not express its spirit.[31]

In the next issue of *Camera Work*, however, with an article entitled "Photography and Artistic-Photography," De Zayas reassessed his original categories. Recognizing their arbitrary nature, he refined them by distinguishing further between two kinds of photography. "Photography is not Art," he still maintained, "but photographs can be made to be Art." Thus he arrived at the concepts of straight and pictorial photography within the art/anti-art framework of his own views. For De Zayas, straight or "pure" photography captured the unadulterated form of nature, whereas "the artist photographer uses nature to express his individuality." At this point of comparison, De Zayas could not decide which of the two modes was superior. Although he still clung to the distinction between art and nature—the fulcrum of his art/anti-art ambivalence—his approval of both modes suggests that he was not doctrinaire. By citing Stieglitz and Steichen as successful practitioners and proponents of straight and art photography respectively, he revealed that creativity was the overriding criterion for his anti-art views.[32]

The situation, as De Zayas saw it, was not the same in painting. In an essay entitled "Modern Art: Theories and Representation," he followed Picabia in noting the dual nature of modern painting, which "presents the phenomenon of being equally subjective and objective." In his view, however, "We could say that one is a 'mental' analysis while the other is a 'plastic' analysis. With its theories it wants to get at the subjective truth; and with its practice at the objective truth." Although he saw a parallel between modern painting and science, he felt that the former fell short of the latter. Indeed, he saw the dualism of modern painting as crucially disjunctive because "it has not been able to give a convincing proof of its representations by its theories."[33] For De Zayas the internal weaknesses of modern painting were sufficient to justify his opposition.

After the outbreak of European hostilities in 1914, De Zayas

wrote to Stieglitz, "I believe that this war will kill many modern artists and unquestionably modern art. It was time, otherwise modern art would have killed humanity. But what satisfies me is that at least we will be able to say the last word."[34] Presumably, De Zayas had washed his hands of modern painting. Nevertheless, the scientific element that he perceived in modern art intrigued him. In "Modern Art: Theories and Representation" he had expanded upon its scientific method and goals:

> Formerly art was the expression of a collective or individual belief; now its principal motive is in investigations. It proceeds toward the unknown, and that unknown is objectivity. It wants to know the essence of things; and it analyzes them in their phenomena of form, following the method of experimentalism set by science, which consists in the determination of the material conditions in which a phenomenon appears. It wants to know that *significance* of plastic phenomena, and accordingly, it has had to enter into the investigation of the morphological organism of things.[35]

Although the analogy between the experimentalism of science and that of modern art was at best dubious, the comparison, nevertheless, allowed De Zayas to view modern art in terms of progress: it did not have to die out in his era. Moreover, the analogy provided a rational order for modern art as it progressed into the unknown. Finally, he had characterized the avant-garde in such a way that it might not be hampered by a dead art in its experimentations.

Thus De Zayas was able to continue, despite his pessimism. In 1915 he opened the Modern Gallery, with Stieglitz' approval, as a healthy means of sustaining contemporary artistic experimentation. But at the same time, he was still hesitant to label such work "art," as he announced in *Camera Work*: "Here modern and primitive products of those impulses which for want of a more descriptive word, we call artistic, will be placed in exhibition and offered for sale."[36] Even more important was his collaboration with members of the Stieglitz circle on the magazine *291*, which was devoted to the experimentation of the day. Throughout 1915, the year in which *291* appeared, *Camera Work* was not published, and it was later resumed for only two more issues. Though the magazine was not committed to Dada, *Camera Work* nevertheless expostulated anti-art views concerning the merits of straight and pictorial photography in relation to modern painting. In these discussions the magazine set the stage for the proto-Dada efforts of *291*.

2 | *291* and Francis Picabia

By 1914 the Stieglitz circle was aware of the activities of Guillaume Apollinaire, the French avant-garde poet and self-proclaimed champion of modern art. Apollinaire's magazine, *Les Soirées de Paris*, provided the indirect means of communication. "That the 'Soirées de Paris' crowd must be interesting goes without saying," Stieglitz wrote to De Zayas, who had returned to Paris. "Haviland," he added, referring to a close friend who would write for *291*, "gets its magazine." De Zayas' reply favorably assessed the efforts of the French poet: "He is doing in poetry what Picasso is doing in painting. He uses actual forms made up with letters. All these show a tendency toward the fusion of the socalled arts." The realization of artistic cross-pollination, which De Zayas had forecast as early as 1910, made it all the more imperative that he increase communication between French and American artists. "I am working hard in making these people understand the convenience of a commerce of ideas with America," he wrote. "And I want to observe the spirit of what they are doing to bring it to '291.' We need a closer contact with Paris. There is no question about it."[1] The cultural gap between France and America in artistic matters, dramatized so shockingly by the Armory Show, had to be narrowed.

It was partly out of this need to develop relations with France that the Stieglitz group published *291* during 1915 and early 1916. Paul Haviland, Marius De Zayas, and Agnes Ernst Meyer, the wife of the publisher of the Washington *Post*, proposed the idea to Stieglitz in January 1915. The photographer took a detached stance toward the project. "I was more or less an onlooker," he indicated, "a conscious one, wishing to see what they would do so far as policy was concerned if left to themselves." In other words, he allowed them the freedom to experiment and to publish anything they found of interest.[2]

Paralleling the need to further international relations was a desire to emulate the French, so that *Les Soirées de Paris* ostensibly became

the model for *291*. Like *Les Soirées*, *291* cut across the arts, but whereas Apollinaire's magazine followed a conventional format, interspersing essays, poetry, and fiction with illustrations, much in the manner of *Camera Work*, the Americans conceived of *291* along the lines of Apollinaire's poetry. As *Camera Work* announced in retrospect, "'291' is always experimenting. During 1915–16, amongst other experiments, was a series with type-setting and printing. The experiments were based upon work which had been done with type and printers' ink, and paper, by Apollinaire in Paris, and by the Futurists in Italy. No work in this spirit had as yet been attempted in America."[3] Hence, rather than conduct artistic experiments within an issue, the editors of *291* viewed each issue as an experiment in itself that would relate the verbal to the visual. And although *291* was more than a magazine of experimental typography, it was nevertheless a forerunner of those Dada publications, particularly Picabia's, whose print would explode off the page.

In contrast to *Camera Work*, which, because of its format, was inadequate to the group's goals, *291* was to be "a monthly magazine devoted to satire and related to some of the things which are being done in France in a modern sense."[4] Although *Camera Work* had not sustained satire and experimentation,[5] it had posed important questions of an anti-art nature that the group felt should be explored most fully and cogently through creative activity. Consequently, *291* would pursue a dual goal of satire and experimentation so as to become "a real instrument of expression of the day."[6] Since the editors could not ignore the restrictions of a conservative artistic climate, they considered satire a potent means of breaking the negative bonds that hindered creativity.

Neither the group's satire nor their experimentation was entirely successful, however, until Picabia brought the two together in his machine drawings. Nor did every issue of *291* reach the same peak of achievement, for the quality of most issues was determined by the particular preoccupation of the editors at the time. Thus the first three issues were marked by a concerted attempt to create an identity, and whereas the third declined in quality, the fourth improved as the magazine moved toward Dada. A climax was reached in Number 5–6, which was devoted to Picabia, who had returned to New York in June 1915. The following two issues (Nos. 7–8 and 9) pushed further in the same direction, exploring the implications of Picabia's machine draw-

ings, while the last two (Nos. 10–11 and 12), comprising the review's final phase, turned from Dada to aesthetic criticism once again.

De Zayas' cover for the first issue of *291* (March 1915), which presented a semi-abstract image of a human figure, was meant to convey the review's commitment to modernism, inasmuch as the "abstract," referring to Cubism or any of its variants, was then dominant in avant-garde art. The caption, "291 throws back its forelock," suggested a personification of Stieglitz' gallery in echoing the line of contributors to *Camera Work* who had answered the question, "What is '291'?"[7] It also reflected De Zayas' illustration, with the mild gesture of defiance implicit in the tossed forelock, reinforcing the expression of self-mockery in the orange bug-eyes, the sharply pointed nose, and the black rectangular gap for a mouth. Indeed, the gentle wit suggested that the review and its stance were not taken too seriously by either the editors or their contributors.[8]

Paul Haviland dealt more explicitly with the nature of "291" (referring, in this instance, not only to the magazine, but to the gallery as well) in a dialogue between "The Professor" and "291" as personae.[9] The dialogue attempted to create a semimythic context in which certain attitudes toward avant-garde development were articulated, though in a somewhat contradictory fashion. Anticipating Dada, Haviland first identified the "291" spirit closely with avant-garde freedom, claiming that "291 represents nothing definite; it is ever growing, constantly changing and developing," in order that there be infinite possibility for creation outside the encrustations of academic institutions. On the other hand, the Professor narrowly defined avant-garde growth in terms of scientific experimentation, a position which approximated that of De Zayas. The underlying tension between creative freedom and rational order was finally resolved by the Professor's emphasis upon a dynamic rationalism, which served as a guideline for "291" in its avant-garde quest, "What next?"[10] Experimentation here was meant not to be an end in itself but rather to lead to new empirical laws which, in turn, would facilitate new artistic discoveries.

In the attempt to plot a course for "291," Haviland's dialogue suggests a nascent dissatisfaction with the drift he sensed permeating the Stieglitz circle. But the unforeseen Dada phase of the review, though it provided direction, highlighted the dangers of applying false analogies of scientific experiment to artistic endeavor. These

pitfalls were dramatized by an otherwise perceptive essay by Agnes
Meyer. Addressing herself to American art criticism, she railed
against its "most unintelligible twaddle," those subjective methods
of criticism grown obsolete and futile. Like De Zayas, Agnes Meyer
upheld the concept of evolution in art, terming its latest development
of "pure reason" the "SCHOLASTIC PERIOD OF ART."[11] But like the
Dadaism to come, she tended to deplore this rationalist trend and
suggested that the critic adopt an empirical stance as a corrective.
He must forsake his impressionistic evaluations for a rigorous ex-
perimentalism so as to work in tandem with the artist. Despite the
possible failure of many experiments, out of their cooperation would
emerge a new art with its own laws and its own integrity.

Although her tolerance of experimentation fell within the dic-
tates of Dada, she went off on a tangent in misapplying a scientific
analogy to the creative process—a conceptualization that surely ran
counter to her desire to free the artist from all restrictive systems.
Moreover, the artist's "experimentalism" differs qualitatively from the
critic's, since the creative process involves more than rational manipu-
lation. Thus despite a recognition of the emotional dimension of art,
her polemic was weighted in favor of the rational. Even so, her insis-
tence upon the integrity of the artist's efforts could well produce un-
foreseen results. Indeed, her guidelines for experimentalism could
easily transform rational deliberation into the deliberately irrational
pirouettes of Dada.

The first issue of 291 provided little to support its claims of
experimentation. Its best offering was an "ideogramme" entitled "Voy-
age" by Apollinaire, reprinted from *Les Soirées de Paris*.[12] Its pub-
lication indicated the efforts of 291 not only to promote international
discourse but also to bridge the cultural gap between French and
American art. Attempts at satire—presented in a newsletter format—
were the weakest aspect of the issue. Stieglitz later explained this
failure in national terms. "The American seemed to be afraid of sat-
ire, afraid of caricature," he claimed. "He did not mind cartoons, ever-
lasting cartoons. Caricature could not exist in America." But he was
dismayed when "eventually it was decided before printing number I,
that too much satire, too much truth-telling about how the game of art
and its business was played, should not appear in 291."[13] Possibly the
group felt that satire would siphon off too much attention and energy

from experimentation at a time before the two had been synthesized, as in Picabia's machine drawings.

Although the first issue of the review did not fulfill its promise, the editors attempted to work out a specific ambience for subsequent issues. While the second number, dated April 1915, more or less followed the format of the first, it did contain a most promising contribution, a visual poem entitled "Mental Reactions" by Marius De Zayas and Agnes Meyer. In the manner of Apollinaire, they made the first successful American attempt at relating the verbal to the visual as a prelude to Picabia's machine drawings. This collaboration, though hardly a Dadaist conception, certainly appeared to be radical at the time. Its importance lay in the fact that the Stieglitz group could quickly assimilate Apollinaire's techniques to create a work that had merits of its own. They managed to meet and resolve a technical challenge, transcending the level of mere exercise.

In the first issue, under the heading of "Simultanism," the editors had postulated the problems involved in verbally expressing simultaneous thoughts and emotions: "In literature the idea is expressed by the polyphony of simultaneous voices which say different things. Of course, printing is not an adequate medium, for succession in this medium is unavoidable and a phonograph is more suitable."[14] The visual poem in the second issue demonstrated, however, that the desired nonlinear and nonlogical effects could be achieved on paper without a phonograph, thereby anticipating the simultaneous poetry of Zurich Dada. As the first of several poems in *291* that would center on womanhood or be written from a feminine point of view, "Mental Reactions" ultimately pointed to the myth of the female machine, expressed in the November issue by Picabia's drawing *Voila Elle* printed beside De Zayas' exploding poem "Femme."

"Mental Reactions" is set in the boudoir of a New York apartment amid the "silence of snow-covered roof-tops" at twilight. A woman takes in the view from her bedroom window and observes that "New York is best from the back and from above" (the perspective in many of Stieglitz' photographs). She hears the clock sounding six; and she responds to the interior decoration of her apartment with an anti-art loathing that is hardly coincidental: "Whenever I pass that canvas I want to put my foot through it." As she prepares her toilette, she notices her cosmetics: "Parfumerie-de-Nice. / N-I-C-E. / Sunshine. /

Flowers. / Color. / Land of eternal loves,"[15] The erotic promises of her jars are in ironic contrast to her own sexual problems, for throughout the woman's reactions and impressions runs a scattered and eliptical meditation upon her identity, particularly in relation to her husband. In fact, she is revealed to be a female Prufrock who has difficulty affirming her own life. "He is telling me this . . . / to find out whether I have dared to live." As she explores her dulled emotions, rejecting "our grey passions pathetic as that struggling city tree— evanescent as that melting city snow," she comes to see herself as small, egotistical, and selfish: "Ah, why cannot all the loves of the world be mine? / without the sacrifice of any of those things I think of when I say / MYSELF / Sacrifice? Coward, cheat. / Yes, we women, cowards, cheats all of us who, when our / kingdom is offered, stop to calculate the price."[16] Anticipating Prufrock, this woman has already measured out her life with coffee spoons.

The formal significance of this work lies in the integration of its visual and verbal elements. Otherwise, the play of figurative language taken alone is hardly complex; nor do words and letters create visual patterns as in Apollinaire's ideogramme, where, for example, a group of words forms the pattern of a bird in flight. Much more important in the American poem is the relationship between the visual design and the words themselves. A close reading reveals that the words move down the page in roughly two columns so that the eye may note a linear progression. But the abstract, geometrical shapes that move diagonally integrate the two columns and obliterate their linear logic. This spatial dislocation is also caused by the visual ambiguities of words and phrases that cut across planar elements so as to lend motion to the total design. Moreover, the nervous thrusts of the visual lines add another dimension of motion, suggesting thought processes in action. In these ways, an illusion of mental simultaneity is created, the random chaos of thought occasionally interpenetrated by its own internal logic and rhythm.

The successful collaboration on "Mental Reactions" was only half-heartedly pursued, and scarcely fulfilled, in the next number, published in May 1915. The inside spread was devoted to poems which were minimally integrated by De Zayas' visual design. On the left was an untitled poem by Katherine H. Rhoades, whose typographical arrangement was derived from Whitman's poem "A Patient, Noiseless Spider." A woman walks into a concert hall to hear the last act of

Die Meistersinger. She experiences "a condition of oneness" with the music and audience. As the feeling grows and then recedes, the lines of the poem extend and then shorten. Of less significance was the poem on the facing page, entitled "Woman," by Agnes Meyer. Meditative, and explicitly pessimistic, it amounts to a prose statement rather than poetry. In neither case was viable interplay achieved between verbal and visual elements. The cover by Abraham Walkowitz—depicting turbulent dark forms with the title "291" at the vortex—augured, in retrospect, either a morass of forthcoming mediocrity or a spiral into Dada.

And indeed, the fourth issue, dated June, 1915, spiralled straight into Dada. One of John Marin's New York skyscraper series graced the cover, the best yet: its nervous calligraphy, combined with the disintegration of forms, suggests the dynamic energy of the city; the amassing of shapes at the base of the skyscraper moves rhythmically upward and develops a concentration of strength at the center, exploding in all directions. For it was this energetic movement, above all, that characterized Marin's romantic attitudes toward an urban environment wrought by technology.

What might have been merely a continuation of those attitudes expressed earlier in *Camera Work* was abrogated by a turn of the page. For on the back of Marin's cover appeared Picabia's black and white drawing *Fille née sans mère.* Much as Duchamp painted his *King and Queen Traversed by Swift Nudes* on the back of a canvas portraying Adam and Eve, Picabia's *Fille* reflects the opposite side of Marin's technological paradise. In conceptualization as well as content, Picabia's drawing assumes anti-art proportions with its minimal sketching and plays against the aesthetic expression of Marin's skyscraper.

Picabia sketched a mechanomorphic form without any rational structure whatever. Springs, rods seemingly disconnected, tangled wires, and templates all lend recognition to the form as a machine, but no function, order, or tangible working is discernible. The seemingly logical paraphernalia of machinery ironically feeds upon itself so as to undercut its own logic. In addition, the machine takes on a post-fetal life of its own: an organic body with billowy shapes emphasizes the erotic quality of the metamorphic breasts, eyes, or nipples. Witty yet ominous, Picabia's *Fille* suggests the mysterious machine creation of man ("née sans mère"), henceforth capable of autocreation. A religious icon, with polarized inversions from virgin birth to hetaera, it might

well deserve the prayer of a Henry Adams to an "occult mechanism."

The anti-art mechanism of Picabia's drawing was reinforced by "Flip-Flap," a free-verse poem by Katherine N. Rhoades. In contrast to her previous poem, with its Whitmanesque attitudes toward art and life, the narrator of "Flip-Flap" assumes anti-art attitudes while listening to a piano solo in a large concert hall. Whereas previously she admired the "sound, / giving, / Will. feeling, / an insistent entity reached," now she scorns the music as "manufactured Soul-stuff for those who dare not create." In the previous poem the narrator became "a part of the attunement of the moment" with the audience; now she despises the audience with their "cringing, countless, / round heads, and shapeless — and hair upon hair — and hats — and heads again." The music projects a "tuned-up Beauty" which "flatters some few hundred humans." The audience is enthralled by the music, "yet all these souls are flapping and turning / and beating and yearning."[17] Their emotions suggest the mechanistic swing of the "Flip-Flap," the giant amusement ride at the Franco-British Exposition of 1908:

> Emotions gyrate in the heavy air, keeping time with the
> whirl and swirl of perfectly poised tones.
> Sound and sound and sound
> Rippling —
> Flip-flap.

Spasmodically and absurdly enslaved, the narrator sardonically comments, "We are great! we men of inner response."[18]

As an escape, the narrator offers her soul what was to become a Dada antidote. "But you — Soul — could you laugh, yours would be the miracle — / Chopin and Schumann against your laugh! / Why don't you?" Her response, near the end of the poem, is curious:

> Why mock the Artist? the Art that does the trick? the thing
> that stirs and sighs?
>
> What's a laugh to that?[19]

These questions possess undertones of rhetorical ambiguity. Either the artist and his work should be mocked, thereby suggesting that the questions are indeed rhetorical, needing no response except laughter, or the questions contain elements of self-doubt. The answer undercuts their rhetorical nature:

> A Laugh! such as this would be — could I laugh now!
> Out into this sea of dreadful stutterings I'd throw an inversion —
> a revision —
> Fool!

A Whole Self—laughing—
Yes, all—only my body dead—left here—
 Flip-flap—

 But the laugh?
Suppose they didn't feel a life float there before them—laughing—
Didn't know just what a soul sounds like—
 Could I ever stop?
 Who's laughing?

Laughter would turn the entire experience upside down, mocking the artist and his work, and would restore the soul as "a Whole Self."[20] The two final questions, however, suggest the fear of acquiescing to laughter, which might destructively turn upon the person laughing—a possibility, of course, that Dada assiduously courted. The very fact that Katherine N. Rhoades could only talk about laughter without articulating or provoking it in her poetry reveals both her distance from and proximity to Dada.

By June of 1915, Picabia—whose life had been radically changed into a nightmare by the war in Europe—had returned to New York, supposedly on a military mission to Cuba, a mission that was side-tracked by his arrival in Manhattan. But unfortunately, his stay in America did not ameliorate his state of mind. Described by the Dada historian Sanouillet as lost in an existence "fiévreuse et tourmentée," Picabia nevertheless found some respite among the small circles of artists around Stieglitz and Walter Arensberg.[21] In fact, he had returned just in time to collaborate on the July-August issue (No. 5–6) of *291*, which was devoted to five of his machine drawings, related to an essay by De Zayas. Unlike the previous issue, with its scattered Dada implications, the Picabia number made a direct and unified assault on art and culture.[22]

The drawings portray Stieglitz, Picabia himself, Haviland, and De Zayas, while the fifth presents a generic figure, the young American girl. For each one, Picabia chose an element that was particularly characteristic of the individual, so that Stieglitz, for example, is represented by his camera. None of the drawings is abstract, each consisting of a recognizable mechanical device—a camera, an automobile horn, a spark plug, an electric lamp, and so on. And all of the drawings are quite linear, in black and white, with a machine element in an occasional red or blue.

In the last issue of *291* (No. 12, February 1916), Picabia explained

the significance of his works' titles: "The subjective expression is the title, the painting the object. But this object is nevertheless somewhat subjective, because it is a pantomime—the appearance of the title; it furnishes to a certain point the means of comprehending the potentiality—the very heart of man."[23] Viewed for the first time, however, these drawings present some difficulties in relating their content to the captions. The Stieglitz portrait, for example, bears the caption, "Içi, c'est içi Stieglitz / Foi et Amour." The phrase, quite obviously, pays homage to Stieglitz, who is depicted by a drawing of a camera. But the imagery undercuts, if not the homage, at least any nascent sentimentality. The camera, which at first glance would seem to be drawn in strict representational terms, is in fact distorted by multiple views. The box and the lens are shown from different perspectives, while the middle apparatus appears flat on the plane of the page. There is, moreover, a total discontinuity between the lens and the film box. The twisted bellows falls slightly to one side, parodying a limp phallus. Other mechanical elements bear no logical relationship to the functioning of the camera. And it soon becomes evident that the camera does not work; the "ideal," written in English script above the lens, will never be attained. What sort of tribute, then, did Picabia intend?

The second drawing, a self-portrait of Picabia, is of an automobile horn. The phallic overtones of its interlocking elements indicate Picabia's self-mockery. He is, so to speak, "blowing his own horn," anticipating his pseudonym, "Funny-guy," the life of the party, the American wiseguy. But does this broad humor mean that none of these drawings is to be taken seriously? Apparently not, because in the next drawing, a *Portrait d'une jeune fille américaine / dans L'état de nudité*, the young girl is depicted as a spark plug. Hence she is figuratively stripped of all sensuality, foreshadowing the sterility of American pin-ups. Drawn in stark black and white, with severely precise lines, the spark plug has a phallic quality that perhaps suggests the latent masculinity of the "emancipated" American female, who exhibits her frigid nature with a mechanical spark of love and no evident passion. The spark plug's brand-name, "Forever," ironically echoes the slogan of valentines, while denoting the lasting quality of the product. Indeed, the young American girl becomes a commercial package, replete with artificiality. Clearly, then, this stringent cultural criticism, with its aggressive wit, demands that the drawing be taken seriously.

Yet the next portrait, that of De Zayas, appears to be highly per-

sonal and private. The machine representing him is a most enigmatic contraption whose function can be only surmised.[24] In the upper right-hand corner is a sighting device, such as one might see along an ocean boardwalk. Beside this device is the assertion, "J'ai vu," with a diagrammatic line that guides the eye from the viewing apparatus to a corset, apparently intended for a buxom woman. The garters of the corset, as well as the crotch, are attached to the rods or pipes of the machine, and lead eventually to two suction cups, which rest in the water. These appendages are possibly witty substitutes for the legs of the missing female who belongs to the corset. There is also a steering wheel beside the eye-viewer that might start the machine after change is dropped in the slot. A series of wheels and rods, if they could turn, would cause the corset to shimmy, and eventually, perhaps, strip the discreetly absent woman of her corset. Only after the viewer of the drawing has played with the mechanism does he realize his own complicity. He has, in effect, become the peeping tom of the drawing, vicariously taking in a girly-show.

The final drawing of Haviland ("Voilà Haviland"), however, shifts from licentiousness to the realm of poetry. Haviland is portrayed as a blue electric lamp, complete with a black cord that partially encircles the bulb. The cord has no plug, thereby suggesting a lack of current.[25] This omission might indicate that Haviland is lost, perhaps alienated by the war or by American culture itself. The caption announces that "la poésie est comme lui," from which two other meanings can be derived. Either poetry is worthless, since there can be no light without a plug, or else poetry is intuitional, without logic, since there are no visible means of current. Read on a symbolic level, then, the logical circuits that constitute prose discourse would not apply to poetry. Although Haviland's alienation, if indeed that were the case, would not be incompatible with either additional meaning, internal evidence in the portrait does not provide sufficient clues to determine which interpretation predominates.

At this juncture there seems to be little or no consistency among these drawings. Their enigmas might be shrugged aside as a Dada joke, intended by Picabia for his friends. Or at best, some of the drawings might be considered to offer fragmented criticism of American culture. Such interpretations might suffice were it not for the companion essay by De Zayas, who provided a context for the drawings, and for Picabia himself, who indirectly offered a clue in the final issue

of *291*: "We immediately understand a painting if we know its conventions, but it is necessary to let our imagination give a form to the metaphysical and invisible world; we must endeavor to make our symbol analogous to the invisible symbol of the painter. Thus the object and the idea become a sublime and superior language." Picabia and De Zayas were engaged in an exploration of the possibilities of American creativity, given their understanding of the conditions of American culture. The machine drawings, then, are the outer symbol or form of "the metaphysical and invisible world" that comprised their conception of America.[26]

In his essay De Zayas was virulent about the commercial nature of America. "Success, and success on a large scale, is the only thing that can make an impression on American mentality," he claimed. "Any effort, any tendency, which does not possess the radiation of advertising remains practically ignored." So rampant was this commercialism that the press, according to De Zayas, "has succeeded in creating in the American people a fictitious need for a false art and a false literature. The press has in view but one thing: — profit." Running throughout this indictment is a series of sexual metaphors implying impotency. American intellectuals "wish to impregnate you, believing themselves stallions when they are but geldings." The object of their desire was New York, "a circumspect young girl or a careful married woman," thus indirectly identified with Picabia's spark plug.[27]

Stieglitz was portrayed ambivalently in this essay. On the one hand, he was shown to be successful in his photographic efforts, which were again described in sexual terms: "Stieglitz, at the head of a group which worked under the name of Photo-Secession, carried the Photography which we may call static to the highest degree of perfection. He worked in the American spirit. He married Man to Machinery and he obtained issue." In painting, Picabia emulated Stieglitz' success: "He has married America like a man who is not afraid of consequence. He has obtained results."[28] In short, Picabia metaphorically married the machine, the spark plug that symbolized the young American girl. The issue of this marriage were his machine drawings.

De Zayas considered that Stieglitz, on the other hand, had failed in his endeavors to promote American painting: "When he wanted to do the same with art [remember that De Zayas did not view straight photography as art], he imported works capable of serving as ex-

amples of modern thought plastically expressed. His intention was to have them used as supports for finding an expression of the conception of American life. He found against him open opposition and servile imitation. He did not succeed in bringing out the individualistic expression of the spirit of the community." His failure stemmed in part from the commercialism of American culture. But Stieglitz himself was also responsible because he "tried to discover America with prejudices" that were European derived in origin. "In politics, in industry, in science, in commerce, in finance, in the popular theatre, in architecture, in sport, in dress,—from hat to shoes—the American has shown how to get rid of European prejudices, and has created his own laws in accordance with his own customs. But he has found himself powerless to do the same in art or in literature."[29] This conception of Stieglitz' failure accounted for Picabia's peculiar tribute to the photographer. Although deserving of faith and love for his noble attempt, his broken camera bears overtones of sexual impotence, thus symbolizing his cultural failure to create an American art. The ideal is unnecessary and irrelevant, since it is the reality of American culture that must be expressed in art. In contrast to his failure to promote American art, Stieglitz was successful in his photography precisely because he set aside "the shield of psychology and metaphysics" to capture the real directly in his straight photography, which, according to De Zayas' standards, was not art.

Picabia's "issue" fits into this framework because his drawings were conceived as anti-art.[30] By depicting machines, he utilized subject matter that was ostensibly not suitable for fine art. His spare use of color, as well as the mechanical precision of the drawings, emphasized a denial of recent modern painting, which favored the sensuous qualities of the medium. A hermetic irony and sexual overtones made the drawings unfit for the genteel parlor, where all American art was supposed to belong. Picabia's machine drawings could only shock and scandalize an American public that wanted sentimentality in its art.

Even more importantly, the anti-art dimension of Picabia's drawings matched De Zayas' essay point for point. Picabia depicted, not art, but "life" directly. As De Zayas maintained, "America remains to be discovered. And to do it there is but one way:——DISCOVER IT." In openly confronting his new environment, Picabia "does not protect himself with any shield"; his drawings offered "the objective truth." In contrast, "the inhabitants of the artistic world in America

are cold blooded animals. They live in an imaginary and hybrid atmosphere. They have the mentality of homosexuals. They are flowers of artificial breeding."[31] Picabia detoured that effete world to expose himself to America's prime reality, the machine. In discovering the machine in as direct a way as possible, he discovered America.

Picabia's ability to confront America head on was facilitated by certain assumptions:

> In all times art has been the synthesis of the beliefs of peoples. In America this synthesis is an impossibility, because all beliefs exist here together. One lives here in a continuous change which makes impossible the perpetuation and the universality of an idea. History in the United States is impossible and meaningless. One lives here in the present. In a continuous struggle to adapt oneself to the milieu. There are innumerable social groups which work to obtain general laws—moral regulations like police regulations. But no one observes them. Each individual remains isolated, struggling for his own physical and intellectual existence. In the United States there is no general sentiment in any sphere of thought.[32]

Since such synthesis of belief was supposedly impossible in America, De Zayas thought that art in America was impossible as well. He also claimed that given the conditions of rapid cultural and social change, history in America became meaningless, so that the American artist ought to forget history—the traditions out of which European art was derived—and create his own indigenous art. But since American art could not exist because of the peculiar cultural and social flux, the results of creation had necessarily to be either anti-art or non-art.

De Zayas drew a fit parallel between America and the modern artist, whom he viewed as possessing an a-historical imagination. "America has the same complex mentality as the true modern artist," he wrote, "the same eternal sequence of emotions, and sensibility to surroundings. The same continual need of expressing itself in the present and for the present; with joy in action, and with indifference to 'arriving.' For it is in action that America has not yet learned to amuse itself." The modern artist for De Zayas was paradoxically anti-art because he deliberately cut himself off from the past and its artistic traditions in order to concentrate upon the present. Picabia had thus found the proper culture in which to create. Having wed an a-historical America, he had broken his ties with Europe, for as De Zayas maintained, "Of all those who have come to conquer America, Picabia is

the only one who has done as did Cortez. He has burned his ship be-hind him."[33] By way of this metaphorical marriage, Picabia became an American, cut off from Europe. Within such a context, the electric lamp of American poetry had no need for a plug, for it had its own source of light and energy from within. Moreover, the De Zayas por-trait, with its voyeuristic contraption, could help America amuse itself. By intuition, Picabia could become attuned to America, because mod-ern art (synonymous with anti-art) and America were like a compatible husband and wife. Consequently, America could well become the breeding ground of Dada.

The irony of the European Picabia being metamorphosed into an American was surpassed by the fact that he was copying the copyists. According to De Zayas, with the importation of European modern art to America, "those lepers . . . the copyists got busy." While they were commercially imitating the new European art, Picabia borrowed their own commercial techniques. As Gabrielle Buffet has correctly ob-served, "These objects are depicted with the precision and relief of a mail order catalogue, with no attempt at aesthetic expression."[34] His drawings appropriated, yet mocked, commercial expression. At the same time, he "blew his own horn," blatantly announcing the anti-art of Dada in America, since only by emulating American advertising methods could he be successful in the New World.

The September-October issue 291 (No. 7–8) published Stieg-litz' famous photograph of *The Steerage*. Essays by Haviland and De Zayas used this photograph as the central example around which to discuss the ideas unleashed by the Picabia number. In an untitled essay Haviland elaborated on some of the implications of the previous issue:

> We are living the age of the machine.
>
> Man made the machine in his own image. She has limbs which act; lungs which breathe; a heart which beats; a nervous system through which runs electricity. The phonograph is the image of his voice; the camera the image of his eye. The machine is his "daughter born without a mother." That is why he loves her.

These ideas, derived directly from Picabia, constituted a new myth. But unlike Picabia's ironic ambiguity toward the machine, Haviland was clearly optimistic: "He has made the machine superior to himself. That is why he admires her. . . . But the machine is yet at a dependent stage. Man gave her every qualification except thought. She submits

to his will but he must direct her activities. Without him she remains a wonderful being, but without aim or anatomy. Through their mating they complete one another. She brings forth according to his conceptions."[35] The machine, then, was no monster to be feared, because man controlled it. Haviland could not conceive of a machine that would dominate man, even though the sexual metaphor implicitly offered that possibility.

Haviland concluded that "photography is one of the fine fruits of this union. The photographic print is one element of this new trinity: Man, the creator, with thought and will; the machine, Mother-action; and their product, the work accomplished." In an essay on Steiglitz, De Zayas amplified Haviland's conclusion in anti-art terms. He considered Stieglitz to be the prototypical straight photographer who allowed his camera full rein, "its full power of expression," to achieve "pure objectivity." Since the straight photographer emphasized "the true importance of natural fact," the limitations imposed by art were swept aside. "He has surpassed 'Art,' that idiotic word which during centuries has dominated everything, and which in reality has only expressed a mental state, a state of unconsciousness," De Zayas proclaimed. "'Art' had become an esoteric God who had his sole prophet 'Conventional Beauty.' 'Art' and 'Conventional Beauty' together have exercised a tyranny. It is surely due in great part to photography, that we have finally freed ourselves from that spell."[36]

De Zayas believed that the downfall of art would open new realms of creativity. "We have escaped from the fetishism into which that word 'Art' had hypnotized us, making us insensitive to the respective realities of our inner selves, and of the outer world." Representational art had denied the psychic realm that nonobjective art could reveal. At the same time, the camera achieved an objectivity that had been denied by an imperfect representational mode of painting. Typically enough, De Zayas neatly divided up the creative realm between photography and nonobjective painting: "A group of men in France has flooded our inner world with the light of a new plastic expression. Stieglitz, in America, through photography, has shown us, as far as it is possible, the objectivity of the outer world."[37] Such a division was highly arbitrary and fallacious. Creative individuals would not remain within such limits; nor could the "inner" and "outer" worlds be differentiated that easily. Although De Zayas ignored, or overlooked, these complexities, his conceptualizations suggest that art was an impasse for the creative individual. The fact that abstraction

and straight photography had already won their place among the avant-garde of the time was not enough; the cultural conventions and traditions defining the concept of art necessitated a frontal attack upon the very concept itself so that full creativity might be achieved. To be sure, De Zayas' guidelines were never followed. But they did suggest areas which could be exploited without being hindered by cultural preconceptions about art.

The November issue of *291* (No. 9) had a Braque drawing on the cover and a Picasso drawing on the back page, both of which were Cubist variations on a violin. The issue also contained a typographical poem entitled "Femme" by De Zayas and opposite it, a machine drawing by Picabia, *Voilà Elle*, both in marked contrast to the Cubist drawings. Whereas the hermetic and analytic violin images reflect an aesthetic tranquility, De Zayas' typography and Picabia's machine aggressively attack the viewer, and foreshadowed the shock tactics of Dada.

But even more than aggression, the typographical poem and the machine drawing reveal the interdependence of the visual and the verbal as opposed to the visual integrity of the Cubist drawings. The metaphorical significance of the machine would remain a mystery were it not for the title *Voilà Elle* and the previous essays on the machine as woman. There is no doubting its identity as a very sleek machine, with the usual conglomerate of wheels, rods, screws, nuts, cables, and polished jointed pipes—again, of course, with no discernible function. In contrast to the first machine drawing, *Fille née sans mère*, Picabia created an aggressive mechanomorphic complex with masculine-feminine elements of eroticism. If the *Fille* is the emerging foetus, then *Voilà Elle* is the adult sophisticate about to join the ranks of *Playboy's* gatefolds.[38]

The satirical significance of the drawing is heightened by De Zayas' typographical poem. Here is a portrait of the modern woman whose emancipation is matched by the arrangement of the words on the page—a reminder of the Futurist slogan, "les mots en liberté." The viewer's first impression is one of chaos and anarchy. But the syntax, broken on the surface, has an order within groupings of words that are related by association. The page is organized around the verticality of "hurluberlu." The archetypal woman portrayed indulges in pleasure ("noyée par le vice elle a surgi") and is anti-intellectual ("pas d'intellectualism," "atrophie cérébrale"). She is the *femme fatale*, with "le sacrifice sadique des saints" alluding to a Salomé

winning the head of St. Picabia (self-characterized as "le saint des saints"). But paradoxically enough, she wants to be dominated; "Je le vois dans sa pensée / et comme elle aime à être / une ligne droite tracée par une main mécanique."[39]

This line offers a hint that the woman of the poem and the woman of the machine drawing are one and the same. Otherwise, De Zayas' poem would be a repetition of that collaboration with Agnes Meyer—an attempt at feminine insight. The juxtaposition of poem and drawing, however, leads the viewer into a mechanistic universe where correspondences between the feminine ideal and the mindless machine are overwhelming. Just as the machine ironically undercuts the ideal, the entire mechanomorphic mythology derives its power from an inhuman eroticism. The circle is completed as one feeds on the other.

291 did not continue this Dada machine phase in its last two issues. The inclusion of Braque and Picasso in the ninth number portended the dispersion of *291* into non-Dada avant-garde concerns. The combined issue for December-January, 1915–16 (No. 10–11), bore on its cover a Picasso collage. Within, De Zayas offered a caricature of Picasso. And the French poet Max Jacob contributed an essay, "La Vie artistique," that was continued in the final issue. Nevertheless, the issue contained vestiges of Dada. Picabia, for example, submitted an abstract drawing, *Fantaisie*, whose subtitle, "L'Homme créa Dieu à son image," suggested not only Dada shock tactics in its Biblical inversion but also a mechanistic universe as well.[40] Also included was a poem entitled "Musique" by Georges Ribemont-Dessaignes, who was to figure in the deluge of Dadaism that inundated Paris right after the War.

The twelfth and final issue of *291* was fairly optimistic as a whole. Picabia concluded a short essay by affirming, "I maintain . . . that the painting of today is the most truthful and the purest expression of our modern life"—hardly a comment one might expect from an antipainter, unless interpreted ironically.[41] De Zayas reversed his views on modern art and its search for the primitive: "The introduction of the plastic principles of African art into our European art does not constitute a retrogradation or a decadence, for through them we have realized the possibility of expressing ourselves plastically without the recurrence of direct imitation or fanciful symbolism." More significant than his change of heart toward primitivism, however, was his renewed acceptance of art.

What appeared to be apostasy was actually consistent with the Dada phase of 291. The machine drawings were horrific, sustaining a surface wit that approached cheerfulness. But characteristically of Dada, this wit fed upon itself cannibalistically, with a thrust which affirmed the possibilities of creation in America and which was consonant with a culture pervaded with anti-art values. In this light, Picabia and De Zayas were able to be affirmative, even optimistic, in their last two essays for 291.

The Dada phase of the review did not, properly speaking, simply wither away, even though the slackening rhythm of its intensity would suggest so. Rather, it seems more probable that 291 was deliberately terminated, just as a scientific experiment, the original analogy for 291, would end after a determined period of time.[42] Even so, the Dada nature of that experiment—in all probability unforeseen at the start— had much to do with its termination. Closely allied to a consideration of American culture and creativity, the machine drawings at the heart of 291 had made their point and could lead only to repetition, presumably of the worst sort, since there was always the risk that the drawings would become "art" and betray their creator.

The American nature of 291 was later implicitly confirmed by 391, Picabia's review, which deliberately set out as a "double" of 291.[43] Despite its intention to carry on the work of its predecessor, 391 did not prolong 291's Dada phase. Its first four issues, published in Barcelona, continued the eclecticism of the last two issues of 291, for Picabia was somewhat restrained by his moderate collaborators in Spain. But even when he returned to New York in 1917, he neglected to resume the Dada phase of 291, as his subsequent illness isolated him not only from his former collaborators but ultimately from American cultural concerns. Thus Nos. 6 and 7 of 391 became strictly a vehicle for Picabia, and De Zayas and Arensberg became peripheral contributors rather than collaborators on a review.

The machine drawings in 391 stand as a mute testament to this shift in perspective. Though still anti-art, the drawings were torn from their American context, and carried on Picabia's mechanistic mythology in a cultural limbo. The "conventions" that Picabia spoke of in 291—the cultural context provided by De Zayas—no longer existed with any immediacy, so that "the metaphysical and invisible world" of America was abrogated in the early issues of 391. A brief flash appeared in No. 6, with *Américaine*, a lightbulb portrait of the American

female, illuminating "divorce and flirtation." But the cannibalistic wit and satire were not adequately sustained until *391* gained renewal in the eighth issue, published in Zurich. There, Picabia's meeting with the European Dadaists revitalized not only the magazine but also the machine drawings, which were now created within a new cultural context. Picabia's talents were revived by his return to Europe and to his native culture, which had lurked as a horrific backdrop during his stay in America. Consequently, the machine drawings were transmuted into diagrammatic skeletons that expressed the scatological tactics of Dada rebelling against a civilization in moral decay.

Back in America, the termination of *291* had the apparent effect of dissipating the collective energies of its collaborators. Without the dynamic personality of Picabia, who had gone to rejoin his wife in Spain during the summer of 1916, the Dada center of the review fell apart. Stieglitz himself, although a charismatic force, had always remained in the background of the project. Moreover, his *Camera Work* failed to provide a suitable outlet, for its two final issues were published just before America's entry into the War, which further alienated Stieglitz. Although he occasionally showed his sympathy for sporadic Dada activities in New York, he could in no way be considered a Dadaist. As for De Zayas, he eventually quit caricature to devote his time to the running of the Modern Gallery, renamed the De Zayas Gallery in 1920. The others—Paul Haviland, Agnes Meyer, and Katherine N. Rhoades—had been only minor participants in *291* and no longer figured greatly in either Dada or American art.

Despite the group's dispersal, *291* had established a general pattern for subsequent magazines in touch with Dada. Not Dada alone but an awareness of its relevance to the American context would validate their relationship, the vitality of which would be derived from the ensuing tensions accommodating a European phenomenon to American culture. In *291* De Zayas and Picabia had established the pattern of American Dada, as their criticism swung between negation and affirmation. Just as compelling to American artists in such matters were the ironic nuances of Marcel Duchamp, who, like his friend Picabia, was to bring his own Dada mythology of the machine to America, contributing a whole gamut of contradictory values and attitudes toward art and the machine for American artists to consider.

3 | Marcel Duchamp and Man Ray

When he arrived in New York during the summer of 1915, Marcel Du-
champ discovered that he had been preceded by a scandalous repu-
tation. Understandably enough, his *Nude Descending a Staircase* had
caused even greater shock at the 1913 Armory Show than she had at
the Parisian Salon des Indépendants in 1911.[1] *Arts and Decoration*
took the lead by interviewing him for their September issue. Terming
him an "iconoclast," the interviewer sensed Duchamp's detachment.
"He is young and strangely unaffected by the vast amount of argu-
ment created by his work. . . . He neither talks, nor looks, nor acts
like an artist. It may be that in the accepted sense of the word he is not
an artist. In any case he has nothing but antipathy for the accepted
sense of any of the terms of art." After praising the "scientific spirit"
of Seurat, Duchamp predicted that "the twentieth century is to be
still more abstract, more cold, more scientific"—a prediction that had
much to do with his own cerebral tendencies, which would be soon
expressed in a large glass construction, *The Bride Stripped Bare By
Her Bachelors, Even*. He admired New York as "a complete work of
art" and approved in particular of the demolition of old buildings.
"The dead should not be permitted to be so much stronger than the
living," he asserted. "We must learn to forget the past, to live our own
lives in our own time." The rest of the article consisted of Duchamp's
pronouncements on various artists. As Robert A. Parker, a journalist
of the day, later reminisced, "Duchamp answered every impertinent
and puerile question we put to him."[2]

A second interview with Duchamp was published in the *New
York Tribune* in October, as part of an article on several French artists
who had migrated to America because of the war in Europe. As in-
dicated by its title, "French Artists Spur on an American Art," the
article endeavored to explore the relationship between contemporary
French and American art. The French felt that what New York lacked

in the way of modern art was redressed by its mechanized environment. Turning from Albert Gleizes and Jean Crotti, who praised the technological advances of America, the interviewer interpolated Duchamp's views on art with American notions of progress. "The highest intelligence," wrote the reporter, "seems that which recognizes, even in the full flush of any given 'period,' that there must be a wane and a new rising. Marcel Duchamp corroborates this eternal individual development. 'I am never deceived, myself, into thinking that I have at length hit upon the ultimate expression. In the midst of each epoch I fully realize that a new epoch will dawn.'" Implicit was Duchamp's extreme assumption that gave impetus to his avant-garde exploration: "I have forced myself to contradict myself in order to avoid conforming to my own taste."[3] But the article framed his restlessness in terms of American growth and European decadence. The reader was meant to draw the conclusion that America, like Duchamp, could achieve "progress" in the arts.

In the November issue of *Current Opinion* Duchamp was alone in the spotlight and summed up the ideas he had previously aired. Once again he deplored reverence for past art. "Why this adoration for classic art?" he asked. "It is as old-fashioned as the superstitions of the religions, and the reverence given to it is mere stupidity." He also attacked the notion of "good taste" as a "bore." Although these views would not endear him to a conservative American public, Duchamp saw America itself as imbued with avant-garde ideals. "But here—from the very instant one lands one realized that here is a people yearning, searching, trying to find something," he claimed. As Picabia and De Zayas had done in 291, he posited the mythical dichotomy between the Old and New Worlds. "If only America would realize that the art of Europe is finished—dead—and that America is the country of the art of the future, instead of trying to base everything she does on European traditions!"[4]

Possibly the most interesting part of the article was the caption and comment under a photograph of the handsome Duchamp:

HE IS TRYING TO WAKE US UP

Marcel Duchamps, who painted that notorious nude coming downstairs, is of the opinion that America may conquer the world of art; but we must learn to forget the past and stop worshipping the dead in matters artistic and esthetic. We must, the brilliant young Frenchman declares, create new values in art—values scientific and not sentimental.[5]

Here Duchamp was portrayed as the young prophet of art coming to save America from the clutches of academicism. Yet his public image at this point was hardly that of an anarchist Dadaist. Not conversant with the term, journalists could only underscore what they called his "iconoclasm," which was evidently construed to be consonant with American values.

How much Duchamp believed in these American myths and how much was fabricated by journalists eager to package an art personality for the public is open to question, even though other French artists, including Picabia, mouthed similar views. That America had little direct influence on his work was indicated by Duchamp himself. For the *Tribune* interview he maintained, "So far as painting goes—it is a matter of indifference to me where I am. Art is purely subjective, and the artist should be able to work in one place quite as well as another."[6]

In the same breath Duchamp also asserted with characteristic understatement, "But I love an active and interesting life. I have found such a life most abundantly in New York. I am very happy here. Perhaps rather too happy. For I have not painted a single picture since coming over."[7] Upon his arrival he had become close friends with the poet and art collector Walter Conrad Arensberg[8] and was soon the center of the Arensbergs' salon, one of the few places besides Stieglitz' "291" where New York's emerging avant-garde might gather. According to a French friend, Henri Pierre Roché, "Duchamp was the toast of all the young *avant-garde* of New York. Projects built up around him. His smile inspired daring and a sense of confidence."[9] Duchamp's old friend Picabia, along with Arensberg's cousin John Covert, as well as Morton Schamberg, Charles Demuth, Joseph Stella, Man Ray, and later Charles Sheeler, appeared at the Arensbergs' for the exhilarating discussions, the hi-jinks, and the endless chess games after a night on the town. As an acknowledged French modern, Duchamp assumed leadership among the relatively provincial and young Americans, many of whom had just become fully aware of the European revolution in painting. Supremely detached, unlike his counterpart Picabia, whose work was directly affected by America, Duchamp nevertheless exerted a profound influence by virtue of his restless mind mercilessly probing the assumptions of art.

In accord with Picabia, Duchamp emphasized ideas in the visual arts over and against the pictorial values of Cubism. In his interview for *Arts and Decoration* he expressed his scorn for Cubism, which, he

claimed, "means nothing at all—it might just as well, for the sense it contains, have been policarpist. An ironical remark of Matisse's gave birth to it. Now we have a lot of little cubists, monkeys following the motion of the leader without comprehension of their significance." (Picabia was to express the same sentiments somewhat more succinctly in *La Pomme de pins*, a manifesto of 1922: "Le Cubism est une cathédrale de merde.") Duchamp later asserted, "I wanted to get away from the physical aspect of painting. I was much more interested in recreating ideas in painting. . . . I wanted to put painting once again at the service of the mind."[10] His emphasis upon the cerebral aspects of art while minimizing its sensual factors was to be of prime importance to Man Ray, Charles Sheeler, and, in a more limited sense, Charles Demuth.

Duchamp's readymades constituted a major innovative mode of expressing his ideas about art. A logical conceptual extension of his *Coffee Mill* painting for his brother's kitchen in 1911, his first readymade was the *Bicycle Wheel* of 1913, mounted upside down on a stool.[11] The object thus presented gave rise to a number of critical issues about art: the nature of subject matter (deflated by such a common object), the involvement of the viewer (who could give the wheel a spin), the nature of the aesthetic process (with emphasis upon the artist's prerogative of choice), and the ontology of a work of art (its relationship to "reality")—all these factors were brought into question by the disturbing presence of a readymade. Obliterating preconceived cultural notions about art, the readymade particularly invalidated the arbitrary distinctions between art and nature that lay at the center of the controversy over straight and pictorial photography. And indeed, it was Man Ray, who, keenly aware of the inner workings of the readymade, might be said to have bridged the gap between straight and pictorial photography with his Rayographs.

Duchamp's most important readymade for American artists after his arrival in New York was his *Fountain*, a urinal submitted to the exhibition of the newly formed Society of Independent Artists held in the spring of 1917.[12] A member of the exhibition committee, Duchamp must have been enthusiastic about the show's possibilities, for he suggested to his friends that they publish a magazine commemorating the event. Thus, on April 10, 1917, the first issue of *The Blindman* appeared, celebrating the inauguration of the Independents in New York.

The cartoonist Alfred Frueh drew the cover: a blindman walking with his seeing-eye dog passes a painting of a nude who thumbs her nose at the pair. The cartoon, which recalled the audacity of Duchamp's famous nude at the Armory Show and foreshadowed the scandal that was yet to come, indicated the irreverent nature of the new art that was to confront the viewer and challenge the blindness of certain New York critics. Roché related the New York exhibition to what had become a French tradition against academic art. "The Independence became the first spring event of Paris—gay, frank, bold, fertile, surpassing itself every year—while the big jury exhibitions became more and more like grandmothers patiently repeating themselves," he claimed. Inveighing against the geriatrics of the past, "the Blindman celebrated to-day the birth of the Independence of Art in America."[13]

The title of the magazine was a metaphor for the myopic attitudes of New York toward modern art. For one thing, New Yorkers were not visually accustomed to the new art. Nevertheless, Roché argued, "To learn to 'see' the new painting is easy. It is even inevitable, if you keep in touch with it. It is something like learning a new language." But far worse than an inability to see, according to Roché, was the fact that "New York . . . [is] indifferent to art in the making." Consequently, the necessity arose for New York "to learn to think for itself, and no longer accept, mechanically, the art reputations made abroad."[14] Although others, particularly Robert Coady and William Carlos Williams, were to perceive the contradictions of such a declaration written by someone with Duchamp at his side, the tensions involved were somewhat mitigated by Duchamp's disavowal of Europe and the past, consonant with the goals of the exhibition for American art.

The Blindman elaborated on the various functions of the Independents. First and foremost, the exhibition would provide the opportunity for artists to be seen. They would achieve a measure of independence and fairness of evaluation by a no-jury system which would welcome the entire gamut of art from conservative to radical. Duchamp's refusal to define art arbitrarily was conceived to be the informing spirit of the exhibition. Out of tolerance and respect for the artist's assessment of his own creative efforts, new art would be brought to light.[15]

All in all, *The Blindman* was optimistic about the prospects of the Independents to cultivate American art. (In fact, the review invoked Whitman as its mentor: "May the spirit of Walt Whitman guide the

Indeps. Long live his memory, and long live the Indeps!")[16] The magazine cast itself in the role of mediator between the artists and their public. It invited readers to contribute to future issues, which would publish their reactions to the art exhibited. Its role was thus conceived as somewhat akin to that of *Camera Work*—as a forum for the pronouncements of New York critics about exhibitions of modern art. To be sure, Stieglitz had an ironic purpose in mind, as he juxtaposed rash and intransigent statements against reasoned judgments without making editorial comments. Nevertheless, both magazines attempted to fill a cultural vacuum by creating a milieu in which artists might engage in fruitful dialogue among themselves and with the public as well.

Before the publication of the next issue in May, however, Duchamp discovered that the exhibition committee was not going to live up to its professed ideals. The outraged committee rejected his *Fountain*, signed by a pseudonymous "R[ichard]. Mutt" (perhaps the Mutt of Mutt and Jeff fame, but certainly the name of a well known plumbing shop in New York at the time), and decorously veiled the readymade behind a curtain, where it was conveniently "lost." Thus provoked, Duchamp resigned from the Independents Committee. The second and final issue of *The Blind Man* (its title now spelled differently) was devoted to what Duchamp called "The Richard Mutt Case," a parody of all the dime mystery novel titles.

The cover reproduced Duchamp's *Broyeuse de chocolat*, a grinder closely related to the readymades and central to the bachelors of the *Large Glass*. Here, of course, was an indirect reference to the problem of defining art. Moreover, for those few who were familiar with the *Large Glass*, the grinder alluded to the French adage, "the bachelor grinds his chocolate by himself." The sexual undertones pointed out the sterility of the Independents Committee, unable or unwilling to abide by its own rules. In the pages of the magazine was a frontal view of the urinal itself, photographed by Stieglitz, who, though a member of the committee, was sympathetic with Duchamp's aims.

In "The Richard Mutt Case" Duchamp lucidly and rationally defended himself, first establishing the background of the incident:

They say any artist paying six dollars may exhibit.

Mr. Richard Mutt sent in a fountain. Without discussion this article disappeared and never was exhibited.

He went on to outline the committee's position:

What were the grounds for refusing Mr. Mutt's fountain:—

1. Some contended it was immoral, vulgar.
2. Others, it was plagiarism, a plain piece of plumbing.

Duchamp then presented his own arguments. "Now Mr. Mutt's fountain is not immoral, that is absurd, no more than a bath tub is immoral," he mocked. "It is a fixture that you see every day in plumbers' show windows." Disregarding such Victorian objections, Duchamp addressed himself to the central problem of defining art. "Whether Mr. Mutt with his own hands made the fountain or not has no importance. He CHOSE it. He took an ordinary article of life, placed it so that its useful significance disappeared under the new title and point of view —created a new thought for that object." After this succinct explanation of his readymades, he scornfully concluded, "As for plumbing, that is absurd. The only works of art America has given are her plumbing and her bridges."[17]

Louise Norton, the wife of Allen Norton, editor of the satirical *Rogue*, followed Duchamp with a vigorous defense humorously entitled "Buddha of the Bathroom," possibly a reference to the inscrutability of the urinal. After reiterating his arguments, she considered the ambiguities that were to become essential to the Dada spirit: "Then again, there are those who anxiously ask, 'Is he serious or is he joking?' Perhaps he is both! . . . In this connection I think it would be well to remember that the sense of the ridiculous *as well* as 'the sense of the tragic increases and declines with seriousness.' It puts it rather up to you." Most likely unaware of the term "Dada," Mrs. Norton described the current attitude as a "spirit of blague." Unlike Dada in Zurich, which arose primarily out of anti-war sentiment, an analogous spirit arose, according to her, against "an over-institutionalized world of stagnant statistics and antique axioms." The unstated problem for American artists, then, was to find ways to avoid both the encrustations of the academy and the vacuum of an a-historical American culture chasing after "Progress, Speed, and Efficiency."[18]

Stieglitz himself wrote a letter advocating the future submission of all works to the exhibition anonymously so that art would be completely autonomous, liberated from critics, dealers, and even the artist himself, and therefore free to be judged completely on its own merits. Charles Demuth contributed a sparse poem which explicitly indicated

his sympathies with Duchamp's avant-garde position. Otherwise, the
rest of the review was imbued with that "spirit of blague" Louise
Norton spoke of, nowhere more evident than in a "Letter from a
Mother" who pleaded, "Therefore as woman who has done her duty
towards the race and experienced life, I make a plea to all other
mothers and women of constructive comprehension, that we keep this
exhibition sane and beautiful."[19] Her cause for concern were the
Cubists and Futurists, "people without refinement." (Little did she
know that she was to appear in a disreputable review for Dada!) The
letter, out of the heartland of Middle America—Minneapolis, Minnesota
—rings true enough to cast a doubt on whether it was a deliberate
hoax by the editors.

The second issue of *The Blind Man* was dominated by Marcel
Duchamp. Probably for that reason the magazine did not explode
with the bitter invective that was so characteristic of Dada elsewhere,
particularly in war-torn Berlin. As constricted as American art may
have been during the war years, the editors of *The Blind Man* did
not choose to engage in exacerbative nihilism. Duchamp set the tone
for the review with his Olympian irony, his ability to disengage him-
self from any situation, to joke and yet be serious at the same time.
Having begun as an educational review, *The Blindman*'s aims were
only slightly deflected by the events that shaped the second and last
issue, which was still reasonable enough in tone so that its shock value
was determined less by its contents *per se* than by the narrowness of
the prevailing academic values in American art.

The Blind Man was an important document in American art be-
cause its participants, European and American, shared a common
cause. In contrast, *Rongwrong*, Duchamp's second publication in
1917, emerged as a rather pale *blague*, precisely because it had no
cause, no roots in the American situation. Americans such as Carl
Van Vechten and Allen Norton simply became contributors to a mild
Dada review that had little relevance for American art beyond the
fact that it was published in New York City.[20] The repartée between
Duchamp (as "Marcel Douxami") and Picabia in *Rongwrong* had an
esoteric significance tangential to American concerns. To be sure,
the cover featured two mongrels sniffing each other's behinds—a
risqué matchcover image that was calculated to distress genteel Ameri-
cans; but *Rongwrong* was as proportionately distant from *The Blind
Man* as Picabia's *391* from its predecessor, *291*.

If *Rongwrong* was harmless Dada ephemera, Duchamp's other preoccupations were highly significant to American artists of his circle. Although for several years prior to 1915 he had conceived and planned out the elements of his *Large Glass*,[21] it was not until he had settled down in his New York studio that he actually began work on the nine-foot glass itself. For the next eight years, he engaged in a meticulous ritual of craftsmanship until in 1923 he left the *Bride* unfinished, a "Delay in Glass." (In 1927 the *Bride* was shattered in transport to Connecticut, but nine years later, Duchamp carefully glued the glass back together, its myriad cracks forming an integral part of the design.)

The *Large Glass* challenges the concept of organic art, which is meant to achieve a self-contained integrity. The work, transparent and unobtrusive (likened to a room divider), is unintelligible upon first viewing. As one becomes aware of the concepts involved, he realizes that the work's significance lies in its meaningless content. The Bride, in the upper half of the glass (a fact which the viewer cannot deduce from the work itself), is totally abstract. If abstraction is associated with coldness, as Duchamp asserted in his first American interview, then the Bride is cold indeed on her wedding night. In the lower half of the glass are the bachelors, virtually indiscernible among a mélange of Rube Goldberg contraptions. The work itself provokes a minimal aesthetic response: there are no sensuous paint textures, as in Cubist canvases; nor are there particularly beautiful forms, despite an elegance of craftsmanship. Indeed, the viewer is left with a surface inscrutability.

Faced with this enigma, he is prompted to turn to the "Green Box," a set of working notes written by Duchamp ostensibly to "explain" the *Large Glass*.[22] The reader's expectations are not met, however, for Duchamp's intentions were, after all, merely to jot down notes for the construction of the *Bride*. Nevertheless, since the notes appear to hold forth the promise of reconstruction, the viewer might readily turn from the confusing realm of the *Bride* to an equally confusing realm of ideas which, once synthesized, create a mythic context for the work.[23] After reading the notes, the viewer is left with the ironic consolation that the meaning provided by the notes for an otherwise unintelligible visual experience is that the *Large Glass* is meaningless indeed, leaving a profound sense of spiritual and intellectual waste corresponding to the onanism of the Bachelors.

The notes and the *Large Glass* together dramatize the failure of

love, as the Bride eternally awaits sexual consummation with her Bachelors, who can engage only in a frustrated onanism, forever separated from the Bride, the object of their desires. The *Large Glass* offers a world of mechanistic despair, all the more nihilistic for Duchamp's deceptive wit and humor. As Gabrielle Buffet has warned, "Make no mistake, there are no innocent games, the humor of Duchamp is gay blasphemy." A peculiar Duchampian irony—the irony of indifference, which he has called "meta-irony"—lies at the center of the *Large Glass* as well as of his other work. Harriet and Sidney Janis have noted that "Duchamp negates the seriousness of his own inner motivations by running it through with skepticism. . . . Instead of accepting the alternatives of annihilation or of living in a vacuum, he has worked out a system that has produced a new atmosphere in which irony functions like an activating element, causing a pendulum-like oscillation between acceptance and rejection, affirmation and negation, and rendering them both dynamic and productive."[24]

Thus it becomes extremely difficult, if not foolhardy, to delineate arbitrarily Duchamp's values in either the *Large Glass* or the ready-mades. Nevertheless, his radical departures from conventional art, including those works characterized as modern, were surely apparent to his American contemporaries even then. Along with Picabia, he was one of the first of the twentieth-century artists to treat the machine in his work: sometimes playful and witty, always ironical (or "meta-ironical"), he thereby revealed an absurd universe. Carefully balancing the element of chance with extreme craftsmanship, informed by a cannibalistic rationalism, as it were, he sought to deny his role as an expressive artist—a goal he symbolically achieved by declaring himself an engineer in 1920.[25]

Like T. S. Eliot's epic *The Waste Land*, Duchamp's *Large Glass* is a major work of the twentieth century in its feeling for modern life. Although the two works share common motifs, a shifting irony, sexual themes, and even a substructure of ancient myth, *The Waste Land* is hardly Dada in quality. Eliot did not engage in nonsense, nor did he partake in the final measure of Duchamp's despair. But whereas *The Waste Land* was widely circulated among the avant-garde when it was published in 1922, the *Large Glass* remained relatively unknown. No American painter produced a work of similar magnitude, although Man Ray's *Rope Dancer* was an affirmative response to the *Large Glass*, just as Hart Crane and William Carlos Williams attempted to respond

affirmatively to what they perhaps erroneously perceived as Eliot's nihilistic poem. Rather than thematic concerns, it was primarily the machine metaphors of the *Large Glass* and its formal innovations that attracted the attention of Americans in Duchamp's circle.

Duchamp's anti-art endeavors anticipated Dada in Europe. He claimed that Dada "was a way to get out of a state of mind—to avoid being influenced by one's immediate environment, or by the past: to get away from clichés—to get free." Because he prized freedom, Duchamp remained somewhat aloof from his Dadaist comrades in Europe; yet he was not loath to introduce Dada virtues to Americans. And so a belated proclamation of Dada's freedom appeared in April 1921, with *New York Dada*, a review on which Duchamp collaborated with Man Ray. Unlike its predecessors, *The Blind Man* and *Rong-wrong*, *New York Dada* appropriated the nonsense rhetoric of Dada. However, according to Man Ray, the review was none too successful in transplanting Dada to America: "the paper attracted very little attention. There was only one issue. The effort was as futile as trying to grow lilies in a desert."[26] Failing to mount a full-scale assault, *New York Dada* was significant less as a directive for American artists than as a first-hand manifestation of explicit Dada values which had imperceptively taken root in America.

The cover of *New York Dada* visually symbolized the importance of Duchamp. A rectangle in the center of this rather large quarto (10″ by 15″), covered with vertical rows of "new york dada" in tiny lettering printed upside down, made room for "Belle Haleine," originally a collage of a perfume bottle with a photograph of Duchamp leering out in drag as his female alter ego, Rrose Selavy ("Éros, C'est la vie"). On the whole, the cover design offered an unnerving and subversive introduction to the review's contents.

In addition to a photomontage by Stieglitz ("Watch Your Step!")[27] and a mixed-media object by Man Ray ("dadaphoto"), there was a statement on Dada right from the chief Dadaist's mouth—that is, an "art-cover authorization" by Tzara, which increased the already bewildering display of nonsense:

NEW YORK DADA
You ask for authorization to name your periodical Dada. But Dada belongs to everybody. I know excellent people who have the name Dada. Mr. Jean Dada; Mr. Gaston de Dada; Fr. Picabia's dog is called Zizi de

Dada; in G. Ribemont-Dessaigne's play, the pope is likewise named Zizi de Dada. I could cite dozens of examples. Dada belongs to everybody. Like the idea of God or of the toothbrush. There are people who are very dada, more dada; there are dadas everywhere all over and in every individual. Like God and the toothbrush (an excellent invention, by the way).

After such reassurances, by which Tzara indicated the antiauthoritarian nature of Dada, he went on to explain its origins and dramatized its nonrational spirit ("the so precious enamel of your intelligence is cracking").

On the third page was a Rube Goldberg cartoon, depicting a mad scientist shooting his revolver at some convoluted tubing held by bearded men in top hats. The disjunct tubing eventually leads to a bound fellow sitting on the ground. Not particularly humorous in itself, the cartoon appealed to Duchamp's sense of the absurd, for Goldberg's fascination with gadgets, machines that rationally deny logic, coincided with Duchamp's *Large Glass*, which was based in part on his desire to "slightly distend the laws of physics and chemistry."[28]

The review also blared pseudo newspaper headlines: "Pug Debs Make Society." In a mélange of boxing and society page rhetoric, the subsequent article poked fun at Marsden Hartley and Joseph Stella, bedecked in "very short skirts" and "flesh-colored complexions." The final page was made up of a poem by Hartley and two upside-down photographs of Elsa Baroness von Freytag-Loringhoven, first depicted in a wig and then shown shorn, the would-be lover of William Carlos Williams exposed in all her glory.

The institutional legacy of the artistic freedom Duchamp and his friends espoused in *New York Dada* was the Société Anonyme, Inc.: Museum of Modern Art, founded in 1920 by Duchamp, Man Ray, and Katherine Dreier, a wealthy businessman's daughter, who had taken up painting as a girl, and then became interested in modern art after the Armory Show.[29] Man Ray's title for the organization is deliberately redundant ("société anonyme" in French actually means "incorporated"), so that it was inaugurated in true but mild Dada fashion. The Société established certain educational goals which were based upon those very principles that Duchamp had proclaimed during the *Fountain* controversy at the 1917 Independents. According to an introductory pamphlet of the organization, "One of the chief aims of the Directors of the Société Anonyme, Inc., is to rise above personal taste

and to conduct a gallery free from prejudice." True to form, the corporation's exhibitions were quite heterogeneous, and tolerant of all modern groups, even though the opening show on April 30, 1920, was dominated by the artists surrounding Duchamp: Man Ray, Picabia, Morton Schamberg, and Joseph Stella. Above all, the Société was faithful to the present, taking its motto from the painter Franz Marc: "Traditions are beautiful—but to create them—not to follow."[30] Since opportunities for viewing the new art during the decades after the Armory Show were few, the Société's exhibitions through the years were particularly important to the small avant-garde community and its growing public.

In order to pursue its educational aims, the Société established, in addition to their exhibitions, a series of lectures on modern art at 19 East 47 Street. On the evening of April 1 (appropriately enough), 1921, Marsden Hartley participated in a symposium to discuss: "What is Dadaism?"[31] No record of the proceedings exist, but later that year Hartley published a collection of essays entitled *Adventures in the Arts*. An appreciation of the popular as well as the fine arts, anticipating the attitudes of younger writers such as E. E. Cummings and Matthew Josephson, his collection concluded with an Afterword on "The Importance of Being 'Dada,'" a brief essay that probably summed up what Hartley had said at the symposium.

Hartley's position, though an unlikely one for him, nevertheless had its own logic. Originally associated with Stieglitz, he viewed the Société Anonyme as "in a very fair way to continue what was so well begun . . . at 291." Although his paintings were in an Expressionist vein, without yielding to Dada's scatological wit, he still felt the encroachments of tradition. In a letter of 1917 to Stieglitz, he commented on the destructions of war, but added, "Paris must recreate itself also after this which is likewise good as tradition is bound to kill creation." Similarly, in "Modern Art in America," an essay included in *Adventures in the Arts*, he railed against American intransigence toward the new art. "Our national stupidity in matters of esthetic modernity is a matter for obvious acceptance, and not at all for amazement," he dryly asserted.[32]

In light of these attitudes, then, it was not surprising to hear Hartley claim, "Dada-ism offers the first joyous dogma I have encountered which has been invented for the release and true freedom of art." The means for achieving this artistic freedom were to be found

in Dada's devaluation of art: "One of these ways is to reduce the size of the 'A' in art, to meet the size of the rest of the letters in one's speech." Hartley agreed with the aims of Dada because "art is at present a species of vice in America, and it sorely and conspicuously needs prohibition or interference." America was being exploited by the "idolators and the commercialists" of the art scene.[33]

Dada offered Hartley a psychological means of escape rather than an enervating confrontation. "I ride my own hobby-horse away from the dangers of art which is with us a modern vice at present, into the wide expanse of magnanimous diversion from which I may extract all the joyousness I am capable of, from the patterns I encounter." Dada, he felt, would lead to the discovery that "life and art are one and the same thing, resembling each other so closely in reality." He concluded with a metaphor that Cummings was to use later on: "You will learn after all that the bugaboo called LIFE is a matter of the tightrope and that the stars will shine their frisky approval as you glide, if you glide sensibly, with an eye on the fun in the performance."[34]

Hartley articulated the broad significance of Dada for a number of American artists. Yet it was the liberating spirit of Duchamp that must have been especially exhilarating for young men who felt restricted by the conservative attitudes that pervaded the American art scene. His influence on Man Ray in particular was of great import, since Ray joined with Duchamp and Picabia to comprise the nucleus of Dada in America. Indeed, it was their efforts, collectively and individually, that established the substance of Dada to which the little magazines and individual artists could respond variously in their quest for an American art.

During the summer of 1915 Arensberg and Duchamp visited a small artist's colony near Ridgefield, New Jersey, where they met Man Ray. Upon his return to New York, Ray became close friends with Duchamp, as they discussed and analyzed concepts of art during the ensuing war years. Although the Frenchman was clearly the bolder and more incisive innovator of the two, Man Ray was not simply a three-dimensional shadow of a fourth-dimensional Duchamp.[35] Prior to 1915 Ray had given ample indication of his own incipient Dada temperament, which contributed to their friendship. Nevertheless, his creative efforts were occasionally derivative or in a minor key, lapses which occurred somewhat less crucially in his Dada objects than in his airbrush paintings.

Ray's achievement lay primarily in painting and photography. An episode which he recounts in his *Self Portrait* reveals where his interests lay, and how he differed from Duchamp:

> In my room was a chess table with one of my first designs for a set of unorthodox pieces, simple geometric shapes. The [chess] master inquired whether they were intended to be chess pieces and when I nodded, he at once proposed a game. It took him about ten minutes to beat me. I was pleased and asked him if he did not think the design was practical — might be accepted by players. He replied that the pieces did not matter, he could play with buttons, or even without pieces. Then he proposed turning his back, that I announce my moves to which he would reply. I did not accept the challenge and decided that chess players were not susceptible to form, unless they were also artists.[36]

By 1923 Duchamp had given up art for chess. His transformation from artist to engineer and then to chess player constituted a successive renunciation not simply of art but of plastic creation, as he plunged into a world of ideas. Although Man Ray also played chess, he was as much interested in the pieces themselves as in their respective moves or in the strategy that determined the moves. Similar interests informed his work. Although he shared a wide range of anti-art attitudes with Duchamp, Ray was predisposed to explore their plastic implications rather than make salient statements about aesthetics in his work.

As a result, during his early Dada years he expanded the formal and technical possibilities of painting and photography. For example, his exploration of painting in relation to collage culminated in a large oil of 1916, *The Rope Dancer Accompanies Herself With Her Shadows*. And intrigued by the photographic efforts of Stieglitz and his group, he carried the implications of straight photography to their logical conclusion with the Rayograph, a technical innovation which revealed a poetic realm of fantasy in the object itself. That he never settled down to exhaust either mode of expression testifies to his restless Dada spirit, hazardous yet at the same time rewarding.

That Ray's Dada objects do not substantially enhance his stature either as a Dadaist or as an artist was a result less of a provincial impulse to imitate Duchamp than of the subversive nature of the readymades from which Ray drew inspiration. For Duchamp the idea that animated the readymade was always paramount, so that the loss or destruction of a readymade was of little consequence. His conceptual approach to the object remained constant through the years, even though his readymades became increasingly complex after he came to

America. Not only did he manipulate the object beyond simple selection but he also placed it in a more mysterious ambience. *Why Not Sneeze?* (1921) is a birdcage filled with *trompe-l'œil* sugar cubes made out of marble. This constructed object, despite the enigmatic title and strange juxtaposition of components, including a thermometer, has nevertheless much the same cerebral quality as one of his more simple and earlier readymades, such as *Bottlerack* (1914). In contrast, Man Ray's objects did not measurably build upon the ideas that Duchamp espoused. Because the readymade was clearly Duchamp's intellectual forte, Ray's *New York 1920* suffers in comparison with Duchamp's *Why Not Sneeze Rose Selavy?*, even though it anticipated by a year the ideas of Duchamp's readymade down to the gastrolithic dangers lurking in an olive jar filled with ballbearings. Although Ray's objects helped to generate excitement over the possibilities of Dada, their value lay more in their physical presence as objects than in the ideas they dramatize. And with second-hand ideas, they always run the risk of becoming alreadymades. For example, Ray's *Enigma of Isadore Ducasse* (1920), a sewing-machine wrapped in burlap, remains more interesting today for its plasticity than for its clever allusion to *Les Chants de Maldoror*, an important literary antecedent of Dada and Surrealism, whose recognition had become a stock piety even then.

At their best, Ray's plastic objects possess an aura of magic and mystery, just as his *Enigma of Isadore Ducasse* most certainly lives up to its title. His most successful efforts were *Cadeau* (1921), a hand-iron with a row of long tacks embedded down the center of its bottom, and *Object To Be Destroyed* (1923), a metronome with an image of an eye attached to the pendulum. The former, with its mysterious juxtaposition of tacks against an iron, directs the viewer to its human creator, to the imagination that could construct such an aggressive object and ironically entitle it *Cadeau*. As for the metronome, it must have had a maddening hypnotic effect as its eye oscillated back and forth, matching the eye of the viewer, who would thus be incited to destroy the object, as indeed happened during an exhibition.

In 1917 Man Ray borrowed the technique of painting with an airbrush from commercial artists and produced a series of monochromatic "Aerographs," as these were generically called.[37] The use of an airbrush was a literal but logical extension of Picabia's machine drawings or Duchamp's meticulous draftsmanship in his *Large Glass*. As an idea, the aerograph anticipated the underlying premise of Duchamp's

declaration to be an engineer in 1920, symbolizing his rejection of the artist's expressive hand in favor of mechanization. In the final analysis, however, Ray's aerographs fail to embody that idea effectively. Only out of an awareness that an aerograph was done with a machine does the viewer realize the ironic implications of a mysterious, out-of-focus image and its mechanical origins. But examined more closely, the irony of Ray's anti-painting gesture dissipates. Although in concept the aerograph might be a forerunner of such machine art as computer paintings, the airbrush is less a machine than a mechanized hand-tool, akin to the mundane paintbrush.

Ray's early insistence upon the literal presence of an object, determined and fostered in large measure by his work in assemblage, carried over into his painting. In 1911 he sewed together fabric samples to make a *Tapestry*, which he claimed was a gesture of rebellion provoked by a session at an evening art school.[38] From this abstract wall-hanging and bedspread, Ray moved on to an expressionist *Dream* painting the following year, and then came to realize the fantastic through the literal in *Man Ray 1914*.[39] Chronologically, this sequence moved from abstraction to an incipient Dadaism, but the inner and most significant dimension of his work in subsequent years explored the relationship between assemblage and painting.

Man Ray 1914 dramatized the artist's self on the threshold of Dada. Certainly a variation on Cubism, and possibly even anti-Cubist at the same time, the painting was a prelude to Picabia's machine portraits for *291* the next year. The image, comprised of Man Ray's name and the date, 1914, completely merges the verbal and the visual. Man Ray becomes the mysterious center of his painting as the visual ambiguity of letters and numbers create a Cubist landscape.[40] The essential irony is that the artist's signature *is* the painting, as Marcel Jean, the historian of Surrealism, has pointed out.[41] But Ray's undertones of cynicism are transcended by the painting's aesthetic commentary akin to that of the readymade: just as the artist (Duchamp), in selecting a common object, suggests its new status as art by his signature alone, so Ray's signature, here comprising the entire painting, is the ultimate determinant of a work as art.

These early works of Man Ray do not have the sparkle and wit that permeate slightly later works by Picabia and Duchamp, who were dealing with essentially the same ideas. By 1916, however, Ray was at work on his great oil painting, *The Rope Dancer Accompanies Her-*

self With Her Shadows, which brilliantly developed the ideas and values that were suggested by *Man Ray 1914*. By this time, too, Ray was aware of Duchamp's glass construction, as the discursive title of his painting echoes the rhythm of *The Bride Stripped Bare By Her Bachelors, Even*. Ray also borrowed some iconographical elements: the shapes of the shadows are reminiscent of the Nine Malic Molds; the multiple lines of the dancer's rope possibly have their source in the Three Standard Stops; and the painting has a schematic undercurrent which subtly alludes to the diagrammatic quality of the *Large Glass*.

In addition to these correspondences, *The Rope Dancer* further approximates the *Large Glass* by its ambivalent existence in the realm of ideas. Tactile and intellectual values are held in tension as the brilliant greens, oranges, and reds are offset by their smooth application and hard, interlocking edges. As the bright colors "dance" on the canvas, the rope dancer maintains her balance, however precariously her legs flash in multiple image, the designated iconography metaphorically reflected by the color balance of her monumental shadows. Set against these sensual colors, the persistent echo of the enigmatic title keys the viewer to intellectual contemplation as well as aesthetic perception. Despite her important affinities with *The Bride*, Ray's *Rope Dancer* raises and resolves her own set of questions about art through the motion of her dance. Significantly enough, as a popular artist who is not hermetically sealed into an effete aesthetic world, she is consonant with Dada, whose goal, among others, was to infuse art with a new vitality.[42] Not only must she perform before a live audience, but she must commit her life to the dance. Her precarious and thus dangerous balance, performed with grace, results in an art that is essential to life. The rope dancer stands, therefore, in marked contrast to the hanged bride of the *Large Glass*, who fails in communicating with the Bachelors as their attempts at sexual intercourse ironically lead to frustration and isolation. Ray inverts this Duchampian irony, for although the rope dancer dances alone, she does indeed dance, her solitary gesture paradoxically resulting in effective communication.

The Rope Dancer follows Dada not only in its ironic discourse between art and life but in its formal play as well. Its motif evolved out of *Promenade* and *Dance*, two of Ray's paintings of 1915 that initially treat the movement of the human figure. More importantly, however, the figures of *Dance* are conceived in two-dimensional patterns, painted in what Ray has called his "flat manner," which led him to the

formal composition of *The Rope Dancer*. To determine the multiple forms of the central figure, he tried preliminary sketches on colored paper (the flat, painted patterns being amenable to paper cutouts). Dissatisfied with the results, he made a discovery:

> Then my eyes turned to the pieces of colored paper that had fallen to the floor. They made an abstract pattern that might have been the shadows of the dancer or an architectural subject, according to the trend of one's imagination if he were looking for a representational motive. I played with these, then saw the painting as it should be carried out. Scrapping the original forms of the dancer, I set to work on the canvas, laying in large areas of pure color in the form of the spaces that had been left outside the original drawings of the dancer.[43]

Ray here obliterated the differences between the literal and the metaphorical. The metaphorical shadows of the dancer—the paper cutout areas—become the literal patterns for the shadow forms in the oil painting.

Man Ray's perversity was typical of Dada, for though he might have used the cutouts to make a collage, he preferred to use traditional paint for representing his forms on canvas. This unexpected Dada twist allowed Ray more than the simple freedom to do as he pleased, for the distinctions between collage and painting became blurred, thereby opening new formal and thematic possibilities. If to call *The Rope Dancer* a *trompe-l'oeil* collage is to overstate the case, there can at least be no doubt that the painting is a metaphor for collage.[44] Earlier Braque and Picasso had led the way by mixing media within their collages. Moreover, they occasionally used a paintbrush to simulate *trompe-l'œil* collage elements on the canvas. Their illusions and counterillusions raised important questions about art and reality that Duchamp carried to an extreme with his readymades. Paralleling Duchamp, but returning to the canvas, Ray consistently developed such ideas by asserting the complete and mutually fluent interchange between modes of expression. A painting might well take the guise of collage and *vice versa*. In emphasizing the transmutation of media, Ray underscored the magic of art, one of the prime tenets of Dada.[45]

During the same period, Ray played similar variations with a series of actual collages entitled *Revolving Doors*: "I began working on the series of pseudo-scientific abstractions, but before transferring them to canvas, I traced the forms on the spectrum-colored papers, observing a certain logic in the overlapping of primary colors into secondary ones, then cut them out carefully and pasted them down

on white cardboard. The result was quite satisfactory and I felt no immediate need of transferring them to canvas."[46] These collages pass for what could be construed as watercolors. *Trompe-l'œil* is truly an appropriate term here, referring not to a representational illusion created by a particular medium, but to an illusion of one medium for another. In other words, art comments upon art, as its illusory means are emphasized and exploited.

Man Ray further developed the interplay between the literal and the fantastic in his photography, which, before he discovered the Rayograph itself, involved but occasional experiments in the fantastic. For example, a relatively early but famous photograph, his *Élèvage de Poussière*, the raising of dust on the *Large Glass*, was taken in Duchamp's New York studio sometime in 1920. Here anti-art begat a photograph which assumed illusory proportions: the *Large Glass* section where the diagrammatic glider chants its litanies to the Bachelors resembles an aerial photograph or a lunarscape.[47] No ordinary work in itself, the *Large Glass* was thus seen in yet another guise. Man Ray's interest in the fantastic aspects of an object was to reach its logical conclusion with the Rayograph. But in working toward that process, he also carried out the implications of straight photography. Paul Strand had earlier pointed out one of the directions it might take with a series of photographs that appeared in the final issue of *Camera Work*—photographs which heightened attention upon the subject with such an intensity that its formal, even abstract, qualities came to the fore. Consequently, anti-art was led full circle to art once again. Stieglitz himself tended in this direction with a later series of photographs called "equivalents," whereby the scenes photographed (and contact-printed so that the final image matched the view through the camera lens) might assume emotional values equivalent to Stieglitz's original experience. At the same time, these images, like Strand's, display abstract form without distortion.[47] The Rayographs play with abstraction and fantasy in their own way by following literally the dictates of straight photography.

The Rayograph came into existence quite by accident. After moving to Paris in 1921, Ray took up photography professionally. In the course of developing some commissioned work in his makeshift darkroom, he came across the process:

> It was while making these prints that I hit on my Rayograph process, or cameraless photographs. One sheet of photo paper got into the developing tray—a sheet unexposed that had been mixed with those al-

ready exposed under the negatives—I made my several exposures first, developing them together later—and as I waited in vain a couple of minutes for an image to appear, regretting the waste of paper, I mechanically placed a small glass funnel, the graduate and the thermometer in the tray on the wetted paper. I turned on the light; before my eyes an image began to form, not quite a simple silhouette of the objects as in a straight photograph, but distorted and refracted by the glass more or less in contact with the paper and standing out against a black background, the part directly exposed to the light. I remembered when I was a boy, placing fern leaves in a printing frame with proof paper, exposing it to sunlight, and obtaining a white negative of the leaves. This was the same idea, but with an added three-dimensional quality and tone gradation. I made a few more prints. . . . Taking whatever objects came to hand; my hotel-room key, a handkerchief, some pencils, a brush, a candle, a piece of twine—it wasn't necessary to put them in the liquid but on the dry paper first, exposing it to the light for a few seconds as with a negative— I made a few more prints, excitedly, enjoying myself immensely.[49]

The Rayograph logically derives from straight photography, for the object itself is presented directly to the photo-contact paper, and any intervening apparatus, including the camera, is eliminated. A straight photographer could not get any closer to his subject. But the technique requires manipulation of the print, a process that was abhorrent to Stieglitz. This subversive twist must have appealed to Ray's Dada sensibilities as much as the idea of producing a cameraless photograph. At the same time, then, the Rayograph is a culmination of Duchamp's desire to eliminate or de-emphasize physical techniques in the arts.

As an accidental yet logical development of straight photography, the Rayograph embraced both the abstract and what was soon to be called the Surreal, already an integral aspect of Dada in Paris. Moreover, it is related to Cubism by Ray's use of familiar objects in the photographic process—objects that are small and could be found in the artist's studio (or darkroom). Yet while he paid some attention to the intrinsic form of these objects, his formalism never actually picked up the vocabulary of Cubism. For example, a 1924 Rayograph entitled *Ribbons* (related in iconography to his *Lampshade* object and Duchamp's roto-reliefs) is a near-abstraction, consisting merely of a twisted strip of paper in spiral form. Primary interest, however, centers upon its form in terms of the mystery it creates. Ray further explored such possibilities in a Rayograph entitled *Sugar Loaves* (1925), which has the strange appearance of a lunar or underwater landscape. He ma-

nipulated objects in such a way that their conventional representational dimension is distorted if not obliterated. A strange new world comes into being, carrying with it a sense of mystery, as the viewer's empirically conditioned expectations are completely undercut.

Partly because of the emphasis on the process, and partly because of its deceptive ease, the end results were often uneven in quality. A Rayograph like *Clock Wheels* of 1925, however, presents an exceptional synthesis of mystery and form. Its iconography, although indebted to Picabia's machine drawings (particularly *Reveil Matin* of 1919), has an integrity of its own. As the title suggests, the mechanical forms in the Rayograph are recognizable watch parts, predominantly gears, ironically depicted as non-functional: the gears do not quite mesh, while some minor ones are halved, sliced off by the surrounding dark. Like Picabia, Ray was emphasizing the irrationality of the machine.

Ray first published his Rayographs in 1922 in an album entitled *Les Champs délicieux*.[50] The previous year, his first in Paris, he had given a one-man show at the Librairie 6, which was acclaimed by the Dadaists. His departure from the United States in 1921, along with Duchamp's, signified the end of New York Dada; with the exception of the Baroness Elsa von Freytag-Loringhoven, no one else was any longer inclined to carry on the shenanigans of Dada. It was renewed briefly four years later when *Aesthete 1925* was published by a number of young expatriates who had returned from Europe, intent upon creating a fuss in the conservative literary circles of New York. But even that small eruption was related to Man Ray and New York Dada in a roundabout way. In 1921 William Carlos Williams had warned against the dire consequences of Dada in New York. In its stead he asked his fellow artists to remain faithful to their cultural environment in order to create an indigenous American art. Clearly, for Williams, Man Ray and Duchamp formed an enemy camp. Yet it was Ray who had introduced the young Americans recently sojourning in Paris to all the Dadaists congregated there, and out of those exhilarating encounters emerged *Broom* and *Secession*, which, taking precisely Williams' position, encouraged the creation of an indigenous American art. That the internationalism espoused by Man Ray led to a consciousness of purely American values in art was one of the many paradoxes that Dada was to foster.

4 | *The Soil* and *Contact*

The little magazines that responded most fully to Dada sought to explore its relevance for the creation of an indigenous American art. After Stieglitz terminated *291* and then *Camera Work*, Robert Coady, a New York art dealer, undertook similar goals in 1917 with his magazine *The Soil*. And three years later, William Carlos Williams collaborated with Robert McAlmon, the expatriate writer, to pursue an American art in *Contact*.[1] These magazines were significant far beyond their brief appearance, for as successors to *291*, they provided an essential point of view for young Americans abroad to consider in their response to Paris Dada during the 1920's.

Whereas *291* came only gradually to reject its artistic ties with Europe, *The Soil* carried the banner for an indigenous American art from the outset. Coady's enthusiastic commitment, however, did not resolve the cultural ambiguities which were not only traditionally inherent in American discourse with Europe but amplified by American artists in contact with Dada after the Armory Show. And so, just as *291* paradoxically focussed on Picabia and his view of America, Coady's aggressively American journal featured Arthur Cravan, a self-promoting Englishman who had anticipated Dada earlier with his anti-art review *Maintenant*.[2] As a congenial sounding-board for Cravan in America, *The Soil* took its impetus from the fact-laden catalogues of Walt Whitman's poetry. In this respect, Coady clashed vividly with his contemporaries who published the highly-regarded *Seven Arts*, a magazine which, in also espousing a national art, preferred to follow Whitman's spiritual vision of America.[3] This sharp divergence was to establish the lines of controversy that developed in the 1920's between the Dadaism of the *Broom* group and Waldo Frank, the foremost proponent of a mystic nationalism.

In 1917 Williams lent his approval to *The Soil* by asserting, "It is all very democratic, all very decorative, this apotheosis of trust

magnates and trip hammers and Jack Johnsons. I like it. I think it makes a fine lively magazine." But he had one serious reservation: "*The Soil* makes a peculiar mistake in imagining that a mere ability to live well is art." Realizing that neither a lively journal nor an emphasis on the energetic life would alone create a purely American art, Williams soon rejected Coady's preoccupation with the surface of American phenomena and came out in favor of exploring their psychological implications: "I don't give a damn about airplanes and airplane poetry," he confessed, "but I do give a damn about the distraught brain that must find its release in building gas motors and in balancing them on cloth wings in its agony."[4] As a consequence, *Contact* hardly even considered, let alone glorified, American technology, vaudeville, the movies, or sports—in other words, all the trappings of *The Soil*.

But like Coady, Williams espoused anti-art values in his theory of contact, which was a process conceived as a necessary prerequisite for the creation of art. Coady's emphasis upon an art grown from native soil paralleled Williams' insistence upon the artist's involvement with his cultural environment, and both objected to imitating European art, which they considered to be a counterproductive cultural model for the American artist. Consequently, *Contact*, as indeed *The Soil* before it, took Marcel Duchamp to be its antagonist. But perhaps even more irritating to Williams than Duchamp was his sense that American art itself was inimical to the growth of art. The tensions informing *Contact* were thus derived from Williams' feeling of entrapment between the forces of Europe and America and from his subsequent attempts to adjust theory and experience to one another.[5] In contrast, the five issues of *The Soil* were all of a piece: once Coady had made his argument, he devoted the magazine to promoting his position with all the rhetorical strategems at his command. To be sure, *The Soil* implicitly embraced the same ambiguities and tensions that animated *Contact*. But Coady himself was only dimly aware of the contradictory undercurrents that Williams could not ignore, living as he did, in the aftermath of a World War that opened Europe to America, an opportunity denied to Coady, who died in January 1921.

In the first two issues of *The Soil* Coady published an essay on "American Art" that established the main outlook of the magazine. From the beginning, he boldly asserted that "there is an American

art. Young, robust, energetic, naive, immature, daring and big spirited. Active in every conceivable field." By exaggerating its vitality, he envisioned its endless possibilities and brought into question established aesthetic criteria just as Duchamp had done with his readymades. The bulk of his essay simply listed examples of American art:

> The Panama Canal, the Sky-scraper and Colonial Architecture. The East River, the Battery and the "Fish Theatre." The Tug Boat and the Steam-shovel. The Steam Lighter. The Steel Plants, the Washing Plants and the Electrical Shops. The Bridges, the Docks, the Cutouts, the Viaducts, the "Matt M. Shay" and the "3000." Gary. The Polarine and the Portland Cement Works. Wright's and Curtiss's Aeroplanes and the Aeronauts. The Sail Boats, the Ore Cars. Indian Beadwork, Sculptures, Decorations, Music and Dances. Jack Johnson, Charlie Chaplin, and "Spike" in "The Girl in the Game." Annette Kellerman, "Neptune's Daughter." Bert Williams, Rag-time, the Buck and Wing and the Clog. Syncopation and the Cake-Walk. The Crazy Quilt and the Rag-mat. The Minstrels. The Cigar-store Indians. The Hatters, the Shoe-makers, the Haberdashers and the Clothiers. The Window Dressers.[6]

Overflowing onto another page, the list of objects could be likened to the incantations of a Whitman catalogue: the names had only to be chanted in a ritualistic way to impart a magical sense of art. By the very shape of his argument, Coady implied that the artist should abdicate his active role, for the objects themselves would apparently assume aesthetic value without the intervention of the artist, who would remain passive before the repetitive dint of words.

Coady's prophetic voice was unclear, however, even as he pointed to new creative possibilities. On the positive side, Coady covered a wide range of material — from sport to Indian artifact, from jazz to poetry. By first calling attention to American activity in the arts broadly defined, he underscored the aesthetic qualities of material that previously had not been adequately treated or even considered as art. More crucially, however, Coady's American litany obscured the counterpoint of subtle issues informing indigenous creation. For example, he overlooked the European origins of some of his citations and thus simplified a complex cultural relationship. Adding to the confusion of his catalogue was the inclusion of even a natural phenomenon such as the East River, as Coady apparently obliterated distinctions between art and nature. Or was the East River art simply because of the human intelligence that could apprehend its natural beauty? The problem was compounded by Coady's failure to provide qualifying clues. In this

regard, was the Cigar-store Indian a work of art already created, or was it to be a worthy subject for the artist, or both? Not least of all, Coady placed everything on the same level of aesthetic value without making any distinctions. To be sure, the kinds of questions that he provoked were similar to those raised by Duchamp's readymades. Nevertheless, Coady's rhetoric, when seriously analyzed, fails to evoke the logical lucidity implicit in the readymades.

Only tentative answers can be garnered from Coady's concluding statement:

> —This is American Art.
> It is not a refined granulation nor a delicate disease—it is not an ism. It is not an illustration to a theory, it is an expression of life—a complicated life—American life.
> The isms have crowded it out of "the art world" and it has grown naturally, healthfully, beautifully. It has grown out of the soil and through the race and will continue to grow. It will grow and mature and add a new unit to Art.[7]

According to Coady, American art was directly related to American life in the sense that they were almost one and the same. Neither the life nor its art was effete or bound by any particular aesthetic. By implication, not only would Europe and its hot-house tendencies hinder the creation of American art, but its sources would be of little consequence for the American artist, who had to work with what he had on hand on this side of the Atlantic.

Ultimately, Coady espoused an aesthetic primitivism. He exhorted American artists to strip away every preconceived notion of art that might block the expression of American life. Although he maintained that the experience was indeed complicated, he believed that the prevailing art merely obscured the life it was meant to express.[8] Hence he was not immediately concerned with establishing a hierarchy of aesthetic values. Anything and everything would be valuable in the representation and promotion of American life.

Coady's primitivism was reinforced in part by his use of metaphor. The title of his magazine was obviously taken from his belief that American art "has grown out of the soil." He employed an agrarian metaphor which now seems inappropriate, given the fact that most of his catalogue was concerned with urban activities. While his image suggests a return to the simplicities of nature, Coady would have been

the last to advocate such a return, even though he did seek primal experiences of the sort that nature was once supposed to offer. Yet, despite the nostalgia or sentimentality implicit in the very use of an agrarian metaphor, Coady generally avoided such attitudes by the force of his primitivism, his will to capture experience directly, without the "shield of psychology and metaphysics," which De Zayas would have had Stieglitz put aside. Although Coady's strength lay in his exuberant and direct confrontation with things American, the use of a worn metaphor such as the "soil" suggests the inadequacies of his cultural expression, outstripped by the ideas and attitudes which it intended to convey.

In the second installment on "American Art" Coady attempted, but with only partial success, to modify and clarify his previous position. Addressing himself both to those who had been inhibited by tradition as well as to those who were falsely liberated by modernism, Coady retraced his argument. "By American Art," he explained, "I mean the aesthetic product of the human beings living on and producing from the soil of these United States. By American Art I mean an American contribution to art." In this final analysis the soil was no more than a simple geographical referent. Nor did Coady turn completely away from Europe. "The Old World can teach us a lot," he admitted. "Her masters can develop our taste and help us realize ourselves. Greece can show us where subtle emphasis goes farther than exaggerated distortion and where affinity of subject and object will generate a work of art. . . . Lorrain and Van Gogh can show us that color is light. Cézanne can show us form."[9] Europe, therefore, could provide guidance in a broad sense, by developing American taste and by setting forth principles rather than specific works of art to emulate.

Nevertheless, Coady still clung to the stereotypes of the Old and New Worlds. "We are developing a new culture here," he insisted. "Its elements are gathering from all over the earth. We are making adjustments and getting results—physical, intellectual, aesthetic. Traditions are being merged, blood is being mixed. Something new, something big is happening here."[10] In viewing America as a unique synthesis of elements derived from the Old World, Coady overrode his previous qualifications and placed America beyond European tradition and history, so that a new art might eventually occur.

The inadequacy of Coady's assumptions were particularly pro-

nounced in his attempt to provide guidelines for an American art. He could present only a reductionist argument which jettisoned a broad variety of approaches:

> We need our art. But we're getting very little from our art world. It can't come from the Academy or the money little old ladies leave. It can't come from imitating "Representation" or by substituting rule for taste. It can't come from turning paint into brush-strokes and marble into mush. It can't come from "Greek Plays" or "The Yellow Jacket." It's not in "the march of civilization" from the Chinese Theatre to "When Did You Last Write Mother?" It's not in the imitation of Franz Hals and Velasquez or Cézanne and Picasso. It won't come from the "Photo-drama," "Intolerance" or a multiplication of naughts. It can't come from the substitution of dexterity for taste. It can't come from the clouds or "the womb of the soul." It's not in the fifth dimension or the three hundred and sixty-first degree. It can't come from "bigness" for fullness. It can't come from reducing drawing to angles and curves, or separating color from form. It can't come from "Elimination" beyond the unit, or from "Cubism," "Planeism," "Lineism" and blank canvases. It can't come from labels or labeled mysticisms. It can't come from theory in place of taste. It can't come from inventing nativities and organizing cosmoses; from smart sets or synchromocivic insolence. It won't come if we rub out yesterday and to-day. It's not coming from oyster talks, from lectures, write-ups, pamphlets, prefaces, catalogues, books, volumes of explanations that don't explain.[11]

Whatever the validity of his negations, and many were indeed valid, Coady was carried away by his rhetoric, as he discounted both the genteel tradition and the revolutionary forces of modern art. Anti-intellectual as well as antimystical (his remark was possibly a covert reference to Waldo Frank and *The Seven Arts*), Coady was left with something which he vaguely called "taste," a term he did not attempt to explain until the final issue of *The Soil*.

By the process of elimination, Coady returned to his original anti-art position: "Our art is, as yet, outside of our art world. It's in the spirit of the Panama Canal. It's in the East River and the Battery. It's in Pittsburgh and Duluth. It's coming from the ball field, the stadium and the ring. Already we've made our beginnings, scattered here and there, but beginnings with enormous possibilities. Where they will lead, who knows? To-day is the day of moving pictures, it is also the day of moving sculpture."[12] The affirmative imagery throughout indicates an enthusiasm which, unbridled by logic, allowed Coady to

discount what he considered to be the nonessentials that obstruct creativity. His reductions, despite a nihilistic undercurrent, were intended to reaffirm the possibilities of American life for open-ended creation.

Coady's reactions to the Independents Exhibition of 1917 further reveal his attitudes toward art. In an essay entitled "The Indeps," published in the final issue of *The Soil*, Coady advocated a national show instead of an international exhibition. He viewed the show as it was then mounted as a hodge-podge failure because the Committee looked to a European model for art. Scoring the exhibition on its own terms, Coady demanded independence not only from the American academy but also from European tradition, modern or otherwise.[13]

He also inveighed against the Society's hanging the entries in alphabetical order, which he felt implied a facile egalitarianism. For Coady, art invited, if not required, evaluation, which was determined by personal judgment, the exercise of which in turn developed "taste" in the individual. Although he claimed that taste adhered to standards and principles which the application of personal judgment would develop over the years, he was not rigidly doctrinaire about the matter, for he saw the entire process as closely allied to life. According to his logic, if one loved steam shovels (for Coady, a prime example of "life"), then one would appreciate the aesthetic quality of machines, which had stimulated personal judgment. Not only was the entire polemic circular, but Coady's tolerance had implicit limits. Life, he believed, was most closely related to the raw energies of the steam shovel in the construction pit and quite apart from the genteel world of the parlor.

In such a fashion, Coady circumscribed "taste" to protect art. Taste could create an aesthetic hierarchy for appreciation (a function of exhibitions), but it could not determine what constituted art. "There may be," he conceded, "within the realm of taste, an honest difference of opinion as to the degrees of the value of a given work of art, but I don't believe that that difference can ever occur as to whether a given work is or is not art." For Coady art was "positive; it comes from a feeling of human being. It is an extension of life and travels the earth and goes on to eternity. It creates its own forms, many and enough for all its needs, and brings its own freedom with it. It spreads living into the superlative and by its magic it makes men of some and fools of others."[14]

Although this sentiment is vague, Coady's instincts ran true in

developing a strategy for American art: his idea was to acknowledge the validity of personal judgment without submitting art to the capricious or subjective criteria of taste—especially that refined taste which might drain the vitality out of art. In a rare instance of subtlety, Coady intimated an awareness of the dangers facing American art at the hands of its public, seeking genteel forms and feelings. Ironically enough, however, once his definition of art is deflated, Coady's position, extolling a free discourse between art and life, in fact approximated that of the foreigner Duchamp and his readymades, particularly his *Fountain*, which was rejected at the Independents.

These two essays, which began and concluded *The Soil*, embrace the range of material appearing in the magazine. Sponsoring an indigenous American art, *The Soil* understandably promoted articles on American sports, vaudeville, crafts, movies, dime novels, and the like. Moreover, Coady's values informed most of the articles that were published. Those on European artists stressed certain anti-art attitudes and portrayed the artist as a common human being. Ambroise Vollard's essay on "Cézanne and Zola," for example, depicted the painter's matter-of-fact attitude toward his efforts. "When a picture is not achieved, one chucks it into the fire and begins another!" he was quoted as saying. Essays of this sort attempted to demythologize the artist, to bring him out of the romantic clouds back to a common existence. In a similar vein, Coady praised a popular artist like Toto, the Italian clown, "the most creative artist that has visited our shores in many a day. He is a clown at the Hippodrome who has invented a bow which has given pleasure to thousands. His message is delivered direct. He bows and thousands roar." This Tolstoian view of art also prompted him to serialize a Nick Carter mystery as a popular genre of American fiction, fully vital and alive. Indeed, the editors printed many letters from Nick Carter fans who mistook their hero for a living person.[15]

To illustrate his ideas in *The Soil*, Coady used specific pictorial arrangements. In the first issue, for example, he threw together a collage made up of bits and pieces of modern works of art, presented as a "Cosmopsychographical Organization," with a caption that spoofed the pretentiousness of the aesthetic jargon which often accompanied modern art:

> "COSMOPSYCHOGRAPHICAL Organization," or, the "plastic" "visualiza-
> tion" of my "intellectualized sensations." Wherein is "infinity strug-

gling for birth in the womb of the soul," "surrounded by swift moving nudes." Wherein, also, "I pay no heed to mere objects" for, "the path moves towards direction" where I pay "homage" to "the absence of M..... D....." And, again, wherein, I have "invented" "nativity" and "organized" "organization" 1, 2, 3, 4, 5, 6, 7 times. "Thus" do I "kill the feeble and invigorate the strong," my "creative vision handling the whole surface with supple control."

Somewhat heavy-handed in his parodies, Coady later used a related technique to better advantage. He juxtaposed two paintings, one entitled *Motion* by Marsden Hartley, the other *The Busted Ford* by a thirteen-year-old boy. Spread across both pages was the question, "Which has—the motion?"[16] Prepared ahead of time by Coady's attitudes, the reader is obviously supposed to opt for the adolescent's semirepresentational painting of the "busted Ford" over Hartley's abstraction of motion. But even today, giving all due recognition to Hartley as a painter, the juxtaposition is unsettling enough to make the reader think twice about the values of a child's spontaneity as against the artist's craft. Indeed, Coady's arrangement was sufficiently open-ended to revive fundamental questions about art. Unlike many critics who spoofed modern art, particularly at the time of the Armory Show, Coady did not dictate academic values but rather cast his net far beyond such limitations in seeking the creation of an American art.

In this context appeared Arthur Cravan, French poet and "the World Champion at the Whorehouse." According to Gabrielle Buffet, Cravan arrived in New York in the early part of 1917, obviously his second coming after an initial trip in 1903. He fulfilled his apocalyptic mission with an infamous lecture on modern painting:

In March 1917, at the Grand Central Gallery, the American Independents Exhibition took place. It was there that Picabia and Duchamp had the idea of having him deliver a lecture, counting on a repetition of the Paris scandal of 1914. As it happened, things took a rather different turn, one that went beyond all their expectations. Cravan arrived very late, pushing his way through the large crowd of very smart listeners. Obviously drunk, he had difficulty in reaching the lecture platform, his expression and gait showing the decided effects of alcohol. He gesticulated wildly and began to take off his waistcoat. A canvas by the American painter, Sterner, was hanging directly behind him, and the incoherence of his movements made us fear that he would damage it. After having taken off his waistcoat, he began to undo his suspenders. The

first surprise of the public at his extravagant entrance was soon replaced
by murmurs of indignation. Doubtless the authorities had already been
notified, for, at that moment, as he leaned over the table and started
hurling one of the most insulting epithets in the English language at
his audience, several policemen attacked him suddenly from behind,
and handcuffed him with professional skill. He was manhandled,
dragged out, and would have been thrown in jail, but for the intervention
of Walter Arensberg, who bailed him out and took him to his house,
while the protesting crowd made a tumultuous exit. If we add that it
was a very smart audience, that the most beautiful Fifth Avenue host-
esses had been urged to be present—all those who professed interest
in painting and had come to be initiated into the new formulae of
"futurist" art—it will be seen that the scandal was complete. What a
wonderful lecture, said Marcel Duchamp, beaming, when we all met
that evening at the home of Arensberg.[17]

An imaginary playbill for this inverted morality play would cast Picabia
and Duchamp as the wily co-producers, Cravan as the star, and Arens-
berg as the conservative investor who had to bail out his troupe. A
prototypical Dada demonstration, Cravan's strip-show outraged an
audience which deserved abuse for having viewed art as a social event.

Cravan first made known his attitudes in *Maintenant*, the little
review that he published sporadically from 1912 to 1915. The tensions
of art/anti-art were manifest in his essay "Oscar Wilde is Alive!" which
was reprinted in the last two issues of *The Soil*. In the first episode Cra-
van, claiming to be the nephew of Oscar Wilde, presents a mélange of
attitudes ranging from *fin de siècle* boredom to proto-Dada absurdity.
The second episode is enlivened by a confrontation between an un-
kempt Cravan and the effete Wilde. This vignette might be viewed as
part of the hoax that Cravan had already perpetrated upon a gullible
public by circulating the rumor that Wilde was still alive after his death
in 1910. From that perspective, the article was clearly a vehicle for
publicity and scandal. Beneath the self-promotion, however, ran a dram-
atization of Cravan's divided psyche, in which the aesthete struggled
with the man of action. This tension was never completely resolved,
because Cravan remained a poet, despite a simulated "swift kick"
aimed at the retreating Wilde, thereby symbolizing his apparent rejec-
tion of all that Wilde stood for. In the next breath, however, Cravan
expressed regret at his behavior, so that it is difficult to accept him
completely as "the World Champion at the Whorehouse." This posture
was just one of many guises that Cravan adopted, for as he himself ad-

mits in this fantasy, "I, who dream myself even amid catastrophes, I say that man is only so unfortunate because a thousand souls inhabit a single body."[18]

The same tensions that Cravan dramatized in his article on Wilde were inherent in *The Soil*. But Coady generally kept them under control by conveying a sense of the interpenetration of art and life. Thus the first episode on "American Art" was followed by Cravan's invitation to "Come now, chuck this little dignity of yours to the winds! Go and run across fields, across the plains at top speed like a horse; skip the rope and, then, when you shall be like a six year old, you'll know nothing and you'll see most marvellous things."[19] Out of context, this return to a child's sensibility seems to leave little room for artistic creation; but coming, as it did, directly after Coady's article on American art, the statement implied that art must refresh itself with the directness of life.

This pattern of primitivism and art was repeated over and again in the pages of *The Soil*. For example, in an interview with Cravan about his experience in the ring with Jack Johnson, the American expatriate heavyweight boxing champion, Cravan praised Johnson for his exuberance: "Outside the ring he's a man of scandal—I like him for that—eccentric, he's lively, good-natured and gloriously vain; anything that has to do with Johnson has to do with a crowd of policemen." At the same time, Cravan saw this form of action as related to art: "After Poe, Whitman, Emerson, he is the most glorious American." This interview climaxed a series of articles on boxing by Robert Alden Sanborn, who venerated the sport as a rough and tumble art.[20]

Coady's focus on urban technology best illustrates his concern for an art related to contemporary reality. Although *Camera Work* and *291* had already concentrated on the machine, Coady apparently believed that more attention was necessary, so that the pages of *The Soil* were filled with photographs of machinery, while in the margins was the question, "Who will paint New York? Who?" Such an emphasis is understandable when one realizes that Marin's watercolors of the city were roughly Cubist in syntax and thus probably subject to Coady's disapproval. Moreover, Marin was just one painter, whereas Coady desired a renaissance of urban art. Given the various articles remarking on the inherent aesthetic qualities of the machine, Coady clearly wanted technology to be taken seriously as subject matter for American art.[21]

The only satisfactory example Coady could offer, however, was an

excerpt from Whitman's "Crossing Brooklyn Ferry," juxtaposed with the opening lines of "Sifflet," a poem by Cravan. Whitman's lines first establish a vision of the future:

Others will enter the gates of the ferry and cross from shore to shore,
Others will watch the run of the flood-tide
Others will see the shipping of Manhattan north and west, and the heights
 of Brooklyn to the south and east,
Others will see the islands large and small;
Fifty years hence, others will see them as they cross, the sun half an hour high,
A hundred years hence, or ever so many hundred years hence, others will
 see them. . . .

The lines of "Sifflet," which follow the above, were intended, of course, to fulfill Whitman's prophesy:

> The rhythm of the ocean cradles the transatlantics,
> And while the heroic express arriving at Havre
> Whistles into the air, where the gases dance like tops,
> The athletic sailors advance, like bears.
> New York! New York! I should like to inhabit you!
> I see there science married
> To industry,
> In an audacious modernity,
> And in the palaces,
> Globes,
> Dazzling to the retina
> By their ultra-violet rays;
> The American telephone,
> And the softness
> Of elevators. . . .[22]

Here, the "transatlantics" echo the "shipping of Manhattan," while the skyscrapers ("palaces") surpass the "heights of Brooklyn." The "American telephone" and the "softness of elevators," complementing the ferries that "cross from shore to shore," maintain the continuity of past and present, Whitman's future realized. Just as important, Cravan's narrator, who sees the ships and trains at Le Havre, turns his mind to New York, which becomes the New World symbol of technology that unites old and new, past and present, in the tradition of Whitman's "Passage to India," whose unseen presence is felt in this poem.

Both poems convey hints of a romantic exoticism that could bog Coady's America down into a slough of sentimentality.[23] Moreover, despite the clever juxtaposition, Whitman was a nineteenth-century

figure, and Cravan was a European, for all his American ways. Where, then, was the American poet who would succeed Whitman? And would a new Whitman fulfill the nonmystical nature of Coady's industrial scene? In the next decade the young poet Hart Crane would attempt to resolve such questions.

In the meantime, the overwhelming problem facing Coady was the extent to which European artists ought to be emulated in the American artist's quest for an indigenous art that would embody the realities of a culture undergoing radical transformation through its rapidly growing technology. In the first issue of *The Soil* Coady indirectly dramatized this dilemma in an open letter to Jean Crotti, who had constructed a metal and wire sculpture of his brother-in-law Marcel Duchamp.[24] Coady rejected the portrait on the implicit assumption that art should be grounded in representational images, comparing Crotti's work to a bust of Socrates, "done with the conventional and commonplace materials of sculpture." Clearly, naturalistic representation and the use of traditional materials took highest priority in Coady's position on visual form.

But the controversy had broader implications than Coady might have realized. More than he knew, Duchamp was indeed at issue, symbolic, as he was, of the European avant-garde that had migrated to America. Coady did recognize the danger of the kind of conformity set forth by some European moderns: "absolute expression," to use Crotti's own words, conveyed with unconventional material might well become fashionable and get a facile grip on American artists. At the same time, however, although Coady was later to reject slavish representation in art, he did not clearly recognize the tyranny of absolute expression that was being endorsed by American academicians. Yet in his most sweeping arguments, Coady, like the Dadaists, addressed himself to problems of creation. By questioning prevailing cultural definitions of art, he gave American artists free rein to create as they would. Nevertheless, his own standards remained limited, and left unexamined, as they most often were, they too could hinder creativity. Consequently, the initial problem remained unresolved: how could American artists go about expressing their culture without being influenced by the encrustations of European tradition or the anarchy of innovation?

Coady thought that American artists would be liberated by indigenous subject matter, more or less naturalistically represented, but

art does not consist in subject matter alone, as Coady sometimes only dimly realized. As a result, the question of form and technique was left open, if not generally ignored—and open yet again to the underlying question of the extent to which American artists should borrow from Europe. What was the possibility, let alone the price, of liberation?

As coeditors of *Contact*, William Carlos Williams and Robert McAlmon took up Coady's dilemma with all its ensuing ambiguities. The title of their magazine alluded to the "contact" an airplane makes with the earth upon landing.[25] On a symbolic level the expression refers to the view that a live art requires contact with the local environment in terms of particular experience. A statement on the magazine's first cover revealed implicit tensions within this thesis as it pertained to the American locale. Americans were viewed as an "information-cultured people" whose orientation toward fact rather than art combined aesthetic indifference (if not hostility) with a false prejudice in favor of European art as prestigious "culture." Americans thus engaged in what was for Williams and McAlmon the "supreme hypocricy."[26] In order to be viable, art had to conform to the life of a people in a broad cultural sense. But how could contact be achieved, how could an indigenous American art be created against this sort of deeply ingrained cultural opposition? The first four issues of *Contact* were devoted to setting forth theoretical possibilities, while the fifth and final issue, published in 1923, returned to those basic questions.

On the first page of the first number, Williams and McAlmon announced their manifesto, which was "issued in the conviction that art which attains is indigenous of experience and relations, and that the artist works to express perceptions rather than to attain standards of achievement." Criteria for judging the artist's work would derive from the work itself rather than from extraneous sources, essentially "hangovers from past generations." Henceforth the editors would reject traditional art. But at the same time as they championed contemporaneous creation, they did not accept experimentation without qualification. Like Coady, they were skeptical of "isms" and recognized that modernism, if shallowly perceived, could dissipate the energies of American artists who were anxious to be up-to-date.[27]

Williams and McAlmon sought a middle ground on the entire question of emulating current European modes of expression. "We will

be American," they asserted, "because we are of America; racial or international as the contactual realizations of those whose work we publish have been these. Particularly we will adopt no aggressive or inferior attitude toward 'imported thought' or art." Although the editors were willing to publish those who had established genuine discourse with Europeans, they were not very optimistic about such prospects, since literature could not be created "by smearing a lick of borrowed culture over so many pages."[28]

The editors concluded their announcement by addressing themselves to the possibilities of Dada for American artists. Asserting that they "wish above all things to speak for the present," they asked, "Why not in that case have devoted ourselves to Dadaism, that latest development of French soul, which we are about to see extensively exploited in New York this winter without there being—we venture to say—any sense whatever of its significance and fulfill Rodker's prediction?" Ostensibly, Dada would be doubly appropriate because it was a contemporary movement out to destroy past traditions. Further, the prediction of John Rodker, the foreign editor of *The Little Review*, that "this movement should capture America like a prairie fire" would presumably involve Williams and his fellow-artists in the vanguard of the latest European craze.[29]

Sensing Rodker's ironic reasoning, the editors of *Contact* rejected Dada. They suspected that American artists, whatever their degree of commitment to Dada, would not grasp its significance (which the editors themselves failed to spell out). Just as important was their feeling that America itself was not conducive to the growth of Dada. "Well America is a bastard country where decomposition is the prevalent spectacle but the contour is not particularly dadaesque and that's the gist of it." But in the same breath, the editors made qualifications. "We should be able to profit by this french orchid but only on the condition that we have the local terms," they hastened to add. "As it is we should know what is before us, what it is and why. Or at least we should know our own part in the matter: which amounts to the same thing." After intimating the possibilities of America's role, they fell back from their inquiry and immediately discounted Dada. "Not that dadaism is particularly important but—there it is. And where are we?"[30] The editors left the American artist with nothing to guide him through the European maze of Dada.

The second issue of *Contact*, published in January 1921, presented the same ambivalent view. Robert McAlmon satirized Dada in a passage regarding "The Blue Mandrill,"

> [who] is high color, harsh blue, vermillion, with liquid fireball eyes. He does not know Dada, but Dada should take up with him. Without a doubt his grrrhs and gnashings would have greater value recorded, as art, than anybody's intellectual sterilities. He is full of passion, rage, rebellion! . . . Poor brute. Poor Dada. He cannot rebel against the rational, cannot be tired-minded, and know that he is weary of the tyranny of forms in nature. Poor brute! should he attempt to record his emotions he would become awkward and self-aware! The medium of conveyance would force him to selection — destroy the primal urge of vicious resentments — cripple his vigour — My God! My God! Poor Brute. Poor Dada. Ugh! Ack! Ack! Grrrrh! Ugh! Huh! O hell! Poor Dada! ! ![31]

Although this baboon's grunts and groans, parodying the nonsense of Dada, are more valuable than "intellectual sterilities," the "brute" is ironically mocked as well as pitied for his inarticulate primitivism. Like De Zayas earlier, McAlmon recognized the inconsistency of assuming a primitivistic stance in the modern world. While the self-consciousness of contemporary art might crucially undermine the spontaneity of gut expression, a rejection of "the medium of conveyance" leaves the blue mandrill with meaningless expletives, pitiful or perhaps even admirable in a baboon, but hardly fitting for viable communication. By implication, a similar plight confronted the Dadaist.

Yet McAlmon went along with many of the attitudes assumed by Dada at the same time that he satirized it, for however much he disliked a false primitivism, he scorned the "intellectual sterilities" of contemporary literature even more. His strongest indictment was reserved for T. S. Eliot, who, he claimed, having remained "too long within his library," "continually relates literature to literature, and largely overlooks the relation of literature to reality — age, age-qualities, and environment." Against such aesthetic incest, he argued that "the one quality that gives any art a reason for being is the exuberance and impact behind it, of a personality discovering reality for itself." McAlmon also spoke for Williams, who felt "betrayed" by the publication of Eliot's modern epic *The Waste Land*. Williams saw the poem as an outgrowth of Eliot's move to England, and its despair as an expression of his refusal to work out of American cultural values.[32]

Although Williams and McAlmon reacted against Eliot, they

attempted to formulate an affirmative course for American artists. In a "Comment" for the second issue, Williams outlined the terms of a viable posture toward Europe. In order to gain an equal footing with Europeans, Americans would have to become aware of their own culture, lest they "stupidly fail to learn from foreign work or stupidly swallow it without knowing how to judge of its essential value."[33] Implicit was Williams' reluctance to accept Dada until American art matured in its own context.

Yet Williams' skepticism toward Dada was paradoxically tempered by his very theory of contact. In the third issue he emphatically defined contact as the *prerequisite* for an American literature, and not as a set of aesthetic criteria. Taking his lead from Duchamp's admiration of American engineering abilities, he turned the argument to the American creative process:

> It has been by paying naked attention first to the thing itself that American plumbing, American shoes, American bridges, indexing systems, locomotives, printing presses, city buildings, farm implements and a thousand other things have become notable in the world. Yet we are timid in believing that in the arts discovery and invention will take the same course. And there is no reason why they should unless our writers have the inventive intelligence of our engineers and cobblers.[34]

Here, too, Williams saw beyond Coady in conceiving such cultural self-knowledge to be the basis on which American artists could develop their attitudes toward Europe, "the continental hurley-burley," which presently threatened to drain off native energy. Yet his reasoning generated certain tensions. Although his values obviously approximated those of Dada, they were embodied in a theory of contact which, by its very nature, had to reject Dada as a foreign movement. Otherwise, American artists would produce a second-hand Dada in an incongruous cultural milieu.

Williams' strategy took shape in the fifth issue of *Contact*, published in June 1923. By this time the death of Paris Dada was imminent, and New York Dada a thing of the past, highlighted by ephemera. The superficial poverty of these local Dada events led Williams to write in an opening essay entitled "Glorious Weather" that "Dada was the small, sweet forget-me-not of the war."[35] Previously conceived as an orchid, it had now shrunk to a small flower, struggling against oblivion. The occasion for the essay was spring, the time of rebirth and new creation, in contrast to what Williams viewed as the disin-

tegration of Dada. Here again, he stressed values which he either failed or refused to recognize in Dada. Yet his apparent inconsistency is understandable, since Dada, by its very suicide, would suggest that absurd destruction and self-destruction were its only goals.

However, like the proponents of Dada, Williams saw that the destructiveness of the recent war demanded new creation. In consequence, he insisted that "one must write something, even if only an arbitrary confusion of consonants and vowels, that shall be, not a mere re-shuffling, but an escape, new, an invention upon the moment." His primary emphasis was upon a creativity that would escape "everything in its time that is deadly" by way of its own deliberate fragmentation of traditional modes of expression as a last resort.[36] Williams thus refined his theory of contact by urging the artist to discriminate between "deadly" and live elements in his time and culture.

Also running through the essay was Williams' insistence upon the necessity of the act of writing. He opposed, therefore, Duchamp's cessation of painting as a protest against art. "If the object of writing be to celebrate the triumph of sense, and if Marcel Duchamp be the apex of modern sense, and if he continue in New York, silent . . . ," Williams mused, unwilling to articulate, and thus possibly to accept, the conclusion of such premises for his own efforts.[37]

Williams went on to counter the assumptions informing the *Large Glass*:

> there is no comment on pictures but pictures, on music but
> music, poems but poetry:
> > if you do, you do
> > if you don't, you don't
> and that's all there is to that.
> > Combinations of glass
> are combinations of glass, without value as a critique of
> pigments mixed with oil and spread upon cloth—
> Photographic combinations, methods, modes, etc., may or may
> not be the facet of the moment directly presented to the
> light—
> > but there is no excuse
> in these things for BAD WRITING
> Nor does work in glass, wire, sun-prints, etc., abolish the use
> of other modes.[38]

By asserting the strict autonomy of each new art form, Williams rejected the *Large Glass* as a criticism of painting on canvas or, by exten-

sion, of poetry, his closest concern. This argument, while not entirely valid, was essential for Williams because it permitted him to continue his quest for artistic creation without succumbing to Duchamp's unsettling nihilism. He had therefore to contain Duchamp's protest within the *Large Glass* itself.

Indeed, Williams tried to turn Duchamp's gesture to affirmative use: "The only thing that the occasional work of such a man as Marcel ABOLISHES is bad work in every line of endeavor — BAD WRITING, senseless composition with improper use of materials out of which the sense has passed and into which a new sense must be put before THAT material can be used again."[39] This begrudging tribute implies that Williams could see affirmative values in the Frenchman's work — but values that were overshadowed, nonetheless, by what he viewed as an outrageous nihilism. Duchamp's gesture to renounce art must have indeed been profoundly disturbing to a poet battling for the creation of an American art.

Contact, then, attempted to establish an affirmative point of view, a matrix of local American culture out of which Americans could find sources for their own works. To achieve this end, Williams and McAlmon took an anti-art stance, directed as much against America as against Europe, for the American artist, they realized, was caught between two cultural forces that could easily dissipate his creativity. America, self-conceived as a new nation, viewed art as "culture," following its provincial impulses. As a "bastard country" without a viable past, it had turned to worn-out traditional modes of art for its aesthetic values or, just as debilitating, to modernism or any current vogue without fully understanding their implications. In either case, the presence of Europe was thought to corrupt any possibility of American originality. And at that time, Dada was one of the most formidable threats, since both Duchamp and Picabia had befriended many young American writers and painters in New York. Moreover, these incipient avant-gardists were emigrating to Europe after the War and becoming acquainted with the French Dadaists, who might also deviate American creativity from its true course.

To counteract such threatening possibilities, Williams developed the concept of contact, a theory that turned out to be inadequate for the resolution of the problems he sensed in American culture. His notion that America was a "bastard country" persisted, so that he felt the need to set himself and his work against the time — a need that conflicted

with local contact. Assuming for the moment that an artist could shore himself against European encroachments, how could he create art in an America that was inimical to art?

Williams' resolution of this urgent problem is not to be found in his poetics narrowly construed. His theories about poetic form obviously illuminate the texture of his poetry but not its psychological dynamic, the ambiguous responses to his cultural environment that gave rise to his formal precepts in the first place.[40] Rather, it was in *Contact* that Williams perceived his dilemma and sketched the broad outlines for its solution. Yet the actual circumstances of writing poetry were subject to contradictory pressures, such that his position could be hardly straightforward or simple. Williams' anti-art sentiments articulated in *Contact* implied the course he would take in his poetry, treading an anti-art line between the temptations of European tradition and innovation, on the one hand, and the artistic obtuseness of America, on the other. In order to liberate his own poetic impulses, he found that he had to take a radical stance. It was not enough to be against European art, which might corrupt him with second-hand forms and materials; nor could he turn freely to America, whose culture, as *The Soil* implicitly disclosed, was not only intrinsically anti-art in spirit, but also anti-art in the worst sense by indiscriminately welcoming European modes of expression. The full dimension of this problem and its art/anti-art resolution was revealed only in the poetry that Williams wrote while publishing *Contact*.

KARAWANE

jolifanto bambla ô falli bambla

grossiga m'pfa habla horem

égiga goramen

higo bloiko russula huju

hollaka hollala

anlogo bung

blago bung

blago bung

bosso fataka

ü üü ü

schampa wulla wussa ólobo

hej tatta gôrem

eschige zunbada

wulubu ssubudu uluw ssubudu

tumba ba- umf

kusagauma

ba - umf

Hugo Ball

dada-kasserolle 1916

(1917)
Hugo Ball

Hugo Ball, reciting abstract poetry, in *Dadaco* (Munich, 1920). *Courtesy of The Museum of Modern Art, New York City.*

LA · SAINTE-VIERGE ·

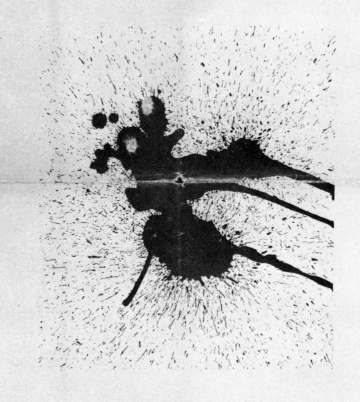

FRANCIS PICABIA

Francis Picabia, *La Sainte-Vierge*, in *391*, No. 12 (1920). *Courtesy of The Art Institute of Chicago.*

Alfred Stieglitz, *The Hand of Man* (1902), photogravure in *Camera Work*, No. 36 (October, 1911). *Courtesy of Special Collections, University of California, San Diego.*

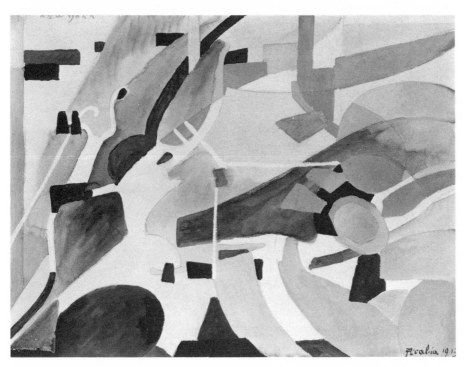

Francis Picabia, *New York* (1913), watercolor, gouache, and charcoal, 555 x 755 mm. *Courtesy of The Art Institute of Chicago.*

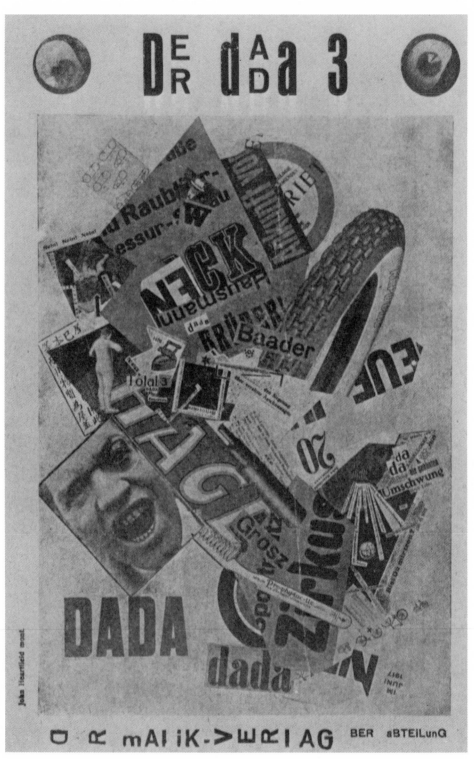

Cover of *Der Dada*, 3 (Berlin, 1920). *Courtesy of Galleria Schwarz, Milan.*

MERCER 85 HP

Les 2 exhibitionnistes intoxiqués
par l'abus de l'automobile

(Le Populaire. — 17 mai 1920)

Messieurs les révolutionnaires vous avez les idées aussi étroites que celles d'un petit bourgeois de Besançon. Francis PICABIA.

Tristan Tzara and Francis Picabia, in *Cannibale*, No. 2 (May, 1920). *Courtesy of The Museum of Modern Art, New York City.*

Edouard [Edward] Steichen, *Self-Portrait*, photogravure in *Camera Work*, No. 2 (April, 1903). *Courtesy of Special Collections, University of California, San Diego.*

VOYAGE

A Mlle Paula Valmont

Adieu Amour Nuage qui
FUIS REFAIS LE VOYAGE DE DANTE
ET N'A PAS CHU PLUIE FÉCON

TÉLÉGRAPHE

OISEAU
QUI TOMBER
LAISSE
SES AILES PARTOUT

? E L A P

OU VA DONC CE TRAIN QUI MEURT AU LOIN
DANS LES VALS ET LES BEAUX BOIS FRAIS DU **TENDRE ÉTÉ SI P**

Idéogramme Guillaume Apollinaire

ONE HOUR'S SLEEP ——————
THREE DREAMS

I.

I was to be buried. The whole family stood about. Also hundreds of friends. My wish was carried out. Not a word was uttered. There was not a single tear. All was silence and all seemed blackness. A door opened and a woman came in. As the woman came in I stood up; my eyes opened. But I was dead. All screamed and rushed away. There was a general panic. Some jumped out of the windows. Only the Woman remained. Her gaze was fixed upon me. Eye to Eye. She said: "Friend are you really dead?" The voice was firm and clear. No answer. The Woman asked three times. No answer. As she asked the third time I returned to my original position and was ready to be buried. —— I heard one great sob. I awoke.

II.

I was very ill and everyone asked me to take a rest. No one succeeded to induce me. Finally a Woman said: "I will go with you. Will you go?" We went. We tramped together day and night. In the mountains. Over snow. In the moonlight. In the glaring sun. We had no food. Not a word was said. The Woman grew paler and paler as the days and nights passed by. She could hardly walk. I helped her. And still not a word was uttered. Finally the Woman collapsed and she said, in a voice hardly audible: "Food—Food—I must have food." And I answered: "Food—Food—, Child, we are in a world where there is no Food—just Spirit—Will."—And the Woman looked piteously at me and said, half dead: "Food—Food" —— and I kissed the Woman, and as I did that there stood before the Woman all sorts of wonderful food—on a simple wooden table, and it was Springtime. And as the Woman began to eat ravenously—conscious of nothing but Nature's Cry for Food, I slipped away. And I continued walking Onward. —— I heard a distant cry. I awoke.

III.

The Woman and I were alone in a room. She told me a Love Story. I knew it was her own. I understood why she could not love me. And as the Woman told me the story—she suddenly became mad—she kissed me in her ravings—she tore her clothes and mine—she tore her hair. Her eyes were wild—and nearly blank. I saw them looking into mine. She kissed me passionately and cried: "Why are you not HE?" "Why not?" And I tried to calm her. But did not succeed. And finally she cried: "What makes me kiss you—it is He I want, not you. And yet I kissed you. Kissed you as if it were He."—I didn't dare to move. It was not fear that made me stand still. It was all much too terrible for Fear. I stood there spell-bound. Suddenly the woman moved away—it was ghastly. Her look. Her eyes. —— The Woman stood immovable, her eyes glued on mine; when suddenly she screeched: "Tell me you are He —tell me—you are He. And if you are not He I will kill you. For I kissed you." I stood there and calmly said, what I really did not want to say, for I knew the Woman was irresponsible and mad. I said, "I am not He." And as I said that the Woman took a knife from the folds of her dress and rushed at me. She struck the heart. The blood spurted straight ahead, as if it had been waiting for an outlet. And as the Woman saw the blood and saw me drop dead she became perfectly sane. She stood motionless. With no expression. She turned around. Upon the immaculate white wall she saw written in Blood Red letters: "He killed himself. He understood the kisses."—There was a scream. I awoke.

ALFRED STIEGLITZ

Guillaume Apollinaire, "Voyage," in *291*, No. 1 (March, 1915). *Courtesy of The Philadelphia Museum of Art; The Louise and Walter Arensberg Collection Archives.*

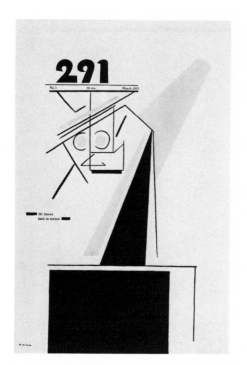
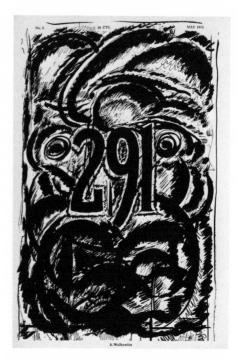

Marius De Zayas, cover of 291, No. 1 (March, 1915), at left, and Abraham Walkowitz, cover of 291, No. 3 (May, 1915). *Courtesy of The Philadelphia Museum of Art; The Louise and Walter Arensberg Collection Archives.*

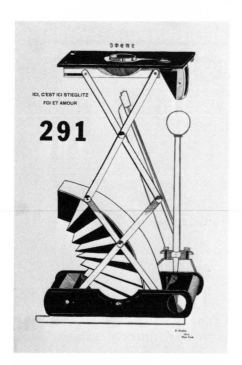

Francis Picabia, *Içi, C'est içi Stieglitz*, at left, and Francis Picabia, *Self Portrait*, in 291, No. 5–6 (July–August, 1915). *Courtesy of The Philadelphia Museum of Art; The Louise and Walter Arensberg Collection Archives.*

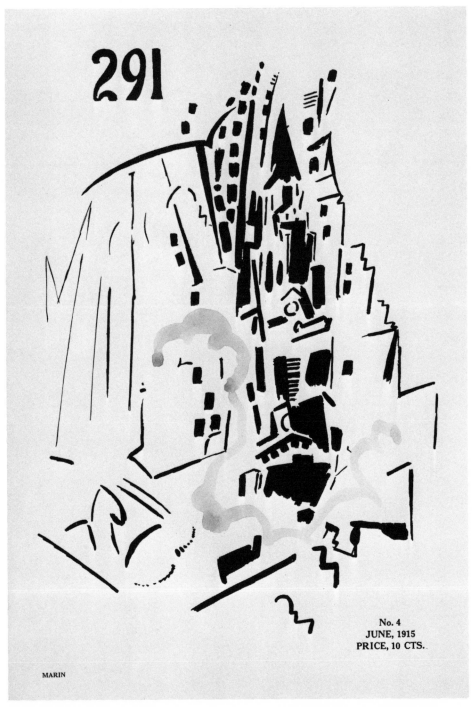

291

No. 4
JUNE, 1915
PRICE, 10 CTS.

MARIN

John Marin, cover of *291*, No. 4 (June, 1915). *Courtesy of The Philadelphia Museum of Art; The Louise and Walter Arensberg Collection Archives.*

FILLE NÉE SANS MÈRE.

PICABIA
New York, 1915

Francis Picabia, *Fille née sans mère*, in 291, No. 4 (June, 1915). *Courtesy of The Philadelphia Museum of Art; The Louise and Walter Arensberg Collection Archives.*

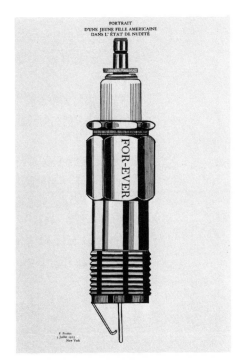

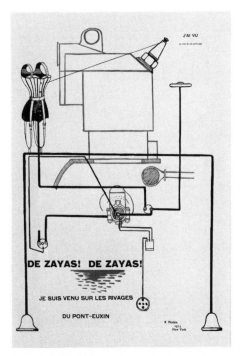

Francis Picabia, *Portrait d'une jeune fille américaine*, at left, and Francis Picabia, *De Zayas! De Zayas!*, in *291*, No. 5–6 (July–August, 1915). *Courtesy of The Philadelphia Museum of Art; The Louise and Walter Arensberg Collection Archives.*

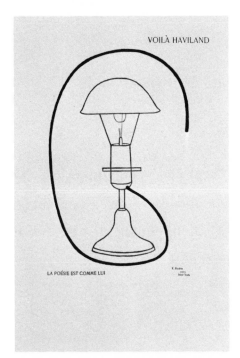

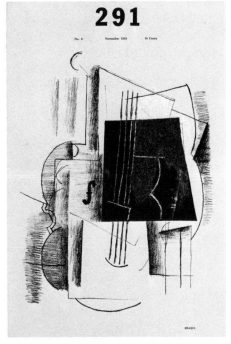

Francis Picabia, *Voilà Haviland*, in *291*, No. 5–6 (July–August, 1915), at left, and Georges Braque, cover of *291*, No. 9 (November, 1915). *Courtesy of The Philadelphia Museum of Art; The Louise and Walter Arensberg Collection Archives.*

Manifeste

du

Mouvement

DADA

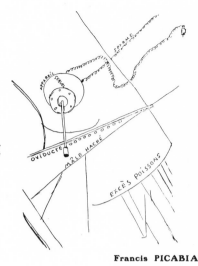

VOUS NE COMPRENEZ PAS N'EST-CE PAS CE QUE NOUS FAISONS.
EH BIEN CHERS **AMIS** NOUS LE COMPRENONS ENCORE MOINS.
QUEL BONHEUR HEIN VOUS AVEZ RAISON. J'AIMERAIS COUCHER ENCORE UNE FOIS AVEC LE PAPE, VOUS NE COMPRENEZ PAS? MOI NON PLUS COMME C'EST TRISTE.

Francis PICABIA

à priori c'est-à-dire les yeux fermés, **DADA** place avant l'action et au-dessus de tout : **LE DOUTE.** Dada doute de tout. Dada est tatou. Tout est **DADA.** Méfiez-vous de **DADA.**
Aa l'antiphilosophe.

Vivent les concubines et les concubistes. Tous les membres du Mouvement **DADA** sont présidents.

"Manifeste du Mouvement Dada," in *Bulletin Dada*, No. 6 (February, 1920). *Courtesy of The Museum of Modern Art, New York City.*

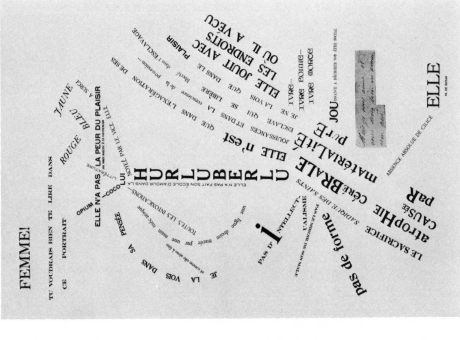

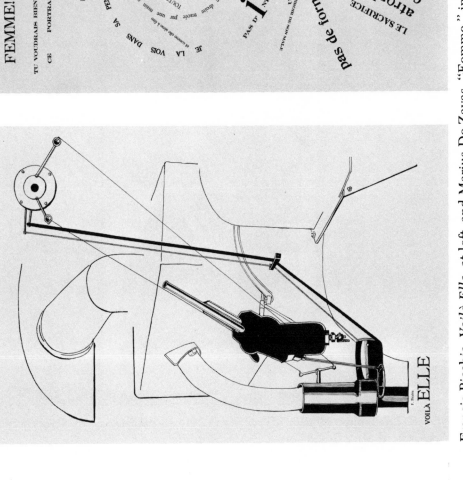

Francis Picabia, *Voilà Elle*, at left, and Marius De Zayas, "Femme," in *291*, No. 9 (November, 1915). *Courtesy of The Philadelphia Museum of Art; The Louise and Walter Arensberg Collection Archives.*

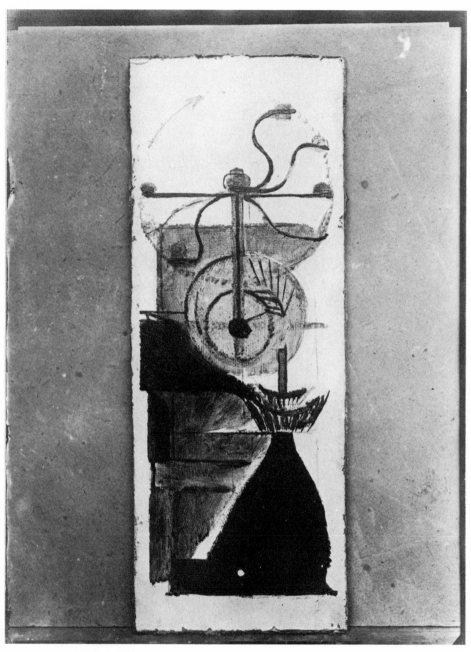

Marcel Duchamp, *Moulin à café*, 1911, oil on cardboard, 13 x 14 15/16 in. *Courtesy of Mrs. Robin Jones, Rio de Janeiro.*

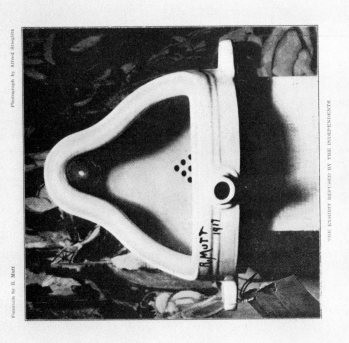

Marcel Duchamp, *Fountain*, in *The Blind Man, No. 2* (May, 1917). *Courtesy of The Philadelphia Museum of Art; The Louise and Walter Arensberg Collection Archives.*

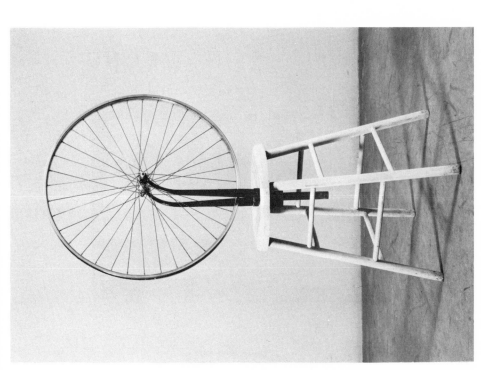

Marcel Duchamp, *Bicycle Wheel*, 1951 (third version after lost original of 1913), assemblage. *Courtesy of The Museum of Modern Art, New York City; The Sidney and Harriet Janis Collection.*

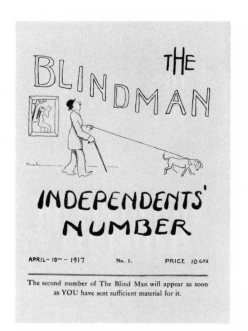 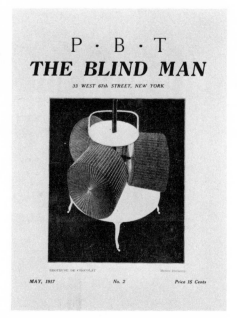

Alfred Frueh, cover of *The Blindman*, No. 1 (April, 1917), at left, and Marcel Duchamp, cover of *The Blind Man*, No. 2 (May, 1917). *Courtesy of The Philadelphia Museum of Art; The Louise and Walter Arensberg Collection Archives.*

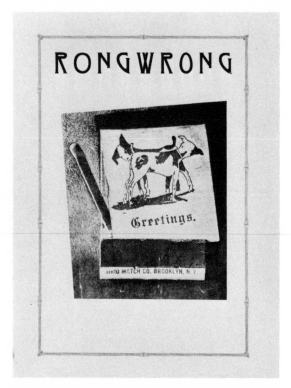

Marcel Duchamp, cover of *Rongwrong* (1917). *Courtesy of The Philadelphia Museum of Art; The Louise and Walter Arensberg Collection Archives.*

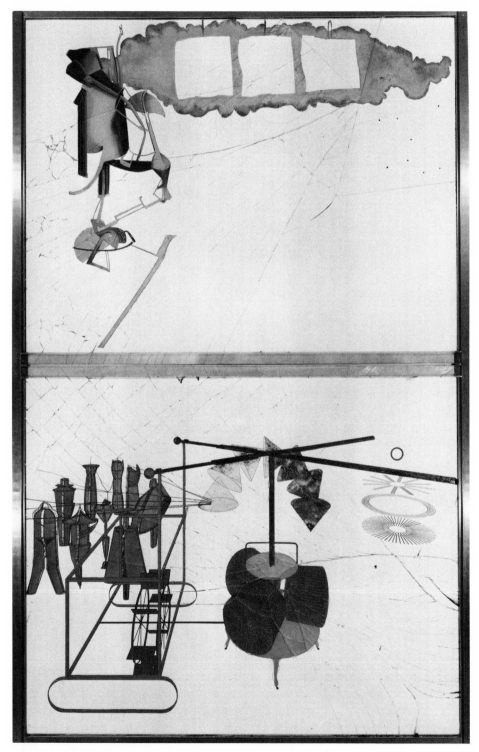

Marcel Duchamp, *The Bride Stripped Bare By Her Bachelors, Even* (*The Large Glass*), 1915–1923, oil and lead wire on glass, 109 1/4 x 69 1/8 in. *Courtesy of The Philadelphia Museum of Art; bequest of Katherine S. Dreier.*

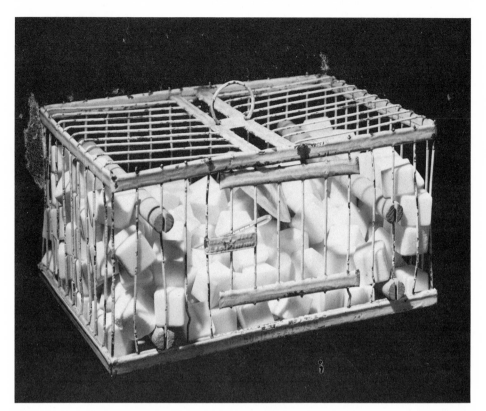

Marcel Duchamp, *Ready-Made, Why Not Sneeze Rose Selavy?*, 1921, marble blocks in the shape of lump sugar, thermometer, wood, and cuttlebone in a small bird cage, 4 1/2 in. high, 8 5/8″ long, 6 3/8″ deep. *Courtesy of The Philadelphia Museum of Art; The Louise and Walter Arensberg Collection.*

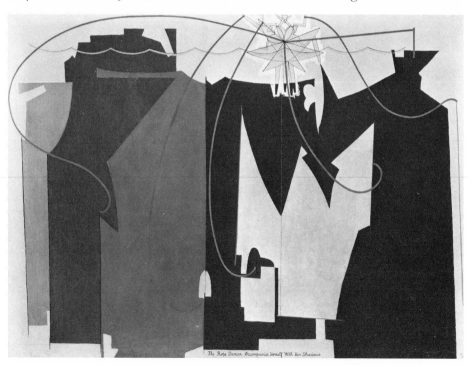

Man Ray, *The Rope Dancer Accompanies Herself with Her Shadows*, 1916, oil on canvas, 52 x 73 3/8 in. *Courtesy of The Museum of Modern Art, New York City; gift of G. David Thompson.*

Marcel Duchamp, cover of *New York Dada* (1921). *Courtesy of The Beinecke Rare Book and Manuscript Library, Yale University; The Alfred Stieglitz Archive in the Collection of American Literature.*

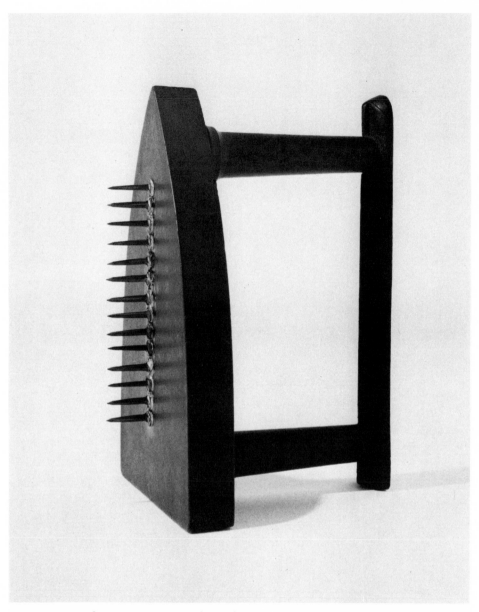

Man Ray, *Cadeau*, 1921, mixed media, 5 x 3 1/2 in. *Courtesy of The Los Angeles Museum of Art; Collection of Mr. and Mrs. Michael Blankfort.*

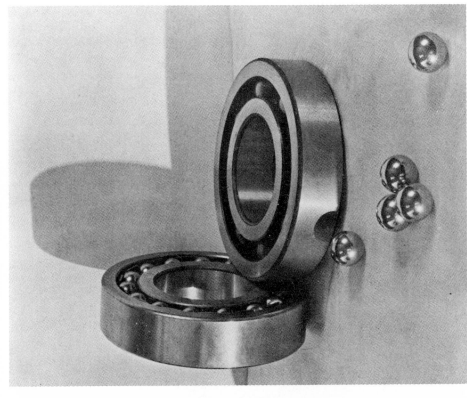

Paul Strand, *Ball Bearings*, frontispiece, *Broom* 3 (November, 1922). *Courtesy of Special Collections, University of California, Los Angeles.*

Marcel Duchamp, *Bottlerack*, 1964, sixth version of 1914 readymade, galvanized iron, 59 cm. high with a base diameter of 37 cm. *Courtesy of Galleria Schwarz, Milan.*

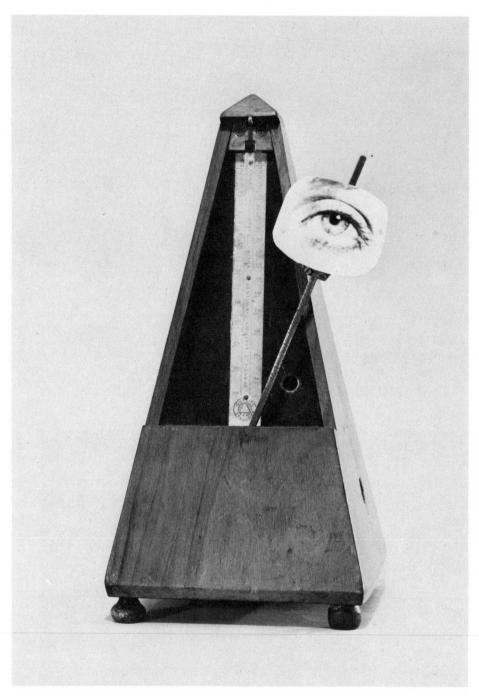

Man Ray, *Indestructible Object*, 1964, replica of *Object To Be Destroyed* (1923), destroyed in 1957, mixed media, 8 7/8 in. high x 4 3/8 in. wide x 4 5/8 in. deep. *Courtesy of The Museum of Modern Art, New York City; James Thrall Soby Fund.*

Man Ray, *Man Ray 1914*, 1914, oil on canvas, 7 x 5 in. *Courtesy of Sir Roland and Lady Penrose, London.*

Man Ray, *Sugar Loaves*, 1925, rayograph, 11 7/8 x 9 3/4 in. *Courtesy of The Yale University Art Gallery; gift of Collection Société Anonyme.*

Paul Strand, *The White Fence, Port Kent, New York*, 1916, photograph, 14 x 10 3/4 in. *Courtesy of The Philadelphia Museum of Art; gift of Mr. and Mrs. Robert A. Hauslohner.*

Alfred Stieglitz, *Equivalent, Mountains and Sky, Lake George*, 1924, photograph. *Courtesy of The Dorothy Norman Collection.*

"Motion"

By Marsden Hartley

"A Busted Ford"

By P. W. Henderson, 13 years

Which has—

the motion?

"Which has—the motion?", *The Soil*, No. 3 (March, 1917).

Above: Arthur Cravan, *The Soil*, No. 4 (April, 1917). *Right*: Jean Crotti, *Portrait of Marcel Duchamp*, 1916, metal and wire assemblage, illustrated in *The Soil*, No. 1 (December, 1916).

The Johnson-Cravan fight in Barcelona, *The Soil*, No. 4 (April, 1917).

The *Others* Group, 1916. In front, from left, Alanson Hartpence, Alfred Kreymborg, William Carlos Williams, Skip Cannell; in back, from left, Jean Crotti, Marcel Duchamp, Walter Arensberg, Man Ray, Robert Alden Sanborn, Maxwell Bodenheim. *From the Poetry Collection of The Lockwood Memorial Library, State University of New York, Buffalo; Courtesy of New Directions.*

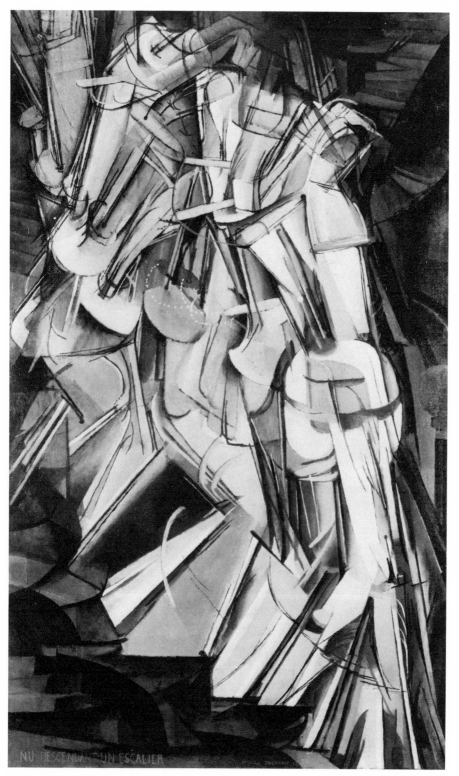

Marcel Duchamp, *Nude Descending a Staircase*, No. 2, 1912, oil on canvas, 58 x 35 in. *Courtesy of The Philadelphia Museum of Art; The Louise and Walter Arensberg Collection.*

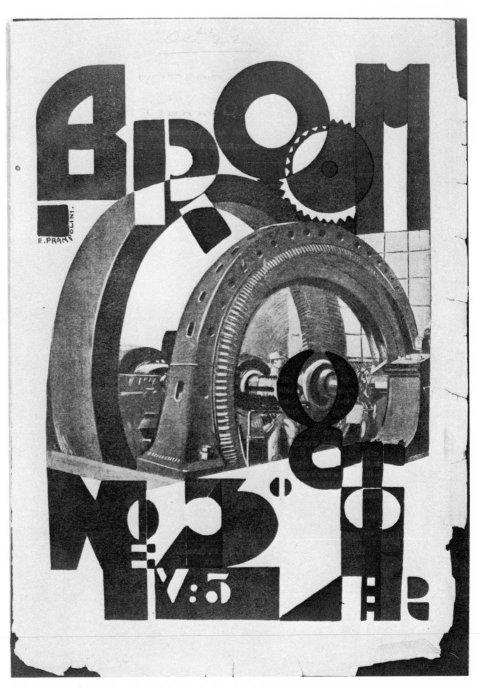

Enrico Prampolini, cover for *Broom* 3 (October, 1922). *Courtesy of Special Collections, University of California, Los Angeles.*

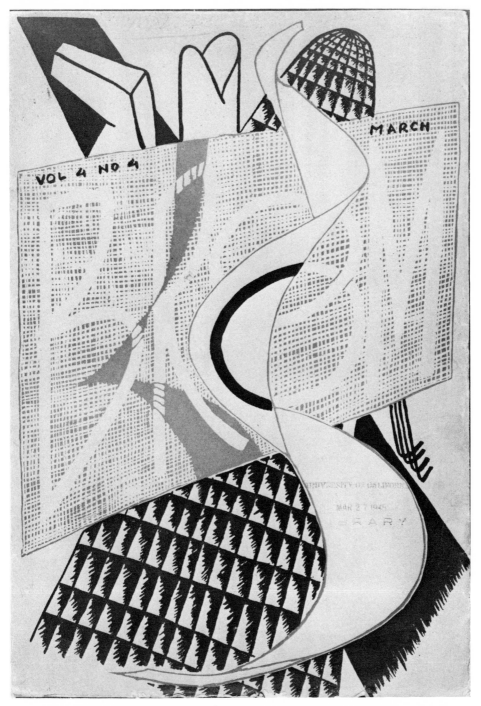

Man Ray, cover for *Broom* 4 (March, 1923). *Courtesy of Special Collections, University of California, Los Angeles.*

Francis Picabia, *Reveil Matin*, in *Dada* 4–5 (Zurich, 1919). *Courtesy of The Museum of Modern Art, New York City.*

5 | William Carlos Williams

Because Williams' desire for contact forced him to resist both Europe and America, he adopted Dada attitudes at the same time as he denounced them. The course of this subterfuge, obviously ambiguous if not downright confusing at times, can be traced through his poetry and prose from 1919 to 1925. Taken sequentially, his writings reflect not only a concern for poetic creativity, their proper subject matter, but also the rhythms of his quest for renewal through the American experience. That the dialectic of affirmation and negation intensely modulated Williams' regard for creation as opposed to art, which met prevailing cultural norms and was hence considered repressive, indicates his Dada sensibility throughout this period.[1]

Although Williams' recognition that the Armory Show virtually destroyed traditional modes of expression was a commonplace among the American avant-garde, his perceptions made him amenable to the disturbing forces of Dada to come. "What were we seeking?" he later asked. "No one knew consistently enough to formulate a 'movement'. We were restless and constrained, closely allied with the painters. Impressionism, dadaism, surrealism applied to both painting and the poem." One of the centers of this turmoil was, of course, Marcel Duchamp, that "extraordinary and popular young man," whom Williams defended for his urinal entry in the 1917 Independents.[2]

In his *Autobiography* he recalled how, standing before Duchamp's *Nude Descending a Staircase* at the Armory Show, "I laughed out loud . . . happily, with relief."[3] The usual reactions of outrage or pretentious appreciation were foreign to the poet who could gauge and welcome the significance of Duchamp's painting as a force for destroying the bonds of tradition. In this instance, laughter released Williams' anxiety while expressing his exuberance, and in turn suggested a temperament easily caught up in disgust, his "most moving emotion," as he wrote to a friend in 1920.[4] Like the Dadaists, Williams wanted to

free himself both from the past and the stupidities of his time, the war being a particularly horrific development—all of which he vigorously attacked. Defiantly expressing these emotional views in an early essay entitled "Belly Music," written in 1919 for the Imagist review *Others*, Williams assailed the current state of American literature with his own declaration of war: "I am in the field against the stupidity of the critics in this country about poetry today." With that warning, he flailed his way through "such oatmeal mush," "such ataxic drivel," the "terrific jumble of assinity," "this card-board shoebox of English flimflam," to arrive at the pressing question, "How IS one to go about getting something done in this welter?"[5]

His attack, while centered upon "sophomoric, puling, nonsensical" critics, also reveals a spectrum of attitudes regarding poetry. Williams inveighed against the concept of poetry as an aesthetic sedative. "The American editorial—and critical mind is hipped on the question of 'good stuff' especially if it be 'lovely'. But for the reason that American editors, critics, publishers do no more than this they merit only to be branded and ignored."[6] Opposed to poetry that was precious and hermetic, he strongly asserted the relationship between art and life—a relationship best expressed by the vitality of the artist, which enables him to withstand the deadening aspects of his surrounding culture.

Whereas Williams' views in *Contact* a year later took on the rhetorical quality of a public manifesto, "Belly Music" exposed the turmoil of his inner emotions, vividly expressing the tensions that would later be somewhat held in check by his more logically formulated theory of contact. "It is the NEW!" he insisted here, "not one more youthful singer, one more lovely poem. The NEW, the everlasting NEW, the everlasting defiance."[7] Although an awareness of and an engagement with one's time would presumably lead to fresh creation, Williams also equated the new with "defiance." Here was an ambivalence that was nearly impossible to convey on a logical level and, to be resolved, required the dramatic play of his poetry.

That same necessity for defiant innovation led Williams away from the format of *Al Que Quiere!*, a collection of poems published in 1917, to *Kora in Hell*, which appeared in 1920.[8] Although the former conveyed the thematic concerns that were to continue to preoccupy Williams over the years, *Kora in Hell* mobilized his energies toward the creation of an organic work whose central subject was the processes of the imagination.

The sequence of construction of *Kora* reveals its integrated design. According to Williams, it was composed backwards: first the Improvisations, then their appended notes, the title and cover design, the Stuart Davis frontispiece, and finally the Prologue. From among the later elements of the work, the cover design and the frontispiece serve as visual analogues for the Improvisations. Williams suggested that the cover design "represents the ovum in the act of being impregnated, surrounded by spermatozoa, all trying to get in but only one successful. . . . The cell accepts one sperm—that is the beginning of life." As for the frontispiece, Williams recalled, "I had seen a drawing by Stuart Davis, a young artist I had never met, which I wanted reproduced in my book because it was as close as possible to my idea of the Improvisations. It was, graphically, exactly what I was trying to do in words, put the Improvisations down as a unit on the page . . . an impressionistic view of the simultaneous."[9] Thus the cover design announces the subject of *Kora*, the creative process itself (not limited to art alone), while the frontispiece represents the form of his work as the organic field of the imagination in which all facets are revealed at the same time.

Although an understanding of these aspects of the book renders the Improvisations more comprehensible, an awareness of the circumstances of their composition sheds even greater light on the entire work and clarifies the relationship between Williams and Dada. He described his working habits as follows: "For a year I used to come home and no matter how late it was before I went to bed I would write *something*. . . . Even if I had nothing in my mind at all I put something down, and as may be expected, some of the entries were pure nonsense and were rejected when the time for publication came. They were a reflection of the day's happenings more or less, and what I had had to do with them." The Improvisations refer back to Rimbaud's *Illuminations*, the same source used by two young French Dadaists in Paris, André Breton and Philippe Soupault, in creating *Les Champs magnétiques*. Both poets, in collaboration, were giving a free rein to their subconscious, writing "automatically," at approximately the same time that Williams "let the imagination have its own way to see if it could save itself,"[10] in an attempt to release his captive psyche from the bonds of traditional writing. That he did not publish pure nonsense distinguished his work from public Dada gestures but not from its essential values.

This method of composition not only accounts for the personal quality Williams prized in *Kora*, but also explains what Ezra Pound

called its "opacity."[11] Whereas some of the Improvisations are merely mystifying and others virtually impenetrable, all defy paraphrase or encapsulation. Although Williams appended italicized "notes" to many of them as an interpretive aid, rarely are these explicit in meaning. More often, they provide a dramatic situation which establishes the explanatory context for the emotional releases of sensibility, and although they occasionally mystify as much as the Improvisations, they generally supplement or complement the major text.

Despite the title, neither the Improvisations nor their accompanying notes give in to despair. As Williams said, "I am indebted to Pound for the title. We had talked about Kora, the Greek Parallel of Persephone, the legend of Springtime captured and taken to Hades. I thought of myself as Springtime and I felt I was on my way to Hell (but I didn't go very far). This is what the Improvisations were trying to say."[12] The legend provided Williams with an apt metaphor as he probed the depths of his imagination in the context of the dark American experience.

Thus the third improvisation of Chapter XIV conjures Dionysian imagery from "misery and brokeness":

> THIS is the only up-cadence. This is where the secret rolls over and opens its eyes. Bitter words spoken to a child ripple in morning light! Boredom from a bedroom doorway thrills with anticipation! The complaints of an old man dying piecemeal are starling chirrups. Coughs go singing on springtime paths across a field; corruption picks strawberries and slow warping of the mind, blacking the deadly walls—counted and recounted—rolls in the grass and shouts ecstatically. All is solved! The moaning and dull sobbing of infants sets blood tingling and eyes ablaze to listen. Speed sings in the heels at long nights tossing on coarse sheets with burning sockets staring into the black. Dance! Sing! Coil and uncoil! Whip yourselves about! Shout the deliverance!

These sequential images dramatize the aphoristic note for the first improvisation of the same chapter: "*Out of bitterness itself the clear wine of the imagination will be pressed and the dance prosper thereby.*"[13] Just as the dance emerges out of the darkness of life itself, so, with the Improvisations taken as a whole, the light is balanced with the dark, birth with death—Springtime in the Underworld, which is, after all, our world.

Relationships among improvisations are generally subliminal, leaving a surface feeling of discontinuity and reinforcing an initial impression of their hermetic sensibility. The ultimate unity of the Im-

provisations lies in Williams' paean to creativity—to the powers of the imagination, art, poetry, sexuality, and nature. At the peak stands the imagination, embracing the antipoetic as well as the poetic, hence the entire range of experience: *"Filth and vermine though they shock the over-nice are imperfections of the flesh closely related in the just imagination of the poet to exclusive cleanliness."* With this presupposition, the opening improvisation declares, "Fools have big wombs. For the rest?—here is pennyroyal if one know to use it. But time is only another liar, so go along the wall a little further; if blackberries prove bitter there'll be mushrooms, fairy-ring mushrooms, in the grass, sweetest of all fungi."[14] This improvisation demonstrates as well as asserts that Williams could create poetry out of insignificant or ugly material, a gesture initiated by T. S. Eliot and the Imagists earlier in the twentieth century, but flaunted by Williams here in Dada fashion.

In writing the Prologue, Williams completed the plan begun by appending notes to the Improvisations and so lent a self-conscious form to the imaginative processes they embody.[15] Subtitled "The Return of the Sun," the Prologue nonetheless contains more of the artist's "hell" than the Improvisations. Williams thought that it expressed his own poetic situation at the time, with all its difficulties and restrictions: "I felt I had to give some indication of myself to the people I knew; sound off, tell the world—especially my intimate friends—how I felt about them. All my gripes to other poets, all my loyalties to other poets, are here in the Prologue." Literature itself was a major source of pain. "There is nothing sacred about literature," Williams insists in the Prologue, "it is damned from one end to the other. There is nothing in literature but change and change is mockery. I'll write whatever I damn please, whenever I damn please and as I damn please and it'll be good if the authentic spirit of change is on it."[16] This antiliterary attitude reflects Williams' defiance, which promises "the return of the sun" in "the authentic spirit of change."

Although Williams declares that the Prologue is chaotic and written in a "broken style," he does forcefully develop an argument in his preface. His initial vignette deals with recollections of his mother, who comes to represent the life-force, symbolized in turn by the ovum of the cover design. The innocence of his mother, "an impoverished, ravished Eden," who "has always been incapable of learning from benefit or disaster," generates the spirit of *Kora* in turning away from the past to create out of its own impulses. Her temperament also

reflects the tensions of dark and light in his work. "My mother is given over to frequent periods of great depression being as I believe by nature the most lighthearted thing in the world," Williams observes. "But there comes a grotesque turn to her talk, a macabre anecdote concerning some dream, a passionate statement about death, which elevates her mood without marring it, sometimes in a most startling way." But most importantly, he sees his mother as an embodiment of the live imagination: "Thus seeing the thing itself without forethought or afterthought but with great intensity of perception my mother loses her bearings or associates with some disreputable person or translates a dark mood. She is a creature of great imagination. I might say this is her sole remaining quality. She is a dispoiled, moulted castaway but by this power she still breaks life between her fingers."[17] In the Improvisations, Williams attempted to duplicate this intensity of perception by dint of his imagination released from rational restraint.

In the second segment of the Prologue, Williams recalls a conversation with Walter Arensberg and in the process points up the Dada structure of *Kora*.

> Once when I was taking lunch with Walter Arensberg at a small place on 63rd St. I asked him if he could state what the more modern painters were about, those roughly classified at that time as "cubists": Gleisze, Man Ray, Demuth, Du Champs—all of whom were then in the city. He replied by saying that the only way man differed from every other creature was in his ability to improvise novelty and, since the pictorial artist was under discussion, anything in paint that is truly new, truly a fresh creation is good art. Thus, according to Du Champs, who was Arensberg's champion at the time, a stained glass window that had fallen out and lay more or less together on the ground was of far greater interest than the thing conventionally composed *in situ*.[18]

In effect, a thinly veiled allusion to Duchamp's *Large Glass*, which was actually to shatter in transit less than a decade later, in 1926, the broken cathedral window suggests a preference for chance over controlled craftsmanship, and the metaphor indicates not only the compositional method of *Kora* but also its departure from tradition. The stained glass window of the cathedral represents traditional art that would lay shattered by the *Large Glass*, just as the "broken style" of *Kora* forsakes traditional narrative to destroy the boundaries between poetry and prose.

The entire emphasis upon chance does not square, however, with Williams' preoccupation with craft. Nor, for that matter, does it

coincide with that of Duchamp, whose *Large Glass* was meticulously constructed around elements of chance. Williams achieves a counterbalance in the Prologue by an allusion to Duchamp's readymades: "One day Du Champs decided that his composition for that day would be the first thing that struck his eye in the first hardware store he should enter. It turned out to be a pickaxe [in actuality, a shovel] which he bought and set up in his studio. This was his composition."[19] Duchamp allowed a chance discovery to determine his choice of a readymade. But then human volition took over, for he had to purchase the pickaxe, which, by being placed in the studio environment, was dislocated from its intended function. (It could be easily argued that volition was operative even earlier in the process, when Duchamp decided to let chance determine his choice.) Similarly, Williams allowed the chance rhythms and moods of his imagination to dictate the Improvisations for *Kora*; But the very decision to sit down and write—however automatically—is an act of will. Moreover, Williams wrote self-conscious notes for many of the Improvisations. Just as an object becomes a readymade by virtue of its placement in a new context—say, a bicycle wheel inverted upon a stool—the Improvisations were given a new referential framework of creation from raw sensibility by virtue of Williams' notes, which focus on the imagination.

The third segment of the Prologue is centered upon Williams' views of the imagination. First and foremost, it has to forsake facile academic paths: "If the inventive imagination must look, as I think, to the field of art for its richest discoveries today it will best make its way by compass and follow no path." But Williams also foresaw obstacles beyond the academic confronting the imagination: "The thing that stands eternally in the way of really good writing is always one: the virtual impossibility of lifting to the imagination those things which lie under the direct scrutiny of the senses, close to the nose."[20] The necessity of cultivating keen perception must be supplemented by reworking the material and by constantly sharpening the imagination with self-conscious commentary.

The final segment of the Prologue deals with the notes in relation to the Improvisations. In discussing the construction of the work, William says, "I thought at first to adjoin to each improvisation a more or less opaque commentary. But the mechanical interference that would result makes this inadvisable. Instead I have placed some of

them in the preface where without losing their original intention
(see reference numerals at the beginning of each) they relieve the
later text and also add their weight to my present fragmentary argu-
ment."[21] His reasoning has a limited cogency. Dealing with the mul-
tiple facets of the imagination, the notes selected for the Prologue
support his views in the previous segment. But since there are ap-
proximately eighty improvisations in the main text, of which sixty-
three have notes, it seems unlikely that twelve more notes (those in
the Prologue) would make the text unwieldy because of "mechanical
interference."

Other more significant reasons are suggested, starting with the
mixed order of the Improvisation chapters to which these notes belong.
Initially, the confusion of Roman numerals implies that the sequence
of notes in the Prologue takes precedence over the proper numerical
sequence of the Improvisations in the main text. Equally convincing,
however, is the possibility that a mixed order suggests a logic that
transcends linear discourse. This view is supported by Williams' note
that "a poem is tough by no quality it borrows from a logical recital
of events nor from the events themselves but solely from the atten-
uated power which draws perhaps many broken things into a dance
giving them thus a full being."[22] By extension, these notes, broken
away from their improvisations and released from linear logic, will
achieve "full being" in the dance.

This metaphor of the dance is picked up again in an other Pro-
logue note, which amplifies the rejection of a rational order: "All is
confusion, yet, it comes from a hidden desire for the dance, a lust of
the imagination, a will to accord two instruments in a duet." Ulti-
mately, the destruction of logic, causing confusion, chaos, and opacity,
is an invitation to the dance, which offers its own patterned movement.
In like manner, the extraction of some notes from the text of the Im-
provisations invites the imagination of the reader to participate in a
duet with Williams. "On this level of the imagination all things and
ages meet in fellowship. Thus only can they, peculiar and perfect,
find their release. This is the beneficent power of the imagination."[23]
Lost in the chaos of the text, the reader is tempted to relate the notes
in the Prologue to their original Improvisations in the main text, there-
by uniting Prologue and Improvisations in a cross-weave. Thus Wil-
liams nudges the reader out of his lockstep into the field of the imagi-
nation, causing him to gain "an impressionistic view of the simulta-

neous," as in Stuart Davis' sketch for the frontispiece. In other words, the Prologue generates an open-field of images radiating throughout the work.

The success and failure of *Kora in Hell* reside in its opacity. The impenetrability of the Improvisations and of the Prologue, for that matter, measures the reader's involvement as well as his disaffection from the text.[24] Placed in the sequence of Williams' writings, *Kora* illuminates his creative preoccupations not simply as a historical document but also as a dramatization of them, fluctuating between art and life, embodied in Williams' reflexive imagination.

One person who understood *Kora in Hell* at the time of its publication was Elsa Baroness von Freytag-Loringhoven, a Greenwich Village emigrée. Williams first met the Baroness through Margaret Anderson and Jane Heap, editors of *The Little Review*. "At their apartment," he recalled, "I also saw for the first time, under a glass bell, a piece of sculpture that appeared to be chicken guts, possibly imitated in wax. It caught my eye. I was told that it was the work of a titled German woman, Elsa von Freytag-Loringhoven, a fabulous creature, well past fifty, whom *The Little Review* was protecting. Would I care to meet her, for she was crazy, it was said, about my work." "A woman who had been perhaps beautiful. . . a lean masculine figure," the Baroness experienced a brief but tempestuous relationship with Williams.[25]

A friend of Marcel Duchamp and a woman associated with the Dada shenanigans in New York, the Baroness Elsa has been generally dismissed as a Bohemian eccentric.[26] But in *The Little Review* this unlikely person responded to *Kora in Hell* with a prophetic poem rather formidably entitled "Thee I Call 'Hamlet of Wedding-Ring': Criticism of William Carlos Williams' 'Kora in Hell' and Why . . ." Even though her criticism occasionally degenerated into hysterical cant, mixed with savagely *ad hominem* arguments which appear harsh and wide of the mark, an attack on Williams himself was nonetheless a valid tactic. She accurately perceived that *Kora* was a personal statement, not intended as a conventional work of art but as a living embodiment of the imagination at work, so that she felt justified in extending her attack beyond the poem to the poet. In this regard, her frontal assault corroborates and highlights the psychological and aesthetic miasma in which Williams felt himself to be engulfed as he wrote *Kora*. Most significantly, Elsa's poem manages to transcend the

personal so as to offer a statement about the cultural obstacles confronting the creative person in America. In the poem Williams comes to embody the aesthetic problems which the Baroness senses are endemic to American culture.

Elsa begins by recognizing the sentimental side of Williams, just as Wallace Stevens did in his Preface for the *Collected Poems 1921–1931*. She sees William's facade as "the inexperience [that] shines forth in sentimentality—that masqueraded in brutality; male bluff." Characteristically, however, she enlarges this personal commentary into cultural criticism, portraying Williams in the extreme as a savage American.[27] And at the very least, he is cast as the arch-primitive, the anticulture man:

> True to formula—male brute intoxicated bemoans world—(into that
> he never stepped)—his existence—all existence!
> Example:—Hamlet of Wedding-Ring:
> "WhatshallforFlosh—agh? eckshishtensh—eck—eck—eck—shish—damn!
> life damn! wife damn! art damhell! Hellshotashell—"
> Elaborately continued swing on trapeze in "circus of art" following
> this article—if tempted.
> In vino veritas.
> Try it—W.C.[28]

Williams as the inarticulate drunkard, afraid to have extramarital relations, is later contrasted with the true intoxications of art.

But at this point, Elsa's perception of Williams as a shallow primitive serves as a paradigm for an ersatz America masquerading as a civilization. Lacking tradition and history ("no time—no time—no time to fasten roots downward"), both Williams and his culture exist in a limbo: "Americans not possessing tradition—not born within truth's lofty echoing / walls— / born on void—background of barren nothingness— hand such / truth's coin—picked up—flippantly!"[29]

The Baroness Elsa and Williams both wrote out of the same mythic matrix, although they pitched their arguments against the New World from radically opposed positions. Sensing a need for cultural models that Europe might provide, Elsa mockingly admonishes Williams for being "an immature man! / One has to learn to be grown-ups." Likewise, she points up a crucial provincialism in Williams by portraying him as a "country lout—trying to step into tights," who merely "juggles words" instead of being the skilled acrobat of language. She finally

and magnificently dismisses him as a "wobbly-legged business satchel-carrying little louse!"[30]

Although Elsa was apt to obscure critical issues in personal invective, she was still able, out of her vehemence, to formulate an inverted Whitmanian image of America and the poet:

Brutality child of denseness — inability to feel — think clean — vulgar
blood-fogged brain — despair
of helplessness to escape blindness of junglevines of thought tangled — of
waste-seered — barren —
infertile — violent action — noise — clamor: American lynchings.
 Did he not lynch Art?[31]

The intensity of a rhetoric that could conjure such a powerful vision was derived from a position that was intrenched in European culture, dismissing any possible value in anti-art attitudes. Similarly, even though the Baroness knew full well the terms by which to evaluate *Kora in Hell*, her assessment of the poem as an "insult to life's beauty" is very wide of the mark.

Despite the heat of controversy, their dispute as a dialectic reveals the central ambiguities of American culture. Williams struck back at the Baroness in a "Sample Prose Piece," subtitled "The Three Letters," written for the fourth issue of *Contact*. Thinly disguised as Evans Dionysius Evans, Williams recounted his affair with Elsa in terms of Europe and America and tried to present his own position. Wooing America as "a virginal young woman," Evans D. Evans soon becomes disillusioned and turns to the Bohemian Baroness, "the Old Woman," who in her "peculiar, pungent smell of dirt and sweat," replete with "her broken teeth, her syphilis," comes to represent a worn yet experienced Europe in contrast to a maiden America.[32]

In refusing to accept Evans as he is, the Baroness is transformed into a "maddened old lady." Evans himself has a sudden epiphany and violently rejects the old woman out of hand: "You damned stinking old woman . . . you dirty old bitch." After exorcising Europe from his soul, he contents himself with America. "At least . . . the American hussey has a great future before her."[33] Williams' preference for America over Europe was not without ambiguity, however. Evans admires the Baroness for her understanding of art; and America does not remain a virgin but becomes a "hussey," such images suggesting Williams' fundamental ambivalence toward the two continents.

His next volume of poetry, *Sour Grapes*, which appeared in 1921, reflects the same ambiguities. On the one hand, the title suggests that he had come to terms with his antipoetic material. According to Williams, "sour grapes are just as beautiful as any other grapes. The shape, round, perfect, beautiful. I knew it— *my* sour grape—to be just as typical of beauty as *any* grape, sweet or sour." On the other hand, the title implies that he was still at odds with his world. "When I decided on the title I was playing a game, sticking my fingers up my nose at the world. All the poems are poems of disappointment, sorrow. I felt rejected by the world."[34] *Sour Grapes* thus presents a grey world, with Spring barely emerging from her Hell. But the volume employs a different format from that of *Kora in Hell*. A collection of discrete poems, it suggests that Williams had resumed his role as poet, albeit with a difficulty that is dramatized by the motif of the seasonal cycle impinging upon the poet as he attempts to create. Looked upon as an isolated work, neither the organizing metaphor nor the preoccupation of *Sour Grapes* was particularly Dada in feeling. But seen within the context of Williams' development at the time, the collection was moving toward an affirmation of creativity, gained in large measure from his art/anti-art ambiguities.

Although the poems do not lend themselves to strict categorization, they fall within a loose rhythm of seasonal change. The opening group establishes the movement from a waning winter to spring, with its attendant effects upon the poet. The first poem, "The Late Singer," announces the return of spring as the narrator expresses his astonishment at surviving the winter: "Here it is spring again / and I still a young man! / I am late at my singing." But he must recoup the silence of poetry enforced through the winter. Yet the second poem, "March," poses the unpredictability of early spring and suggests the problems of coming alive for the poet:

> March,
> you are like a band of
> young poets that have not learned
> the blessedness of warmth
> (or have forgotten it).
>
> At any rate—
> I am moved to write poetry

> for the warmth there is in it
> and for the loneliness—
> a poem that shall have you
> in it March.

Like the warmth of spring, the creation of a poem can protect the poet from the coldness of his soul, "my own starved misery." But such creation, natural or poetic, takes its toll, for as the narrator notes in "April," "I awoke smiling but tired."[35]

Following this tentative emergence of spring is a return to winter with such poems as "A Goodnight," "January," "The Desolate Field," and "Complaint." This movement between early spring and late winter is repeated throughout *Sour Grapes*. Not the logic of chronological sequence but the swell of creativity within the poet determines the rhythmic pattern. One group of poems blossoms into summertime, but the concluding poems return to the original configuration with signs of affirmation yet to come. Thus "The Birds" announce renewal as "the world begins again!"[36]

But once more, the coming of spring has its price. In "Portrait of the Author" the narrator declares that "the birches are made with green points / the wood's edge is burning with their green, / burning, seething—No, no, no." The narrator protests this burgeoning of life because of its destructive intensity: "the birches are mad, mad with their green. / the world is gone, torn into shreds / with this blessing." In this new world,

> Every familiar object is changed and dwarfed.
> I am shaken, broken against a might
> that splits comfort, blows apart
> my careful partitions, crushes my house
> and leaves me—with shrinking heart
> and startled, empty eyes—peering out
> into a cold world.

Dislocated from the comforts of winter, the narrator cries, "In the spring I would drink! In the spring / I would be drunk and lie forgetting all things." He finally overcomes his terror with a resigned acceptance. "And coldly the birch leaves are opening one by one. / Coldly I observe them and wait for the end. / And it ends."[37] The conclusion is ambivalent, since the narrator regards spring not as warm, but as cold and even hostile. The final opening of all the birch leaves

coincides with the deliberately noted conclusion of the poem, thereby suggesting that the creative-destructive processes are held in abeyance, both in nature and in art.

Appearing next in 1923, *Spring and All* transcends the grey uncertainties of early spring permeating *Sour Grapes*. This new work presented a formal departure from both *Kora in Hell* and *Sour Grapes* in combining poetry and prose. Unlike the previous collection, *Spring and All* was not subtitled "A Book of Poems"—an omission indicating that the poetry and prose should be read together in order to gain a full sense of the work. Furthermore, its preoccupations suggest that Williams once again turned partially away from poetry as such in order to concentrate upon the pressing problems of creation. That he shared similar concerns with Dada is indicated by his later statement in *I Wanted to Write a Poem*. "I didn't originate Dadaism but I had it in my soul to write it. *Spring and All* shows that."[38]

Like *Kora*, *Spring and All* has a density which makes it difficult to penetrate. Twenty-seven poems are interspersed with thirteen prose sections. The volume begins with a three-page preface, followed by Chapter 19 and the rest, in a numerically disordered sequence. The poems begin in what is designated as Chapter XIX and run through Chapter 1, the final chapter of the work. This disorder functions primarily to suggest the destructive chaos of creation—a Dada insight. (And if the disorder is "a travesty on the idea" of typographical arrangements, as Williams later suggested, then he was appropriately spoofing Dada itself.)[39] By placing the first chapter last, Williams pointed to a new beginning, the major theme of *Spring and All*. Most of the poems in the volume are placed in this chapter to suggest specifically a fresh initiation of poetic creation. Another important function of the disorder is to dramatize a break with linear logic. A nondiscursive, suprarational logic takes priority in *Spring and All*, showing the inner workings of the creative process in poetry. The loss of familiar coordinates takes the reader into the new realm of the imagination, which creates its own order. The reader is jarred out of his conventional world much as the narrator of "Portrait of the Author" in *Sour Grapes* is forced to confront spring, which destroys the comforts of winter hibernation. In this way, the form of *Spring and All* leads the reader to Williams' central preoccupations.

The opening section, however, is antagonistic, for Williams assumes a hostile attitude toward the reader: "If anything of moment

results — so much the better. And so much the more likely will it be that no one will want to read it." "Anything of moment" suggests not only his high purpose in this work, the desire to create something significant, but also his theory of contact, since "there is a constant barrier between the reader and his consciousness of immediate contact with the world." To break down this barrier, in order to establish a "moment" of intensity, Williams hypothesizes all the objections that a conventional reader of poetry might pose: his verse is "positively repellent" in its lack of rhyme and rhythm and in its cultivation of the grotesque; and so the reader reacts by accusing him of lacking faith, of being emotionally shallow, and indeed, of writing antipoetry.[40]

Williams' irony throughout this passage is quite complex. On the one hand, he strongly implies that his writing in some ultimate respect is not antipoetic, so that the reader's sense and judgment of his verse are erroneous. Yet Williams grants the legitimacy of the reader's desire for "poetry that used to go hand in hand with life, poetry that interpreted our deepest promptings, poetry that inspired, that led us forward to new discoveries, new depths of tolerance, new heights of exaltation." The irony redounds to Williams, for in order to endow his poetry with such qualities, he must reject art in favor of the imagination. Like Picabia and De Zayas before him, Williams claims that art blocks perception by seeking the pretentious, the "beautiful illusion."[41]

Williams' denials take on an affirmative dimension in his paean to the imagination: "To refine, to clarify, to intensify that eternal moment in which we alone live there is but a single force — the imagination. This is its book. I myself invite you to read and to see." Although the invitation echoes Whitman in "Song of Myself," Williams does not attach mystical overtones to the imagination: "In the imagination, we are henceforth (so long as you read) locked in a fraternal embrace, the classic caress of author and reader. We are one. Whenever I say 'I' I mean also 'you.' And so, together, as one, we shall begin."[42] Thus Williams wants to involve the reader intimately in this quest for creativity.

The search, however, takes the reader through an apocalyptic landscape, as Williams imagines America to be destroying the Old World in a slaughter that would be a credit to Dada:

The imagination, intoxicated by prohibitions, rises to drunken heights

to destroy the world. Let it rage, let it kill. . . . Then at last will the world be made anew. Houses crumble to ruin, cities disappear giving place to mounds of soil blown thither by the winds, small bushes and grass give way to trees which grow old and are succeeded by other trees for countless generations. A marvellous serenity broken only by bird and wild beast calls reigns over the entire sphere. Order and peace abound.[43]

Most specifically, as Williams makes clear, it is the American imagination which, released from its cultural restrictions, needs to destroy the existing order of Europe before a truly new world can be created.

The title of the third chapter (designated XIII) is written backwards and upside down to show not only the chaotic destruction of the imagination but also the movement backwards, from behind the poem to the poetic process itself. And again, Williams presents a scene of chaos and destruction, from which creation ensues:

Thus, weary of life, in view of the great consummation which awaits us—tomorrow, we rush among our friends congratulating ourselves upon the joy soon to be. Thoughtless of evil we crush out the marrow of those about us with our heavy cars as we go happily from place to place. It seems that there is not time enough in which to speak the full of our exaltation. Only a day is left, one miserable day, before the world comes into its own. Let us hurry! Why bother for this man or that? In the offices of the great newspapers a mad joy reigns as they prepare the final extras. Rushing about, men bump each other into the whirring presses. How funny it seems. All thought of misery has left us. Why should we care? Children laughingly fling themselves under the wheels of the street cars, airplanes crash gaily to the earth. Soneone has written a poem.[44]

This apocalyptic imagination (at once the imaginative projection of Williams) swings between destruction and creation, as the affirmation of destruction becomes analogous to the writing of a poem.

By the fourth chapter (designated VI), the entire life process, intimately related to the imagination, has begun again. Williams continues, "Yes, the imagination, drunk with prohibitions, has destroyed and recreated everything afresh in the likeness of that which it was. Now indeed men look about in amazement at each other with a full realization of the meaning of 'art.'"[45] With the creation of the world anew by the imagination, the sterile quality of that which was previously known as "art" will be revealed. Most significant will be the realization that the true meaning of art resides in the creation of a new vision by the imagination.

With the arrival of spring, poetry becomes possible. Thus Williams includes two poems in the next chapter (fifth in sequence, but labeled XIX). He announces, "It is spring. That is to say, it is approaching THE BEGINNING." At this point, the first poem of the volume appears and is given the Roman numeral I, indicating the start of the new order, issued from the primordial chaos wrought by the imagination. "By the road to the contagious hospital" dramatizes the emergence of spring:

> All along the road the reddish
> purplish, forked, upstanding, twiggy
> stuff of bush and small trees
> with dead, brown leaves under them
> leafless vines—
>
> Lifeless in appearance, sluggish
> dazed spring approaches—[46]

Although the agony of rebirth is manifest, this poem is predominantly affirmative, unlike the poems in *Sour Grapes* that present spring ambivalently. In this context it gains an added force as the climax of the poet's struggle to create, and thus dramatizes the processes of the imagination.

In the sixth and final chapter, designated Chapter 1, Williams eventually begins to discuss the possibilities of art once again, although his view is that of an art transformed and revitalized by the imagination, the force of which grasps experience, the thing itself, directly. Williams promises: "What I put down of value will have this value: an escape from crude symbolism, the annihilations of strained associations, complicated ritualistic forms designed to separate the work from 'reality'—such as rhyme, meter as meter and not as the essential of the work, one of its words." Or, expressed in a more positive way, "the work will be in the realm of the imagination as plain as the sky is to a fisherman."[47] Williams rejects poetic symbolism, for it obscures the material under scrutiny. Although his ideas partake of the tenets of Imagism, set forth almost a decade before, they achieve here a new intensity, given his rebellion against the restrictions of art, and take on the dimensions of a well-conceived epistemological framework.

In order to achieve this freshness of perception, the poet must regard nature. "Nature is the hint to composition not because it is

familiar to us and therefore the terms we apply to it have a least common denominator quality which gives them currency—but because it possesses the quality of independent existence, of reality which we feel in ourselves. It is not opposed to art but apposed to it." For Williams, poetry is the "new form dealt with as reality itself."[48]

He therefore turns away from the Cubists, with their hermetic images, to Marcel Duchamp and his readymades. Whereas in *Kora in Hell* the imagination turned upon itself becomes a readymade improvisation, in *Spring and All* it seizes the particular experience as a readymade: "Poetry has to do with the crystallization of the imagination—the perfection of new forms as additions to nature." Williams prefaces this statement with "The Little Red Wheelbarrow" (Poem XXII) as a readymade:

> so much depends
> upon
>
> a red wheel
> barrow
>
> glazed with rain
> water
>
> beside the white
> chickens.

Aside from the opening declaration, which serves to underscore the significance of the wheelbarrow (much as Duchamp in choosing his object determined his readymade), Williams presents the wheelbarrow itself, the readymade transposed into language through accurate, concise description and subtle phrasing. The wheelbarrow on the page gains its reality as an addition to nature because it already exists as a reality in human experience. As Williams explains, "the word is not liberated, therefore able to communicate its release from the fixities which destroy it until it is accurately tuned to the fact which giving it reality, by its own reality establishes its own freedom from the necessity of a word, thus freeing it and dynamizing it at the same time." Because the fact has no need of the word, the word in turn becomes free and dynamic in its precise attachment and identification with the fact.[49]

Spring and All emerges from the grey season of *Sour Grapes*. The

destructive nature of the imagination clears the stale world for spring, for new creation. But since the process of atrophy (promulgated by those whom Williams calls the "Traditionalists of Plagiarism") is a persistent phenomenon, the imagination must continue to address itself against art and literature. The poems amid the prose are akin to Duchamp's readymades, as Williams discovers language in experience directly perceived through the imagination. When toward the end of *Spring and All* Williams begins to discuss poetry in relation to the imagination, it is in large measure because he has established a clearing for himself where it is possible to concentrate upon poetic creation once again.

Inevitably, then, Williams had to assume the task of finding a context for words once they could be articulated—a quest undertaken in *The Great American Novel*, which appeared in 1923 at about the same time as *Spring and All*. The liberation of language by attachment to fact required an indigenous American experience, which was to be gained only by the destruction of the European background, erroneously held forth by the "Traditionalists of Plagiarism" as the American model. Williams thus mounted an exercise complementary to European Dada. Like Picabia, he cleared out the past by turning from Europe to America in order to create a new art, unrecognized as such by the standing cultural order. *The Great American Novel* was thus a prelude to *In the American Grain*.

The Great American Novel measures up to Williams' favorite descriptive term, "opacity." The narrator claims, "It is Joyce with a difference. The difference being greater opacity, less erudition, reduced power of perception—Si la sol fa mi re do. Aside from that simple, rather stupid derivation, forced to a ridiculous extreme. No excuse for this sort of thing. Amounts to a total occlusion of intelligence. Substitution of something else. What? Well, nonsense. Since you drive me to it." Given certain clues, one could penetrate the Improvisations, whereas *The Great American Novel* sprawls in all directions with a protean elusiveness. The most evident unifying element is provided by a narrator-novelist who "goes in search of a word," a quest that explores the American context. "Let us learn the essentials of the American situation," suggests Williams.[50]

Williams parodies the idea of the great American novel because those who attempt to write such a work incorrectly assume that Ameri-

can subject matter is a necessary and sufficient condition for its achievement. He affirms, on the contrary, the importance of form, but even here, form must be original, free from Europe:

> Take the improvisations: What the French reader would
> say is: *Oui, ça; j'ai déja vu ça; ça c'est de Rimbaud.* Finis.
> Representative American verse will be that which will
> appear new to the French. . . . prose the same.[51]

The American artist must not be betrayed by a provincialism that mistakes conventional or traditional European forms for innovation. Consequently, Williams goes beyond parody to deal with the words themselves, so that American writing can emerge distinct from that of Europe.

Williams begins his "novel" with chaos:

> If there is progress then there is a novel. Without progress there is nothing. Everything exists from the beginning. I existed in the beginning. I was a slobbering infant. Today I saw nameless grasses—I tapped the earth with my knuckle. It sounded hollow. It was dry as rubber. Eons of drought. No rain for fifteen days. No rain. It has never rained. It will never rain. Heat and no wind all day long better say hot September. The year has progressed. Up one street down another. It is still September. Down one street, up another. Still September. Yesterday was the twenty second. Today is the twenty first. Impossible. Not if it was last year. But then it wouldn't be yesterday. A year is not as yesterday in his eyes. Besides last year it rained in the early part of the month. That makes a difference. It rained on the white goldenrod. Today being misplaced as against last year makes it seem better to have white—Such is progress. Yet if there is to be a novel one must begin somewhere.[52]

The author must struggle with the chaos of language and experience, adjusting them one to the other in an attempt to shape the novel.

Williams suggests that the order and continuity of progress are essential for the making of the novel. This problem is compounded by the fact that words must record experience. "But how have milk out of white goldenrod?" asks the narrator. Words become the key to the novel's progress: "But can you not see, can you not taste, can you not smell, can you not hear, can you not touch—words? It is words that must progress. Words, white goldenrod, it is words you are made out of—THAT is why you want what you haven't got."[53] The words are lacking for Americans, however, because they do not exist to record the peculiar American context.

One such way to achieve the verbal articulation of experience is to break up words:

Progress is to get. But how can words get.—Let them get drunk. Bah. Words are words. Fog of words. The car runs through it. The words take up the smell of the car. Petrol. Face powder, arm pits, food-grease in the hair, foul breath, clean musk. Words. Words cannot progress. There cannot be a novel. Break the words. Words are indivisible crystals. One cannot break them—Awu tsst grang splith gra pragh og bm—Yes, one can break them. One can make words. Progress? If I make a word I make myself into a word. One big word. One big union. Such is progress. It is a novel. I begin small and make myself into a big splurging word: I take life and make it into one big blurb. I begin at my childhood. I begin at the beginning and make one big—Bah.[54]

Williams had already rejected this elementary destruction of words in *Spring and All*. Words are not liberated by their dissociation from experience.

Rather, words must be liberated from a particular kind of experience—the European experience, which is second-hand for most Americans. "Europe we must—We have no words. Every word we get must be broken off from the European mass. Every word we get placed over again by some delicate hand. Piece by piece we must loosen what we want. What we will have. Will they let it go? Hugh." Similarly, in discussing Joyce, Williams avers, "But you must not mistake his real, if hidden, service. He has in some measure liberated words, freed them for their proper uses. He has to a great measure destroyed what is known as 'literature.' For me as an American it is his only important service."[55] After Joyce, the American writer could begin to be free.

But Joyce could not provide the entire force of liberation. American writers had also to oppose all art as part of an established past from which America as a new nation must escape if genuine creativity is to exist. Williams cries, "To hell with art. To hell with literature. The old renaissance priests guarded art in their cloisters for three hundred years or more. Sunk their teeth in it. The ONE solid thing. Don't blame me if it went down with them. DOWN, you understand. Fist through the middle of the rose window. You are horror struck. One word: Bing! One accurate word and a shower of colored glass following it. Is it MY fault? Ask the French if that is literature"[56]—all of which leads to the possibilities of Dada:

Expressionism is to express skilfully the seething reactions of the contemporary European consciousness. Cornucopia. In at the small end and—blui! Kandinsky.

But it's a fine thing. It is THE thing for the moment—in Europe.

The same sort of thing reversed, in America has a water attachment

to be released with a button. That IS art. Everyone agrees that that IS art. Just as one uses a handkerchief.

It is the apotheosis of relief. Dadaism in one of its prettiest modes: *rien, rien, rien.*—But wait a bit. Maybe Dadaism is not so weak as one might imagine.—One takes it for granted almost without a thought that expressionism is the release of SOMETHING. Now then Aemilius, what is European consciousness composed of?—Tell me in one word.—*Rien, rien, rien!* It is at least very complicated. Oh very.

Throughout this ironic meditation runs the image of Duchamp's *Fountain*, replacing the "rose window" of the medieval church. Williams uses Dada attitudes also to exorcise the "swarming European consciousness" from America. "Europe is nothing to us. Simply nothing," he asserts. "Their music is death to us. We are starving—not dying—not dying mind you—but lean-bellied for words. God I would like to see some man, some one of the singers step out in the midst of some one of Aida's songs and scream like a puma."[57] Like Arthur Cravan before him, Williams seeks the destruction of European art by means of the barbaric cry of the New World—Whitman's yawp pitched to a new key.

Yet his conception of America is not by any means optimistic: "America is a mass of pulp, a jelly, a sensitive plate ready to take whatever print you want to put on it—We have no art, no manners, no intellect—we have nothing. We water at the eyes of our own stupidity. We have only mass movements like a sea." At the same time, however, Williams affirms his nationality:

I am a beginner. I am an American. A United Stateser. Yes its ugly, there is no word to say it better. I do not believe in ugliness. I do not want to call myself a United Stateser but what in—but what else am I? Ugliness is a horror to me but it is less abhorrent than to be like you even in the most remote, the most minute particular. For the moment I hate you, I hate your orchestras, your libraries, your sciences, your yearly salons, your finely tuned intelligences of all sorts. My intelligence is as finely tuned as yours but it lives in hell, it is doomed to eternal—perhaps eternal—shiftings after what? Oh to hell with Masters and the rest of them. To hell with everything I have myself ever written.[58]

Williams finally turns upon himself to a Dada-like self-destruction in order to create anew.

He concludes in despair, "Tell me, wet streets, what are we coming to, we in this country? Are we doomed? Must we be another

Europe or another Japan with our coats copied from China, another bastard country in a world of bastards? In this our doom or will we ever amount to anything?" Yet Williams offers some hope for America on the grounds that its culture charges the imagination:

> Jazz, the Follies, the flapper in orange and green gown and war-paint of rouge—impossible frenzies of color in a world that refuses to be drab. Even the movies, devoid as they are of color in the physical sense, are gaudy in the imaginations of the people who watch them; gaudy with exaggerated romance, exaggerated comedy, exaggerated splendor or grotesqueness or passion. Human souls who are not living impassioned lives, not creating romance and splendor and grotesqueness—phases of beauty's infinite variety—such people wistfully try to find these things outside themselves; a futile, often destructive quest.

Williams cannot give himself up entirely to despair; rather, he entrusts himself to the irrepressible imagination which will provide relief for the American artist and his art. "The imagination will not down. If it is not a dance, a song, it becomes an outcry, a protest. If it is not flamboyance it becomes deformity; if it is not art, it becomes crime. Men and women cannot be content, any more than children, with the mere facts of a humdrum life—the imagination must adorn and exaggerate life, must give it splendor and grotesqueness, beauty and infinite depth."[59]

Derived from the logic of his previous works, the writing of *In the American Grain* was a necessary task for Williams. This study was an affirmative culmination of his Dada preoccupations which railed against America's cultural orientation toward Europe. Now he could turn to America and discover its native background. So while he continued to promulgate the myth of America as the New World distinct from the Old, he saw the New World as growing old. As he had previously asserted in *The Great American Novel*, "We shall not be able to plead childhood any longer."[60] With age come maturity and responsibility, gained in large measure from self-evaluation, which informs *In the American Grain*.

This history, to use the term for a moment, was shaped by Williams' theory of contact. He attempts to examine historical figures of early America so as to show how the New World affected them. Thus he disapproves of the Puritans because they retained their European theology. The wilderness tightened their grip upon European culture.

In contrast, Daniel Boone is drawn as the hero who gave himself to the wilderness:

> By instinct and from the first Boone had run past the difficulties encountered by his fellows in making the New World their own. As ecstacy cannot live without devotion and he who is not given to some earth of basic logic cannot enjoy, so Boone lived to enjoy ecstacy through his single devotion to the wilderness with which he was surrounded. The beauty of a lavish, primitive embrace in savage, wild beast and forest rising above the cramped life about him possessed him wholly. Passionate and thoroughly given he avoided the half logic of stealing from the immense profusion.[61]

Quite possibly Williams' Boone and the historical Boone may merge without violence; nevertheless, he, like the Puritans, is obviously a reincarnation of Williams' own values and preoccupations.

In the American Grain ultimately transcends such biases, which were, however, essential for its conception. Williams endeavored to provide a moral and aesthetic basis for Americans to withstand the encroachments of Europe:

> I said, It is an extraordinary phenomenon that Americans have lost the sense, being made up as we are, that what we are has its origin in what *the nation* in the past has been; that there is a source IN AMERICA for everything we think or do; that morals affect the food and food the bone, and that, in fine, we have no conception at all of what is meant by moral, since we recognize no ground our own—and that this rudeness rests all upon the unstudied character of our beginnings; and that, if we will not pay heed to our own affairs, we are nothing but an unconscious porkyard and oilhole for those, more able, who will fasten themselves upon us. And that we have no defense, lacking intelligent investigation of the changes worked upon the early comers here, to the New World, the books, the records, no defense save brute isolation, prohibitions, walls, ships, fortresses—and all the assininities of ignorant fear that forbids us to protect a doubtful freedom by employing it. That unless everything that is, proclaim a ground on which it stand, it has no worth; and that what has been morally, aesthetically worth while in America has rested upon peculiar and discoverable ground. But they think they get it out of the air or the rivers, or from the Grand Banks or whatever it may be, instead of by word of mouth or from records contained for us in books—and that, aesthetically, morally we are deformed unless we read.[62]

By turning to America's "peculiar and discoverable ground," the vir-

tues of America might be restored and an identity established so as to contend with Europe.

Given these premises, *In the American Grain* cannot be judged simply as another compendium of historical sequence of fact. Rather, the work stands as a landmark in Williams' development in light of its broad exploration of American culture. No longer filled with shrill invective, he comes to terms with America in his imagination and recreates the American past as a mixture of history and fable:

> History must stay open, it is all humanity. Are lives to be twisted forcibly about events, the mere accidents of geography and climate?
>
> It is an obscenity which few escape — save at the hands of the stylist, literature, in which alone humanity is protected against tyrannous designs.

According to Williams, the poet is best suited to fulfill America's need for an integral identity. "This want, in America, can only be filled by knowledge, a poetic knowledge of that ground."[63] In its own terms, then, *In the American Grain* dramatizes Williams' concept of the poet's role in the formulation of a viable American culture — a role that came out of his abrasive immersion in the contradictions of Dada.

It was precisely this crucial ambivalence toward Europe and America that generated Williams' avant-garde explorations for several decades to come. Highly regarded for both his poetry and his declared stand, Williams encouraged a younger generation of writers less wary than he of Europe and its Dada emblandishments, from which they gained their own sense of American art. Their adventures and contributions to the arts were logged in the pages of *Broom* and *Secession*, two important magazines of the 1920s that addressed the issues raised by Dada.

6 | *Broom* and *Secession*

After graduating from Princeton in 1921, Harold Loeb decided to expend his patrimony on "an international magazine of the arts." Initially sharing his editorial duties with the poet Alfred Kreymborg and then with Matthew Josephson, a fellow expatriate, Loeb managed to sustain *Broom*, as the magazine was called, for three years by taking advantage of the international dollar exchange and publishing the review first throughout Europe and then back in New York before its demise.[1] But more important than financial considerations or changes in geographical locale was a vital editorial policy that led *Broom* from the views held by *The Seven Arts* to those of *The Soil* and beyond. At the outset, however, *Broom* was undistinguished in its eclecticism. The magazine's sentiments generally complied with Waldo Frank's thesis that the dehumanizing forces of American technology had to be offset by the cultivation of spiritual values—an argument he had tendered in *The Seven Arts* during the War and developed most fully in *Our America*, which was published in 1919. From this early opposition to the anti-art fulminations of *The Soil*, Loeb and Josephson directed *Broom* toward Dada and, in the process, affirmed an American art that was consonant with the attitudes of Coady's magazine.

This development can be charted by shifts in editorial personnel and contributors. After the fourth issue, Kreymborg resigned his editorial position because Loeb had become interested in Europeans and Americans who were considered extreme avant-gardists. In the fifth, an essay by Jean Epstein marked a rejection of Waldo Frank's views and foreshadowed the subsequent publication of Matthew Josephson, Malcolm Cowley, and E.E. Cummings in the review. Since they were well aware of the latest artistic developments in Europe, particularly of the activities of the Dadaists, who gathered in Paris during the early 1920s *Broom*'s orientation toward European art was soon focused on Dada.

The leverage, if indeed any were required, was provided by Gor-ham Munson's little magazine *Secession*, which appeared in the spring of 1922.[2] Matthew Josephson dominated the first issue, which clearly reflected his approval of Dada. Since Munson had become skeptical about it, Josephson switched his allegiance to *Broom* when Loeb of-fered him a coeditorship. *Broom* had already provided Josephson with an outlet for affirming Dada and American literature, so that it was perhaps to be expected that a month after his appointment he published an "Instant Note on Waldo Frank," challenging the anti-Dada position. In response, Munson maneuvered *Secession* through perilous Dada antics in alliance with Frank, who finally called "For a Declaration of War" in the winter of 1924. By this time, the two magazines had ex-changed their initial views on Dada.

It was inevitable that the debate over Dada and American art engage other magazines. While Cowley and Frank were exchanging letters in *1924*, Edmund Wilson was dramatizing the question in *The New Republic*. It was *Broom* and *Secession*, however, that provided the barometers by which to gauge the pressures of this tempestuous controversy. To be sure, neither magazine ever fully embraced Dada or assumed the chaotic proportions of a Dada publication like, say, Pica-bia's *391*. But *Broom* in particular focused upon the implications of Dada for American writers, stating its belief in aesthetic form as the key to creativity and in American technology as a major source of liter-ary material. As Josephson later asserted in exploring literary direc-tions "After and Beyond Dada," "The hunt is now on for 'purity' of form and content, while expressing the distinctive modern attitude developed in post-war Europe."[3]

In his opening editorial Loeb stated that the magazine would abstain — at least for the time being — from adopting any specific course. A rather unassuming manifesto on the back inside cover indicated *Broom*'s role as "a sort of clearing house where the artists of the pres-ent time will be bought into closer contact," thereby concurring with some of the goals of Williams' review. Having defined its role, *Broom* promised to publish both unknown and established artists. The editors would seem to have sought a kind of balance: at the same time that they claimed to emphasize both literature and the visual arts, they also wanted to publish American and British as well as continental artists. Only in their insistence upon the publication of "artists of the present

time" did the editors take a stand that was to assume radical significance.[4]

The allusion of the magazine's title, taken by Kreymborg from a passage in *Moby Dick*, also pointed to avant-garde possibilities. The back cover bore Ishmael's disclaimer, "What of it, if some old hunks of a seacaptain orders me to get a broom and sweep down the decks? What does that indignity amount to, weighed, I mean, in the scales of the New Testament? Do you think the Archangel Gabriel thinks any less of me, because I promptly and respectfully obey that old hunks in that particular instance? Who ain't a slave?" The adoption of this motto bore witness to things American, a consciousness of an American literary tradition. Likewise, Ishmael's subversive acquiescence to authority implied that *Broom*, a humble and little-regarded review, might sweep the past aside, and take on avant-garde dimensions.

That *Broom* would eventually focus upon those young American writers who embraced the possibilities of Dada was not evident, however, during its first year; on the contrary, the magazine opposed the nonsense of Dada. Alternatives to this "European disease," as Kreymborg characterized it,[5] were posed by Emmy Veronica Sanders in the first issue of *Broom*. Her essay, "American Invades Europe," later called by Loeb the statement closest to an editorial policy at the time, deplored the attractiveness of the French avant-garde, particularly the Paris Dadaists. Like Loeb and Kreymborg, she saw Dada as a dead-end for literary ventures and advocated broadening America's vision beyond its confines to the rest of Europe. But, even so, she felt that artists should remain faithful to indigenous American materials, and assimilate them without foreign intrusion.[6] Moreover, Miss Sanders was skeptical about the admixture of Dada aesthetics and American technology. The machine was "interesting, ingenious, valuable in its way—but limited," and its combination with Dada's nihilism would probably have little or no humanistic value. In lieu of such an apparently sterile synthesis, she offered the work of Randolph Bourne, Carl Sandburg, Sherwood Anderson, and Waldo Frank. "From these," she thought, "the modern European world will get a better understanding of the new America's contact with herself, of her self analyses, self criticism, self transformation, than from all the ultra modern followers of France combined."[7]

In the second issue of *Broom* Leon Bazalgette, the French translator of Walt Whitman, supported Miss Sanders by praising Waldo

Frank's *Our America*. He approved of Frank's vision of the "real America" as against "the spurious phases of the American scene." In his introduction to *Our America* Frank had indeed preferred to view his country as "a mystic Word." From this premise he readily drew his conclusion about twentieth-century America: a land dominated by industrialism would inevitably breed spiritual starvation. At the heart of the industrial complex was the machine, causing fragmentation and destruction. Entrapped in this desolate machine-scape, Frank's modern American could find no salvation through his cultural endeavors, such as they were. "America is a joyless land," Frank asserted. "And nowhere is this so crying-clear as in the places of New York—Broadway, the 'movies,' Coney Island—where Joy is sought." In disparaging precisely those phenomena once praised by *The Soil* Frank measured his distance from Coady. By way of further contrast, Frank had only praise for the mystic "spirits" of Lincoln, Whitman, and Stieglitz. The latter in particular was lauded for his subjugation of the machine (his camera) to a "unifying vision of the human spirit." Similarly, American literature became estimable only when a novelist like Sherwood Anderson could transcend the ugliness of industrial America with an "impalpable marriage of substance and of human spirit which is art." The Mid-West, in his view, was the spiritual garden of America, the last bulwark against "industrial Despair."[8]

By the fourth issue of *Broom*, however, Loeb rebelled against the purple prose of Paul Rosenfeld, the cultural critic who was a protégé of Frank and Stieglitz. In an editorial "Comment," Loeb referred to a particular essay by Rosenfeld as "an offence to American criticism and a calumny on American art." He ascribed the chaotic nature of American literature to the imprecision of its criticism, and in so doing, he indirectly criticized Frank's mystical approach to literature in which the implicit criterion for judgment was the spiritual nature of the content. Presumably, if the content were spiritual enough, one could minimize or ignore problems of form. Although Loeb did not necessarily reject mysticism, he was aware that subjective emotions had to be wrought "into communicable form"—hence his newly found concern for aesthetic matters, derived in part from a greater familiarity with the writing of his peers.[9]

As Loeb gradually broke away from Frank and his group over the question of literary formalism, the fifth number of *Broom* (now in-

dependent of Kreymborg) proclaimed a thematic break as well. Jean
Epstein welcomed technology for defining "The New Conditions of
Literary Phenomena":

> Man has never seemed to me so beautiful and so capable and so ener-
> getic as this day in which I live. But in truth, it is undeniable that he
> has changed, and today the most important factor in the change is the
> intensely cerebral, intensely nervous life of humanity, a life which
> normally, logically, evidently, inevitably entails fatigue, a fatigue corre-
> sponding to the nervous expenditure, that is to say cerebral and intel-
> lectual. A light fatigue, universal in the measure that civilization is
> universal, not pathological, since it is not exceptional in the new state
> of health.

Epstein's celebration of modern nerves was in direct contrast to Waldo
Frank's castigation of New York City, which was "too high-pitched,
its throb too shattering fast. Nerves and spiritual fiber tears in such
a strain."[10]

Epstein, however, would not bow beneath the weight of such
new phenomena, which he recognized as shaping modern literature.
Accordingly, he extolled "spatial speed, mental speed, multiplication
of intellectual images and the deformations of these images, extension
of auto-observation and of the importance given to the interior life,
cerebral life and the fatigue that results from it. Such are the most
important conditions under which the contemporary literary phe-
nomenon comes into being." Far from rejecting "the machine tech-
nology of civilization," Epstein accepted it as a new extension of man.
"All these instruments: telephone, microscope, magnifying glass,
cinematograph, lens, microphone, gramophone, automobile, kodak,
aeroplane, are not merely dead objects," he claimed. "At certain
moments these machines become part of ourselves, interposing them-
selves between the world and us, filtering reality as the screen filters
radium emanations. Thanks to them, we have no longer a simple, clear,
continuous, constant notion of an object."[11] While Epstein brilliantly
perceived that the machine changed man's concept of reality, he also
asserted that the machine was not necessarily destructive. So by the
fifth issue, published in April 1922, *Broom*, which had heretofore
followed Frank's lead against technology, now began to forsake him
and to pursue its possibilities for literature.

While Epstein's essay introduced American writers such as
Cowley, Josephson, and Cummings to the readers of *Broom*, those

same young men were already associated with *Secession*, Gorham
Munson's little magazine, specifically created to serve their generation.
The first issue, published in the spring of 1922, coincided with *Broom's*
shift from Frank's mysticism to technology. Munson had been inspired
by an article of Cowley's written in mid-October of the previous year.
Corresponding with Cowley on December 6, 1921, Munson exclaimed,
"Your essay, *'This Youngest Generation'*, in the *Literary Review* has
impressed me with the feasibility of operating a review which will
provide a forum for just those writers and their kin whom you men-
tion."[12]

In that essay Cowley had claimed that a new generation of
American writers had broken with the preoccupations of their pred-
ecessors: "One can safely assert that they are not gathered in a solid
phalanx behind H. L. Mencken to assault our tottering American
Puritanism." Instead, they were turning to French literature, "from
Baudelaire and Laforgue down through the most recent and most
involved Parisian schools." Following such French models, the
Americans would emphasize "form, simplification, strangeness, re-
spect for literature as an art with traditions, abstractions." Munson,
who later characterized himself as "nothing if not alert in those days,"[13]
did have a sharp eye when he focused on that rather naïve yet extra-
ordinarily self-conscious essay in which Cowley had outlined the
major trends of at least his group, if not of his entire generation. They
did indeed turn to Europe, particularly to France, for their literary
guidance; and in the process they pointed up the conservatism of a
Mencken (and indirectly that of the American public, which viewed
Mencken as a radical), who was still championing what had become
the outdated naturalism of Theodore Dreiser.

By the early 1920s, Cowley's ideas were already circulating
among his peers. Munson and his wife had been in Europe since the
summer of 1921. In Paris they met Josephson through an introductory
letter from Hart Crane, the young poet back in Cleveland, Ohio.
Josephson, who in turn introduced Munson to Cowley, discussed the
possibility of a new review to supplant *Gargoyle*, which was edited
by Arthur Moss in Paris.[14] In his desire to establish a magazine for
new, experimental writers, Josephson clearly agreed with the views
put forth earlier by Cowley in the *Literary Review*.

As a result of this exchange, Munson sent out a circular to present
the aims of *Secession*, as he called his forthcoming magazine. It was

to be "the first gun for this youngest generation," which would assault the last decade of American writing and launch the next, highlighting the "criticism, insults, and vituperations" of young Americans and Dadaists, and exposing "the private correspondence, hidden sins and secret history" of such supposedly stodgier magazines as *The Dial*, *Broom*, and *The Little Review*. Although rather mildly stated, Munson's prospectus promised a bellicose attitude in subsequent literary controversies. As he said ten years later, with only slight exaggeration, "Mars was certainly present at the birth of *Secession*. In fact, it was invoked. The review was to be intransigent, aggressive, unmuzzled. The contributors were to handle everybody, including each other, without kid gloves."[15]

The note of aggression was sounded by the Europeans whom Munson cited. With the exception of Apollinaire, the list was comprised of young Parisian Dadaists such as Louis Aragon, André Breton, Paul Eluard, and Philippe Soupault. Munson had met Tristan Tzara, their leader, through Man Ray during the fall of 1921. Upon Tzara's invitation, Munson "dashed off three dada 'poems,' making use of multiplication tables and the mention of forbidden things, and being properly idiotic." Indeed, his initial attitudes toward Dada appear to have been cavalier. This description was written a decade later, however, when he attempted to play off the frivolities of Josephson and Dada against his own subsequent efforts at serious criticism. Yet he was probably accurate in saying, "Of course, I attached no importance to this little stunt, but dadaism as a movement continued to interest and puzzle me."[16] Insouciant at the outset, he soon grew aware of Dada's significance.

The generally skeptical attitude of Munson was reinforced by the respected views of his friend Kenneth Burke. Writing for the *New York Tribune* in February 1921, Burke successfully captured the chaotic, nonsensical essence of Dada, even though the title of his article, "Dadaisme Is France's Latest Literary Fad," failed to convey his complex reactions to the movement. At the same time that he characterized the Dadaists as petulant children who wanted to take over the literary spotlight, he saw their nihilism, which stemmed from the war, extending to art: "These men have discovered a fluctuating aesthetic. Their byword is 'rien,' which means nothing." Yet Burke could also understand that "the joy of creation is here unlimited; it is carried to the extent of anarchy."[17]

It was this affirmative side of Dada that Josephson would soon embrace. As the self-proclaimed American spokesman for Dada, he recognized the cultural and historical circumstances that distinguished the French Dadaists from their American counterparts. American expatriates simply did not share the French war experience to the same degree. "Though the impact of World War I upon American destiny was immense," he wrote, "it is nonsense to hold that a generation of American youth were 'lost' or driven to despair as a result of that brief war."[18] Without the sense of nihilistic revolt provoked by the horrors of war, Josephson could not be expected to have reacted to Dada in the same way as young Parisian poets did after it had spread to France from Zurich.

Louis Aragon, then a medical student, was Josephson's preceptor in French literature. Through his tutelage, Josephson became familiar with the works of Stendhal, Rimbaud, Jarry, and Apollinaire. His bookish interests, however, comprised only one aspect of his attitudes toward Dada. The public assaults and general hell-raising of his new compatriots also appealed to him. In his memoirs Josephson claimed: "I also felt the excitement of danger as I found myself being drawn into the absurd and scandalous enterprises of the Dadaists, as their American recruit. There were risks in this business, but there were special satisfactions too. At least we writers would leave our sedentary lives in our studies, cafés, or the parlors where we used to read our poems to old ladies, and go forth into the streets to confront the public and strike great blows at its stupid face."[19] It was inevitable, then, that at a Dada meeting in January 1922 he almost started a brawl.

At the same time that Josephson was engaging in such demonstrations, he nevertheless feared that his behavior would siphon away energy from writing literature. The disjunction which he sensed between Dada shenanigans and the writing of poetry may have been a throwback to his initial skepticism about the movement. In corresponding with Cowley in December 1921, he had claimed in defense of his French cohorts that "these young men, when they break away from the rubbish of Dada will be the big writers of the next decade. They are working at more or less the same problems that we are, although they abjure technique, and accuse each other in turn of toadying to the Academy."[20] At this early juncture Josephson apparently tolerated "the rubbish of Dada" only because of the literary potential of the Paris participants. But by the spring of 1922 he had

become involved to the extent that he contributed his own nonsense to *Le Cœur à barbe, Journal Transparent*, since recognized as an ephemeral pamphlet cast among the imbroglios of Paris Dada.[21]

At this time, too, Josephson began to discern the implications of Dada for American writers. His first essay on the subject was entitled "Apollinaire: Or Let Us Be Troubadours" and appeared in the opening issue of *Secession*. Minimizing Dada's nihilism, Josephson thus dissented from Williams' views in *Contact*. He insisted on the contrary that the French "are not exhausted, these young men who have survived 1914–1918. Witness the excellent morale of the writers of the *avant-garde* in France, who, in isolation from the rest of their countrymen, have completely forgotten the war. Talented, extravagant, intolerant, fun-loving, these young writers whether of Dada affiliations or not have broken with the direct line of French literature."[22] Although this description could have easily applied to his own group, his interpretation of the Dada spirit was a refreshing contrast to the stereotyped notion of Dada as being utterly nihilistic; yet his enthusiasm glossed over Dada's intrinsic despair, for "funloving" was not quite the word to describe the group, considering the specters of Jacques Vaché and Guillaume Apollinaire among the millions dead, haunting the consciousness of the French avant-garde.

Josephson accurately discerned, however, a split in this younger generation. One group was distinguished by its allegiance to the *Nouvelle Révue Française*, in the pages of which André Gide, André Salmon, and Paul Morand exhibited "a certain penchant for mockery, a certain cleverness at the comedy of manners." As for the other group, consisting primarily of Breton, Aragon, and Soupault, "one meets an unexpected sincerity, a desperate willingness to go to any lengths of violence in opposing the old regime." Although Josephson rightfully noted that their writing had not yet been fully realized, he maintained that "they are inventive to an extreme degree and are utterly without blague or snobbery. They are bent frankly on unbounded adventures and experiments with modern phenomena."[23]

Ultimately, then, the young American writer was to emulate the French Dadaists and become a troubadour of the contemporary world. Josephson thus praised Apollinaire, who, as a predecessor of the Dadaists, had "urged the poets of this time to be at least as daring as the mechanical wizards who exploited the airplane, wireless telegraphy, chemistry, the submarine, the cinema, the phonograph, what-

not." Whitman had said as much as Emerson had before him, but Josephson derived a fresh impetus from contemporary interest and exhorted "the modern poet to create the myths and fables which are to be realized in succeeding ages."[24] His rhetoric soared when he emphasized technology's seemingly unlimited possibilities as the material out of which the poet might create anew.

In prophesying new myths and fables, Josephson vaguely designated technological phenomena as "folk-elements" for the artist to consider. But unless carefully defined, the notion of folk material generates either a debilitating self-consciousness or, worse yet, sentimentality, that precisely which Josephson was to deplore in Frank. Yet he was never clear as to what he meant by "folk." Munson later tried to press him on this point. "What, for instance," he asked, "is your attitude toward folklore as an art-expression? Is folklore wonderful in itself, or only valuable for development?"[25] While future controversies between the two were generally personal in nature, here was an issue that had critical substance, extending back at least to Coady's attitudes about America. Like Hart Crane, Munson wanted to determine the aesthetics of modern technology; yet Josephson's failure to articulate such an aesthetic was the greatest weakness in his rhetoric.

Josephson's terminology further suggests an important departure from Dada's anti-art attitude toward the same material. In an essay on "The U.S.A. Cinema" for *Broom* in 1923, Soupault stressed the vitality of American culture, which he claimed generated a "close relationship between art and life." He related how he and his friends had been astonished by the appearance of American movies in Paris:

> Then, one day we saw hanging on the walls great posters as long as serpents. At every streetcorner a man, his face covered with a red handkerchief, leveled a revolver at the peaceful passerby. We imagined that we heard galloping hoofs, the roar of motors, explosions, and cries of death. We rushed into the cinemas, and realized immediately that everything had changed. On the screen appeared the smile of Pearl White—that almost ferocious smile which announced the revolution, the beginning of a new world. At last we knew that the cinema was not merely a perfected mechanical toy, but a terrible and magnificent reflection of life.

This experience provided the paradigm that allowed a condemnation not only of the French cinema but of European art as well. "One might note that European art exists on a misunderstanding," he added. "It

escapes from life in order to return to it by a detour. This is a symptom of age and a warning of decadence."[26] Soupault's appreciation of America may have been tinged by a typically French fascination with the exotic, but as a consequence of his Dada rejections he directly accepted things for their vitality, in contrast to Josephson's "folklore" approach.

Josephson's position, however, was never simplistic. In the same essay he praised Tzara's poems "as naturally expressive of the beauty of this age as Herrick's are of the 17th century. With an utterly simple and unaffected touch they employ all the instruments of the time, the streetcar, the billposter, the automobile, the incandescent light, etc." He went on to stress Williams' point that "the poems are not modern because they indicate: 'I was riding in the tramway' (instead of a diligence), but because the tramway gets into the very rhythm, form and texture of the poems." And in consonance with Williams' poetic preferences, Josephson admired the clean and fresh techniques of the Dadaists.[27]

Ultimately, again like Williams, Josephson declared America's independence from Europe. "Americans need play no subservient part in this movement," he insisted. "It is no occasion for aping European or Parisian tendencies. Quite the reverse, Europe is being Americanized. . . . The complexion of the life of the United States has been transformed so rapidly and so daringly that its writers and artists are rendered a strategic advantage. They need only react faithfully and imaginatively to the brilliant minutiae of her daily existence in the big cities, in the great industrial regions, athwart her marvelous and young mechanical forces."[28] This directive, perhaps naïve in its sense of the creative process, had more validity than folkish concepts which could be of little use to the relatively sophisticated urban American artist.

Josephson's essay, fraught with provocative implications for American art, highlighted the first issue of *Secession*, which endeavored to complement his views. Munson published not only the poetry of Josephson and Cowley in support of the younger generation, but also the works of Aragon and Tzara, thereby putting two Dadaist writers on international display. Included, too, was an attack on *The Dial* for its eclecticism—a criticism which applied equally to *Broom*. Munson thus hoped to achieve what he had previously declared to be the goals of his magazine. More importantly, though, the appearance of *Seces-*

sion, led off by Josephson's essay, brought pressure to bear upon Loeb to change the direction of his magazine to one he had already found provisionally acceptable.

The actual presence of Josephson, who met Loeb in the winter of 1922, also had its influence on *Broom*'s shift in policy regarding the position of Waldo Frank. According to Josephson, as his friendship with Loeb grew, "we agreed that, instead of pursuing an education function, as others, such as *The Dial*, were then doing, *Broom* should become in essence a *tendenz* magazine, expounding a militant modernism in literature as well as in the plastic arts. We would become a 'fighting organ,' sponsoring the avant-garde of postwar Europe, the German as well as the French experimenters, and the youth of America."[29]

Broom, however, had not yet reached its final stage of "militant modernism." Loeb made tentative overtures in that direction with an essay on "Foreign Exchange," which appeared in the review's second issue (May 1922) without the editorial aid of Kreymborg. And henceforth Loeb publicly dissociated himself from Waldo Frank, whom he thought to be a typical visionary or idealist. Loeb suggested instead that Americans accept a European reassessment of their country. In place of Frank's ideal America, he offered a European depiction of an America with its industrial vitality intact, unclouded by sentiment or idealism. In other words, by accepting environmental realities, American artists, he believed, could create an indigenous art.[30]

In the next number of *Broom* (June 1922) Josephson took issue with Loeb, but in effect only to make a stronger case out of the editor's essential position. In rejecting the idea that American expatriates saw America anew through French eyes, he maintained in "Made in America" that there was no general accord among Americans in Paris, let alone an interchange of ideas with the French. The avant-garde was more fragmented and isolated than ever before. Nevertheless, for the perspicacious American, there was an important group to watch. Josephson claimed that the Dadaists "have been producing prose and poetry since the close of the War which sought a mood of humor instead of pathos, aggression instead of doubt, and complete freedom of method for the restriction of the previous age."[31] Given such liberating attitudes, Dada could fearlessly and creatively confront its technological environment. "A strong impetus has been given to unlimited experiment with form, to a greater daring and a more penetrating humor. . . . To be at least as daring as the mechanical geniuses of the age which

has attained the veritable realization of the miracles forecast in primitive fables. To be prophets alike, the fable-makers for the incredible ages to come!" Once again echoing Emerson and Whitman, yet closer in time to the attitudes of Picabia and De Zayas, Josephson identified himself with these self-projected Dada attitudes. "The machine is not 'flattening us out' nor 'crushing us!'" he protested. "The machine is our magnificent slave, our fraternal genius. We are a new and hardier race, friend to the sky-scraper and the subterranean railway as well."[32] Here he reiterated the central conviction of his previous essay in *Secession*, but in even stronger terms. His strategy in contradicting Loeb's thesis of foreign exchange was now clear: he wanted to establish America's independence of Europe, to recognize no literary or cultural debts, much as Williams would deny Europe in *The Great American Novel*.

Despite the flag-waving implicit in such declarations, Josephson was not engaged in mere chauvinistic exercises. Rather, he related the new technological-cultural developments to potential American literary efforts. Indirectly attacking Theodore Dreiser and his apologist H. L. Mencken, Josephson wanted to set aside the French model of naturalism that was still the literary gauge by which American critics judged current writing. He advocated instead flexibility of aesthetic criteria, experimentation in writing, and attention to the techniques of other media such as film.[33]

In the subsequent issues of *Broom*, during the summer of 1922, Josephson reiterated his arguments in a series of essays[34] that were merely a prelude to Loeb's article, "The Mysticism of Money," which appeared early in the fall and which brought the magazine around full circle to Robert Coady and *The Soil*. Loeb, of course, denied that he had any intention of imitating his predecessor. "I don't want to repeat *The Soil* even if I could, and I can't because I'm different," he wrote to his recently appointed American editor, Lola Ridge. Nevertheless, Malcolm Cowley saw the essay for what it was: "There was a clear set of ideas, ideas which are fresh to American literature and which ought to revitalize it. Of course in *Soil* they were explicit, but you have drawn the implications out of *Soil*. Here is *Broom's* set of principles; all that remains is to apply them."[35] Cowley's optimism, not entirely unfounded, was to require the poetic talents of Williams, Crane, and Cummings to achieve those goals.

In his essay Loeb took a stand that was compatible with both *The Soil* and its successor, *Contact*. He warned Americans against imitating

a decadent European art. That America simply could not withstand such corruption was based on the premise that the New World involved "the archaic expressions of less sophisticated races." From the same premise was drawn a characterization of American culture as "a conceptual system . . . not known as religion, and which expresses itself in diverse forms, not recognized as art." The "mysticism of money," as Loeb referred to the central complex of American values, manifested itself in several ways—through machines (which Loeb called "moving sculpture," as Coady did), jazz (which reflected the tempo of modern industrial civilization), and the mass media, itself a product of technology. Out of such cultural phenomena Loeb sought "a revitalizing force to meet aesthetic expressions."[36]

The next issue of *Broom* (October 1922) dramatized its new-found stance with a cover by the Italian Futurist Enrico Prampolini, who depicted in a photomontage the huge turbine wheels of a factory, among which were enmeshed the coglike letters of the magazine's title. Loeb's choice of articles also reflected his insistence upon the recognition of American technology as a source for art. But most important was his tribute to Robert Coady, who had died in 1921. In a commemorative essay entitled "A Champion in the Wilderness," Coady's former associate Robert Alden Sanborn declared, "It is especially important now when we are close to the event of Coady's death to examine his message in order that we may take up those threads laid down by him that may seem worth weaving into the muddled aesthetic pattern of our national art." Evoking a curious image of Coady as St. John the Prophet in boxing gear, Sanborn asked, "Who dares put on the shoes and gloves of this dead champion and take his fighting place in the wilderness of [the] age?"[37] Presumably *Broom* was prepared to continue Coady's struggle for an indigenous American art.

Josephson lost no opportunity in that direction, for he launched a campaign against Waldo Frank as early as November 1922. Writing about "The Great American Billposter," he implicitly attacked Frank by defending contemporary American culture. Josephson recognized and embraced the anti-art nature of America just as Coady had done five years earlier in *The Soil.* He welcomed an America "where the Billposters enunciate their wisdom, the Cinema transports us, the newspapers intone their gaudy jargon; where athletes play upon the frenetic passions of baseball crowds, and skyscrapers rise lyrically

to the exotic rhythms of jazz bands which upon waking up we find to be nothing but the drilling of pneumatic hammers on steel girders." Swept by a lyrical vision of technology, Josephson called for "poets who have dared the lightning, who come to us out of the heart of this chimera; novelists who express for us its mad humor."[38] He even found poetry in American advertising. "The terse vivid slang of the people has been swiftly transmitted to this class of writers, along with a willingness to depart from syntax, to venture sentence forms and word constructions which are at times breath-taking, if anything, and in all cases far more arresting and provocative than 99 per cent of the stuff that passes for poetry in our specialized magazines." He viewed copywriters not only as the avant-garde of American literature but also as a source of inspiration for more conventional poets. Serious yet perhaps tongue-in-cheek, the essay caused Frank much consternation; indeed, he wrote to Loeb, complaining about that "silly Billboard article," and tried to shrug Josephson off as "simply another young man whose head has been turned by the cerebrations of certain French artists he does not understand."[39]

The following month, Josephson retaliated by publishing an "Instant Note on Waldo Frank," whom he identified "with a group of American Impulsionists, with the exponents of mystical or unconscious behavior such as James Oppenheim and Sherwood Anderson." The attack on Frank had come out into the open as Josephson criticized not only his conception but also his literary rendering of the unconscious: "It will be remarked that the sub-conscious is extremely mystical, that it prefers to speak in monosyllables, to employ only the short sentence, of which the stress always comes in the opening phrases, thus giving the effect of the rhythmic spasms of the gasoline motors in back country districts." He concluded that Frank "rides a vague and flaccid vocabulary"—altogether devastating criticism from one who had come to seek a precision aesthetic.[40]

Josephson's ideas about Dada and America placed him at the extreme of the "literary left-wing," as proclaimed by the promoters of *Broom* and *Secession*. But there were others of this group who lacked the certitude of Josephson. Gorham Munson in particular voiced an initial skepticism about Dada. Such doubts, coupled with an allegiance to Waldo Frank, set off a debate among the young American writers—a controversy with important intellectual yet ludicrous repercussions, entirely befitting the contradictory nature of Dada.

Munson's first essay for the opening issue of *Secession* (Spring 1922) illustrated his luke-warm feelings toward Dada. "A Bow to the Adventurous" was merely a conciliatory gesture toward the French Dadaists and their American enthusiasts. Taking Tzara's poetry as typical of Dada, Munson saw in it a debilitating tendency toward a "sign esthetic," that is, a movement toward an abstract language, virtually stripped of all symbolic value. Then, shifting from poetry to fiction, he indicated a preference for the socio-psychological content of the novel. The slippage in the logic of his argument suggests his loyalty to Frank, Nevertheless, Munson did make his bow, claiming that "In some periods what a writer says is of supreme importance to the esthetic emotion, in others the evasion of the grandly serious is the most provocative."[41] Thus, while his conclusion gave Dada its due, the body of his essay was implicitly at odds with it.

Munson's skepticism should not be attributed to a failure of understanding. A year later, in a review for *The New Republic*, he perceptively recognized the revolutionary quality of the Dadaist disgust with art.[42] Yet his quest for aesthetic order prevented him from fully accepting the chaos of Dada. Louis Untermeyer accurately summarized this ambivalence: "Gorham Munson accepts Dada's exploration of the materials created by the machine's impact on human life but rejects its arbitrary symbols and elaborate formlessness."[43] Munson's position was most clearly stated in his monograph on Waldo Frank, published in 1923, praising *Our America* but tentatively objecting to Frank's disapproval of technology. Munson claimed that there were two ways to deal with the machine. The first, which he deemed highly ineffectual, involved an escape to nature; whereas "the second way has been the acceptance of Machinery as a necessary evil . . . and the creation of anti-bodies to offset its ravages, as *Our America* does." Munson turned to Dada for an alternative approach "to relate man positively and spiritually to Machinery as well as to nature. It has produced a series of mechanized art, one capable of carrying intellect, courage, humor, aggressiveness, tension, speed, of giving minor esthetic thrills."[44] Yet in going along with Dada's affirmation of the machine, Munson agreed with Frank that America should develop its spiritual resources in the Whitman tradition as a prerequisite for exploring the technological environment.

On the basis of this synthesis of Dada and Frank, Munson predicted: "We are in the childhood of a new age, we are, by the chronological accident of our birth, chosen to create the simple forms, the

folk-tales and folk-music, the preliminary art that our descendants may utilize in the vast struggle to put positive and glowing spiritual content into Machinery." He apparently held this view at least through 1925 when he wrote an article for another little magazine called *The Guardian*. He praised the late Robert Coady as "a skyscraper primitive," who "would have become a leader for Young America. Like Guillaume Apollinaire in France, Coady in America was the first spokesman of certain new impulses and his death, like Apollinaire's death, deprived the oncoming movement of a directive stand."[45]

At this late juncture, it would seem that Munson was directly aligned with his by now former co-editor, Matthew Josephson, in accepting the machine and emphasizing aesthetics. Indeed, sounding exactly like Josephson, he had earlier insisted in his study of Frank that "we must make the Machine our fraternal genius." Even his skepticism about a folk approach to technology had dissipated by 1925, for he made use of the same terms. Yet at a much earlier date, Munson was at loggerheads with Josephson—a conflict that carried through "The Skyscraper Primitives," as he lashed out at Josephson and his allies. "I have the temerity to write about a literary school which has had an origin, yet never achieved an existence," mocked Munson. "But rays of energy from its source are much in the air today: they have inspired certain pimply manifestations by two or three of our youngest writers in the now defunct *Broom*: they stimulate the critic to make theatrical programs for an unborn school of poets and fictionists."[46]

The reasons for this breach between the two friends who had shared their Dada experiences in Paris three years earlier were varied, and the controversy itself was never clearcut. In part, it was a matter of personalities, since both men were strongheaded, if not opinionated, about literary matters. Moreover, Munson was loyal to Frank and would not countenance a public rejection of the sort articulated by Josephson in *Broom*, particularly in his "Instant Note on Waldo Frank." Finally, Josephson was far more confident than Munson about the creative possibilities of Dada.

The battleground for these two contestants can be mapped out in the pages of *Secession*, each issue of which contained a new skirmish. Munson himself was of two minds about the guerrilla warfare that ensued. For even though he asked for no quarter from Josephson and Cowley, he nevertheless sought an armed truce so that they might all give their minds to aesthetic concerns. But such hesitation was

fatal for one who had initially called for a literary insurrection. And since Dada was the guiding force, it was inevitable that no principle except that of anarchy was observed. A subscription advertisement in the second issue of *Secession* asked, "Do You Enjoy Seeing a Magazine Take Risks?" These risks began in the third issue (August 1922), after Munson had left for New York, enabling Josephson to sabotage editorial policy at will—for example, his butchering of a poem submitted by Hart Crane. Such Dada gestures were hardly appreciated by Munson, who was powerless, however, except to vent his anger from a distance at the exiled culprits.

In the meantime, at the peak of these squabbles during the early summer of 1923, Josephson came back to New York to take over the editorship of *Broom* from Loeb, who preferred to remain in Paris to work on his forthcoming novel, *Doodab*. Indeed, *Broom* was being prepared for its return to America with the spring publication of chapters that would later comprise William Carlos Williams' *In the American Grain*. The September issue, published in New York, presented a series on the American film in compliance with Josephson's interest in broadening the scope of American writers. The October issue continued the same policy of presenting American material through a Dada lens. Cummings contributed his "Five Americans," which are portraits of prostitutes. And Little Joe Gould, the Harvard graduate who had become a Greenwich Village indigent, published fragments from his ongoing Oral History of the World.

It was in this issue, too, that Josephson wrote his first essay since his return, summarizing the Dada attitudes he had garnered in France. He began with his customary plea to "expand once more the functions of art." But the essay soon came to focus on Henry Ford as a symbol of machine values in America. At this point, Josephson's attitude toward technology became ambivalent for the first time. Appropriating the imagery Henry Adams used in "The Dynamo and The Virgin," a chapter from his *Education*, he imagined the religious aura of the Ford factory:

> Mr. Ford was opposed to the erection of imposing and costly churches. He refused to contribute to his own parish church for this end. But in his automobile plant, he built the costliest and most beautiful powerhouse in America. It was placed on the avenue alongside the office buildings. Powerhouses are usually in the rear of the factories, dark, dusty, greasy holes in the ground with mountains of coal piled outside. Ford filled the

windows of his powerhouse with stained glass. And now the ponderous
fly-wheels turn in utter silence, sending all the throbbing energy through
more than five departments of the plant with its 55,000 contented work-
ingmen.[47]

In line with Loeb's identification of capitalism with religion, Joseph-
son conceived the powerhouse as a cathedral that lulled the workers.
But he could not bring himself to pray to this "occult mechanism" as
Adams had:

> Mr. Ford, ladies and gentlemen, is not a human creature. He is a
> principle, or better, a relentless process. Away with waste and competi-
> tive capitalism. Our bread, butter, tables, chairs, beds, houses, and also
> our homebrew shall be made in Ford factories. There shall be one great
> Powerhouse for the entire land, and ultimately a greater one for the
> whole world. Mr. Ford, ladies and gentlemen, is not a man.
>
> Let Ford be President. Let him *assemble* us all into his machine.
> Let us be *properly* assembled. Let us all function unanimously. Let the
> wheels turn more swiftly. Coolidge! Bah, what is Coolidge? A rococo
> Yankee lawyer.[48]

Unlike Adams' subtle and ironic acquiescence to the dynamo, Joseph-
son submitted to it with a Dada vehemence that was calculated to
destroy the Ford process as much as its victims.

After the publication of the November issue, which contained an
unsolicited story called "An Awful Storming Fire" by Charles L. Dur-
boraw, a Chicago paperhanger, Josephson was warned about its "licen-
tious" nature by the postal authorities, notifying him that another such
transgression would result in the loss of second-class mailing privileges
for *Broom*. As was to be expected, the subsequent issue in January was
censored because of "suggestive" references in a story by Kenneth
Burke. And so, the banned issue, reduced to a scant thirty-one pages,
brought to a controversial end the magazine that originally had wanted
to create no disturbance.

Munson was now determined that *Secession* would outlast *Broom*.
In its seventh issue (Winter 1924) he broke even more deliberately
with Josephson, in a manner that exacerbated the formal dissociation
of editorial ties a few months previous. Accusing him of timidity, lack
of mature thought and feeling, and general tomfoolery, Munson dis-
missed Josephson's most recent poetry as shallow and derivative.[49] If
such a review was a calculated insult, the inclusion of Waldo Frank in
the same issue clearly placed the magazine in the enemy camp. In

point of fact, *Broom* and *Secession* had exchanged positions during the course of their controversies.

Frank brought heavy artillery to bear in his essay explicitly calling "For A Declaration of War." In his opinion this war was "wider than America and deeper than the issue of our generations: a war vastly more important than any clash of states or social orders . . . a war of a new consciousness, against the forms and language of a dying culture." Yet he claimed that though the basic assumptions of western culture were fragmenting, the most essential remained. "Unity is truth. This is a universe, not a multiverse," he insisted. And even this conviction was under Dada assault. Over and against such disintegration, Frank set forth a credo that he hoped would bring about cultural rebirth. Art, he claimed, was a major instrument of the intellect by which to understand the spiritual mysteries of life. Criticism could bring understanding "only when it contacts the work of art on a common plane of spiritual and philosophical conviction." Such an approach, essentially religious in nature, was doubly important in times of disintegration; otherwise, he said, criticism would be "idle, irrelevant, impotent, and anti-social."[50]

The intensity of this debate took the issues beyond the pale of the little magazines. The controversy concerning Dada and America was sharply scrutinized by Edmund Wilson in particular, a recent Princeton graduate who had become the literary critic for *The New Republic*. In April 1924 he published "An Imaginary Conversation: Mr. Paul Rosenfeld and Mr. Matthew Josephson," which dramatized the various attitudes of the two writers as representatives of their respective groups. Wilson had stated his own position two years earlier in an article for *Vanity Fair*. Although he recognized the French Dadaists' discovery of America as a vital force, he nonetheless deplored the contemporary American environment: "The electric signs in Times Square make the Dadaists look timid; it is the masterpiece of Dadaism, produced naturally by our race and without premeditation which makes your own horrors self-conscious and which makes them offend our taste doubly because we know that they first offended yours. Our monstrosities are at least created by people who know no better. But yours are like risqué stories; told by well-bred girls to show off their sophistication; they sadden even the ribald; they make even the barbarian wince!"[51] Implicitly, then, one wincing barbarian aligned himself, if not with Frank, at least with tradition and culture, against what he felt were the contemporary forces of disintegration.

Yet in his dialogue, no less accurate for being "imaginary," Wilson presented both sides of the issues at hand. The point of departure for the debate was Josephson's book review in *Broom* entitled "Poets of the Catacombs," in which he had cast aside Elinor Wylie's poetry in favor of contemporary life. She came to represent those poets whose traditional orientation led to what he felt was a hot-house sensibility that could not come to terms with modernity. Needless to say, Rosenfeld disagreed. Wilson managed to convey the controversy between Rosenfeld and Josephson at its most extreme without ever simplifying the issues. In fact, much of the "conversation" he reproduced would have been familiar to any reader who had followed the polemics of *Broom* and *Secession*. Josephson's admiration for Dada and its mocking wit, his enthusiasm for technology, Rosenfeld's impressionistic criticism, his defense of the genteel tradition—these had become the staples of the ongoing argument. But Wilson struck at the heart of the matter by opposing Rosenfeld's plea for diversity in American art with Josephson's total commitment to popular culture as against fine art (unlike a critic such as Gilbert Seldes, who appreciated both.).[53]

In taking this position, Josephson necessarily rejects both Eliot and Joyce, whom Rosenfeld cites as two modern writers who follow tradition. His examples fail to convince Josephson, who, in agreement with William Carlos Williams, says, "You are like all Americans who think themselves modern; you have the thrill of doing something sensational and the virtuous glow of doing something bold when you come out for The Waste Land or Ulysses. But the one is only the last spasm of naturalism as the other is the last gasp of romantic poetry." For Josephson, Eliot, even more than Joyce, looks to the past, "and on that account neither is of very much interest to us."[54]

Rosenfeld responds with the argument that the expressive modes of the past are valuable on the assumption that "the life of feeling is always real." Taking exception, Josephson asks, "What does the shower or the subway train care about the language of the heart?" Modern technology, being nonhuman, finds such emotions irrelevant. Moreover, human beings attuned to this new environment find the "language of the human heart" irrelevant. In perhaps the most frightening assertion of the conversation, Josephson claims, "People who spend all day in the glory of washing themselves in silver-fitted snow-dazzling bath-rooms with delicious non-sinkable soap . . . have learned to do without the heart; their life is all in the joy of action." This new

sensibility has no need of art. "You will never be able to interest them in what you call literature again," Josephson predicts. "Or music. Or plastic art. . . . I tell you that culture so-called is finished; the human race no longer believes in it."[55] He thus prophesies the destruction of traditional cultural values, including art, because they are no longer adequate to cope with the new machine environment and its concomitant sensibilities.

Rosenfeld, however, reaffirms value "beyond the nonsense of events." He becomes the conservative who harbors "the imagination of Europe." In contrast, Josephson claims to welcome the new barbarism of the streets. "I, all new to the States as I am, hear the people dancing to their music everywhere and I respond to its prodigious joy. There is no desolation in that music — only the drunkenness, the vertigo of life — vulgar life, unrestrained, taut-nerved, hurtling out with howling trombones in its great gaudy circus parade into the unknown mechanical future." Significantly enough, Wilson lets Rosenfeld have the last word (a view that Josephson himself actually began to share, as evidenced by his final essay in *Broom* on Henry Ford). "If there is to be a defeat," Rosenfeld warns, "You will be among the victims. You are a poet, like Elinor Wylie; you are a critic, like me. And you can never march with that procession: they have no places for critics or poets. You can only prostrate yourself before the monster in amazement and awe at his strength. But if you choose to pretend to enjoy it, that is your own affair."[56]

Wilson skillfully created a dialogue that avoided a doctrinaire conclusion. He clarified the issues and set forth the complexities of the artist's position in relation to his culture. To what extent should he court the fine or vulgar, whatever these might be? And could they be courted simultaneously? How much attention should the artist pay to tradition, especially if he has an eye upon the new? Can, or indeed should, he embrace technology without retaining some of the old values, or any values at all? And what was the role of the critic in these matters? The questions were dramatized, but hardly resolved, by Wilson's dialogue, for implicit, too, was the possibility that such questions might be swept aside by the onslaught of technology.

The controversy could not be kept on rational grounds, especially considering the irrationality evoked and invoked by Dada. With the argument still open, Frank answered his young critics in the September

issue of *1924*. He dismissed Dada as an ephemeral rebellion, perhaps briefly reviving a dying Europe, but scarcely appropriate for America:

> Good jokers the Dadaists were: wistful creators, against sour sense, of sweet absurdity. But they did nothing more ridiculous than the installation of the Dada mood in American letters. Europe called for Dada by antithesis: America for analogous reasons calls for the antithesis of Dada. For America *is* Dada. The richest mess of these beanspillers of Italy, Germany and France is a flat accord beside the American chaos. Dada spans Brooklyn Bridge . . . it prances in our shows; it preaches in our churches; it tremulos at our political conventions. Dada is in the typical western university that spends $50,000 on cows and $200 on books . . . It is in the counterpoint of callow Hollywood and the immemorial dessication of the California desert. It is in the medley of strutting chimneys and bowed heads, of strutting precepts and low deeds that make America. We are a hodgepodge, a boil.[57]

Because American culture was essentially chaotic and nonsensical, Frank thought that order rather than Dada was necessary. Before America imported European Dada, an American tradition was necessary, a tradition that, according to Frank, had yet to come into existence. In sum, he found it difficult if not impossible to distinguish between Dada values and those prevailing in American culture. If the American artist were to embrace either, would he not in effect acquiesce to chaos and anarchy?

Malcolm Cowley responded to Frank with a "Communication on Seriousness and Dada" in the following issue of *1924*.[58] That their subsequent exchange added nothing new to the debate suggests the inevitable impasse resulting from radically different assumptions regarding literature and culture. Cowley, of course, had long before declared himself an American Dada. At first skeptical like all the rest, he had changed his mind after Josephson introduced him to the Dada group in Paris during the winter of 1923. At the same time he appreciated the liberating effects of their nonsense, he was impressed by a fundamental commitment to literature underlying their absurd behavior. It was within this framework that Cowley not only assaulted a café proprietor and was arrested, but later burned a set of Racine in the company of Aragon, Dos Passos, and Cummings.[59]

Armed with a desire for action, Cowley returned to New York in July 1923, intent upon revolution. His plans were thwarted, however, by unfavorable circumstances. The economic situation that forced Williams to be a doctor and a part-time, albeit full-fledged, poet brought

strong pressure on this younger generation. Josephson's enthusiasm, for example, began to wane. In October he wrote to Loeb, "Cowley believes *Broom* should have a spectacular end. . . . He has some great ideas, such as calling a meeting of all the friends and enemies of *Broom* for a grand powwow out of which he hopes the air might be cleared, and perhaps another magazine . . . *Moi, je m'en fiche*. I am looking for a job as ever."[60]

Held at an Italian restaurant on October 19, 1923, Cowley's meeting was successful only from the perspective of Dada anarchy. Instead of promoting unity against the American philistine, Cowley fragmented the opinions of those present and created nothing but chaos. The absence of Williams and Slater Brown contributed as much to the failure of the meeting as the wine and the diverse attitudes and allegiances of those gathered. Finally, the meeting exploded when Cowley read a letter sent by Munson, who was recuperating from an illness. The letter, long since lost, presented not only his literary position but also an invective against Josephson, who was accused, among other things, of being "an intellectual faker." And the tension was not eased by Cowley's hammed-up delivery. Thus the meeting's only result was Josephson's epic encounter with Munson at Woodstock, New York, ten days later. All the energy meant to fight the philistines was drained off by fisticuffs in the mud.[61]

A final rallying point for Josephson and Cowley occurred when H. L. Mencken published the first issue of the *American Mercury* in December 1923. Deemed the iconoclast of American letters, Mencken was actually a literary conservative who preferred the naturalism of Dreiser to the experimentation of the younger generation. It should have come as no surprise, then, when Mencken ran Ernest Boyd's barrage on the "Aesthete: Model 1924." After its publication, Burton Rascoe, in his column for the *New York Tribune*, stated his perplexity over the furor caused by the article. He could not understand why the "aesthetes" were disturbed over a composite portrait that might have applied to Mencken himself when he was young. But Josephson and company did not need to be paranoid in order to discern many barbed remarks that were specifically aimed at them and their ideas. They could take even less solace in Rascoe's contention that Boyd's essay was "timeless and universal," for his satire often hit the mark, albeit in a rather superficial way. His was a stereotypical portrait that managed to stir up enough half-truths about the issues at hand to be unsettling.[62]

In this light, the "aesthetes" could ignore many of Boyd's indict-
ments as farfetched. That they were middle-class social conformists
with an ersatz education, that they were nonachievers and incestuous
in their parochial enclaves, could be easily shrugged aside. It must
have rankled, however, when they saw Boyd side with Waldo Frank in
accusing them of lacking social consciousness. Josephson in particular
must have writhed at the accusation that he bathed the popular arts in
an "aesthetic mysticism," especially after his own criticism of Frank.
Similar ironic inversions were implied in Boyd's contention that these
writers were "saved from those sordid encounters with the harsh facts
of literary commerce which [their] predecessors accepted as part of
the discipline of life." Cowley, of course, was crusading precisely
against the isolation of literature from life—an attitude he had picked
up from Dada. But to follow Dada, according to Boyd, was to set one's
sails in the direction of current literary fashions, "the right thing to
do."[63] In cleverly striking at the surface ambiguities of the controversy,
Boyd made the "aesthetes" uneasy, but worse still, he had stolen the
thunder of those who claimed to be iconoclasts and yet who remained
at loose ends in New York.

With their reputations on the line, the "aesthetes" were quick to
retaliate, prefiguring Louis Aragon's assault upon the editorial offices
of a Parisian weekly that had published a review of *Le Paysan de Paris*
against his wishes in 1926. According to Josephson, "we had a gather-
ing of Malcolm, Kenneth Burke, and Hart Crane in my apartment, and
we all took turns at calling up Mr. Boyd and delivering our poor
opinions of his composite portrait and his own character. Hart Crane
excelled us all in invective." Rascoe gleefully blew up the fiasco in his
column. "There he [Boyd] was kept a prisoner by expediency for
three days while Dadaists pushed his door bell, kept his telephone
abuzz, scaled the walls to his apartment and cast old cabbages and
odor bombs through the windows, sent him denunciatory telegrams,
and rigged up a radio receiving outfit with an amplifier through which
they broadcast the information that he was a liar, sneak, thief, coward
and no gentleman."[64]

Satisfaction gained from such a hullabaloo gradually dissipated as
1924 wore on. The brief flare-up between Cowley and Frank in the
pages of *1924* did not compensate for the termination of both *Broom*
and *Secession*. Plans for an American program modeled on the festivals
and scenarios of Paris Dada were canceled by the economic neces-

sities facing the young writers. Josephson, for example, became increasingly occupied with his position on Wall Street. Nevertheless, the group did not disperse. Josephson, Cowley, Burke, Brown, Crane, and Tate joined together for weekly dinners at Squarcialupi's Restaurant, where, among other matters of literary discussion, schemes were laid to cannonade Boyd and Mencken. Finally, after a sustained all-night session, *Aesthete 1925* appeared in February in a brief flurry of three-hundred copies.

The title of this pamphlet was deliberately up-dated so as to confirm Boyd's notion that the American "aesthete" followed current literary fads. Taking its cue from Dada and echoing the scornful irony of *Littérature* in Paris, the title honed a double edge that mocked not only Mencken and Boyd but also the collaborators themselves. Indeed, the attitudes of Dada, which cut across styles and art forms, along with a general interest in literary form, allowed a disparate group, ranging from Cowley to Burke, from Tate to Williams, to join together in an attack upon the literary establishment of the 1920s.

In "Dada, Dead or Alive," Burke defined the movement as "perception without obsession," the point being that artists and critics must include both "supernal beauty AND the brass band" in the realm of possibility for creative effort. As a response to Frank's doubts about American Dada, Burke exhorted, "Whatever we do, let it be done, not by counter-Dada but by Dada aggrandized." The collaborators, however, did not completely follow his advice. Dada, although idealistically motivated, disintegrated into nonsense, mirroring the bankruptcy of culture. By way of contrast, Burke's essay made an explicit plea for art and criticism. Likewise, in "Little Moments with Great Critics," though a spoof on contemporary criticism, John Brooks Wheelwright nevertheless offered serious criteria for his pronouncements in a footnote which categorized critics on a scale ranging from the academic to the lowly "impressionist," for whom "all positive ratings vanish." Such a hierarchy was derived in part from Eliot and looked forward to the academic orientation of the New Criticism and its opposition to impressionistic surveys of literature. But at the same time that these "aesthetes" reacted against someone like Paul Rosenfeld, they mocked themselves with scientistic percentages as accurate indices of their victims.[65]

Concerns for literary criticism were most often submerged in the over-all zaniness of the pamphlet. Risqué aphorisms, *ad hominem*

invective, and a saturation of inane college humor were the order of the day. Although Munson was an obvious target for the Dadaists, Mencken came in for the largest share of the kidding. Not only did he receive a minus rating from Wheelwright in "Little Moments with Great Critics," but he was spotlighted by the "Mencken Promotion Society." Employing Dada and advertising typography, the Society urged, "Get Self-Respect Like Taking a Pill / MENCKENIZE!" The "advertisement" perceptively noted his anti-intellectualism ("Can't you follow modern philosophy? / Let Mencken snigger with you at William Jennings Bryan") and ambivalent conservatism ("Mencken expresses the conservatism of revolt"). Most incisively, the diatribe recognized the American cultural values that Mencken denounced as really his own. "It is said that Mencken is shaping public opinion. This is a DIRTY LIE. Mencken is *voicing* public opinion."[66]

Despite such trenchant indictments, Mencken was only the occasion for publishing *Aesthete 1925*; he was not its true center. And because that lay elsewhere, the contents of the pamphlet remained diffuse, though hardly inert.[67] There was simply no focus to mobilize the nonsense felt everywhere. Although as early as 1922 Dada had been proclaimed dead in France, the controversy of its significance for Americans continued into 1925. And yet *Aesthete 1925* was not so much a culmination of American interest in Dada as it was symptomatic of the failure to engage an American Dada. Dada did not return to America during the 1920s as a movement quite possibly because it was never a movement in Europe. But far more decisive a factor in the failure of Josephson's program for contemporary American literature was the lack of agreement among his friends. They were united solely by their commitment to literature, their animosity toward established critics, and a general interest in formal literary values (ultimately working against the anti-art of Dada)—common ground that was hardly fertile for the chaos of Dada. Consequently, no "school" was readily available to Josephson. Indeed, Charles Sheeler's pen-and-ink drawing of skyscrapers for the cover of *Aesthete 1925* was the only reminder of Josephson's platform about technology and art delineated in the pages of *Broom*, which had been defunct for less than two years. *Aesthete 1925* thus offered no climactic argument, only explosion and dispersion. And in that sense the pamphlet was indeed the last Dada fling in America.[68]

7 | Hart Crane and the Machine

Hart Crane's participation in the *Aesthete* affair bordered on fiasco. Already a victim of Josephson's mutilation of "For the Marriage of Faustus and Helen," which he had submitted to *Secession*, he was then caught in the crossfire between Josephson and Munson, who was understandably miffed at his apparent desertion to the enemy's ranks; but worse yet, he was thought to have contributed to *Aesthete* 1925 a poem poking fun at Munson's recent interest in mysticism. Little matter that the ditty was actually written by Slater Brown. Crane discovered himself "excommunicated," as he put it, from Munson's company afterwards.[1]

Equally unforeseen because of the inherent contradiction generated was Crane's relationship with Dada. Dead set against it, unwilling to borrow any of its nonsense for the technics of his poetry, Crane nevertheless probably would not have turned to the machine for poetic consideration had it not been for Munson's interpretation of Dada. Given his new-found material, Crane was faced with the problem of treating it poetically. To complicate matters, he lacked adequate models from both the past and present, since neither of the two ideologues, Josephson or Munson, nor, in his view, the two major poets, Whitman and Eliot, were able to provide him with sustained poetic techniques to treat the machine, which had become a major force that twentieth-century art had to reckon with.

Beset earlier with the same problem, De Zayas and Picabia had decided to confront the machine directly, outside the cultural norms of art. Less concerned with the machine than with creation in America, Williams followed De Zayas and Picabia by renouncing poetry for direct confrontation with American culture. Although aware of such an alternative, and even of its necessity, Crane did not pursue that course in his writing, for he was powerfully attracted to the views and personality of Waldo Frank, the distaff side of Picabia's anti-art. Turning to

Whitman for his informing vision, Crane did borrow and develop traditional metaphors for the machine in *The Bridge*, his long poem about America. Nevertheless, the synthesis of the elements that comprise it was entirely his own, reflecting the tensions involved in bringing the machine within the ambience of poetry. Just as Williams' theory of contact required creatively writing out intrinsic ambiguities, so too Crane's position between Josephson and Frank was best resolved through his poetic practice. *The Bridge* was the prime test of Crane's creative powers, addressed to the difficult affirmation of an America transformed by technology.

As an eager reader of little magazines, Crane became aware of Dada in the pages of *The Little Review, Contact*, and, later, *Broom* and *Secession*. The import of Dada became all the greater because of his friendship with Gorham Munson, whom he first met in New York while serving tenuously as the advertising manager of *The Little Review* in 1919. But Crane reacted negatively even to Munson's qualified views of Dada during the early issues of *Secession*. He had already run into the bizarre Baroness Elsa von Freytag Loringhoven and considered such encounters characteristic of the chaotic nonsense of Dada. Writing to Josephson from Cleveland in 1921, Crane exclaimed, "I hear 'New York' has gone mad about 'Dada' and that a most exotic and worthless review is being concocted by Man Ray and Duchamp, billets in a bag printed backwards, on rubber deluxe, etc. What next! This is worse than the Baroness. By the way I like the way the discovery has suddenly been made that she has all along been, unconsciously, a Dadaist. I cannot figure out just what Dadaism is beyond an insane jumble of the four winds, the six senses, and plum pudding. But if the Baroness is to be a keystone for it,—then I think I can possibly know when it is coming and avoid it."[2]

Crane had other, more compelling reasons to reject Dada. As a poet dedicated to his craft, he repudiated Dada's emphasis upon chance. In reference to Man Ray's "theory of interesting 'accidents,'" he asserted, "There is little to [be] gained in any art so far as I can see, except with much conscious effort. If he doesn't watch his lenses, M. Ray will allow the Dada theories and other flamdoodle of his section [to] run him off his track." Thus, despite his deliberate cultivation of Dionysian impulses, Crane carefully wrote and rewrote his poetry—a fact amply corroborated by his numerous explications in correspondence.

Equating Dada with literary impressionism, typified by the fuzzy prose of Paul Rosenfeld (who was, however, by no means a Dadaist), he found the experiments of Dada to be facile. "Well, I suppose it is up to one in Paris to do as the Romans do, but it all looks too easy to me from Cleveland, Cuyhoga County, God's country," he wrote to Munson in 1922. Given his leanings toward poetic tradition, he regarded Dada as the latest literary fad, excessive in its reactions to a previous generation. "Of course, since Mallarmé and Huysmans were elegant weepers it is up to the following generation to haw-haw gloriously! Even dear old Buddha-face de Gourmont is passé."[3]

Along with his rejection of Dada, Crane had many reservations about Josephson's enthusiasm for American technology. After reading the first issue of *Secession*, which contained Josephson's article on Apollinaire, he asked Munson, "But what has happened to Matty!?! And,—just *why* is Apollinaire so portentious a god? Will radios, flying machines, and cinemas have such a great effect on poetry in the end? All this talk of Matty's is quite stimulating, but it's like coffee—twenty-four hours afterward not much remains to work with. It is . . . somehow thin,—a little too slender and 'smart'—after all." Although at this early juncture, Crane mistakenly underestimated the effects of technology on poetry, he did point out, from a poet's point of view, the central problem of Josephson's position. Once the artist was directed toward these new technological phenomena, how specifically was he to use them in his art? Crane accurately noted Josephson's inability to enact his views in poetry: "I recognize him as in many ways the most *acute* critic of poetry I know of—the only trouble is that he tries to force his theories into the creative process,—and the result, to me, is too tame a thing."[4] Unless the machine somehow became an integrated part of the poem, Josephson's theories would remain abstract, and untested in America.

Crane also could not accept Josephson's anti-art alternative, involving the techniques of the billboard, a cultural artifact that shared at least a verbal kinship with poetry. In a letter to Munson he exclaimed facetiously, "Matty's 'gay intellectualism' will eventually expose him to the jibes of a psychoanalyst if he continues in such loose estimates as his article in *Broom* on advertising displays ["The Great American Billposter"]." Crane's objections, however, had a more serious base than Josephson's supposed mental aberrations. "Some things he says may be true," Crane conceded, "but how damned vulgar

his rhapsodies become! I would rather be on the side of 'sacred art' with [Wilbur] Underwood than admit that a great art is inherent in the tinsel of the billboards. Technique there is, of course, but such gross materialism has nothing to do with art." Crane's frustrating experience in writing advertising copy, along with his growing search for spiritual values, militated against the "gross materialism" of the billboards and brought him squarely on the side of art.[5] But most importantly, he raised the issue that Edmund Wilson was to pose less than two years later in his "Imaginary Conversation" between Rosenfeld and Josephson. By looking to the mass media as a model, would not the poet eventually fall prey to the same vulgarity that Josephson extolled for whatever virtues?

Such were Crane's thoughts concerning Josephson's stand on Dada for America in November 1922. Yet by February 1923 he had started to think about a new long poem called *The Bridge*, and in March he could refer to himself quite seriously as "a suitable Pindar for the dawn of the machine age." Crane's attitudes toward technology for the purposes of poetry had certainly been transformed. Earlier, he had treated the urban environment as a setting of despair, at odds with spiritual affirmation. His "Porphyro in Akron," written in 1920, begins with a description of that industrial city:

> Greeting the dawn,
> A shift of rubber workers presses down
> South Main.
> With the stubbornness of muddy water
> It dwindles at each cross-line
> Until you feel the weight of many cars
> North-bound, and East and West,
> Absorbing and conveying weariness,—
> Rumbling over the hills.

Against this scene, which anticipates that of the London crowds of *The Waste Land*, stands the poet: "O City, your axles need not the oil of song./ I will whisper words to myself / And put them in my pockets." And in contrast to Akron's citizens, "using the latest ice-box and buying Fords," is the narrator reading Keats, but aware that "in this town, poetry's a / Bedroom occupation," with little public significance.[6]

Insofar as the poet must affirm the spirit in an America made desolate by the machine, Crane's "Porphyro in Akron" is consonant with his reading of *Our America* upon its publication in 1919. But

even so, he exclaimed to Munson at the time that "Waldo Frank's book IS a pessimistic analysis!" And thus, as in "Chaplinesque" in 1921, "the moon in lonely alleys make[s] / A grail of laughter of an empty ash can,"[7] Crane sought to integrate the past and the present in his poetry so as to transform a tawdry environment. Such an attempt was made in "For the Marriage of Faustus and Helen," composed during 1922 and early 1923.[8] Faustus, whom Crane described as the poet, and Helen, the symbol of abstract beauty, are placed in an urban setting. Helen is initially discovered in a streetcar, and then, in the second part, the scene shifts to a nightclub. Yet the personae from the past are extraneous to the contemporary milieu, which tends to remain abstract in the first part. The subsequent rhythms of the episode in the nightclub might be best described as pseudo-jazz. And even though the music suggests the Dionysian energies of the present, the burden of transformation lies elsewhere. The center of the poem does not reside in the contemporary world but rather in the narrator's mind as he meditates, and thus invests Faustus and Helen with value, the language spinning itself out lyrically as a soliloquy, not as a dialogue or dialectic between past and present, archetypal poet and immediate environment.

Crane's work toward a synthesis of this sort was motivated in large measure by Munson's monograph on Waldo Frank, a study that appeared early in 1923 but which had been in the making the previous year. "I am even more grateful," Crane wrote to Munson after its publication, "for your very rich suggestions best stated in your *Frank Study* on the treatment of mechanical manifestations of today as subject for lyrical, dramatic, and even epic poetry. You must already notice that influence in 'F and H' ["Faustus and Helen"]. It is to figure even larger in *The Bridge*. The field of possibilities literally glitters all around one with the perception and vocabulary to pick out significant details and digest them into something emotional."[9] Pleased with the recognition and praise that came with the publication of "For the Marriage of Faustus and Helen," Crane was nonetheless aware that his treatment of technology in the poem was not entirely satisfactory. If he were to commit himself to Munson's position, as he indicated, it would be necessary to pursue a course different from "Faustus and Helen," regardless of its success and a new set of difficulties ahead—a course that would require full attention to the problems involved and the formulation of his own position in charting the unexplored terrain.

As a poet who avidly read the literature of the past and yet who was also keenly aware of contemporary developments, Crane understandably first surveyed the field outside himself before he assimilated and developed his own strategy—a strategy, it should be noted, that gained shape as much from his poetic practice as from a priori speculation. Closest to Crane was Munson, who, with his insistence upon bringing "the Machine into the scope of the human spirit," mediated between Dada and Frank. Yet, as with Josephson, there was little in that study which would specifically guide Crane in his poetic treatment of the machine. But Munson alone did not inspire *The Bridge*. Other factors, such as the publication of *The Waste Land* in 1922 and Crane's growing interest in Whitman, played a role in the conception of his major work. Yet their importance should not be overestimated, for in the final analysis they, too, offered insufficient poetic solutions to Munson's exhortations regarding technology. Eliot provided a negative impetus, whereas Whitman's integrated spirit could not be sustained by Hart Crane in the twentieth century.

In Eliot's poem, the machine is conceived as a disintegrative force. Thus industrial wastes contaminate nature, as "the river sweats / Oil and tar / The barges drift / With the turning tide . . ." The Waste Landers are portrayed in mechanomorphic terms: the tedium of the clerk-typist enmeshed in bureaucratic schedules is seen "At the violet hour, when the eyes and back / Turn upward from the desk, when the human engine waits / Like a taxi throbbing waiting . . ." This robotic description relates to the meaningless copulations of the "typist at teatime" and the "young man carbuncular." If love has been reduced to sex, art has degenerated into *kitsch* and can provide little solace for empty lives. After her sordid encounter, the woman "smoothes her hair with automatic hand, / And puts a record in the gramophone" to hear, presumably, "that Shakespearian Rag," also heard by the upper classes, who smother and isolate themselves in "closed cars at four."[11] Within this landscape of spiritual desolation it is quite clear that technology can only increase the fragmentation of human life.

Upon the recommendation of Waldo Frank, whom he met in 1923 after an exchange of enthusiastic letters, Crane turned away from Eliot to find spiritual affirmation in Walt Whitman. As he exclaimed in a letter to Munson in March 1923, "Since my reading of you and Frank . . . I begin to feel myself directly connected with Whitman. I feel myself in currents that are positively awesome in their extent and possibilities."

Crane's personal search for spiritual awareness, to be expressed in *The Bridge* as "a mystical synthesis of 'America',", was guided by Whitman out of the past and supported by Frank and other mystical thinkers of the present.[12]

To be sure, Crane did not have Whitman's temperament, nor, conceivably, did he belong within Whitman's tradition of mysticism; but more than an increasing psychic disintegration set up obstacles to the creation and perfection (for Crane desired nothing less) of *The Bridge*. Allen Tate has commented that "Crane was a myth-maker, and in an age favorable to myths he would have written a mythical poem in the act of writing an historical one." The twentieth century, however, is not particularly unfavorable to myth-making. Where Crane's problem lay was in the interaction of myth with contemporary history. Apart from his eclecticism, Eliot had created a new myth with *The Waste Land*, that of twentieth-century disintegration, complete with its sterile geography, anti-heroes, empty rituals, and disvaluations. The poem was and is successful mythically to the extent that it has been considered a "historical" poem; and its myth gained credibility to the degree that it could feed on the disintegrations of contemporary history. Some poets, including Cowley and Williams, could not accept *The Waste Land*; because it corresponded neither with their sense of history nor with their sensibility of the present, they turned away from Eliot to other models and solutions, including Dada.[13] For Crane, however, rejection required a mythic response of his own making. But what out of contemporary history and culture could he appropriate in order to create an affirmative myth? And what out of the past? Crane was gradually becoming aware that Faustus and Helen were not entirely adequate to his mythic needs. His task would be more difficult than that of Eliot, who simply but skillfully borrowed the chaos of his own time (just as Whitman earlier drew upon the supposed "progress" of his). Certainly the chaos of Dada gave Crane more than enough reason to turn elsewhere for guidance.

In the opening "Proem: To Brooklyn Bridge," the narrator stands in the shadows by the piers and casts an invocation to the Bridge: "Unto us lowliest sometime sweep, descend / And of the curveship lend a myth to God." The goal of the narrator's quest, then, is to find mystical affirmation in the twentieth century through the vehicle of myth. So that the Bridge itself, in the present, might project the way to God, Crane borrowed and developed the myth of America as the New World

(just as Williams did in *In the American Grain*). The poet's materials were to be found in America's past and brought to bear upon the present so as to achieve a mythic transfiguration of current values. Thus, for example, Pocahontas would be abstracted from historic into mythic context as the earth mother who can renew contemporary America in the Dionysian ecstacy of the dance.[14]

It is the Bridge that leads back into the American past to unite the New World with the present in a process of renewal and rebirth. Yet as an icon of modern affirmation, it competes with the forces of contemporary chaos—a situation that threatens to engulf the narrator as he exists in the uncertainties of the present, under the shadow of the Bridge. Indeed, the very shadow itself suggests the dark side of technology. Although Dada was certainly open to the machine, its deliberate anarchy scarcely provided the order necessary for Crane's sensibility.

To establish this essential discourse for his narrator, Crane looked to Whitman for his poetic models. But Whitman's treatment of the machine was uneven and ultimately inadequate to Crane's needs. To be sure, Whitman appropriated images of the machine for the purpose of celebrating modernity, and within his metaphysic, mechanical energy becomes the analogue for divine spirit. Yet out of such a concept, the machine imagery, occasionally precise, could just as easily become vague, forced by the sheer will of the narrator in search of spiritual significance. Hence "To a Locomotive in Winter," on the one hand, which eloquently describes the train's "black cylindric body, golden brass and silvery steel, / Thy ponderous side-bars, parallel and connecting rods, gyrating, shuttling at thy sides . . . ," and "City of Ships," on the other, with the inflated exhortation, "Spring up O city—not for peace alone, but be indeed yourself, warlike!"[15]

Whitman's machine images were limited not only in quality but also in kind. For example, the broad-axe, whatever its importance on the frontier, is, in "Song of The Broad-Axe," essentially a hand-tool that bears little relationship to the dimensions of twentieth-century technology, which would radically change man and his environment. And when Whitman turned to large-scale feats, he recognized their limitations within the spiritual order envisioned. In "Passage to India" the Suez Canal, the Trans-Atlantic Cable, and the transcontinental railroad provide human communication and thus appropriately become Whitman's central metaphors for mystic unity. Yet it is the poet-

prophet who, through his awareness and subsequent song, fuses man and nature once again, to take us on a "passage to more than India!"[16] Whitman was thus more important to Crane as a spiritual example than as a source of specific poetic techniques for *The Bridge*.

Having worked his way out of an initial despair about the machine as "the monster that is upon us all" to a Whitmanian affirmation via Frank, Munson, and Dada, Crane attempted to articulate his views in "General Aims and Theories," an essay written perhaps as early as 1924 but left unpublished. After announcing his intent to discover "a new hierarchy of faith," he stated his convictions about the machine and its mythic possibilities. Crane derived his premise from Eliot's seminal essay, "Tradition and The Individual Talent." That is to say, a poet must be fully aware of the past in order to be truly contemporary. But whereas Eliot engaged past myths to counter the spiritual desolations of the present, as in *The Waste Land*, Crane wanted to revive both a contemporary "decayed culture" *and* "the great mythologies of the past (including the Church) [that] are deprived of enough facade to even launch good raillery against." Presumably both the present and the past would be restored by poetic interpenetration. Crane referred to his recent poem "For the Marriage of Faustus and Helen" as an example of this method: "So I found 'Helen' sitting in a street car; the Dionysian revels of her court and her seduction were transferred to a Metropolitan roof garden with a jazz orchestra; and the *katharsis* of the fall of Troy I saw approximated in the recent World War."[17]

Crane realized, however, that these juxtapositions would be merely a "grafting process" which would remain essentially dead were it not for the "organic" powers of the imagination. Without the compelling presence of the poet's own experience, transformed by his vital vision, past mythology would become "useless archeology," claimed Crane, recognizing the risks of alluding to a Faustus or a Helen in a contemporary American milieu. In conceiving *The Bridge* he thus looked to materials closer at hand, indigenous to American history, in order to create a present that would be timeless and meaningful. On the other hand, "to fool one's self that definitions [of "spiritual quantities"] are being reached by merely referring frequently to skyscrapers, radio antennae, steam whistles, or other surface phenomena of our time is merely to paint a photograph." Crane took a more moderate course than De Zayas and Picabia. He attempted

to balance himself between the past and the present by achieving a judicious synthesis of the two in the belief that the power of poetry to unify and harmonize time is derived from the poet's visionary ability "to go *through* the combined materials of the poem, using our 'real' world somewhat as a spring-board, and to give the poem *as a whole* an orbit or predetermined direction of its own."[18]

Crane's description of intent is somewhat at cross-purposes. The poet's movement through his materials (including elements of language as well as subject-matter, the "real world" Crane alludes to) generates the poetic autonomy essential for vision. The poem assumes a reality of its own to the degree that the poet attends to the particulars of the reciprocal and tensive relationship between language and experience. Yet to view the "real world" as a "springboard" implies the poet's seduction by his vision so that language uses experience primarily as a pretext for its rhetorical flights and thus risks a solipsistic rather than a shared consciousness. The crucial tensions that existed in Crane's strategy to become a seer and sayer in the Whitman tradition were held in abeyance and indeed offset by his concept of "the logic of metaphor." Beneath the veneer of logic, Crane sought a primal energy, the "associational meanings" of the poet's language that would comprise the essential vehicle for his vision. The logic of metaphor was to inform the structure of a poem by making its texture organic and alive.

Conceived while Crane was writing *The Bridge*, the logic of metaphor had heuristic value for subsequent creative efforts and so offers significant access to an understanding of this major poem. "Modern Poetry" was an essay written five years later in 1929, after he had formulated and indeed finished most of *The Bridge*. As a consequence, Crane not only outlined additional principles for writing his poetry but also summarized—and occasionally rationalized—what he thought he had accomplished in *The Bridge* with respect to technology and myth. The essay is thus retrospective, in contrast to the earlier "General Aims and Theories," and suggests an a posteriori aesthetic which reveals recurring problems that continued to concern Crane.

The essay is divided into two related parts. The first surveys the development of modern poetry and assesses its present situation:

> Revolution flourishes still, but rather as a contemporary tradition in which the original obstacles to freedom have been, if not always eradicated, at least obscured by floods of later experimentation. Indeed, to the serious artist, revolution as an all-engrossing program no longer ex-

ists. It persists at a rapid momentum in certain groups of movements, but often in forms which are more constricting than liberating, in view of a choice of subject matter.[19]

Crane's pronouncement may appear short-sighted in view of imminent economic disasters and subsequent political directions that artists would feel constrained to pursue. Yet his sense that an era of experimentation and revolution in the arts had come to a close was historically accurate. The Twenties were indeed a period of consolidation of modernism. But Crane was also on the verge of finishing *The Bridge* — an effort that had taken great energy and the better part of a decade — hence the need for a pause, a gathering up of inner forces before embarking on new ventures. Crane also was interested in literary tradition — a conservative bent that complemented his fears that poetry might not withstand the impending chaos.

It was in such a context, then, that Crane turned to what was the major concern of the essay. He addressed himself to the twentieth-century dominance of science and the acceleration of its technological implementation. While conceding that science was "the uncanonized Deity of the times," he took I. A. Richards' position that science and poetry involved different modes of expression and hence provided essentially two different kinds of knowledge. Given this premise, "poetic prophecy in the case of the seer has nothing to do with factual prediction or with futurity. It is a peculiar type of perception, capable of apprehending some absolute and timeless concept of the imagination with astounding clarity and conviction."[20] Crane's conception of poetic knowledge tended toward Williams' without being antipoetic. His seer would achieve clarity of perception, not the sentimental vagaries latent in Frank's vision.

On the basis of the dichotomy between poetry and science, Crane could confidently proclaim:

> The function of poetry in a Machine Age is identical to its function in any other age; and its capacities for presenting the most complete synthesis of human values remain essentially immune from any of the so-called inroads of science. The emotional stimulus of machinery is on an entirely different psychic plane from that of poetry. Its only menace lies in its capacities for facile entertainment, so easily accessible as to arrest the development of any but the most negligible esthetic responses. The ultimate influence of machinery in this respect remains to be seen, but its firm entrenchment in our lives has already produced a series of challenging responsibilities for the poet.[21]

For Crane, poetry remained a traditional and viable repository of hu-

man values; it could not be affected substantially by technology. Yet the poet had to recognize the machine because of its compelling presence in his environment. This was not a concession to the machine, for Crane's argument had a dual charge: although technology was essentially powerless against poetry, it was nonetheless powerfully entrenched in contemporary human life. Crane's surface argument was consistent in its abrogation of a reciprocal relationship between poetry and science. But his underestimation of the corruptions of the mass media suggests an undercurrent of anxiety about technology's destructive forces. That Crane tacitly recognized the risks of his own undertaking in *The Bridge* is evident throughout the remainder of his essay.

According to Crane, so as to fulfill the poet's "challenging new responsibilities," "poetry [must] absorb the machine, i.e., *acclimatize* it as naturally and casually as trees, cattle, galleons, castles and all other human associations of the past." He implied that just as the poet of the past explored a central relationship to nature, so, too, the poet of the present had to address himself to the new machine environment. Unlike Williams, Picabia, and De Zayas, Crane did not want to set art aside in order to embrace the machine directly; rather—and this distinction must be stressed—he wanted to bring the machine within the ambience of art. Although he took his cue from Munson, who had asked for harmonious relationships among men, nature, and machines, he placed such relationships within a Whitmanian context. In his conclusion, Crane acknowledged Whitman for being "able to coordinate those forces in America which seem most intractable, fusing them into a universal vision which takes on additional significance as time goes on."[22]

In the same breath Crane also recognized the conflicting forces generated by technology in America and the difficulties of resolving them in poetry. Consequently, he rejected what he felt were excessive attitudes toward the machine once projected by Josephson. "This process does not infer any program of lyrical pandering to the taste of those obsessed by the importance of machinery," he cautioned. "Nor does it essentially involve even the specific mention of a single mechanical contrivance." Rather, the poet had to become accustomed to technology so as to avoid "sensational glamour": "Mere romantic speculation on the power and beauty of machinery keeps it at a continual remove."[23] Emphasizing the dangers implicit in Josephson's enthusiasm, he reaffirmed the need for poetic clarity of perception in

regard to the machine without adopting anti-art attitudes. At the same time, however, Crane's criticism of Josephson was a way of reminding himself of the necessity to remain in close touch with the experience of this world, lest an overriding desire to achieve "spiritual illuminations," as he had termed transcendant states earlier in "General Aims and Theories," result in a short-circuited consciousness.

The poet's response to technology had to be finely tuned to the subtleties of everyday life. Echoing Williams' views, Crane asserted that "the wonderment experienced in watching nose dives is of less immediate creative promise to poetry than the familiar gesture of a motorist in the modest act of shifting gears." Presumably the poet would avoid the pitfalls of a mechanized dehumanization by following Whitman's guiding vision. But the dangers of this path were all too evident, since the poet had to court his machine environment. Indeed, he had to possess "an extraordinary capacity for surrender, at least temporarily, to the sensations of urban life." Crane was tacitly aware that such sensations were disintegrative because, as he hastened to add, "This presupposes, of course, that the poet possesses sufficient spontaneity and gusto to convert this experience into positive terms."[24] The destructive forces of the city would have to be countered and conquered by the poet's Dionysian spirit, which was Crane's substitute for the integrated self that sustained Whitman's subjective idealism.

To affirm one's milieu yet to be aware of its destructive forces; to draw upon an inner energy ("gusto") so as to withstand the overpowering tempo of modern life, the urban enervation that Waldo Frank so deplored—these guidelines for the contemporary poet were personally directed. And their inadequacy becomes tragically clear in light of the poet's suicide in 1932. However, other principles—insofar as they were realized—found their locus in *The Bridge*. To what extent does the narrator of the poem go *through* this world, both past and present, to achieve a transcendent vision? Does the narrator assimilate the machine so that "its connotations emanate from within—forming as spontaneous a terminology of poetic reference as the bucolic world of pasture, plow, and barn"?[25] Such questions came to rest in the logic of metaphor brought to bear upon Crane's dual sense of technology, which required a strict balance in *The Bridge*.

Given Crane's tendency to look both toward the past and the present, his choice of a bridge as an "objective correlative," to borrow Eliot's phrase, served him well. The bridge is an ancient engineering

structure the long existence of which allowed him to use its image as a metaphor for communication with the past. The bridge is also a traditional, possibly even archetypal, image for mystical union with God—an image that Crane modernized by emphasizing the parabolic curves of the suspension cables leading upward to God. Brooklyn Bridge (which Crane could see from his apartment) was particularly appropriate because Roebling's achievement stood firm against great odds as an engineering feat in a city famous for its technology. Thus, by the 1920s, Brooklyn Bridge was an old, even mythic, achievement.[26] Moreover, the Bridge performed a modern-day function for New York's boroughs that had been fulfilled earlier by the ferry, previously celebrated by Crane's poet-hero Whitman in his "Crossing Brooklyn Ferry." Like the ferry, the Bridge serves as a means of communication for human beings.

The position of a bridge as part of the natural environment established a relationship in Crane's mind not only between man and man but between man and nature as well, transcending this world to God through its metaphorical mediation. In the opening "Proem," Crane interweaves images of nature with those of the Bridge to express such relationships. The logic of metaphor associates the "inviolate curve" of the seagull's motion ("Shedding white rings of tumult, building high / Over the chained bay waters Liberty") with the "curveship" of the Bridge's majestic cables. The transient flight of the bird parallels the "apparitional" dreams of clerks enclosed in office buildings. Nevertheless, the gull is free, in contrast to the human beings confined in a bureaucratic urban environment. The undercurrent of despair is muted, however, by the fact that human beings have the ability to dream, which is shared with the narrator's ability to inform a vision that will liberate urban inhabitants. In the meantime, these people find their dreams in movie houses:

> I think of cinemas, panoramic sleights
> With multitudes bent toward some flashing scene
> Never disclosed, but hastened to again,
> Foretold to other eyes on the same screen.[27]

Although the aspirations of mass man can find little solace in the media, which are as evanescent as the gull, the narrator offers some promise of a larger perspective in the "panoramic sleights."

Such a vista is to be found from the Bridge, as indicated by the narrator's central metaphor of the Bridge as harp. He borrows the

romantic image of the aeolian harp, man's instrument played by winds of nature, another traditional symbol for the spirit of God. The image is extended here in the "Proem" to the Bridge itself as harp *writ large*, a celebration of man's technological skills. This metaphor is related in turn to the Bridge as an altar by way of the "choiring strings"—an association that helps to establish religious overtones in the narrator's quest, thus preparing the reader for the next stanza, which describes evening traffic upon the Bridge. The lights of the automobiles are related to the stars:

> Again the traffic lights that skim thy swift
> Unfractioned idiom, immaculate sigh of stars,
> Beading thy path—condense eternity:
> And we have seen night lifted in thine arms.[28]

The lights "condense eternity," indicating the transcendent nature of the Bridge, which can "lift" night in the "arms" or curves of its cables. By crossing the Bridge, a passage in time, eternity can be gained.

Crane's images of technology achieve greatest clarity in the "Proem." By way of contrast, in "Van Winkle" Rip's dream (*"he'd seen Broadway | a Catskill daisy chain in May—"*) verges on agrarian sentimentality in a rather strained effort to transform Broadway's rinky-tink into a pastoral scene. There is, however, a justification for the impressionistic description in "The Harbor Dawn," the opening section of "Powhatan's Daughter":

> Insistently through sleep—a tide of voices—
> They meet you listening midway in your dream,
> The long, tired sounds, fog-insulated noises:
> Gongs in white surplices, beshrouded wails,
> Far strum of fog horns . . . signals dispersed in veils.
>
> And then a truck will lumber past the wharves
> As winch engines begin throbbing on some deck;
> Or a drunken stevedore's howl and thud below
> Comes echoing alley-upward through dim snow.[29]

The machine images become visually clearer from the first section to the second as the narrator awakens to the harbor dawn, with time telescoped from the past of Columbus ("Ave Maria," Part I) back into the present. At this point, Crane emphasizes the muffled sounds of the machine ("signals dispersed in veils") as they impinge upon the sleepy consciousness of the narrator.

The quality of the machine imagery takes on another aspect in the

concluding "Atlantis" section of the poem, when the narrator returns with variations of his initial metaphors for the Bridge from the "Proem." Although these are modulated to a high pitch in a series of invocations to the Bridge, the narrator does not fall prey to a solipsistic vision in his discovery of spiritual affirmation in a present technological world. Nor does he indulge in what Crane denigrated as "mere romantic speculation on the power and beauty of machinery." Rather, the narrator renders his mythic song through a heightened awareness of the Bridge as the culmination of his quest. The Bridge momentarily absorbs his consciousness and illuminates it all the more intensely after the dark journey on the subway, "(O Thou whose radiance doth inherit me)"—an awareness of union framed as a parenthetic aside to suggest simultaneously separation of self and Other through the narrator's double consciousness. He immediately pleads, "Atlantis,— hold thy floating singer late!" But too late, as his ecstasy is tempered by the concluding question ("Is it Cathay . . . ?") to the poem, suggesting that the narrator is engaged in a never-ending quest for as many renewing, yet evanescent, affirmations as there are harbor dawns.[30]

Images of the machine disjunct from nature underscore the uncertainties of the narrator's quest. In "The River" section, "the 20th Century . . . Limited" (the name of the transcontinental train striking the obvious ironic commentary on the present) ultimately rushes its passengers to the Mississippi and the renewal of "death by water," not in Eliot's baptismal sense but through the perception of the time as historic flow. In this journey by rail, however, the passengers are isolated and thus denied knowledge of the earth and its fertility. Crane uses sterile billboard slogans to suggest the rapid movement of the train:

Stick your patent name on a signboard
brother—all over—going west—young man
Tintex—Japalac—Certain-teed Overalls ads
and lands sakes! under the new playbill ripped
in the guaranteed corner—see Bert Williams what?
Minstrels when you steal a chicken just
save me the wing for if it isn't
Erie it ain't for miles around a
Mazda—and the telegraphic night coming on Thomas

a Ediford—and whistling down the tracks
a headlight rushing with the sound—can you

imagine—while an EXpress makes time like
SCIENCE—COMMERCE and the HOLYGHOST
RADIO ROARS IN EVERY HOME WE HAVE THE NORTHPOLE
WALLSTREET AND VIRGINBIRTH WITHOUT STONES OR
WIRES OR EVEN RUNning brooks connecting ears
and no more sermons windows flashing roar
Breathtaking—as you like it . . . eh?

Immediately following, in a brilliant, almost cinematic shift, the train leaves behind three hoboes along the track. "Blind fists of nothing, humpty-dumpty clods/ Yet they touch something like a key perhaps," a key to the earth.[31]

The rushing train blurs billboard phrases to create ironic, although ostensibly accidental, juxtapositions of slogans. Spiritual matters become confused with crass commercialism, even though the train speeds *"past the din and slogans of the year,"* as Crane's gloss indicates, to eternal truths found in the American soil.[32] In this passage Crane borrowed advertising copy—so enthusiastically praised by Josephson as the true American poetry—but inverted the object of his friend's Dada affirmations into a jumble of significant nonsense that dramatizes the crude and destructive forces within these modern icons.

The subway of "The Tunnel" section becomes the central negative metaphor for the purgatory of modern suffering in the urban world. Dark, usually dirty, full of the train's roar, the subway could easily be taken as a modern analogue for the Underworld. It fragments and isolates people while jamming them together during the rush hour; it offers a brief refuge for the *disjecta membra* of society, the grafitti and the urine stains on the walls their icons. Quite appropriately, Crane borrowed a Blakean epithet for the section: "To find the Western path / Right thro' the Gates of Wrath." The narrator must die before he can be reborn into the new world. The subway devours the narrator with its "scuttle yawn," suggesting the suffocating boredom of urban life in contrast to the openness of "a brisk / ten blocks" walk in the fresh air to the Bridge. Unlike the expansive vision of Whitman, the subway contracts the spirit, as suggested by the narrator's dictum, "Be minimum," literally a means of maneuvering through the crowds ("the hiving swarms," a natural metaphor for urban masses.).[33]

In conjunction with spiritual shrinking is the implication of narcissistic introspection. The entire tunnel experience becomes a metaphor for the interior exploration of a tormented psyche. The narrator warns, "Avoid the glass doors gyring at your right, / Where

boxed alone a second, eyes take fright . . ." The revolving doors iso-
late the narrator, who is reflected into himself with prismatic images.
The vortex effect foreshadows the narrator's hallucinatory vision of
Edgar Allan Poe, Whitman's dark brother, hanging from the straps of
the train. (Poe, of course, had made such good use of the vortex motif
to suggest descent into the self.) In the subway, the narrator hears
fragmented and impersonal voices. They remind him that

> The phonographs of hades in the brain
> Are tunnels that re-wind themselves, and love
> A burnt match skating in a urinal—

Through metamorphosis, the subway becomes the tunnel labyrinth in
the brain, creating an interior hades. Echoing the "interborough fis-
sures of the mind," the subway is a "Daemon" that leads to death. But
the narrator becomes Lazarus instead, because of the strength of the
"Word . . . [that] will not die . . . !"[34] Thus he emerges from the sub-
way at the East River by Brooklyn Bridge, and only then is he able to
sing his redemption of the lost city of "Atlantis."

The perilous nature of the narrator's quest through a disintegrating
landscape dictated to Crane certain corresponding metaphors for the
machine. In the "Proem," a person attempts to commit suicide from the
Bridge:

> Out of some subway scuttle, cell or loft
> A bedlamite speeds to thy parapets,
> Tilting there momently, shrill shirt ballooning,
> A jest falls from the speechless caravan.[35]

Emerging from the subway, the "bedlamite" prefigures the torments of
the forthcoming "Tunnel" section. But just as importantly, the narra-
tor's diction suggests that Crane wanted to invest the Bridge with the
significance of medieval romance. The bedlamite "tilting" echoes a
knight on his quest, and perhaps more specifically, Don Quixote tilting
with windmills. Thus the first doubts of the poem are established. The
narrator might eventually be simply another Don Quixote, who was a
romantic anachronism in a world of mundane reality. There arises the
possibility that he will be the last knight engaged in a hopeless quest
through a world of technological realities.

In "The Harbor Dawn" Crane subsequently shifts his metaphors
for the narrator toward a more affirmative image. As the narrator awak-
ens and his dream of Pocahontas fades, the lights of the skyscrapers
die out:

> From Cyclopean towers across Manhattan waters
> —Two—three bright window-eyes aglitter, disk
> The sun, released—aloft with cold gulls hither.[36]

The narrator describes the windows of the skyscrapers as "window-eyes," banal enough, until combined with the skyscrapers as "Cyclopean towers"—a metaphor that seems inappropriate until it is related to Odysseus and his attempts to return to Penelope. In Greek mythology their reunion roughly parallels the reunion of the white narrator in the twentieth century with the red woman of the land. "Cyclops" suggests the obstacles overcome by Odysseus and the possible hazards that await the narrator in his modern odyssey. Just as the lights in the apartments go out, so too the stars as dawn approaches. The rhythms of the urban world match those of nature. There is the possibility that the narrator will achieve his quest.

The narrator's hopes and fears about technology and his quest are moved toward a crucial resolution in the "Cape Hatteras" section. As before, the narrator informs machinery, in this instance the airplane, with natural metaphors. Since the airplane is initially seen as an instrument of destruction, such metaphors are inverted to reveal the horror of man's invention. The narrator takes a central Emersonian image of circles for ironic and tragic meaning. "Bright circumferences" become "marauding circles." And the circle is conceived as a "blind crucible of endless space" which prohibits transcendent vision.

Without a guiding human spirit, there is only the aimless power of the dynamo:

> The nasal whine of power whips a new universe . . .
> Where spouting pillars spoor the evening sky,
> Under the looming stacks of the gigantic power house
> Stars prick the eyes with sharp ammoniac proverbs,
> New verities, new inklings in the velvet hummed
> Of dynamos, where hearing's leash is strummed . . .
> Power's script,—wound, bobbin-bound, refined—
> Is stropped to the slap of belts on booming spools, spurred
> Into the bulging bouillon, harnessed jelly of the stars.
> Towards what?[37]

Whatever power the dynamos possess, expressed by Crane in terms of sexual imagery, is negated in value by the destruction inflicted. Moreover, the dynamos confine natural power and have an unpleasant sound of "nasal whine." All this energy takes no direction, despite the affirmative possibility of "new verities, new inklings."

The narrator is distracted momentarily by the sound of an airplane, which ironically provides an answer to his question.

> . . . The forked crash of split thunder parts
> Our hearing momentwise; but fast in whirling armatures,
> As bright as frogs' eyes, giggling in the girth
> of steely gizzards—axle-bound, confined
> In coiled precision, bunched in mutual glee
> The bearings glint,—O murmurless and shined
> In oilrinsed circles of blind ecstacy![38]

Although the sound of the airplane is associated with nature ("split thunder"), the association is negated by the demonic heart of the airplane, the engine that runs in "blind ecstasy."

The misuse of technology leads only to war, "the closer clasp of Mars." This classical allusion plays with the line, "Iliads glimmer through eyes raised in pride," which corrupts the machine into destructive use. Crane's reference to *The Iliad* adds a tragic, epic significance to the destructive bent of contemporary man. Again, as in the "Proem," Crane uses medieval, romantic diction ("tiltings," "listings," "gauntlets," "Levin's lance") to invest aerial combat with timeless connotations. Yet he does not minimize the horrors of war: the planes "clip" and "shear" clouds; nature is destroyed by the plane that has "splintered space"; flowers become "screaming petals" that wound men like "hail"; the planes become insects; "Wheeled swiftly, wings emerge from larval-silver hangars. / Taut motors surge, space-gnawing, into flight."[39] They ironically fulfill the erotic promise of the dynamo's "spouting pillars" by "sowing" doom. Given this course of civilization, the narrator implies that spiritual knowledge can be gained only through tragic descent, through the destruction of the airplane in combat.

The narrator discovers an alternative, however, in the song of Whitman, who becomes his "Meistersinger." If the eagle, symbol of the airplane, "dominates our days," the glory of the eagle has diminished because of modern man's self-conception: "Seeing himself an atom in a shroud— / Man hears himself an engine in a cloud!" Man as a naturalistic "atom" consigns himself to the death (the "shroud") of a mechanized existence, "an engine in a cloud!" As a consequence, infinity remains elusive and, despite aeronautic advances, is "subjugated never." Faced with this sterility, the narrator asks Whitman "if infinity / Be still the same as when you walked the beach / Near

Paumanok . . ." Whitman's eyes, which are "bright with myth,"[40] offer an alternative to the blind frogs entrapped in the hopeless revolutions of the airplane's engine.

Informed by Whitman's spirit, the plane could become a force for the mystic Word:

> And now, as launched in abysmal cupolas of space,
> Toward endless terminals, Easters of speeding light—
> Vast engines outward veering with seraphic grace
> On clarion cylinders pass out of sight
> To course that span of consciousness thou'st named
> The Open Road—thy vision is reclaimed!
> What heritage thou'st signalled to our hands![41]

The contemporary destruction and ultimate resurrection of the airplane, and for all intents and purposes, of technology, lies in the poet's song, the vision that Whitman had offered in the past. And so the narrator takes Whitman's hand for guidance through the modern world.

Far from being an inchoate series of indiscriminate lyrics to the machine, "Cape Hatteras" progresses from negation to affirmation as the narrator gradually assumes Whitman's faith. The development of the narrator's consciousness at Cape Hatteras corresponds to the major thematic configuration of *The Bridge*, and yet is counterpointed by the rhythms of the quest, modulated in turn by ambivalent attitudes toward technology. Although Crane's fears and anxieties were clearly never completely laid to rest, his ambivalence found dramatic form and control in the poem. Indeed, the range and quality of metaphors that Crane derived from traditional poetic images reveal a consistent pattern of meaning with respect to the destructive bent or affirmative possibilities of technology. Thus the Bridge and the subway—to select two major motifs—become symbols that convey the narrator's assessment of technological phenomena. Although the ultimate factor is the intelligence informing the machine, Crane's metaphors play between the machine in its social context and the narrator's spiritual development. It is this crucial tension through the logic of metaphor that governs the poem.

Defining the poet as spiritual prophet, Crane did not renounce poetry in favor of fresh creativity outside cultural norms; nor did he seek in a related fashion direct confrontation with the machine. Eschewing anti-art, he attempted to bring the machine within the realm of poetry itself—a task no less difficult or challenging than that set by

Williams, with whom he shared a number of premises about language, but within a different context. And within his own frame of reference Crane was equally innovative in synthesizing traditional literary images and contemporary experience into poetic metaphors of wide range and skillful effect. In retrospect, Crane's imagination was remarkable in its synthetic powers, building bridges against contemporary impulses to blow them up. The poetic construction of *The Bridge* sustained his creative aspirations.

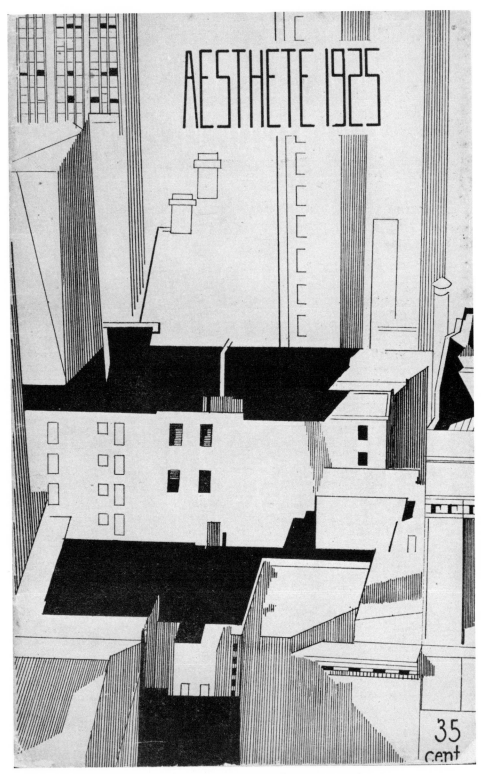

Charles Sheeler, cover of *Aesthete 1925* (February, 1925).

John Covert, *Water Babies*, 1919, oil on board, 25 1/4 x 23 in. *Courtesy of the Seattle Art Museum.*

John Covert, *Ex Act*, 1919, oil on relief of plywood and cardboard, 25 1/4 x 25 1/4 in. *Courtesy of The Museum of Modern Art, New York City; bequest of Katherine S. Dreier.*

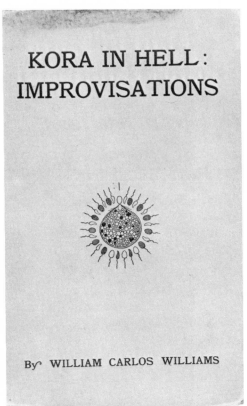

KORA IN HELL:
IMPROVISATIONS

By WILLIAM CARLOS WILLIAMS

Left: Stuart Davis, frontispiece for William Carlos Williams' *Kora in Hell*, 1920. *Courtesy of New Directions. Right*: Cover for *Kora in Hell*, 1920. *Courtesy of New Directions.*

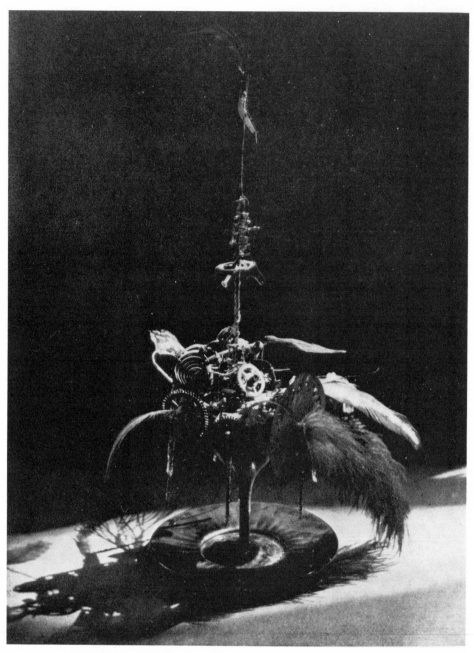

Baroness Elsa von Freytag-Loringhoven, *Portrait of Duchamp*, photographed by Charles Sheeler, in *The Little Review* IX (Winter, 1922).

John Covert, *Brass Band*, 1919, oil and string on composition board, 26 x 24 in. *Courtesy of Yale University Art Gallery; gift of Collection Société Anonyme.*

John Covert, *Time*, 1919, oil and upholstery tacks on composition board, 25 5/8 x 23 9/16 in. *Courtesy of Yale University Art Gallery; gift of Collection Société Anonyme.*

Joseph Stella, *Brooklyn Bridge*, 1918–1920, oil on canvas, 84 x 76 in. *Courtesy of Yale University Art Gallery; gift of Collection Société Anonyme.*

Joseph Stella, *Study for Skyscraper*, undated,
collage, in *The Little Review* IX (Autumn, 1922).

Joseph Stella, *Marcel Duchamp*, c. 1922, silverpoint, 27 1/4 x 21 in. *Courtesy of The Museum of Modern Art; New York City; bequest of Katherine S. Dreier.*

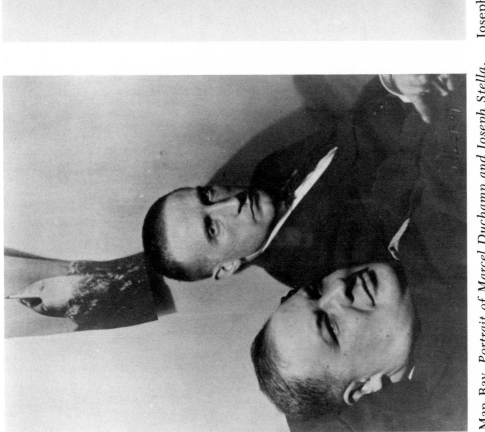

Man Ray, *Portrait of Marcel Duchamp and Joseph Stella,* 1920, photograph, 8 x 6 in. *Courtesy of James Mayor, London.*

Joseph Stella, *The Bridge*, 1922, fifth panel of the series *New York Interpreted*, gouache, 54 x 88 1/4 in. *Courtesy of the Newark Museum.*

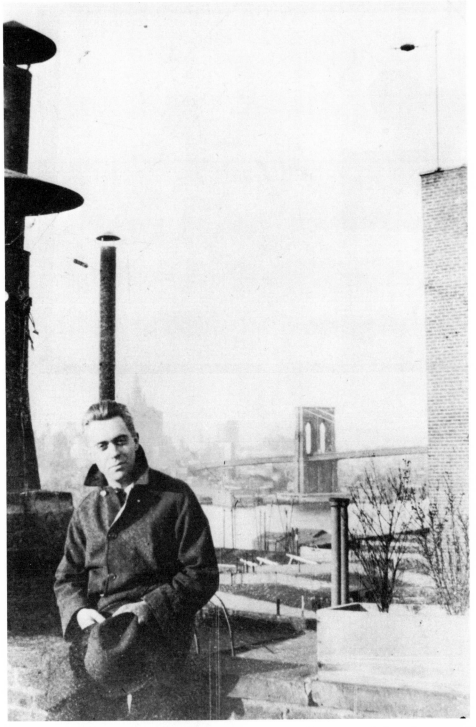

Hart Crane and Brooklyn Bridge. *Courtesy of Collections of the Libraries of Columbia University.*

Joseph Stella, *Collage No. 3, c.* 1918, 11 x 8 in. *Courtesy of Robert Schoelkopf Gallery, New York City.*

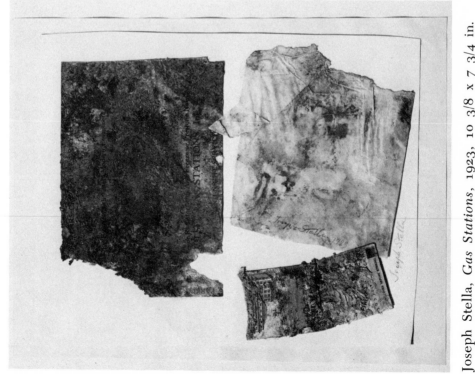

Joseph Stella, *Gas Stations,* 1923, 10 3/8 x 7 3/4 in. *Courtesy of Robert Schoelkopf Gallery, New York City.*

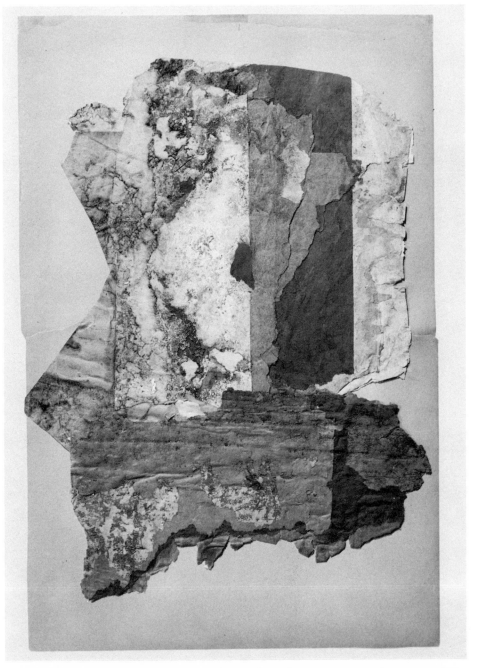

Joseph Stella, *Collage No. 11*, 1923, mixed media, 11 x 17 in. *Courtesy of the Whitney Museum of American Art; gift of Mrs. Morton Baum.*

Kurt Schwitters, *Merz 380; Schlotheim* 1922, collage, 7 1/2 x 5 1/4 in. Courtesy of Yale University Art Gallery; gift of Collection Société Anonyme.

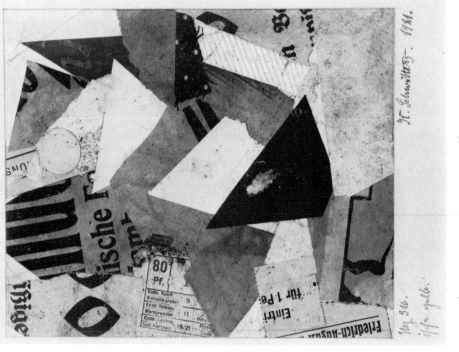

Kurt Schwitters, *Merz*, 1921, collage, 5 3/8 x 4 1/2 in. Courtesy of Yale University Art Gallery; bequest of Katherine S. Dreier.

Arthur G. Dove, *Portrait of Alfred Stieglitz*, 1925, assemblage, 15 7/8 x 12 1/8 in. *Courtesy of The Museum of Modern Art, New York City.*

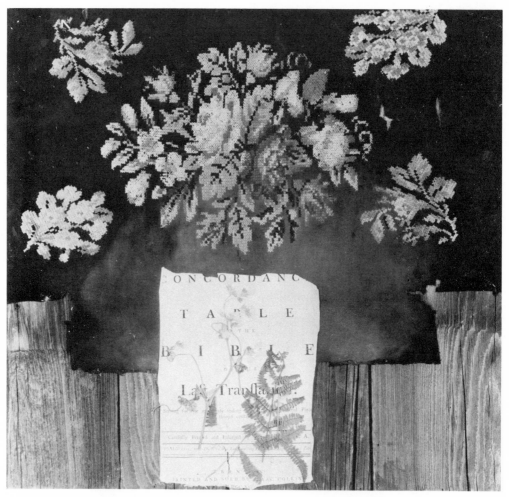

Arthur G. Dove, *Grandmother*, 1925, mixed-media collage, 20 x 21 1/4 in. *Courtesy of The Museum of Modern Art, New York City; The Philip L. Goodwin Collection.*

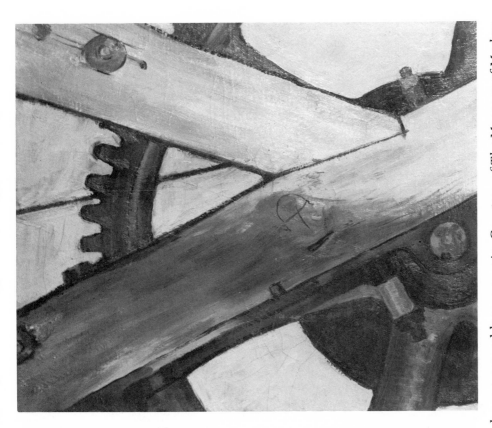

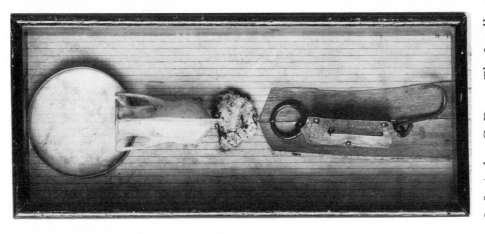

Left: Arthur G. Dove, *The Intellectual*, 1925, assemblage, 17 x 7 in. *Courtesy of The Museum of Modern Art, New York City; The Philip L. Goodwin Collection. Right:* Arthur G. Dove, *Gear*, 1922, oil on canvas, 22 x 18 in. *Courtesy of Terry Dintenfass, Inc.*

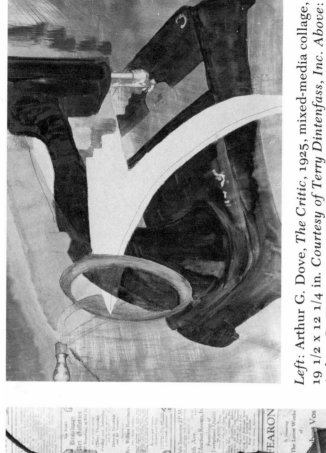

Left: Arthur G. Dove, *The Critic*, 1925, mixed-media collage, 19 1/2 x 12 1/4 in. *Courtesy of Terry Dintenfass, Inc. Above*: Arthur G. Dove, *Hand Sewing Machine*, 1927, cloth and oil paint on metal, 14 7/8 x 19 3/4 in. *Courtesy of The Metropolitan Museum of Art; New York City; The Alfred Stieglitz Collection, 1949.*

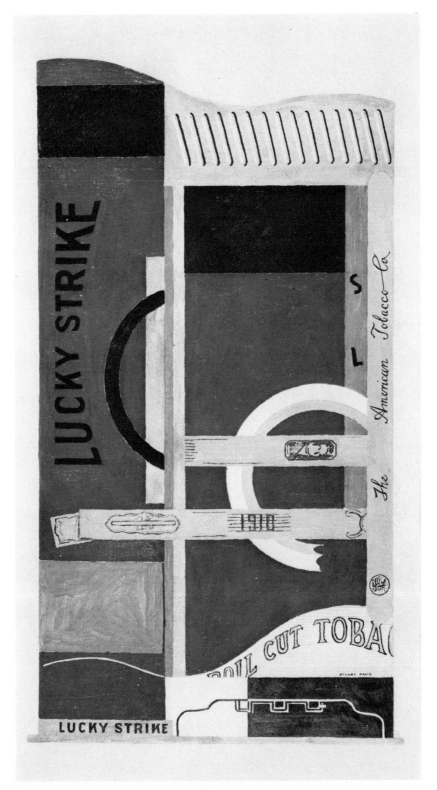

Stuart Davis, *Lucky Strike*, 1921, oil on canvas, 33 1/4 x 18 in. *Courtesy of The Museum of Modern Art, New York City; gift of The American Tobacco Company.*

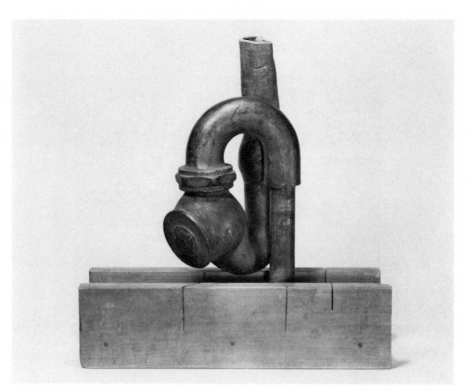

Morton Schamberg, *God*, *c.* 1918, assemblage, miter-box and plumbing trap, 10 1/2 in. high. *Courtesy of The Philadelphia Museum of Art; The Louise and Walter Arensberg Collection.*

Morton Schamberg, *Mechanical Abstraction*, 1916, oil on wood, 13 3/4 x 10 3/4 in. *Courtesy of The Philadelphia Museum of Art; The Louise and Walter Arensberg Collection.*

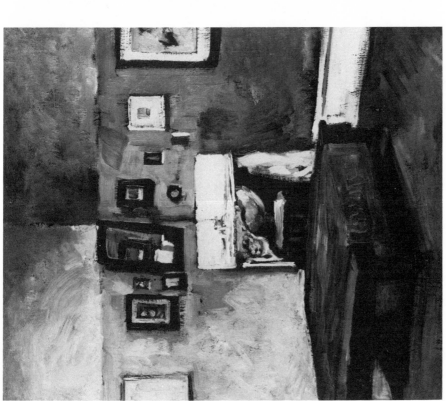

Morton Schamberg, *Studio Interior*, undated, oil on canvas, 20 x 24 in. *Courtesy of Dr. Ira Schamberg.*

Morton Schamberg, *The Well*, 1916, oil on canvas, 18 x 14 in. *Courtesy of Ben Wolf.*

Morton Schamberg, Mechanical Abstraction, 1916, oil on canvas, 30 x 20 1/4 in. *Courtesy of The Philadelphia Museum of Art; The Louise and Walter Arensberg Collection.*

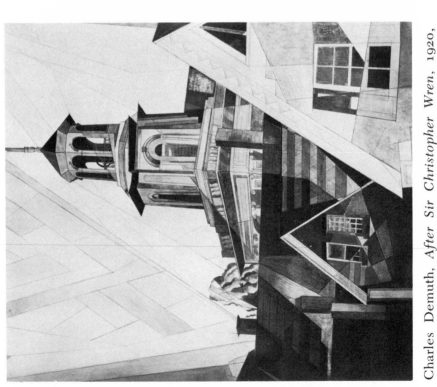

Charles Demuth, *Machinery*, 1920, tempera and pencil on cardboard, 24 x 19 7/8 in. *Courtesy of The Metropolitan Museum of Art; The Alfred Stieglitz Collection, 1949.*

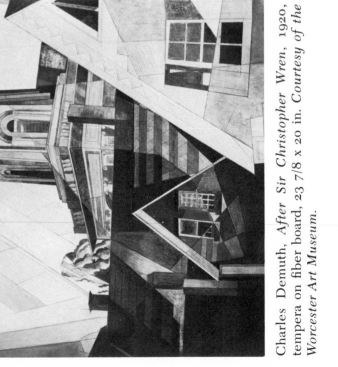

Charles Demuth, *After Sir Christopher Wren*, 1920, tempera on fiber board, 23 7/8 x 20 in. *Courtesy of the Worcester Art Museum.*

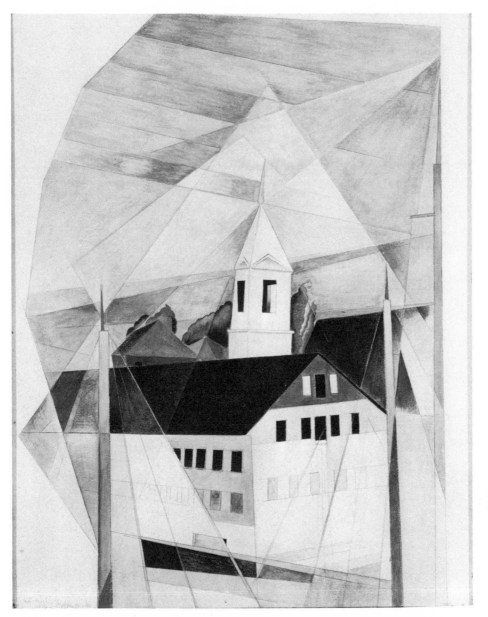

Charles Demuth, *Box of Tricks*, 1920, tempera on sketch board, 19 1/2 x 15 1/4 in. *Courtesy of The Philadelphia Museum of Art; The Seeler Fund.*

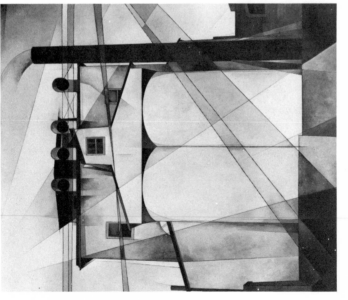

Above: Charles Demuth, *My Egypt*, 1927, oil on composition board, 35 3/4 x 30 in. *Courtesy of the Whitney Museum of Art, New York City.* *Right:* Charles Sheeler, *Upper Deck*, 1929, oil on canvas, 29 1/8 x 22 1/8 in. *Courtesy of The Fogg Art Museum, Harvard University; Louise E. Bettens Fund.*

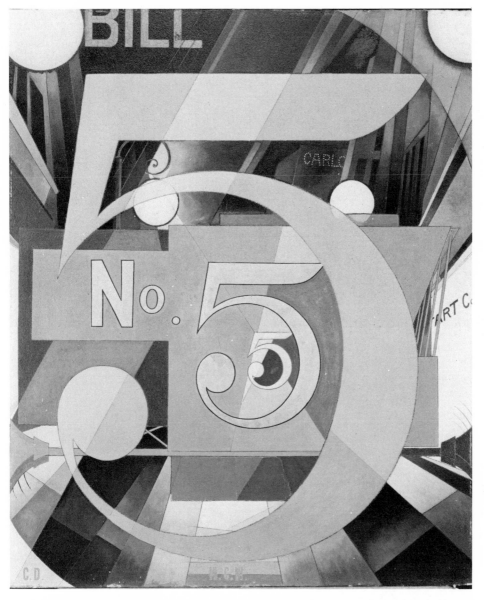

Charles Demuth, *I Saw the Figure Five in Gold*, 1929, oil on composition board, 36 x 29 3/4 in. *Courtesy of The Metropolitan Museum of Art, New York City; The Alfred Stieglitz Collection, 1949.*

William Merritt Chase, *The Open Air Breakfast, c.* 1888, oil on canvas, 37 1/2 x 56 3/4 in. *Courtesy of The Toledo Museum of Art; bequest of Florence Scott Libbey.*

Charles Sheeler, *Bucks County Barn,* 1923, tempera and crayon, 19 1/4 x 25 1/2 in. *Courtesy of the Whitney Museum of American Art, New York City.*

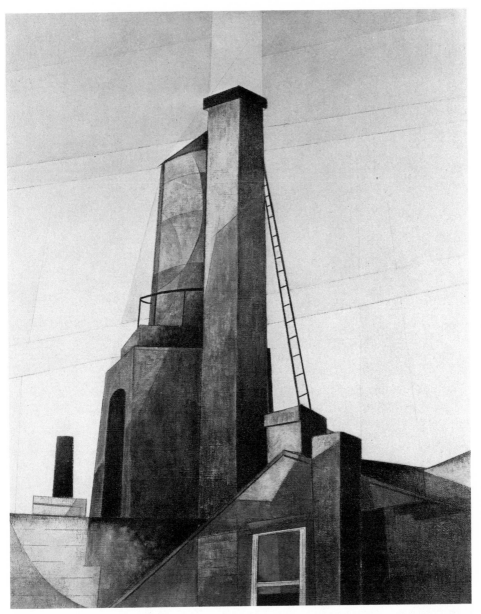

Charles Demuth, *Aucassin and Nicolette*, 1921, oil on canvas, 23 9/16 x 19 1/2 in. *Courtesy of The Columbus Gallery of Fine Arts; Ferdinand Howald Collection.*

Charles Sheeler, *Self-Portrait*, 1923, watercolor, pencil, and conté crayon, 19 3/4 x 25 3/4 in. *Courtesy of The Museum of Modern Art, New York City; gift of Abby Aldrich Rockefeller.*

René Clair and Francis Picabia, still from *Entr'Acte*, 1924. *Courtesy of The Museum of Modern Art, New York City; Film Stills Archive.*

Charles Sheeler, *American Landscape*, 1930, oil on canvas, 24 x 31 in. *Courtesy of The Museum of Modern Art, New York City; gift of Abby Aldrich Rockefeller.*

Charles Sheeler, *City Interior*, 1937, painting on fiber board, 22 1/8 x 27 in. *Courtesy of the Worcester Art Museum.*

Charles Sheeler, *The Artist Looks at Nature*, 1943, oil on canvas, 21 x 18 in. *Courtesy of The Art Institute of Chicago.*

8 | E. E. Cummings and Dada Formalism

When Hart Crane's friend E. E. Cummings first began to appear regularly in the little magazines of the early 1920s, the reviewers tended to place him in mutually exclusive categories. He was thought to be either an arch-experimentalist, a "symbol of extreme modernism," or a traditionalist simply hiding behind a smokescreen of typographical play. Like Crane, Cummings looked both to the past and the present for his poetic models,[1] yet he surpassed Crane in willingness to experiment, in daring to play with various poetic techniques. Consequently, he held easy discourse with the rapidly accelerating avant-garde movements surrounding him as a young poet. Dada in particular offered a wide range of values which Cummings found amenable to his own purposes. His typographical experimentation, its intuitive derivation notwithstanding, and his other anti-art attitudes were validated by the emergence of Dada, with which he was familiar prior to 1920, when he lived in New York. Somewhat later, his literary context, which was largely determined by *Broom*, *Secession*, and *The Little Review*, not to mention the Paris milieu of the early Twenties that such magazines reflected, offered an additional orientation toward Dada that confirmed and encouraged the poetry he was writing.

Despite an extensive exposure to Dada, Cummings did not engage in typographical experimentation simply for the sake of shock alone, as many Dadaists had originally done; rather, he shared their models for the organic transformation of form and content in his poetry. Nor did he undergo the violently anarchic or destructive phase endemic to Dada. He even remained on the periphery of the *Broom-Secession* controversies and disagreed with some of Josephson's views which had been informed by Dada. Yet Cummings was highly aware of the creative-destructive tensions that animated his poetry during this period. By 1927 his play *Him* dramatized his views of the

artist and thus prepared the way for the slowly developing transcendent vision that was to dominate his poetry from then on. Although as a mature poet Cummings had little need of Dada, certainly Dada contributed to the integration of his poetry and poetics.[2]

In his 1915 Harvard graduation lecture about "The New Arts," Cummings revealed not only an awareness of what was happening in the arts but also some proto-Dada attitudes as well. The fact that he talked about painting and music in addition to poetry indicated his multi-media interests, which, though common enough at the time, were to be exploited more fully by Dada than by either Cubism or Futurism. Cummings admired the highly publicized Futurists for their individualism. "Every socalled 'Futurist'," he claimed, "has his own hobby; and there are almost as many kinds of painting as artists." He would look forward to the Dada individualism that veered off into anarchy. As Georges Ribemont-Dessaignes, the Dada painter and poet, later indicated in *The Little Review*, the Dadaists "have materially speaking neither technique nor method, of which one can say—Oh, how very dada! Each one follows his own bent without bothering about dada laws of colour, form or logic. Dada if you can!"[3] Here was a Dada attitude that Cummings anticipated and endorsed as early as 1915.

The most important aspects of his Harvard address were a lack concern for arbitrary definitions of art and a willingness to speculate about future possibilities:

> The question now arises, how much of all this is really Art? The answer is: we do not know. The great men of the future will most certainly profit by the experimentation of the present period. An insight into the unbroken chain of artistic development during the last half century disproves the theory that modernism is without foundation; rather we are concerned with a natural unfolding of sound tendencies. That the conclusion is, in a particular case, absurdity, does not in any way impair the value of the experiment, so long as we are dealing with sincere effort [a reference to Gertrude Stein's "Tender Buttons"]. The New Art, maligned though it may be by fakirs and fanatics, will appear in its essential spirit to the unprejudiced critic as a courageous and genuine exploration of untrodden ways.[4]

Looking both to the future and to the past (as he would do in his poetry) in an attempt to establish a tradition for the "New Art," Cummings was more moderate than Dada, which tried to break with the past by destroying it. But his appreciation of nonsense (reaffirmed later in *Him* and *No Title*), inasmuch as it augmented experimentation, fore-

shadowed the dynamics of Dada, which had been born and bred in absurdity. He thus rejected categories of aesthetic definition so as to embrace the possibilities that might result from experimentation.

In 1920 Cummings further delineated his own anti-art attitudes in an essay on T. S. Eliot for *The Dial*. He defined poetic techniques in terms of a vitality that abhors "the comforting and comfortable furniture of reality." By viewing the artist as "incorrigibly and actually alive," Cummings conceived technique as the means by which energy is transmitted to the reader, who undergoes "a tactile and cohesive adventure" offered by the poem. For him technique created "a unique dimension of intensity," so that arbitrary distinctions between art and life would be obliterated — certainly a Dadaist goal.[5]

Since Cummings thought that most art was hermetic and effete, his techniques to bring the reader closer to life went against the grain of conventional poetry. Thus his unusual use of language, most markedly demonstrated by typography, is characteristically anti-art. Indeed, one critic of the time saw his poetry as replete "with the maddest nonsense of all." But his rampant typography was not directly derived from Dada, no matter how much he delighted in shocking the Cambridge ladies. As early as his 1915 lecture, his praise for Amy Lowell's poem "The Letter" ("superb of its kind") reveals a nascent interest in typographical play. Cummings unequivocally stressed the "absolute vividness of the first two lines": "Little cramped words crawling all over the paper / Like draggled fly's legs."[6] Impressed by their antipoetic quality, he also must have been struck by their prophetic, albeit fanciful, description of what his writing would become.

Cummings' sonnets and ballads of 1915, however, did not give evidence of the typographical experimentation which would come to characterize his poetry. Only by 1917, with the publication of *Eight Harvard Poets*, and in such a poem as "i will wade out," is there a glimpse of typographical play, a dispersal of the line pattern that would suggest his later efforts. In the sheaf of poems contributed to the Harvard anthology, Cummings also introduced his famous lower-case "i," which was capitalized, however, during the course of printing the book. According to him, this eccentricity (which later gained a rationale) was born almost intuitively in the midst of a printing controversy.[7] During the ensuing years he rapidly developed his techniques, and by the time of the publication of *Tulips and Chimneys* in 1923 he had firmly laid the foundation for even his most radical later forms.

In the meantime, concurrent developments in poetry and the

visual arts offered examples of experimentation that Cummings would assimilate into his own poetic sensibility. There was, first of all, a whole series of French poets from a previous generation – Rimbaud, Mallarmé, and Apollinaire – who were preoccupied with radical formal experimentation. Although Cummings probably knew Apollinaire's visual poetry, (as well as the collaborations of Marius De Zayas and Agnes Ernst Meyer in Stieglitz's 291), he later disclaimed Apollinaire's influence, and for good reason.[8] Quite obviously, he rarely engaged in Apollinaire's kind of elementary experimentation whereby words form representational images on the page. Nor did he ever depend upon drawings to complete the poem, as De Zayas had in 291. Instead, he explored the visual dimensions of the words themselves so as to stretch their expressive possibilities beyond conventional use. Nevertheless, Apollinaire and his American followers certainly confirmed Cummings' idea that words have visual possibilities for the poet to exploit.

In the visual arts Cubism, which was a source of inspiration for Apollinaire, worked on the same principle, with its interplay of the verbal and the visual in both collage and painting. Cummings, of course, saw the Armory Show when it came to Boston. Indeed, he was as much a painter as a poet during the early 1920s. Thus in 1924 his close friend Slater Brown maintained that the reader should be aware of Cummings' "translation of one art into the technic of another" as the key to understanding his poetry.[9] Whatever hint Cubism provided, Futurism went even further in its concept of *parole in liberta*. For Cummings, however, words were never absolutely free. Even though they were not bound by conventional syntax and diction, they were never anarchically scattered on the page. Rather, Cummings related form and content organically, following Emerson's view that meter-making arguments, not simply meter, lay at the heart of poetry. Out of the basic Emersonian precept, he could radically extend his typography, cognizant of the experimental liberties offered by contemporary avant-garde movements, and yet maintain his own sense of poetic order.

Given these emerging attitudes, Cummings would have been in accord with the De Stijl Manifesto II of 1920, proclaimed by Theo Van Doesburg, who had been inspired by the literary experiments of Dada. This manifesto reappeared in the Spring 1925 issue of *The Little Review*, where Cummings most certainly would have seen it. After asserting that "the Verb is Dead" because of "a weakened generation," Van Doesburg offered his own resolution:

We wish by every means at our disposition
 syntax
 prosody
 typography
 arithmetic
 orthography
 to give to the verb a new sense and a new force of expression

Such all-out means for rejuvenating language anticipated Cummings' approach in the following decades. Just as relevant was the manifesto's insistence upon poetic process rather than product:

he [the poet] will describe nothing at all
he will content himself with Writing
he will Recreate in the Verb whatever Collective Thing the Action has:
The Constructive Unity of Meaning and of Form.

Cummings' organicism and his "Ineluctable preoccupation with The Verb," as he noted in the Foreword to the 1926 publication of *Is 5*, closely paralleled Van Doesburg's ideas.[10]

Dada itself provided the greatest range of verbal experimentation for Cummings to appropriate for his own creative purposes. Since the days of Zurich in 1916, the Dadaists had been writing abstract poetry in an attempt to free the word from its conventional syntactical pattern with assigned denotation. For example, the Spring 1924 issue of *The Little Review* published an abstract poem ironically entitled "Chorus Sanctus" by Richard Huelsenbeck, the German Dadaist (who eventually became a New York psychoanalyst):

a a o	a e i	i i i	o ii
ou ou o	ou ou e	oui e	a ai
ha dzk	drrr bn	obn br	bouss boum
ha haha	hi hi hi	lili li	leïomen[11]

Even though abstraction characterizes many of Cummings' poems because of their typographical arrangement, he never completely abandoned the denotational quality of words. For example, in a poem that appeared in *And*, published early in 1925, the narrator sits on a public beach and watches some overweight women in bathing attire. The sea reacts playfully:

w h e e saysthesea-brE aking-b Re akin g(brea)K
 ing.[12]

Here the words assume an abstract yet plastic dimension on the page. The reader is forced to see the words as objects in themselves as they become alive. But at the same time, Cummings placed the words

visually to reinforce the meaning of the phrase. The running together of "saysthesea," the capitalization of certain letters, the breaking up of the word "breaking," all suggest the rhythm and movement of the waves as they sweep upon the shore. Cummings thus transformed a purely formal Dada experiment in order that form and content be organically related one to the other.

Whereas much of Dada abstract poetry emphasized sounds rather than the appearance of words, Raoul Hausmann, a poet active in Berlin Dada, attempted to add a visual dimension to the phonetically abstract poem. As early as 1918, he created what he called "optophonetic" poetry: "The poem is an act consisting of respiratory and auditive combinations, firmly tied to a unit of duration. . . . In order to express these elements typographically . . . I had used letters of varying sizes and thicknesses which thus took on the character of musical notation. Thus the optophonetic poem was born."[13]

There is no evidence that Cummings ever saw or heard a Hausmann optophonetic poem. But though each poet emphasized different ends, they would have agreed that the varied sizes of letters on the page add a vital dimension to the poetry. Cummings' poem "i will be . . ." in *And* indicates not only an abstract quality but also a visual effect whereby the letters gain movement just like the pigeons:

l oo k-
pigeons fly ing and
whee(:are,SpRIN,k,LiNg an in-stant with sunLight[14]

The alternation of capital and lower-case letters creates a vibrant pattern that corresponds to the movements of birds—another instance when Cummings appropriated formal experimentation for his own organic verse.

The Dadaists also explored the possibilities of simultaneity, which they dramatized by reciting several phonetic phrases at the same time. The attempt to create simultaneous poetry in America extended back to 291, in which several conversations were juxtaposed to create a mélange of voices as they might be heard on a streetcar during rush hour. Cummings extended the concept of simultaneity by means of several techniques. The least sophisticated, though quite successful, means involved the simple sequence of ostensibly undifferentiated impressions (yet carefully selected by Cummings) within the narrator's consciousness:

> the Bar. tinkling luscious jigs dint of ripe silver with
> warmlyish wetflat splurging smells waltz the glush of
> squirting taps plus slush of foam knocked off and a
> faint piddle-of-drops she says I ploc spittle what the
> lands thaz me kid in no sir hopping sawdust you kiddo
> he's a palping wreaths of badly Yep cigars who jim him
> why gluey grins topple together eyes pout . . .[15]

Even though the words are sequential, the syntax is disjunctive, creating an accumulative effect and suggesting the vocal confusion of a busy bar as the narrator is "sitting in mcsorley's."

Other, more sophisticated techniques for achieving simultaneity were devised by Cummings. His much anthologized early poem, "Buffalo Bill's / defunct," telescopes words, creating in effect a new diction: Buffalo Bill could "break onetwothreefourfive pigeonsjust likethat . . ." Thus the narrator conveys the instantaneous speed with which Buffalo Bill could shoot clay pigeons. In other poems a judicious use of parentheses also creates a sense of simultaneity. In "i will be . . ." the narrator points:

> l oo k-
>
> pigeons fly ingand
> whee(:are,SpRiN,k,LiNg an in-stant with sunLight
> t h e n)l-
> ing all go BlacK wh-eel-ing . . .

Without the parentheses, the pigeons are "wheeling." But the interjected parentheses provide a double motion: the reader sees the birds both as they are wheeling and as they are sprinkling an instant with sunlight.[16]

In reviewing *Tulips and Chimneys* for the last issue of *Broom*, Slater Brown asserted that "the lines of his poems are built for speed." Moreover, "their formal beauty has that quality common to racing cars, aeroplanes, and to those birds surviving because of their swift wings." Cummings' creation of the illusion of simultaneity implemented a poetic sense of speed characteristic of the modern world—a fascination he shared with Dada and Futurism earlier. But more important was the use of simultaneity to break down a sequential sense of time, thereby suggesting an eternal world, "that actual Present," as he phrased it in *The Enormous Room*.[17] Thus Cummings borrowed Dada experiments for the creation of spiritual values consonant with his New England heritage of Transcendentalism.

Not only isolated examples taken from Cummings' volumes of poetry published through 1926, but also significant patterns of poems published in the little magazines of the period, indicate that he associated his experimentalism with the dynamics of Dada. Cummings published primarily in *The Dial, Vanity Fair, Broom,* and *Secession* from 1920 to 1926. In general, the poems he submitted to *The Dial* and *Vanity Fair* expressed romantic notions about love and nature, while he kept typographical experimentation at a minimum. Despite many poems of high quality, this group was in keeping with the nature of the magazines involved. Even though he was to receive the 1925 *Dial* prize, Slater Brown wrote an indictment of the magazine as conservative and uninterested in new art. Cummings apparently did not agree with his friend, for later he had nothing but praise for *The Dial.* More than likely, his traditional leanings motivated his contributions to the review, but he reserved his more radical and newer poems for *Broom* and especially *Secession.*[18]

In his first appearance in the January 1920 issue of *The Dial* Cummings submitted "little tree / little silent Christmas tree / you are so little / you are like a flower," a poem that unfortunately bent the child's vision toward sentimentality. But he also contributed "Buffalo Bill's / defunct," a poem that makes excellent use of typography to match the spiritual dilations of the narrator. In general, however, he contributed love poems of this sort:

> Always before your voice my soul
> half-beautiful and wholly droll
> is as some smooth and awkward foal,
> whereof young moons begin
> the newness of his skin . . .[19]

Despite some syntactical dislocations and an unexpected juxtaposition of images, the poem is hardly unusual. Cummings simply put a simile to good use.

His typographical experimentation for *The Dial* reached a peak with the free verse paragraphs of "at the head of this street" and "at the ferocious phenomenon of 5 o'clock." A superb collection for the January 1923 issue included "will out of the kindness of their hearts a few philosophers tell me," "at dusk / just when," and a series of poems about Paris, where Cummings' sensibilities must have been refreshed by an extended visit of two years. These poems, written after he had submitted the manuscript of *Tulips and Chimneys* for publi-

cation during the summer of 1922,[20] represent Cummings at his lyrical best, as typography, syntax, and diction work together to create a fresh vision of the world born anew. Moreover, they indicate a developing mastery of language that would avoid the dangers of sentimentality, which were ever possible, given his romantic themes.

The nineteen poems that Cummings contributed to *Vanity Fair* from December 1922 to March 1925 and which ranged from his early love lyrics to satire—indicating the general trend of his poetry during this period—made no special demands upon the reader. "Four sonnets in the modernist manner," the rubric under which his poems for the December 1923 issue appeared, play mild variations on the sonnet form. Even though the convention was not simply a surface device but intrinsic to the poetry, Cummings merely made a casual gesture toward the experimentalism that modernism entailed. In other words, the readers of *Vanity Fair* could feel *au courant* without having their sensibilities radically challenged by the poetry.

Such was not the case for the twenty poems Cummings submitted to *Broom*, for which he made the same attempt to select those poems that were amenable to the attitudes espoused by the magazine. It happened that his first appearance in the May 1922 issue coincided with Loeb's new policy that young American writers should be solicited. In that same issue, Loeb published "Foreign Exchange," which was eventually to lead *Broom* through the attitudes of Dada to an acceptance and promotion of indigenous American culture. Rejecting Waldo Frank's national mysticism, with its incipient sentimentality, Loeb, in its stead, accepted America, with its ugly industrial environment and concomitant energy.

Cummings implicitly reinforced these attitudes in his "Three United States Sonnets," which comment upon America. The first concerns a visitor's encounter with the madam of a house of prostitution:

> when you rang at Dick Mid's Place
> the madam was a bulb stuck in the door.
> a fang of wincing gas showed how
> hair, in two fists of shrill colour,
> clutched the dull volume of her tumbling face
> scribbled with a big grin. . . .

Unsentimentally treated, the woman's ugliness is celebrated by a violently juxtaposed image ("a fang of wincing gas") that anticipated

a characteristic of Surrealism already manifest in Dada. Despite a hint
of coyness ("her sow- / eyes clicking mischief from thick lids"), Cum-
mings accepts the woman as she is. This poem was followed by his
famous satire of "the Cambridge ladies who live in furnished souls."
His attack upon an anesthetic Brahmin Boston contrasts markedly
with the previous scene from the demimonde and creates an effective
opposition of European sexual license and American Victorian inhi-
bitions. The third poem, "by god i want above fourteenth," plays the
frenzies of a fragmented urban life ("the mystic screech / of Broadway,
the trivial stink of rich / frail firm assinine life") against "the Square
in spring," the more Europeanized Greenwich Village, where "one
opaque / big girl jiggles thickly hips."[21]

The July 1922 *Broom* had four more Cummings poems, three of
which could be described as minimal poetry, a characteristic exploited
by the young French Dadaists, who wanted to avoid the heavy rhetoric
of traditional verse.[22] The first, entitled "Sunset: stinging," treats
nature lyrically with verbal understatement:

> stinging
> gold swarms
> upon the spires
> silver
>
> chants the litanies the
> great bells are ringing with rose
> the lewd fat bells
> and a tall
>
> wind
> is dragging
> the
> sea
>
> with
>
> dream
>
> -S

The typography, by laying stress upon each particular word on the
line, achieves maximum poetic effect through the use of few words:
The other three poems fell under the single title of "Portraits."

The first, of a jazz pianist, was followed by one subtitled "Caritas," which dramatizes the efforts of a sidewalk Salvation Army band to collect money from the onlookers. Upon the solicitation of the captain, the "Divine Average" asks "why he should / blow two bits for the coming of Christ Jesus." His question is followed by a sequence of punctuation marks:

<div align="center">

?

??

???

!

</div>

along with the concluding refusal, "nix, kid." The multiple question marks not only underscore the importance of the question, which ironically the "Divine Average" does not grasp, but also serve an eliptical purpose, indicating the tambourine as it is passed around the crowd. Cummings might have derived this technique from a Dada stunt. In the Autumn 1921 issue of *The Little Review* Abel Sanders offered a sequence of punctuation nonsense: "@¼%&:¼/?½@3/4) (&?;¼%&. . . ." To score the point, down in the bottom margin, tipped on its side, was this brief poem:

<div align="center">

dada

deada

what is deader

than dada

</div>

Sharing his interest in the comics with Dada, Cummings turned what was comic-strip shorthand for profanity to his own purposes of dramatic economy.[23]

The third portrait, "Arthur Wilson," Cummings' painter-roommate in New York, is a prose poem intoxicated by its manipulation of words. Josephson might have been thinking of it when he was making predictions for poetry in his "After and Beyond Dada," the title of an essay that appeared in the same issue of *Broom*. "The play of the intellect is dominant--intellect, of course, freed from the syllogism as well as from empiricism, therefore naked plundering intellect, in astonishing encounters and adventures," he observed.[24] Although not entirely free from the external world, Cummings' poem certainly forsakes the syllogism to pursue the play of words.

For the October 1923 *Broom* Cummings further complied with its American perspective by submitting five more portraits, this time of prostitutes, entitled "Five Americans."[25] Unlike some of his portraits,

which sentimentally exploit the clichés of prostitution, this series offers a complex response to these women. While their portraits are devoid of false pity, they are not targets for satire. Rather, the women emerge as human beings who ultimately comment upon our own condition. Marj, for example, reveals genuine moral despair:

> "life?
>
> Listen" the feline she with radishred
> legs said (crossing them slowly) "I'm
> asleep. Yep. Youse is asleep kid
> and everybody is." And i hazarded
> "god" (blushing slightly)—"O damn
> ginks like dis Gawd" . . .

Even though she has a limited social view (the madam is the most prestigious person she can indict), Marj's self-awareness stands in contrast to the narrator's prissiness. Only with Fran does he achieve wisdom by accepting life:

> should i entirely ask of god why
> on the alert neck of this brittle whore
> delicately wobbles an improbably distinct face,
> and how these wooden big two feet conclude
> happeningly the unfirm drooping bloated
> calves
> i would receive the answer more
> or less deserved, Young fellow go in peace.

The remaining eight poems that Cummings submitted to the November 1923 and January 1924 issues of *Broom* were quite diverse in kind. Those for the November issue ranged from the outrageous (at the time) description of sexual intercourse in a "lovehouse" to the sentimental "the wind is a Lady with / bright slender eyes." His four poems for the final appearance of *Broom* were just as diverse, but these indicated perhaps that he was "completely innoculated against that galloping stagnation which seems to carry off so many of our younger American poets," as Slater Brown suggested in an accompanying review.[26] Cummings varied from the rhetoric of a prose poem, "will i ever forget that precarious moment," to the childlike primitivism of "i'd think 'wonder'," to the typographical complexities of "ohld song" and "if (you are i why certainly." Although the termination of *Broom* was a sad affair, the entire group must have taken great satisfaction in concluding their magazine with Cummings, the

poet who appeared to be the arch-rebel and hence an index of the group's avant-gardism.

Although *Broom*'s adversary in crime, *Secession*, moved away from its initial overtures to Dada, Munson had originally advertised his magazine as "experimental" and "aggressive." On the initiative of Josephson, the early issues included works by Louis Aragon, Tristan Tzara, Philippe Soupault, and Hans Arp. Cummings did more than his share to hold his own with these iconoclasts, submitting a total of eight poems for the second and fifth issues.[27] In the July 1922 *Secession*, when it had become fashionable to celebrate the death of Dada as one of its many transmutations, Cummings thumbed his nose along with the rest:

> what's become of (if you please)
> all the glory that or which was Greece
> all the grandja
> that was dada?

Obviously, its attitudes were not by any means dead, judging from Cummings' subsequent portrayal in the same poem of the narrator in a Paris sidewalk café:

> i will sit in the corner and drink thinks and think drinks,
> in memory of the Grand and Old days:
> of Amy Sandburg
> of Algernon Carl Swinburned.

The narrator's nostalgia for "the Grand and Old days" is ironically undercut by his intoxication as he mixes up the names of the poets. His unconscious insult is a deliberate calculation on the part of Cummings. The poem concludes with a cliché response to April: "(ask the man who owns one / ask Dad, He knows)." Cummings thus utilized the doggerel slogans of advertising ironically. In the fifth issue he pursued this matter even further in "the season 'tis, my lovely lambs," which lays bare the moral corruption that permeates a commercial America in "the age of dollars and no sense."

The other poems for *Secession* were equally aggressive and/or experimental. In "(and i imagine . . . ," Cummings ribaldly dramatizes the birth of Christ: "the jewess shrieked / the messiah tumbled successfully into the world / the animals continued eating." The fifth issue offered "this evangelist," in which Cummings attacks various social roles, including that of the politician, whom he describes in vicious sexual terms:

> in response to howjedooze the candidate's new silk
> lid bounds gently from his baldness
> a smile masturbates softly in the vacant
> lot of his physiognomy
> his scientifically pressed trousers ejaculate spats

The narrator concludes scatologically, "but / we knew a muffhunter
and he said to us Kid./ daze nutn like it." What appears to be an ob-
scene *non sequitur* comments upon the obscenity of the political
candidate.

In the second issue the poem "on the Madam's best april the . . ."
offers a distorted syntax that once again plays with poetic simultaneity.
Cummings' most daring experiment, however, typographically re-
creates the chaos of life:

> life hurl my
> yes,crumbles hand(ful released conarefetti)ev eryflitter,inga. where
> mil(lions of aflickf)litter ing brightmillion ofS hurl;edindodg:ing
> whom areEyes shy-dodge is bright cruMbshandful,quick-hurl edinwho
> Is flittercrumbs, fluttercrimbs are floatfallin,g;allwhere:
> a:crimbflitteringish is arefloatsis ingfallall!mil,shy milbrightlions
> my(hurl flicker handful
> in)dodging are shybrigHteyes in crum bs(alll) if,ey Es

The central metaphor for such chaos is confetti, the descending motion
of which is reflected by the visual movement of words, with the poet
disregarding syntax, diction, and punctuation to create a verbal ab-
straction for the sake of visual concreteness.

In addition to sending the appropriate poems to *Broom* and
Secession, Cummings shared and even anteceded many of the anti-art
attitudes of Josephson and his friends. If Josephson acted as the Ameri-
can liaison for Aragon and the Parisian Dadaists by providing them
with American comic strips, Cummings had been fascinated by Krazy
Kat as early as his Harvard days. Similarly, he was at home at the old
Howard in Scully Square long before Josephson extolled the virtues
of American burlesque and vaudeville in *Broom*; indeed, Cummings
wrote a series of essays on the circus and burlesque in 1925 and 1926,
and made use of popular song lyrics in his poetry. In a poem from *And*,
he effectively interpolated "In the Good Old Summer Time" with
sexual intercourse, using summer as a metaphor for orgasm.[28]

But Cummings was not in complete agreement with Josephson.
Not only did he prefer the charm of Paris to the mechanistic imper-
sonality of New York, but rarely did he write about the machine in his

poetry. When he did, he generally rejected technology because of its inhuman and nonhuman rational nature. His "voices to voices, lip to lip," appearing in the first issue of *The Transatlantic Review* (January 1924), contrasts the organic and the inorganic, "flowers and machinery." Cummings here rejects the machine in favor of art and nature ("sculpture and prose / flowers"). In fact, his attitude toward technology is summed up in a rhetorical question: "Who cares if some one-eyed son of a bitch / invents an instrument to measure Spring with?"[29]

In a major poem for *Is 5* (1926), "even if all desires things moments be," Cummings took a stance diametrically opposed to that of Josephson. The attitudes expressed by the main narrator, who speaks a tough-guy Brooklynese, are prefaced by an educated narrator:

> even if all desires things moments be
> murdered known photographed,ourselves yawning will ask ourselves
> où sont les neiges . . .[30]

The narrator equates the frozen moment of a photograph and rational knowledge with destruction. Thus, even with this facile and boring memory-bank, we still look back to tradition and echo the words of François Villon, the medieval French poet: "Où sont les neiges [d'antan]."

His tragic testament (with its Christian redemption through his sufferings as an outlaw) stands in ironic contrast to the empty words of the contemporary roughneck, who is also an outcast of sort. This second narrator truculently exclaims:

> . . . some
>
> guys talk big
>
> about Lundun Burlin an gay Paree an
> some guys claims der never was
> nutn like Nooer Leans Shikahgo Sain
> wireless subways vacuum
> cleaners pianolas funnygraphs skyscrapers an safetyrazors

His street accent reinforces the mindless acceptance of twentieth-century technology. The narrator, however, qualifies his own position: "sall right in its way kiddo / but as for i gimme de good ole daze." But instead of asking "où sont les neiges," he exclaims:

> in dem daze kid Christmas
> meant sumpn youse knows wot
> i refers ter Satter Nailyuh(comes but once er

year)i'll tell de woild one swell bangup
time wen nobody wore no cloze
an went runnin aroun wid eachudder Hell
Bent fer election making believe dey was chust born.[31]

The narrator intends to contrast the sterility of Christmas in the present
with the meaningful celebration of Christmas when he was a boy in
"de good ole daze." But he himself in his "daze" confuses Christmas
with Saturnalia, a Roman holiday of sexual and social license. His
ironic choice of the phrase, "Hell / Bent fer election," unwittingly
suggests not only God's chosen few, a variant on the Puritan elect, but
also an indictment of Puritan sexual repression (a fallacious though
common cliché of the 1920s).

The poem ultimately parodies Eliot and *The Waste Land*, for the
Christmas myth is not substantially revitalized by pagan fertility rites.
Even though the narrator is but dimly aware of rebirth in the pagan
myth, he generally negates human values. Thus the poem also criti-
cizes the skyscraper primitivism of Josephson: the servant that became
master during Saturnalia remains an urban slave, caught in the maze of
technology. Cummings strongly implies his own preference for human
values over technology, that any schism between the spiritual and the
sexual (Christmas and Saturnalia) must be repaired before redemptive
rebirth can be achieved in the twentieth century. He sympathizes with
the second narrator only insofar as the latter is aware of his spiritual
predicament. And quite obviously, he possesses only a limited percep-
tion of spiritual values.

Cummings viewed advertising as one source (among many) for
twentieth-century American malaise. Like Hart Crane, he inverted
Josephson's views about advertising by using commercial slogans for
satirical purposes. In the December 1922 issue of S_4N, a little magazine
which spent some time discussing the controversies generated by the
appearance of *Secession*, Cummings contributed his most brilliant and
savage example, "Poem, Or Beauty Hurts Mr. Vinal":

take it from me kiddo
believe me

my country, 'tis of
you, land of the Cluett
Shirt Boston Garter and Spearmint
Girl With The Wrigley Eyes(of you

> land of the Arrow Ide
> and Earl &
> Wilson
> Collars) of you i
> sing:land of Abraham Lincoln and Lydia E. Pinkham,
> land above all of Just Add Hot Water And Serve —
> from every B. V. D.

> let freedom ring . . .

Cummings violently attacks America's sterile values embodied not only in the clichés of its advertising but also in its culturally sanctioned art:

> . . . i do however protest, anent the un
> -spontaneous and otherwise scented merde which
> greets one (Everywhere Why) as divine poesy per
> that and this radically defunct periodical. . . .

Set within the context of S_4N, debating the merits and shortcomings of avant-garde poetry, this poem served as a violent protest, Cummings having singled out Harold Vinal, an academic poet, as the symbolic target of his vituperation. He also ingeniously and ironically inverts the snobbish arguments of those who upheld art with a capital A against banal advertisements by pointing out their similarities:

> . . . Art is O World O Life
> a formula: example, Turn Your Shirttails Into
> Drawers and If It Isn't An Eastman It Isn't A
> Kodak . . .

Both academic art and advertising are formulaic, requiring only an anemic, conditioned response from "americans (who tensetendoned and with / upward vacant eyes, painfully / perpetually crouched, quivering, upon the / sternly allotted sandpile . . ." The poem concludes scatologically, as those dead Americans "emit a tiny violetflavoured nuisance: Odor? / ono. / comes out like a ribbon lies flat on the brush."

Cummings' antipathy toward American mediocrity stemmed from his desire to be alive, a desire that took on spiritual as well as sensual dimensions. While his essay on Eliot in 1920 affirmed such attitudes toward art, *The Enormous Room* offers a glimpse of that process toward affirmation. Near its conclusion, Cummings describes how he and his prison friends experimented with colors by creating collages of leaves and paper scraps from cigarette packages and the like. He

then castigates the American public for its inability to understand such artistic endeavor:

> But of course The Great American Public has a handicap which my friends at La Ferté did not as a rule have—education. Let no one sound his indignant yawp at this. I refer to the fact that, for an educated gent or lady, to create is first of all to destroy—that there is and can be no such thing as authentic art until the *bons trucs* (whereby we are taught to see and imitate on canvas and in stone and by words this so-called world) are entirely and thoroughly and perfectly annihilated by that vast and painful process of Unthinking which may result in a minute bit of purely personal Feeling. Which minute bit is Art.[32]

Equating education with rationality, Cummings here maintains that the artist must disengage himself from such conditioning before he can create art. Thus, practically from the outset of his vocation as a poet, he saw the tensions between creation and destruction as central to the aesthetic process. Unlike the Dadaists, however, he did not engage in ritualistic destruction. Even in *The Enormous Room*, an intensely vivid portrayal of war casualties, there is a quiet tone of acceptance of the situation, out of which human values can be derived and affirmed.

Apparently, however, Cummings did assume a Dada mask upon occasion, for Burton Rascoe, the columnist for the *New York Herald Tribune*, reported an interview with Cummings in Paris that reveals his anti-art notions about poetry in 1924. Cummings expressed his disgust for the American poet:

> "Poets and artists, especially in America, make me sick," he said. "What right has such a beggar to take on airs? I have no more interest in or respect for a man because he can write a poem or paint a picture that will hang in the Louvre than I have for a man because he can fix the plumbing or design a beautiful motor car. Crossing the Place de la Concorde this morning I saw a Rolls-Royce car with a body that was a thing of grace, beauty and utility. Some one designed it. Some one who is a genius, an artist, much more an artist than I am, because it is not only a beautiful thing, it runs and not only does it run, but it is useful and in demand, and the man who designed it can make a living out of his design.

Cummings' equation of the artist with the industrial designer coincided with Picabia's attitudes and may have been derived from him. In the Spring 1922 issue of *The Little Review*, for example, Picabia asserted, "There is sometimes more art in knowing how to drink a

cocktail than in knowing how to mix blue or vermillion with white, more art in designing the practical side of an automobile than in imitating the buttocks of an Italian model of the Place Pigalle."[33] Cummings' deflation of the poet adds a double-edge to this Dada irony, for the tone of his argument implicitly parodies the American value placed on making money and being pragmatic.

Cummings went on to describe his poetic vocation as a "shabby, idiotic disease." He argued that poetry would not sell in America, and he contended that, as a consequence, he would be foolish, as he indeed felt he was, to write poetry. But there was a greater folly in imagining the poet and his useless wares to be superior to other people. Following the lead of Robert Coady, Cummings fulminated against effete and neurotic poets, "a puny lot." He espoused, instead, the athleticism of Arthur Cravan in demanding that poetry be related to life rather than be hermetically sealed off. At the same time, however, he seemed to be ambiguous about art. His final diatribe, far from indicating his distrust of poetic technique, suggests that a poet should be well acquainted with his craft, just as "paper box manufacturers," for example, know how to construct their products. Hence his admiration in a subsequent poem for Picasso: "you hew form truly."[34] Cummings' ambiguity, however, was more apparent than real, given his view in the essay on Eliot that technique brings the poem alive, another anti-art notion.

Cummings occasionally engaged in a Dada gesture, such as the time that he urinated on Cowley's library that was burning in the fireplace—behavior precipitated by a night out in Paris with Dos Passos, Aragon, and Cowley himself. He also indicated his anti-art stance in his poetry:

> mr youse needn't be so spry
> concernin questions arty
>
> each has his tastes but as for i
> i likes a certain party
>
> gimme the he-man's solid bliss
> for youse ideas i'll match youse
>
> a pretty girl who naked is
> is worth a million statues

This poem, probably written before 1926, contrasts the values of the virile "he-man" with those of the implicitly aesthete "mr." Distinctions, however, are ambiguous, for ultimately Cummings would opt for the pretty girl *and* the statue, especially if the statue, like the work of Gaston Lachaise, is alive, "a complete tactile self-orchestration, a magnificently conjugation largeness, an IS.[35]

With the appearance of his play *Him* in 1927, Cummings dramatized most fully his views on art up to that date. His attitudes still fell within the ambience of Dada despite the fact that Surrealism was in full swing as a movement in Paris. To be sure, *Him* coincided with certain Surrealist ideas. The entire play could be considered a dream of Me as she undergoes anesthesia to give birth to the child of Him, the artist-protagonist. But Cummings was not primarily concerned with dramatizing the unconscious as such. Indeed, the sixth scene of Act II spoofs in good Dada fashion the Freudian idea of the unconscious. Instead, Cummings was most concerned with depicting the artist and his creative problems within the ambivalent framework of art and anti-art.

Him emerged from the background of the Dada event, perfected throughout Europe during the previous decade, for the revolving set, the large cast, and the plays-within-a-play attempt to transcend the proscenium stage.[36] In retrospect, however, Dada's sense of theatre as shock tactic was more successful in bringing actors and audience together. As Stark Young noted in his incisive review for *The New Republic* in 1928, even though the Provincetown Players were to be commended for their production of a play so obviously difficult to mount, *Him* required cutting and a dramatic focus as well.[37] All too often the play is more effective in the reading than in the dramatization, suggesting Cummings' inexperience in writing for the stage. In fact, the strength of *Him* exists primarily in the play of language, and in that sense, it is indeed a poet's play. A poet's play, too, for what it reveals about Cummings' sense of art. *Him* must be most seriously entertained as a dramatic statement, a summation, and a forward glance toward a coherent poetics.

Him and Me, the male and female lovers of the play, have pronouns for names, suggesting from the outset split psyches. Him wants to be an artist, a goal he has not yet fully achieved because of his conception of himself as an artist. He does not understand that there should be no difference between art and life within the artist's psyche.

His inability to gain rapport with Me, combined with an unsure identity, indicates a fragmented self which, whole, would integrate art and life. In the meantime, he feels that he must make a choice between his vocation as an artist and his love for Me.

Leading up to this impending decision are hints that Him might come to understand the nature of art. He is properly contemptuous of conventional artists: "The average 'painter' 'sculptor' 'poet' 'composer' is a person who cannot leap through a hoop from the back of a galloping horse, make people laugh with a clown's mouth, orchestrate twenty lions." His anti-art notions parallel those of Robert Coady, not only in an animosity toward conventional art but also in the criteria used to judge the art. The circus with its panoply of entertainment becomes the standard to uphold. Him conceives of the creative act in terms of the circus acrobat: "But imagine a human being who balances three chairs, one on top of another, on a wire, eighty feet in air with no net underneath, and then climbs into the top chair, sits down, and begins to swing."[38] Unfortunately, Him has not yet achieved the necessary delicate balance between art and life to emulate the tightrope walker.

Me is depicted as the intuitive female. Yet she too has her shortcomings. She sacrifices her intuitive nature in order to understand Him and his trial plays rationally. Consequently, she fails. Moreover, her bourgeois values come between them when she suggests that Him create art for money. At another point, she wants to cut herself off from life by refusing to see the freaks in the circus sideshow. Nevertheless, she is the one who ultimately realizes that beauty and truth are not mutually exclusive, that Him had been pursuing false or misconceived goals by rejecting her. In the end, she is the creative one, giving birth to Him's child, the climactic act that suggests Him's imperfect movement toward artistic and spiritual rebirth.

The ritualistic process of birth and rebirth, culminating in the sideshow scene in which Me is reincarnated as Princess Anankay, the Greek Goddess of Necessity, has its roots in the nonsense that permeates the play. In "An Imaginary Dialogue between an Author and a Public," printed on the dustjacket of *Him*, Cummings indicated that the play is predicated upon a certain kind of nonsense:

Public. What is *Him* about?
Author. Why ask me? Did I or didn't I make the play?
Public. But you surely know what you are making . . .

Author. Beg pardon, Mr. Public. I surely make what I'm knowing.

Public. So far as I'm concerned, my very dear sir, nonsense isn't every thing in life.

Author. And so far as you're concerned "life" is a verb of two voices—active, to do, and passive, to dream. Others believe doing to be only a kind of dreaming. Still others have discovered (in a mirror surrounded with mirrors) something harder than silence but softer than falling: the third voice of "life," which believes itself and which cannot mean because it is.

Because of its opacity, *Him* appears to be nonsense to the public. But to the true artist the play is impenetrable just the way life is impenetrable. The viewer must relinquish rational categories of analysis to experience the play the way he experiences life itself. Indeed, Cummings offered such advice to the playgoer: "Relax and give this PLAY a chance to strut its stuff—relax, don't worry because it's not like something else—relax, stop wondering what it's all 'about'—like many strange and familiar things, Life included, this PLAY isn't 'about', it simply is."[39]

Within the play, Him engages in nonsense to give free rein to his imagination. "Whereas this is what's untrue. . . . Anything everything nothing and something were looking for eels in a tree, when along came sleep pushing a wheelbarrow full of green mice."[40] His dialogue has a Dada cast not only because it is nonsensical but also because it refers to the nonrational processes of the imagination. This absurd motif of "eels in a tree" is picked up several times throughout the play, most significantly in that scene in which the unconscious is satirized. An episode of burlesque requires that suspension of rational faculties to allow complete enjoyment, to "relax," to find "eels in a tree."

Cummings inverts commonplace notions of nonsense with the "three Weird Sisters," Miss Stop, Miss Look, and Miss Listen. Serving as a chorus, and possibly as burlesque fates, they too engage in nonsense. Since their names suggest the antithesis of nonrational impulse, their prating becomes ironical. But the three Weird Sisters are not completely dead to the world, for they occasionally reveal insights about art. "Life is a matter of being born, Treat a man like dirt and he will produce flowers. Art is a question of being alive," incants the third sister as she reads Him's palm.[41] Out of the matrix of nonsense comes the knowledge that life, art, and suffering are intimately related.

The first play that Him stages for Me dramatizes the Dada process from negation to affirmation:

The action or content of Scene I consists of the curtain's rising, of its absence for one minute and of its falling. Darkness.

VOICE OF ME: Was that an accident? Or a scene?
VOICE OF HIM: Both I trust.
VOICE OF ME: Did it really mean something?
VOICE OF HIM: It meant nothing, or rather: death.

The emptiness of the stage corresponds to death until the creative process takes place. As for the eight remaining plays, they satirize a wide range of targets, from commercialism and Italian Fascism to a take-off on Frankie and Johnnie. These trial negations pave the way for affirmation. The final play concerning a gentleman with bread surrounded by hungry people suggests that giving and sacrifice are the prerequisites for rebirth.[42]

When Me gives birth, the act of human creation poses the ambiguities between art and life.

Him: . . . and what do you see there? (*Indicating the invisible wall*)
Me: People.
Him (*Starts*): What kind of people?
Me: Real people. And do you know what they're doing?
Him (*Stares at her*): What are they doing?
Me (*Walking slowly upstage toward the door*): They're pretending that this room and you and I are real. (*At the door, turning, faces the audience*)
Him (*Standing in the middle of the room, whispers*): I wish I could believe this.
Me (*Smiles, shaking her head*): You can't.
Him (*Staring at the invisible wall*): Why?
Me: Because this is true.

As Him noted earlier, his preoccupation, indeed obsession ("Damn everything but the circus!") with hermetic art, has sealed him into the four walls of the stage. "That beauty has shut me from truth; that beauty has walls—is like this room, in which we are together for the last time, whose walls shut us from everything outside." Despite his growing awareness, Him cannot transcend the walls of the stage, even after Me's revelation. Nevertheless, the barriers between art and life have paradoxically begun to break down, for as Theodore Hoffman the critic has noted, "In ritual and childbirth the fourth wall is not missing; the participants are themselves the play. The ultimate victory lies with Me. Me is the true author of *Him*."[43] And out of such understanding, Cummings established the dynamics of his future poetic creation.

9 | The Art of Assemblage

Except for Man Ray, American artists generally neglected assemblage during the early phase of modernism after the Armory Show. While they concentrated on painting in their efforts to learn the new pictorial language, Duchamp stimulated some limited avant-garde interest in assemblage by virtue of the *Large Glass* and the readymades. Although the dispersive nature of Dada—its rampant individualism and aversion to formal schools of art—militated against sustained and concerted work, Dada advocated open-ended experimentation and thus attracted the diverse talents of John Covert, Joseph Stella, and Arthur G. Dove to the possibilities of assemblage. And although these artists came independently to Dada and thus differed markedly from one another in the nature of their work, they nevertheless shared certain values in common with Dada. Imbued with the spirit of experimentation, they turned from painting (for which they are primarily known) to assemblage. Theirs was an anti-art gesture of radical proportions in America, as indicated by the ridicule that greeted Jean Crotti's wire portrait of his brother-in-law in 1916. Yet the Dada element in their works was not unadulterated, but was rather appropriated for their own pictorial needs.

This transformation of Dada was consonant with its own metamorphic nature and was particularly in accord with Duchamp's absolute tolerance for any creative effort. Thus, while Stella and Dove made significant contributions to assemblage at a time when its possibilities were generally ignored by other American artists, their success should be measured less by their close emulation of Duchamp or Picabia than by their ability to take a Dada attitude or idea and bend it to their own creative purposes. In contrast, John Covert appears to have been too close to his French friends ever to develop entirely his own artistic independence. Consequently, these artists disclose not only the undercurrents of Dada values in their work but

also the hazardous course that had to be maintained between the extremes of an acquiescence to European Dada, with a subsequent loss of identity, or an adherence to a debilitating provincialism. This was the same course that was independently taken by William Carlos Williams in his quest for authentic creation.

A cousin of Walter Arensberg's, John Covert returned from Europe in 1915 to the stimulating avant-garde circles of New York, where he met Picabia and Duchamp. Their subsequent influence, particularly Duchamp's ascetic aversion to the sensuous quality of brush and pigment, may be seen in the minimal color and linear understatement of his paintings. His canvases, however, tend to be either opaque or excessively ironic.[1] (Covert's paintings of dolls are perhaps an exception, for they take on an ominous air, cut off from their childhood innocence and dislocated in an ambience of fantasy, anticipating the highly erotic work of the Belgian Surrealist Hans Bellmer.) In contrast, Covert's constructions manipulate Dada values in ways accessible to the viewer.

Of the five works that survive, Covert's *Ex Act* is perhaps the most derivative, borrowing its formal play from Man Ray. The title, printed within the work, can be taken as a pun: in the Latin, "ex act" would indicate the former gesture out of which the assemblage comes to exist; read as "exact," however, the title alludes to the visual effects that are subtly deployed. The construction itself is made of plywood and cardboard. Swirling lines establish flat, monochromatic planes randomly integrated into four triangles that are cut out of the surface layer to reveal the board beneath, which is also painted so as to correspond with the abstract design on top. To be "exact," the viewer must discern the triangles matching the dominant pattern. Such manipulation of actual and illusory depth, with all its attendant ambiguities, mimes Man Ray's series of paintings and assemblages executed in 1915. Indeed, Ray's *Still Life*, *Interior*, and *Cutout* are all concerned with the problems Covert later considered in 1919. Although he may not have been aware of Ray's experiments, *Ex Act* suffers in the comparison, for it adds little to Ray's earlier statements, nor does it have sufficient plastic value in its own right.

Related to the curvilinear planes of *Ex Act*, *Brass Band* and *Vocalization* appear at first glance to depict music visually, in the manner of French Orphism, which had earlier been so confidently expounded

in *Camera Work*, during the Armory Show, by Picabia's analogy between musical laws and abstract painting. Despite the interpenetration of planes, neither of these constructions assumes a Cubist syntax. Moreover, the wooden dowels of *Vocalization* and the heavy string for the *Brass Band* are materials derived uniquely from Dada. Covert's use of string points especially to the actual thread that Duchamp sewed and glued onto one of his *Chocolate Mill* versions for the *Large Glass*. Both *Vocalization* and *Brass Band* are designed in abstract patterns which play against the concrete presence of the construction as an object—a prominent characteristic of many readymades. With the dowels in ordered and random clusters immersed in swirling patterns of paint, *Vocalization* offers a visual analogy to sound, expressed not only as the logical sequence of music but also as sheer noise. The more famous *Brass Band* strikes up the same analogy, with its bold design of thrusting and interlocking planes drawn by the string. But since the constructions are silent, their titles may also be taken ironically. The wit of *Brass Band*, for example, plays the viewer's expectation of vibrant colors, metallic and bright, against its monochromatic string, which absorbs, rather than emits, sound. In this instance, Covert's irony and innovative use of materials recast both Dada and Orphism into his own idiom.

Employing a similarly subdued palette, Covert's *Time* echoes Duchamp's concern with metaphysical concepts, reintroducing ideas into art, in contrast to *Brass Band* and *Vocalization*, which, despite their wit, are predominantly sensuous in their treatment of material. Covert continued to select unlikely material with a Dada eye, for *Time* was assembled with upholstery tacks that form linear patterns on the picture plane. Diagrammatic in conception, these patterns overlay a board which is replete with handwritten calibrations, formulae, random numbers, and even the points of a compass. Such pseudo-mathematical graffitti have their source, of course, in the greatest schematism of them all, the *Large Glass*. The irony of Covert's assemblage is twofold, suggesting not only the inadequacy of mathematical jargon to explain time, which lies outside the limits of rational discourse, but also the enigmatic tensions set up between the construction as a laconic object and its metaphorical implications.

Covert's *Weights* contrasts with the surface rationality of *Time* as well as with the somber tones of his other constructions. Three wooden manikins are suspended against the picture plane. Given their happy faces, the figures suggest the whimsey of a child's point of view. Gay

fir trees are painted green in the background, along with some random Roman numerals. The entire assemblage has an aura of fantasy. The title is problematic, however. As a verbal pun, "waits" are wandering singers of Christmas songs, an appropriate interpretation of the affirmative visual image. But "weights" as a designation of units of measure does not make particular sense, not even as a Dada gesture, for it bears no relation to the visual image.[2] And since the pun in no way lessens the construction's sentimentality, which is derived in large measure from its anecdotal nature, the work is weakened by the collision of inadequately controlled disparate values.

Before he gave up painting in 1923 to enter business, Covert contributed his collection to the Société Anonyme, of which he was the treasurer. As for his assemblage, the only one that stands forth unequivocally as an assured work, with its own pictorial integrity, is *Brass Band*, whose very strength reveals the essential weaknesses of Covert's relationship to Dada. To begin with, he generally failed to relieve the sobriety of a monochromatic palette by a quick wit or delicate elegance, as Duchamp was able to do. Nor was Covert's irony informed by a well-developed point of view. The varied nature of his work suggests that he was still seeking to visualize his own sensibility up to the time of his retirement from avant-garde activity. Like Man Ray's, his was a quest that required a firm grasp and understanding of the values and attitudes derived from Duchamp and Picabia. But unlike Ray, Covert had yet to develop the power to withstand Duchamp's domination so as to create in his own image.

In contrast to Covert, Joseph Stella was a perceptive and prolific artist established in his own right by the time he met Duchamp in 1915. Their differences become immediately apparent in a juxtaposition of Stella's *Brooklyn Bridge* (1918–20) and the *Large Glass*. Whereas Duchamp's work presents a mechanistic universe indifferent to human discourse, the Brooklyn Bridge is a means of communication, dramatized in a monumental painting to match the grandeur of its subject. Within the *Large Glass*, which keeps its distance from the viewer with a lucidity that encourages rational meditation, entrapped mechanomorphic figures play out an empty ritual of onanism. In *Brooklyn Bridge*, however, the viewer is caught up in a hieratic structure which is highly animated by color and rectilinear motion, metamorphic in design, as the image becomes an icon to modern technology.

Insofar as Stella's painting most readily evokes the "Atlantis" sec-

tion of Hart Crane's *Bridge* rather than the *Large Glass*, an appraisal of his work from Crane's perspective clarifies the Italian immigrant's place within the context of New York Dada. Like Crane and Waldo Frank, Stella identified with Walt Whitman when he conceived the Brooklyn Bridge as a "shrine containing all the efforts of the new civilization of AMERICA."[3] This mystic nationalism appealed to Harold Loeb, who reproduced *Brooklyn Bridge* in the first issue of *Broom*. For this as well as other reasons, Stella has been most persistently designated an American Futurist. Of course he had met the Italian Futurists in Paris, and when he returned to New York in 1912, he executed a number of large canvases that celebrate the energy and motion of the urban scene. Yet Stella shared with Crane a fundamental ambivalence about technology. An early magazine assignment to illustrate steel mills and mining in Pittsburgh in 1902 had deeply impressed Stella with the misery and poverty inflicted by industry, confirming his sense of the city as a modern Inferno.

On the whole, however, Stella managed to mute his despair throughout his work, which is imbued with the affirmation of artistic creativity. In an informal talk "On Painting," held at the Société Anonyme, and published in 1921 by *Broom*,[4] he asserted the artist's independence from tradition and enthusiastically acknowledged the diverse forms that creative effort might assume. He thus aligned himself with the avowed aims of the Société, which he had joined in 1920. Such attitudes, in combination with enormous energy, account for what would otherwise have remained a disparate body of work after the War: while he continued to explore variations of the Bridge as subject matter, he also painted enigmatic fantasies and erotic images of birds and flowers; and as for media, he turned from oil, crayon, and gouache to collage.

While Stella surpassed Crane in a stated willingness to experiment, he resembled the poet in being a visionary—indeed, perhaps, the visionary Crane himself would have liked to have been. This quality sustained Stella's artistic explorations which, regardless of medium and subject, remain interior explorations of the self.[5] In "Brooklyn Bridge," a brief monograph that was reprinted in *transition* upon Crane's suggestion in 1929, Stella described his mystical experience on the Bridge:

> Many nights I stood on the bridge—and in the middle alone—lost—
> a defenceless prey to the surrounding swarming darkness—crushed by

the mountainous black impenetrability of the skyscrapers—here and there lights resembling suspended falls of astral bodies or fantastic splendors of remote rites—shaken by the underground tumult of the trains in perpetual motion, like the blood in the arteries—at times, ringing as alarm in a tempest, the shrill sulphurous voice of the trolley wires—now and then strange moanings of appeal from tug boats, guessed more than seen, through the infernal recesses below—I felt deeply moved, as if on the threshold of a new religion or in the presence of a new DIVINITY.[6]

The passage is remarkable for the tensions that Stella sensed and sustained in his acquiescence to technology.

Just as the narrator of Crane's "Atlantis" has emerged from the horrific "Tunnel" onto the Bridge as night turns to dawn, so Stella stood on the Bridge as an intermediary between the stars ("fantastic splendors of remote rites") and the subway beneath ("the underground tumult of the trains in perpetual motion"). And like Crane's narrator, who discovered "the phonographs of hades in the brain" while in the subway, Stella felt the sounds of the trains "like the blood in the arteries." Ultimately, the painter's identification with the Bridge balanced affirmation against negation: his experience moved from an initial sense of being a "defenceless prey to the surrounding swarming darkness" to "the threshold of a new religion." His mystic awareness emerges from a loss of self in the night, replenished by a heightened perception of the environment. Here indeed was Crane's visionary, who could submit his creative powers to technology.

Earlier in *Broom*, Stella had expressed the attitudes that would permit such acquiescence when he claimed that the artist "belongs to his own time, he does not only accept it but he loves it—and therefore he can't go back to any past to borrow material."[7] "Material" here refers not only to subject matter but to the medium as well. Stella's love for contemporary material led him to the creation of collage, stimulated by Duchamp's use of common objects for his readymades. In the autumn of 1922 *The Little Review* published a Stella Number, including among the sixteen examples of his varied work not only his fine silverpoint portrait of Duchamp but also two collages, *The Bookman* and *Study for Skyscraper*. The latter, as it appears in the magazine, offers a radical departure from his mural study of New York. Comprised of various pieces of worn paper and cloth precariously piled one on top of the other against a plain background, *Study for*

Skyscraper makes a witty and perhaps bitter commentary on an urban America bent upon progress. A far cry from the idealized *New York Interpreted*, completed the same year, this collage approximates Duchamp's pessimism regarding modern technology.

An equally important influence on Stella were Kurt Schwitters' *Merz* collages, exhibited at the Société Anonyme as early as 1920. Although Stella's collages are difficult if not impossible to date exactly, some may have been independently conceived prior to Schwitters' exhibition. Moreover, unlike Schwitters' *Merz*, Stella did not use wood or metal but restricted himself to paper. What he did share with the German Dadaist was the quality of paper, mutilated and water-clogged, taken from the gutters as material for his collages. Schwitters' work ranges within an art/anti-art ambience, evidenced in the collection of the Société Anonyme alone. For example, *Merz 316* (1921) is a compilation of dirty scraps of brightly colored paper pasted together to suggest a piled-on effect, like some coagulation found in the street. In contrast to such anti-formalism *Merz 380: Schlotheim* (1922) delicately modulates colored and textured paper in a subtle geometrical pattern. Here Schwitters clearly emphasized the aesthetic qualities of the material rather than its identity as urban waste. In like fashion, Stella's collages resolve the art/anti-art polarities of Schwitters' work by presenting the aesthetic value of anti-art material.

Thus it would appear that Stella heeded the plea found on a magazine page that he borrowed for *Collage, Number 8*: "I would remove from music that atmosphere of esotericism, of sacred mystery, which is so dear to the mountebanks and the clowns of the profession." By using paper of a repulsive nature, Stella opened discourse between art and life. As if to emphasize his opposition to a sacrosanct art, he slashed this collage with visible brush strokes, vigorous reds, blacks, and blues, carelessly applied, which, at the same time, call attention to themselves as part of a nonrepresentational configuration. This tension between the concrete and the abstract animates Stella's collages, even those that appropriate material from American advertising. Since he was close to Duchamp, he could not resist an occasional comment on the creative process or the quality of American life, for he had witnessed industrial poverty at firsthand; but in the main, his collages are characterized by a wide variety of formal emphases which assume intrinsic aesthetic value. Indeed, it was precisely his preoccupation with the aesthetic dimension of experience that not only reconciled

his personal despair about urban life with his art, but balanced his inner tensions against the externalized creative act as well.

One major category of Stella's collages includes those that relate to American advertising and the products it extolls. Unlike Josephson, who was fascinated by the verbal and poetic qualities of the mass media, Stella explored the visual qualities of advertising slogans rather than their verbal content. His formalism is exemplified by *Collage, Number 21*, comprised essentially of an extremely grimy French advertisement for a pipe. The sheet appears to be accidently torn so that the various endorsements, set off in what were once white rectangles, now create asymmetrical patterns. To emphasize this purely formal aspect, Stella turned the advertisement upside down, thus diminishing, if not eliminating, its verbal meaning. (With similar intent, the "Luden's" cardboard packet of *Collage, Number 16* is turned on its side.)

Although the transformation of a Luden's cough drop box into art has its minor ironies, Stella was rarely ironic about advertising, as Hart Crane or E. E. Cummings were in their poetry. To be sure, a discolored theatre program of a play entitled "American Madness" is central to *Collage, Number 19*, but the aura of Dada hardly extends beyond the title, since Stella obviously emphasized the plastic aspects of the material—the contrasts of mottled textures against smooth fields, the subtle modulation of pastels, the play between torn and smooth edges.

Conversely, Stella did not glorify advertising or its products, except perhaps in *Telephone*, given his enthusiasm for modern communication technology. Here a glossy advertisement for Bell Telephone is framed by three layers of matting, harmonizing white tonalities with a tan texture. At the top of the advertising sheet, a printed image of a black telephone is partially cut off, as are the words of the caption beneath: "Their words have / as swift as ligh . . ." The implied speed of telephone communication, the verbal disjunction suggesting spatial dislocation (if not the possibility of being disconnected on the line), these connotations are lyrically reinforced by translucent washes of green, white, and red over the remaining small print of the advertisement, which provides a background texture.

In the collages that suggest advertising and technology, Stella preferred to explore an inner realm of experience. His choice of dark and grimy bits of paper creates a subliminal effect, with slogans emerg-

ing dimly out of discolorations as though from the far depths of human consciousness. *Gas Stations*, for example, a collage made in 1923, refers to a patch of a gasoline advertisement in which the faded lettering of "Esso" plays back and forth within the depths of a brown-gray mottled scrap of paper. Beneath this remnant, and tipped at an angle, is a water-soaked, distended match-cover extended full-length. Flakes of red correspond with the lettering of the Esso paper. Upside down, on one half of the exposed cover is a small printed image of a building, suggesting by poetic association the "gas station" of the title. Joined by a multilayered tan piece of paper, these adjacent scraps float upon a slightly textured off-white sheet with a smooth and elegant border of pastel yellow. In sharp contrast to their background, the three scraps appear suspended in a psychological space. Although the aesthetic quality of the collage mitigates the negative implications of the total image, *Gas Stations* joins Stella's *Study for Skyscraper* in their contrast to the surface affirmations of his earlier "Futurist" paintings.

Stella played variations on this floating structure in *Collages, Number 16* and *Number 3*. In the former, the cover of a Luden's cough-drop box, dark and discolored, is suspended vertically with a series of different colored rectangles. The borders of the latter are of varying widths and slightly askew, one against the other. The ensuing structural tension, combined with the projection and recession of colors, succeeds in suspending the Luden's cover. In *Collage, Number 3*, Stella subdued the tension while emphasizing the lyrical quality of the suspension of three Chicklets covers, again torn and discolored, yet showing bright green lettering with red circles. The Chicklets, one above the other, hover and interact, as they rest upon overlapping rectangular sheets of a subtle hue, the entire complex bordered by a maroon strip.

In addition to these effects, "Luden's" and "Chicklets" open discourse between the concrete object and its formal configurations, much in the manner of *Trumpeter*. The title refers to an open pack of Trumpeter cigarettes, situated upside down on the horizontal. Between patches and tears is a brand emblem of a horseback rider blowing a trumpet in the center segment of the unfolded package. By turning the image upside down, Stella partially eliminated its representational impact and emphasized the elegant intricacies of the bright red and green design. The packet rests upon a visually ex-

citing field of silver tin foil, entirely smooth except for some very subtle linear swirls or striations that Stella may have executed intentionally. There is no doubt, however, about the deliberate way in which he placed on the silver field a long piece of paper horizontally beneath the cigarette packet. A slender strip of tin foil shows through, demarcating the two. The lower paper, darker toward the right in its mottled shades of brown and gray, triangulates as if to point toward the right edge. With the silver foil background slightly tipped upward on a border of washed-out red paper, the dark arrow-form moves in a direction opposite to that of the Trumpeter pack. Contrasting textures combine with the carefully executed structure to create a striking collage.

Stella's advertising collages correspond to Josephson's Dadaist contention that advertising was a fruitful source for the artist. Although Stella declined to exploit it for its own properties, appropriating the material for his own aesthetic needs was a bold and successful gesture at the time. In a similar vein of formal exploration, the remainder of his collages are nonrepresentational. Few are imbued with any vestigial Dada values, although *Graph*, while sharing with the others a concern for subtle color modulation, offers a striking juxtaposition of sheets of paper which become increasingly worn toward the center. There is a marked contrast, despite the mild coloration, between the vertical geometry of the graph paper as the background and the worn-out mass in the center. In fact, the collage echoes Duchamp's *Unhappy Ready-made*, a geometry book hung outside on a porch to sustain the ravages of the weather.

Formal integrity was the major point, however, as Stella created art from anti-art assumptions—a point nowhere more obvious than in *Collage, Number 11*, in which, again, the textures of a totally abstract shape contrast with a smooth, clean background. (The latter, however, is subtly dislocated by two sheets, joined together or slightly overlapped.) The mass lies suspended, filling almost the entire field, completely abstract yet endowed with a concrete presence. Stella carefully peeled away certain layers and folded over others so as to create an organic network of tears and straight-edge folds, primarily horizontal, over which delicate shades of washed pastels harmonize. A brightly stained red fleck stands in the center of mottled whites as a visual accent. The transcendence of cast-off material into art testifies to the

strength of Stella's aesthetic sensibility, which was so central to his art of collage that it led him away from the Dada values of Duchamp to his own unique statement in what was then a radical medium.

Heading even further in the same direction, Arthur G. Dove remained relatively aloof from Duchamp and Dada activity in New York. During the 1920s he created twenty-five collages, assemblages to which he referred casually, if at all, as "things." What in all likelihood served him as a change of pace from painting has grown in critical acclaim over the years. Falling primarily into two categories of portraiture and nature studies, Dove's collages were inspired predominantly by Stieglitz and only tangentially by Dada.[9] By the same token, however, Dove's individuality as an artist and his sensitive feeling for nature informed a large number of his collages.

An early abstractionist inspired by natural forms, Dove began exhibiting at "291" in 1910 and continued with Stieglitz at An American Place throughout the Depression. That he owed allegiance to Stieglitz was made clear by an unequivocal tribute in *America and Alfred Stieglitz*, published in 1934. At the same time, given the strength of their relationship, Dove was surely attracted to Picabia's machine portraits in *291*. As the historian Robert Goldwater has suggested, Picabia and Duchamp "taught Dove . . . something of the ironical methods of Dada. In its spirit, but with a gentler touch, he carried out the collages of the 'twenties."[10]

Just as important, however, were Dove's attitudes about painting, which carried over to his assemblages. In reference to his abstract tendencies, he asked, "Why not make things look like nature? Because I do not consider that important and it is my nature to make them this way. To me it is perfectly natural. They exist in themselves, as an object does in nature."[11] By endowing his paintings with an autonomous existence akin to objects in nature, Dove drew closer to the attitudes of Cubism than to those underlying Duchamp's readymades. Nevertheless, Dove's views were easily applicable to assemblage, whereby literal objects rather than images upon canvas might exist in themselves.

Dove's approach both to painting and to assemblage was intuitive. In 1929 he lyricized, "To feel the power of the ground or sea, and to play or paint it with that in mind, letting spirit hold what you do together rather than continuous objective form, gaining in tangibility and actuality as the plane leaves the ground, to fly in a medium more

rare and working with the imagination that has been built up from reality rather than building back to it."[12] Indeed, the majority of Dove's nature collages start simply and inductively with a natural object—a twig, a leaf, a seashell—from which he intuitively and lyrically built up a work into an organic unity of associational values, away from Dada toward Stieglitz.

Informed by such attitudes and values, three portrait-collages relate mainly to Stieglitz. The first of these, a *Portrait of Alfred Stieglitz* (1925), is Dove's tribute to his mentor. As Picabia had done in 291, Dove appropriated parts of a machine, inevitably a camera, to characterize the photographer. A lens is glued against a cream-colored paper background which occupies the top third of this rectangular assemblage. Below, the circular form of the lens behind a photographic glass plate is repeated by a coiled steel spring. Juxtaposed against this spiral is an elongated piece of steel wool, perhaps humorously alluding to Stieglitz' sexual vitality. Unlike Picabia's version, in which Stieglitz' "ideal" is unattainable because of a broken camera, Dove's machine elements are held together by their associational qualities. The dominant matrix is provided by the aqua-blue tones of the plate glass, suggesting a mystic space with unfathomable depths that celebrates Stieglitz' "spirit," a quality both artists emphasized in their work.

Among the characters that Dove portrayed in his assemblages, *The Critic* (1925) serves as a bemonocled antagonist to Stieglitz. His body cut from the art page of a newspaper, the critic balances precariously on rollerskates, which are also paper cutouts, suggesting the slippery role of the art critic who lives by ephemeral fashion. Wearing a top hat perched on his vacant head, he clutches a vacuum cleaner: "This, Dove seems to imply, the vacant critic, plugged to the nearest outlet and armed with an unused monocle, careens into the velvet gallery, picks up the 'dirt' and blows it, through his column, at the public."[13] Significantly enough, the words "American Art" from a headline caption cover the critic's loins, thereby slyly suggesting Dove's opinion of American art as championed by the conservative critic. Although the content is reminiscent of Dada values, the narrative quality of the collage softens and transforms the strident protest so characteristic of Dada into humorous anecdote.

Allied to *The Critic* is *The Intellectual*, also of 1925. In this generic protrait there is an element of abstraction, for the constituent parts might be considered objects in themselves. But their relationship

with one another hints at a portrait of a human figure which becomes more apparent upon closer viewing. This representational tendency vitiates in part what might otherwise have been Duchampian irony arising from the tensions between object and metaphor. The "face" of the intellectual is comprised of an elongated chicken bone (certainly derogatory material) attached to a striated cloth background by two nails whose small heads form the metallic eyes. Above this uncomplimentary bone face looms a large magnifying glass which dominates the composition and distorts the striations of the background. Below the face is a piece of moss and a small handscale ("Excelsior Pocket Balance, Sargent & Co. U.S.A.") with its marker at zero. The scales are contrasted against a piece of brown wood. Clearly, Dove's satire here is directed against the intellectual, who weighs and analyzes all experience. His head is represented by the magnifying glass, which distorts what he sees by virtue of the excessive lucidity of his rationality. The geometric striations of the background contrast with the organic piece of moss, which reminds the viewer of nature, the criterion by which to judge the distortive rationalism of the intellectual.

Although many of Dove's collages as well as his paintings are devoted to nature, he occasionally treated the machine as well. And though he derived this iconography in large part from Picabia and Duchamp, he typically chose machinery which pertains to rural life: a *Lantern* (1921), a *Mowing Machine* and a *Gear* (1922), and a *Mill Wheel* (1930). His pictorial treatment of the machine has actually the same organic emphases as his abstract natural forms. *Lantern*, for example, offers contrasting forms of circles and verticals which do not appear precise or "machine-tooled" the way Picabia's do. The circles of the lantern beam are soft and amorphous, as though a part of nature.

Dove constructed only one collage depicting the machine, *Hand Sewing Machine*, assembled in 1927. A domestic machine that was typical of Dove's sensibility, the *Hand Sewing Machine* but faintly echoes Man Ray's *Enigma of Isadore Ducasse*, seven years earlier. Dove's collage is scarcely surreal, for there is no juxtaposition of disparate objects, no "chance meeting between a sewing machine and an umbrella," to quote Lautréamont's famous phrase, which Dadaists and Surrealists alike were fond of reiterating. Though the viewer will not be shocked by what was once considered anti-art subject matter, there is the surprise of aesthetic perception, which

raises some provocative questions about art and reality in the manner of Duchamp's readymades and Ray's Dada paintings.

What appears at first glance to be a painting on canvas turns out to be a collage constructed on a metal background, so appropriate for the machine. Actual canvas is sewn to the metal to serve as the cloth for the sewing machine. Except for the natural color of the canvas, the colors of the assemblage are monochromatic: the black of the sewing machine itself is set against a brown and gray background, through which scored and scratched metal is occasionally revealed. Yet the use of a monochromatic palette does not serve to call attention to formal matters, as the Cubist works did. Instead, the dull coloring and the visible under-sketching lend an air of hastiness, a half-finished quality, to the assemblage, relating it more to Picabia's sketch for *291*, *La Fille née sans mère*, rather than to his finished and precise machine portraits.

This assemblage is also reminiscent of Duchamp's very early *Coffee Mill* of 1911, that unobtrusive kitchen device turned slightly demonic. Indeed, the motion of the coffee-grinder's wheel corresponds to the vertical blur of the sewing-machine arm as it moves up and down, while the slight distortions of representation slyly poke fun at the machine, which is expected to be precision-built. Recalling Cubist dislocation of form, the sewn canvas runs through the arm of the machine and lends an irrational aura to the total image, as the sewing machine becomes cannibalistic, turning upon itself. Ultimately, the painted machine exists around—and accomodates itself to—the sewn canvas. Illusion interacts ambiguously with reality much in the manner of Duchamp and Ray.

Of the three artists, Dove owed least to Dada, although he was certainly not a home-grown naïf. Though his success in collage lay in his capacity to use aspects of Dada for his own ends, a careful balance was necessary. De Zayas had earlier warned that art might block sensitivity. Close as Dove was to Stieglitz, emphasis on "spirit" or sensitivity occasionally led to sentimentality—in *Grandmother* and *Miss Woolworth*, for example, both of 1925, and which have cloying overtones. But by setting aside preconceived notions about art and using a wide range of material, Dove managed to exercise his sensitivity fully in many of his other collages. Taking his cue from Dada irony, combined with his genuine feeling for nature, Dove constructed a number of

assemblages of exceptional merit, most significantly *Portrait of Alfred Stieglitz, Hand Sewing Machine*, and *The Intellectual*, in which Dove kept both narrative and sentimentality to a minimum.

After these nascent attempts, assemblage lay quiescent long after the Second World War only to reappear full-blown in the guise of Pop Art. Although contemporary artists had to rediscover Dada and assemblage for themselves, there was one link between Pop and early twentieth-century American assemblage, provided by Stuart Davis, whose early cigarette paintings were influenced by Dada assemblages and Man Ray's intermedia experiments. Davis' significance for Pop lay not simply in his commercial subject matter but also in the way it was executed.

A close relationship existed between the collages and paintings in the total *œuvres* of Covert, Stella, and Dove, as it did in the works of their younger colleague, Stuart Davis, even though only one of his collages has survived, a work enigmatically entitled *ITLKSEZ*. Inspired by the anti-art materials of Picabia's collage *Midi*, Davis felt liberated "to sew buttons and glue excelsior on the canvas without any sense of guilt."[14]

Even were *ITLKSEZ* to be set aside as a mere Dada experiment, the concept of collage was important for Davis in a series of cigarette paintings he executed in 1921: *Lucky Strike, Cigarette Papers*, and *Sweet Caporals*. Instead of actually making a collage out of cigarette packets, as Stella did in *Trumpeter*, Davis chose to copy the packet carefully in oil or watercolor so as to achieve a striking visual effect by enlarging the image on the canvas. The sources for that endeavor were twofold. While Duchamp's *Fountain* for the 1917 Independents powerfully suggested the use of commonplace material, Man Ray's manipulation of both collage and painting, evidenced by their ambiguous discourse in *The Rope Dancer* and *Revolving Doors*, might have provided Davis with the necessary formal means four years later, in 1921. At the same time, the commercial nature of his subject, differing in kind from the raw American scene of the Ashcan School, with which he had strong ties, slightly anticipated yet corresponded to Matthew Josephson's plea for American artists to pay attention to advertising. Far from misunderstanding the nature of collage, Davis extended his sense of formal means, media, and subject matter in this important series of canvases, setting the stage for his later paintings, which forcefully ap-

propriate slogans and commercial products in complex formal design, the alpha and omega of his art.

The evolution of Davis' art from those early efforts also lends perspective to Pop. Differing from them in terms of boldness of means, proliferation of materials, direct exploitation of mass media, and a wide range of irony and wit, Pop art would seem to have fulfilled the promise of America's first modernists and their Dada attitudes, whose assemblages, however, appear conservative by contrast. Although Covert, Stella, and Dove appropriated anti-art materials and deployed both irony and wit, they kept some distance from Dada for several reasons. To begin with, the key to their success lay in the degree to which they could maintain a balance between Europe and America — an equilibrium determined less by the exacerbation of a Williams than by their own artistic maturity prior to their awareness of Dada. Moreover, even though all three artists were flexible enough to be amenable to an exploration of the possibilities of assemblage as suggested by Dada, only Stella and Dove retained sufficient artistic integrity and a sense of their own identity to assimilate Dada values into their own works. The results were mixed, insofar as traditional or provincial values were bound to collide with the destructive innovations of Dada. So it was not until forty years later, with Dada supposedly in its grave, that American artists were able to turn once again to assemblage, this time with a confidence based upon a tradition of innovation that had been built up slowly by their American predecessors.

10 | Painting the Machine

Morton Schamberg and Charles Sheeler, who shared a studio in Philadelphia, where they had been students of William Merritt Chase, kept a careful eye on avant-garde activities in New York. The 1913 Armory Show was, to be sure, a major event and turning point for them, particularly since Sheeler had been invited to exhibit six paintings. Subsequently, they met Walter Arensberg and were drawn into his circle of artists. Schamberg maintained such ties from a distance until his premature death in 1918. A year later, Sheeler moved to New York and worked at the Modern Gallery, directed by Marius De Zayas. Earlier, he had often been joined by another artist from Pennsylvania, Charles Demuth, who preferred, however, to commute between Lancaster and New York. All three artists gravitated to Picabia and Duchamp, who strongly influenced their work.[1] Of course, each of them derived a different complex of values from their association with the two Frenchmen. Most important, however, was their ability to assimilate Dada values into their art without sacrificing their identity to the powerful forces of attraction that Picabia and Duchamp exerted on the New York avant-garde during the years of the First World War.

In 1916 Morton Schamberg finished eight canvases with a central machine motif.[2] This departure from conventional subject matter was perhaps precipitated by his having viewed the Picabia paintings on exhibition in early January at the Modern Gallery. But moving as he occasionally did among New York's avant-garde, and being a close associate of Sheeler, who was familiar with the New York art scene, Schamberg was probably aware of the work of Duchamp and Picabia prior to 1916, especially the latter's machine drawings for *291*. And of course, even earlier, *Camera Work* had published its share of enthusiasts for the machine in art, an attitude that *The Soil* would later promulgate in 1916.

Schamberg, then, must have been amenable to these ideas as early as 1913, when he began taking photographs to supplement his income. De Zayas had claimed that Stieglitz "married Man to Machinery and he obtained issue," a metaphor which also applied to Picabia. Capable of seeing the connection independently, Schamberg was open to creative efforts which appeared to run counter to established cultural notions of beauty. "The laws of beauty, like the laws of life, are capable of so many variations and combinations," he asserted in a brief explanatory note for the Philadelphia *Inquirer*, "and as each human being is capable of perceiving only certain of these, that which is beautiful in both art and life to the man with the greater sensibilities is frequently discordant or ugly to those whose limited perceptions grasp only the more elemental laws, or at least until time and familiarity have forced a certain degree of acceptance."[3] To be sure, Schamberg offered the standard arguments about the existence of laws governing modern art in order to allay the fears of a public which could discern only anarchy. But he also related art to life and indicated his tolerance for the new. Schamberg thus anticipated his openness to the radical departures of Picabia and Duchamp.

Except for his appropriation of what at the time was considered unsuitable subject-matter, Schamberg was not intensely opposed to cultural norms in his pictorial treatment of the machine. Although the general public of course rejected him for associating with the avant-garde, he, unlike Duchamp, did not assume an ascetic, antipainterly stance to reintroduce ideas back into art, nor did he attempt to grasp the machine directly, eliminating the barriers of art, as De Zayas claimed of Picabia's machine drawings for *291*. Rather, Schamberg channeled the restless eclecticism of his previous work into varied plastic responses to the machine. Running through his final paintings are vestigial elements of irony, wit, and eroticism. While these canvases show strong traces of Picabia's machine style, Schamberg appears to have been deliberately elusive, and occasionally ambiguous, in his expression of Dada values by way of machine iconography. In fact, the key to an understanding of his works lies in the plastic qualities of his art.[4] Rather than raise the aesthetic questions that Picabia's and Duchamp's experimentations deliberately provoke in the viewer, he preferred to explore intuitively the plastic and formal dimensions of the machine, inflected among varying shades of Dada values and attitudes.

Schamberg's own range of attitudes can be seen if one contrasts

God, constructed in 1918, to an undated earlier painting called *Studio Interior*. The former is an assemblage, with a convoluted and tarnished brass plumbing trap set in a miter box. Its ironic title, echoing the mechanistic universe of Duchamp and Picabia, suggests a direction that Schamberg might have taken had he lived. But unless the title is taken as an expletive, its irony is rather heavy-handed, so that the sculpture is best considered an isolated instance of Schamberg's attempt at overt Dada irony, brought on, perhaps, by domestic problems with a sink. On the other hand, *Studio Interior*, a painting which includes a corner sink, is a Fauvist exercise in color, its subject matter being of secondary importance. The sink stands at the center of the painting for compositional purposes, and is given little emphasis, ironic or otherwise, as a product of twentieth-century technology.

Schamberg occasionally vacillated between symbolic and formal considerations in a single painting. For example, *The Well* of 1916 ambivalently shifts back and forth from sexual tonalities to structural values without ever settling upon one or the other, or accommodating the two. By concentrating on the isolated image, a Picabian device, the machine-forms exist in a mysterious ambience of blank discontinuity. A large rod descends into (or emerges from) a dark hole, presumably a well. But instead of providing a logical element, the rod only serves to increase the irrationality of the machine by its erotic overtones. There are, moreover, masculine-feminine ambiguities: the phallicism of the rod is obvious, whereas the machine casing suggests either male or female genitalia.

Yet it is difficult to determine whether or not such symbolic manifestations were deliberate, in the manner of Picabia's mechano-eroticism. Not only do these sexual elements exist in Schamberg's painting without explicit comment, but they are further obscured by formal considerations of a tentative nature. Schamberg sketched the forms before he painted them over with oils, as evidenced by some pencil tracings at the top of the well. Although the unfinished appearance of the painting might suggest the absence of art in the machine world, such hints are superseded by Schamberg's attention to the actual formal structure of the machine image: the well, the rod, and its casing exist in three-dimensional perspective. Yet the curved band of the casing loses structural perspective and gains a spatial ambiguity in relation to the disk at the top of the composition. Likewise, the flat white area within the casing (bisected by the black rod) rests on the

picture plane, thus emphasizing the abstract quality of the machine. This abstraction is further enhanced by the elegance of the rod and the linear curves. Although Schamberg's play with the picture plane and his use of monochromatic colors owe a small debt to Cubism, the form is more geometric than Cubist. He stressed the formal qualities of the machine to offset what could have become blatantly erotic. As the picture stands, however, the relative value of these two constituent aspects remains indeterminant.

The ambiguities of *The Well* are more or less resolved in his *Mechanical Abstraction*, which has a strong structural presence. Schamberg borrowed the morphology for this particular machine from Picabia's sketch for *291: La Fille née sans mère*. Like Picabia's mother-daughter, Schamberg's machine arches up out of the background. But Schamberg appears to have explored the interior of a machine with tightly interlocking parts, whereas Picabia's daughter is a loose conglomeration of springs, rods, and wires. In his most significant divergence from Picabia, Schamberg not only suppressed the rampant eroticism but also drained the image of its wit and irony. Although the function of the machine is clearly suspended, its parts do not feed on one another in an ironic mockery of the rationality which supposedly animates technology.

By eliminating the machine's function, Schamberg turned from Picabia and Dada to formal structure and plasticity. Whereas Picabia's minimal sketching was derived from anti-art preoccupations, Schamberg asserted his artistry with a conspicuous brushstroke. In certain areas of the canvas he achieved a sculptured effect with a deep blue impasto, as though recalling his early training with William Merritt Chase. Despite the tightness of the structure, the image has a heavy linear movement, as lines and templates converge in the center of the machine. Thus the suspension of mechanical function emphasizes not the irrational but the aesthetic relationships among constituent parts, so that as the machine emerges from the surrounding gray space, it dramatizes the birth not of a mechanical "organism" but of an artistic creation.

By way of contrast to the painterly, almost sculptured iconography of this *Mechanical Abstraction*, a similarly entitled canvas applies Picabia's precise linear style to a diagrammatic cross-section of the machine, exposing its geometric rationality. Picabia, however, was ironic about rationality, dissipating it before the crazy *non-*

sequiturs of the apparatus. To be sure, Schamberg's machine is also dysfunctional, even though it retains a rational geometry. (An element which might possibly represent a fan-belt, for example, is disjunct so that the flywheel cannot possibly turn.) But far from making ironic commentary, such mechanical discontinuity releases the iconography from its pragmatic vise in order to exist as an object for aesthetic contemplation.

Schamberg used barely visible brushstrokes in clearly articulating machine-forms against a subdued background. It would appear at first glance that Schamberg had attempted to remove himself from the painting so as to let the machine stand for itself, thereby following De Zayas' view that art hinders direct confrontation with the machine. Yet, on the contrary, an ascetic stance toward the medium is subordinate to the elegance and refinement of the forms which Schamberg himself envisioned and lucidly depicted on canvas. In other words, the machine ultimately exists through the artist's sensibility, with his presence manifested in terms of line and color. Thus the machine appears almost two-dimensional on the picture plane, as muted reds subtly play against gray rectangles so as to project forward from the surface. The carefully chosen colors harmoniously interact in a meticulously developed structure. Circles within circles are broken by vertical rectangles, which in turn are modulated upward by interior rectangles of varying sizes. The entire machine rests upon a truncated triangle with a tightly structured complex of interlocking rectangles that open up as the eye moves upward—a visual device that Schamberg used elsewhere but perfected here.

Schamberg clearly paid great attention to detail in this painting. A band that curves upward in an arc from the machine, thereby relating it to the surrounding space, concludes with an elegant swirl. Similarly, colors enhance the elegance of line. For example, the second basic rectangle, off-center to the right in the composition, is a gray that is darker than its slim gray border. And within this gray field, an elegant, lighter gray line curves gracefully downward to meet an amorphic shape which is white. These delicate tonalities are combined with a subtle asymmetrical structuring to create a quiet sense of motion in repose. The entire complex, bearing little or no relationship to actual machinery, takes on significance almost entirely because of Schamberg's harmonious delineation of aesthetic details. In this, his best effort, he successfully manipulated Dada values to release and transform the machine into the realm of art.

Like Schamberg, Charles Demuth was something of a dandy. And yet, whatever incongruities existed in the fastidious Demuth's defense of Duchamp's vulgar urinal for the 1917 Independents, they were superseded by his concern for avant-garde principles. Having contributed a poem to *The Blind Man*, Demuth also wrote a sardonic letter to Henry McBride, a sympathetic art critic, calling for a new exhibition. Demuth thus indicated his willingness to make a concerted effort within the avant-garde community to uphold free artistic expression against critical censorship.[5]

Not only principle but kinship of temperament brought Demuth and Duchamp together. Equally cosmopolitan, the two enjoyed drinking together in Harlem, and in 1919 Demuth celebrated one of such occasions in a watercolor entitled *At "The Golden Swan" Sometimes Called "Hell Hole."* But the most significant aspect of their relationship was the ironic perspective that they shared and that extended to their work. Demuth, however, was a complex artist of varied tastes whose detachment from his colleagues enabled him to maintain his own identity as an artist apart from Duchamp. Thus both men were independent and yet had a set of common values and attitudes which contributed to their friendship.[6]

Duchamp's *Large Glass* was one of the sources for Demuth's Cubist-Realism. As Demuth himself once claimed, "the big glass thing . . . is still the great picture of our time." And, indeed, his own linear style, characterized by rays that transect the picture plane, combined with translucent watercolors, creates a fractured surface which is reminiscent of the *Large Glass*.[7] Furthermore, Duchamp directed Demuth to the machine. Like Sheeler, however, Demuth turned to the landscape of the machine—the factory and its urban milieu. But his attraction to the industrial environment was also a result of his general interest in architecture, even that of the eighteenth century, as exemplified in his canvas *After Sir Christopher Wren* (1920).

Demuth was, of course, opposed to academic painting, yet he did not embrace the rampant anti-art values of Duchamp. Since his admiration for the *Large Glass* focused mainly on its linear and transparent elegance, he espoused neither a painterly asceticism nor an abdication of the artist's role. Thus, Demuth's 1920 tempera, *Box of Tricks*, demonstrates his acceptance of the artist's power of transformation. On a purely visual basis, the ambiguously depicted church or mill, with its surrounding landscape, reveals the artist's presence, his shifting sensi-

bility. Then, too, Demuth's use of the ray invites the viewer to analyze the painting on an aesthetic level. Although it is not as opaque and impenetrable as some Cubist works, the rays lend it a structural ambiguity. The sky, for example, consists of intersecting lines which create dynamic planes integrated with those of the buildings. Thus, by using flat tones for the fractured planes of the sky, Demuth emphasized structural rather than representational values. Moreover, the rays create a vibrant space, given their surface movement and rhythm in the composition.

Most significantly, Demuth left an uneven but sharply articulated white border on three sides of the painting. Although at first glance, it suggests sparseness, the border actually serves to emphasize the painted area as tempera on the surface plane. While this aspect is in tension with vestigial allusions to Renaissance space, the overall effect, including the arbitrary discontinuity between paper and painting surfaces, suggests that Demuth was quite willing to assert himself as an artist. The title, ironically referring equally to the church or to the factory, also points up the artist's powers as a magician, the man who can transform actuality into his own aesthetic vision. Indeed, the very choice of metaphor for the title suggests a complex of values which were part of Demuth's sensibility and consonant with Dada.

Modulating the industrial landscape for his own visual purposes, Demuth occasionally approached the machine itself with an ironic eye. His painting of 1920, entitled *Machinery* and dedicated to William Carlos Williams, is close in spirit to the works of Duchamp and Picabia. The image represents a large factory ventilating system in front of a wall that has some windows. Dislocated in space, the imagery assumes a dimension of fantasy, which is further reinforced by sinuous and erotic tubing. At the same time, the tank appears awkward and bulky despite the rays which break up its surface to create flat planes. The discrepancy between representation and abstract form would seem to have been deliberate, intentionally undercutting the eroticism of the tubes.

Why Demuth inscribed the painting to Williams is difficult to ascertain. The two had, of course, been friends since school days, which might account for the inscription. Yet the painting's kinship to the sardonic tone of Picabia and Duchamp at a time when Williams was growing hostile to their influence suggests that Demuth might have gained a perverse pleasure from his dedication. Moreover, in an essay of the previous year, Williams had vehemently declared, "I don't give

a damn about airplanes and airplane poetry but I do give a damn about
the distraught brain that must find its release in building gas motors
and in balancing them on cloth wings in its agony."[8] Demuth's motive
in painting the machine, which is the visual equivalent of "airplane
poetry," may have been to mock, with an undercurrent of erotic wit,
Williams' romantic notion of a "distraught brain."

The relationship between painter and poet is more clearly artic-
ulated in Demuth's famous oil *I Saw the Figure Five in Gold*, com-
pleted in 1929. Eight years earlier, in 1921, Williams had published in
Sour Grapes Demuth's prototype entitled "The Great Figure":

> Among the rain
> and lights
> I saw the figure 5
> in gold
> on a red
> firetruck
> moving
> with weight and urgency
> tense
> unheeded
> to gong clangs
> siren howls
> and wheels rumbling
> through the dark city.[9]

Following the narrator's perceptions in the poem, Demuth painted
the numeral five, borrowed the red and gold colors, and set the street
scene at night.

While the painting is a depiction of the poem, Demuth also in-
tended it as a poster-portrait of Williams. With its connotations of a
Sears catalogue and its machine as subject, the work was derived as
much from Picabia's earlier machine portraits for *291* as from other
sources. In addition to suggesting Williams' outspoken personality
by virtue of the bright colors and a forthright articulation of form, the
painting is also a portrait of Williams as poet. The bright, smoothly
painted colors and hard-edged forms suggest further that he wanted
to present a visual counterpart not simply of the poem but of the epis-
temological assumptions informing the poem—Williams' intense
desire to make "contact," to capture experience, to achieve absolute
clarity of perception in his writing. Hence the billboard effect of the
number five, repeated twice for emphasis, and the suggestion of speed,

all of which, along with the modulations of gold, the bright fire-engine reds, and the aggressive recession and projection of forms, visually dramatize Williams' sense of the artist's relationship to the life around him.

There were, to be sure, fundamental differences in the works of Williams and Demuth. Demuth, for example, did not underplay his role as artist in this particular painting as Williams had proclaimed he was doing in his poetry of that time: the use of color, the rhetoric of form, and the printed signature "C. D." in the corner, all indicate that Demuth was consciously asserting himself as an artist, not wishing to abdicate the role in favor of grasping experience directly. Moreover, there is little, if no, art/anti-art ambiguity in the painting, despite its smooth edges and hidden brushstrokes. Demuth's "Great Figure" reflects, however, his attempt to achieve an American art, a quest he shared with Williams. As he wrote Stieglitz in 1929, "My red and gold picture is about finished and I'll send you that in two or three weeks, — as soon as it's fit to travel. It looks almost American. I hope that it will to you."[10] Even earlier, Demuth had concentrated on what he considered to be American themes, as evidenced by his watercolors of vaudeville and the circus, paralleling the interests of Hartley and Coady. And his insistence upon living in Lancaster, Pennsylvania, which was probably as much psychological as anything else, suggests nonetheless his desire for "contact" with a particular area, the "local," as Williams would say.

But Demuth's longing for an American art was full of ambiguities. He knew as well as Williams that America was a "bastard country." Upon his return from Paris in 1921, he wrote haltingly to Stieglitz, "It was all very wonderful, — but, I must work here. Had I stayed in France when I went to it for the first time, — by now, I would be in to it. It would take years, — and after all there are many able Frenchmen, — and, New York is some thing which Europe is not — and, I feel of that something, awful, as most of it is. Marcel and all the others [s], those who count, say that all the 'modern' is to us, and, of course they are right, but: it is so hard." Despite the difficulties of creating art in a country thought to be without tradition, Demuth could say, "I feel 'in' America," however "empty" he found "its insides."[11]

Such ambiguity of disaffection and attraction clearly accounts for the ironic titles that Demuth gave to some of his works. Although he claimed to prefer the visual autonomy of art to the verbal and literary

aspects of his paintings, his irony nevertheless emerges from the tensions between the verbal titles and the visual image. Unlike Stuart Davis, a younger contemporary, Demuth's use of verbal elements within a painting had less to do with pure visual design than with verbal connotation—that is, to the referential meaning of words.[12] Thus to entitle a painting *Aucassin et Nicolette* is to make a literary allusion; to use William Carlos Williams' name in *I Saw the Figure Five* is to remind the viewer of Williams the poet as much as to take the configuration of his name for its purely visual, formal values. In those paintings which employ verbal irony, then, another affinity with Duchamp is revealed—the effect of breaking the visual autonomy of the painting itself.

Sometimes the meanings of Demuth's ironic titles are clear. *Business* (1921), for example, depicts a calendar with distorted shadows of industrial buildings cast upon it. The lock-step of a business schedule is at odds with the valuable passage of time. Business, moreover, is concerned with the regulation of time, pointing up the adage, "Time is money." Similarly, *Incense of a New Church* (1921), which depicts the dark, billowing fumes from factory smokestacks, points up the cultural differences between industrial pragmatism and medieval religion.

At other times, however, Demuth's irony was related more to Duchamp's "meta-irony," or irony of difference, and derived from what Demuth thought Americans felt about art: "American doesn't really care,—still, if one is really an artist and at the same time an American, just the not caring, even, though it drives one mad, can be artistic material."[13] *Aucassin et Nicolette*, for example, juxtaposes two industrial smokestacks, with the sexual implication of the title an echo of Picabia and Duchamp, emphasizing the discrepancies between the mechanistic world of today and the romantic values of yesterday. But since Demuth was surely aware of the parodic elements that medieval narrative of courtly love, his implicit criticism of the modern world becomes ambiguous, with the criteria for indictment constantly shifting.

If the painting is viewed in relation to *My Egypt* (1927), the irony becomes even more ambiguous, suggesting not only the ironic differences between the romantic past and a pragmatic present, but possibly Demuth's attempt to create a past for himself as well. *My Egypt* certainly cuts both ways. On the one hand, the title can be taken ironically,

contrasting the grain elevators of rural America with the monumental and exotic grandeurs of Egypt. But, the painting also suggests that America does indeed have a past, that the grain elevators are modern American monuments. They are also a reminder of the American soil, as fertile as that of the ancient Nile. Indeed, the rhetoric of the composition, the towering and bulky elevators bathed in a rich blue, would certainly suggest an affirmative interpretation as much as the former.

Like Schamberg, Demuth did not engage in anti-art attitudes, but preferred instead to exert fully his prerogative as an artist to transform actuality. Diverging from Schamberg, however, he concentrated less upon the machine itself than on its technological environment. Working more with verbal than with visual means, his irony also differed from Schamberg's. While their work shared elements of indeterminacy, Demuth's appears to have been consistently and deliberately controlled even in his most symbolically opaque paintings. Most importantly, perhaps, Demuth developed his own sense of wit, elegance, and irony, so that the sensibility evidenced in his works became truly commensurate with the attitudes set forth by Duchamp.

Even more than Demuth, Charles Sheeler has become known for his landscapes transformed by technology. If his later efforts were successful in a style that was neither Cubist nor realist (nor, for that matter, any combination thereof), his work evolved out of his early experiences, conditioned by the art/anti-art stresses which animated the Stieglitz and Arensberg circles. Faced with the bewildering possibilities of modern art as early as 1909 during his European trip with Schamberg, Sheeler gradually became a formalist, allowing the structural aspects of his subject matter, carefully chosen for precisely those qualities, to establish the basic design of his painting. Before achieving his own style, which took almost forty years, Sheeler had to assimilate a complex of sources which vied for his attention in the decade after the Armory Show. The presence of Picabia and Duchamp, the studies of his American colleagues Demuth, Schamberg, and Ray, the straight photography of Stieglitz and Strand, the ideas of De Zayas, Coady and Williams, and then Loeb with the *Broom* group—all those exciting possibilities confronted Sheeler in his quest for style.[14]

Sheeler's early reactions against the technics of brilliance, symbolized by the virtuoso brushstroke of his teacher William Merrit Chase, led him to an appreciation of structure and design in the

Italian masters he saw in Europe. Sheeler thus came to recognize the importance of composition, what he later referred to as "an architectural-like structure," an appropriate simile in light of his own choice of the industrial landscape as the subject of his paintings. And his study of the Italians provided a foretaste of what the Paris moderns would offer: "We realized that a picture might be assembled arbitrarily, with a primary consideration of design, that would be outside of time, place or momentary conditions."[15]

Eventually, he became fascinated by the similar pictorial orientation of the Cubists and the Fauves, whose work required slow absorption and had gained no more than intellectual acceptance by the time of the Armory Show four years later. According to Sheeler, the main obstacle to his understanding lay in the nonrepresentational dimension of the canvases by Picasso, Braque, Matisse, and Derain, whose works, however, were decisive in his development as a painter. "An indelible line had been drawn between the past and the future," he claimed. "And I was pointed in a new direction with an entirely new conception of a picture."[16]

For an artist who would never forsake the tangibilities of the external world, natural or man-made, the nonrepresentational tendencies of the Fauves and Cubists raised disturbing problems. Underlying their modernist explorations, moreover, was a concept of the artist equally foreign to that of Sheeler at the time. In this respect, his reactions against Chase were counterproductive, for although they led him to modern art, they also created an attitude which prevented him from accepting the manipulative role of the artist as explicitly manifested in the Cubists' analytic explorations of form and in the Fauves' arbitrary use of color.

As a result Sheeler's art vacillated between representation and abstraction. At first he attempted to explore abstract forms with little reference to nature. "Following the Armory Show and largely influenced by it, my work dealt with abstract forms," he asserted. "Sometimes with a clue to natural forms being evident, but quite as often without that evidence. Always, however, derived directly from something seen in nature." This move toward abstraction lasted until 1917, when he turned back toward representation. Henceforth his paintings exhibited varying tensions between the two: "Gradually in the years following I came to believe that a picture could be built having incorporated in it the underlying principles of structural design implied

in abstraction, the sharply focussed attention of isolated forms and be presented in a more realistic manner."[17]

Sheeler's belief was based upon the assumption that the external world possessed "an underlying abstract structure and it is within the province of the artist to search for it and to select and rearrange the forms for the enhancement of his design." This assumption was conceivably valid in itself; yet coupled with his distrust of the artist's role, it took on anti-art proportions. In other words, Sheeler hoped to be a modernist, but refused to assert rigorously an artist's prerogatives. Abstraction, he thought, could be achieved simply by following representational motifs. Only when he realized that the artist must dominate his representational sources did his paintings begin to achieve what he later termed a "vision of the facts as well as the facts."[18]

In the meantime, Sheeler's ambiguity about formalism was complicated by the concepts of straight photography set forth by Stieglitz and De Zayas. Taking up the camera in 1912, Sheeler soon became an adept adherent of straight photography, a visual approach which understandably affected his painting. Stieglitz had forcefully argued that photography was not an art like painting at a time when photographers seemed intent upon imitating painting, and to the detriment of the photographic process. By asserting their essential differences, Stieglitz wanted each medium to develop its own creative possibilities. But whereas Stieglitz accurately prophesied that the camera would free painting from representation, Sheeler persisted in emphasizing factual content in his painting.

Of course, Sheeler could discern differences between painting and photography. "Among other qualities peculiar to it," he noted, "photography has the capacity for accounting for things seen in the visual world with an exactitude for their differences which no other medium can approximate." Just as this statement represented the straight photographer's credo, Sheeler also stressed the mechanical character of photography. A camera could record an image in an instant, whereas a painter required the duration of time. "Because of these differences between the two processes in delivering their final results," he argued, "it would seem to make invalid the term photographic, as descriptive of a type of painting, and furthermore it would seem to make the encroachment of one upon the territory of the other, impossible." To bolster this point, he offered yet another distinction: "Photography is nature seen from the eyes outward, painting from the eyes inward.

Photography records inalterably the single image while painting records a plurality of images wilfully directed by the artist."[19]

But such statements were made in the mid-1930s, when Sheeler was writing his autobiography. At that time he had begun to assert the active role of the artist in bending the "facts" of the external world to his vision. From 1925 to 1931, however, photography was one of his major preoccupations. During that period Sheeler wanted to develop his skills as a straight photographer, "for the better statement of the facts." Such goals, however, were no different from those he pursued in painting the famous *Upper Deck* of 1929, "still further intent upon precision of the subject seen in nature." He claimed nevertheless that this work signified a major departure from his previous methods: "With this painting it became my custom to build up gradually a mental image of the picture before the actual work of putting it down. Something seen which keeps reoccuring in one's memory, with insistence increasingly vivid, and with attributes added which had escaped observation on first acquaintance. In the course of time the accumulation takes on a personal identity and the picture attains a mental existence complete within the limits of one's potentiality." Deductive instead of inductive, this process would appear to substantiate the differences he saw between photography and painting, the latter being "a plurality of images wilfully directed by the artist."[20]

Yet there is ambiguity here. The deductive method of painting could just as conceivably eliminate the differences between the two media as Sheeler saw them. That is, "to build up gradually a mental image of the picture" might provide exactly that unity and clarity of vision which he claimed for the camera. That he worked within these unsuspected inconsistencies is further suggested by the fact that he began to make "photographic records" for his paintings. Again, to minimize the possibility of mere imitation, Sheeler emphasized the transformational role of the artist. "As in making direct references to the nature I seek information rather than to reproduce it, so it is in referring to the photograph rather than to transcribe it. Not to produce a replica of nature but to attain an intensified presentation of its essentials, through greater compactness of its formal design by precision of vision and hand, is my objective to achieve in the completed painting."[21]

William Carlos Williams revealed, however, the underlying art/anti-art ambiguities of Sheeler, whom he met in 1925. In an introduction to a catalogue for an exhibition of Sheeler's work in 1939, Wil-

liams praised the painter for the "bewildering directness of his vision, without blur, through the fantastic overlay with which our lives so vastly are concerned, 'the real,' as we say, contrasted with the artist's 'fabrications.'" Even though the intensity of his canvases had a transformational quality, Sheeler considered painting an obstacle to the articulation of the image just as poetry hindered Williams' attempts to seize the verbal image. Thus, in regard to his painting of the *Upper Deck*, Sheeler asserted, "The time was not consumed by an elaborate technical process of under-painting and glazing, but rather in maintaining precision of statement set down directly with the least possible amount of painting."[22]

By reacting against the technical proficiency of his early mentor William Merritt Chase, Sheeler came to emphasize craftsmanship, again with anti-art undercurrents in its preclusion of the artist's presence in the painting. In the mid-1920s he developed an admiration for Shaker furniture because of their handcrafted qualities and geometric structure. Thus Sheeler viewed these folk artifacts as readymade subjects for his painting. His respect for Duchamp, which dated back to the Armory Show, is therefore not surprising. "Marcel Duchamp's Nude Descending A Staircase was the most controversial picture in the show," recalled Sheeler. "It represented the very antithesis of what we had been taught. For in it the statement was all important and the means by which it was presented skillfully concealed." Duchamp's scorn for painting was to be even more manifest in the *Large Glass*, which Sheeler admired for "the craftsmanship [that] gave evidence of the remarkable ability of the hand to carry out the orders of the eye." Duchamp's appeal went beyond simple craftsmanship, however, for he also denied the expressive hand of the artist, that which had already become an anathema for Sheeler because of Chase, and that which would become even more annoying in his pursuit of the clear image, unsullied by the sensuous quality of pigment. (Indeed, in discussing the "mental existence" of an image before painting, Sheeler himself rather reluctantly conceded the necessity of painting: "Since the value of the mental picture can only be determined by the degree of response it is able to arouse in another person, it must be restated in physical terms—hence the painting."[23] Here Sheeler was but one step behind Duchamp and Man Ray, who had once found the thought of a creative act sufficient to make its material reproduction unnecessary.)

Sheeler's asceticism was also reflected in his choice of subject

matter. At first working with Pennsylvania barns (whose structural qualities were self-evident), he then turned to the urban environment when he moved to New York in 1919. In this respect, he had many antecedents. Initially celebrated by Marin, New York's architecture had been subsequently admired by all the French painters upon their arrival in America after the Armory Show. Stieglitz, of course, had photographed the city. And Robert Coady had repeatedly asked, "Who will paint New York? Who?" Quite possibly his insistence upon a national art led Sheeler to say later, "It remains a persistent necessity that I should feel a sense of derivation from the country in which I live and work."[24]

The industrial environment was a variation upon the machine, which had already become a preoccupation of so many of Sheeler's contemporaries. Like the machine, this particular sort of environment appealed to him because of its implicit structure: "Forms created for the best realization of their practical use may in turn claim the attention of the artist who considers an efficient working of the parts toward the consummation of the whole, of primary importance in the building of a picture."[25] He was referring to the barn motif of *Bucks County* in particular, but a technological environment would not only be up-to-date but equally appropriate in its functionalism.

The angle of vision informing Sheeler's early skyscraper images (*New York*, 1920; *Church Street El*; *Offices*, 1922) was derived in part from the snapshot quality of straight photography. But his precise linear style, along with the simplified planar masses of the skyscraper or the later industrial milieu, was derived from multiple sources: Cubism, Picabia's precise delineation of the machine, the diagrammatic quality of the *Large Glass*, the sharp focus of the straight photograph, Schamberg's formal explorations of the machine, Man Ray's hard edges in his *Rope Dancer*, the rays of Demuth's stylistic variation of Cubism. The mere enumeration of these sources is less important than what Sheeler made of them, using their ascetic, sparse qualities to reinforce his antipainterly tendencies.

Sheeler cryptically summarized many of his attitudes toward art and the artist in a crayon drawing entitled *Self Portrait* in 1923, reproduced in the pages of *Broom*.[26] In the vein of Picabia's machine portraiture, a telephone serves as the dominant image, though a seated human figure can be seen dimly through a window pane behind the instrument set on a table, the person's identity concealed by a half-

drawn shade. This drawing thus differs somewhat from Picabia's machine portraits, because the telephone is not anthropomorphically conceived. By retaining a human figure in the shadowed background, Sheeler refrained from entirely draining his portrait of affirmative values, avoiding a completely mechanized self-image.

Quite possibly, this *Self Portrait* may have originated in Sheeler's chance encounter with his reflected image in a window as he sat down to make a telephone call. But the transposition of the figure behind the pane would suggest that his choice of the telephone as the central image passes beyond mere wit to a statement about the artist. As a modern, technological means of communication, the telephone suggests that the artist must be concerned not only with contemporary phenomena (as *Broom* insisted) but also with communication in a fashion commensurate with the new extensions of man. Instead of communicating in person, the artist employs a particular medium, his "telephone," thus minimizing the expression of his personality. At the same time, the telephone as a machine had particular metaphorical significance for Sheeler as a painter. The artist must execute his canvases with economy, efficiency, and rationality, intensifying, not sound, as the telephone does, but vision. The intensity rather than the medium of communication absorbs one's attention, just as the artist's means must be hidden to afford concentration upon the image. As Sheeler commented on his paintings of the early 1920s, "It was also my aim to eliminate the evidence of painting as such and to present a design giving the least evidence of the means of accomplishment."[27]

While Sheeler's withdrawal from his paintings creates problems of interpretation, some extrapictorial clues are helpful in determining his attitudes toward his use of technology. Early in his *Autobiography*, Sheeler laconically states, "I did not believe myself to be a voice crying in the wilderness." No sense of alienation impelled him the way it did Picabia and Duchamp, Demuth and possibly Schamberg. Indeed, Sheeler gives the impression of being a painter who was thoroughly at home in the twentieth century. Just as he appreciated the ordered craftsmanship of a pre-industrial America without nostalgia, he also endeavored "to communicate his sensations of some particular manifestation of cosmic order," available, so he thought, in the world of technology.[28] He differed markedly from Joseph Stella in that he was neither lyrical about the machine nor despairing about its social consequences, for the technology that stimulated Stella's emotions provoked Sheeler's sense of rational harmony in the universe.

Sheeler's views of the industrial world were generally consonant with those articulated by Harold Loeb in his important essay "The Mysticism of Money," published in *Broom*. Although Loeb disapproved of capitalism, he speculated that "the Mysticism of Money may prove, like the Christian Religion in the early centuries, a revitalizing force to most aesthetic expressions." In a similar vein, Sheeler compared the factory to the Gothic cathedral, without the ironic despair of a Henry Adams. "In a period such as ours, when only a few isolated individuals give evidence of a religious content," he maintained, "some form other than that of the Gothic Cathedral must be found for our authentic expression. Since industry predominantly concerns the greatest numbers, finding an expression for it concerns the artist."[29] Like Loeb, Sheeler thought that the modern artist might achieve a valid expression akin to that of earlier religious feeling through paying heed to the contemporary environment shaped by technology.

That Sheeler intended his views of the modern world to be affirmative can be most clearly seen in his motion picture about New York. *Manhatta*, as it was called, was filmed in collaboration with the photographer Paul Strand in 1921. In an article for *The Seven Arts*, later reprinted in *Broom* after the film was completed, Strand maintained that the artist, cast aside in a positivistic age, could reassert himself and his human values if only he could grasp fully the creative implications of the camera, "an instrument of intuitive knowledge." In order to be altogether successful, the artist must demythologize the machine and reject the "somewhat hysterical attitude" the Futurists had adopted toward technology.[30] Strand's emphasis upon "intuitive knowledge," which derived from his association with Stieglitz, would appear at odds with Sheeler's rationalism. Yet the two artists compromised by employing lines from Whitman's poetry to illustrate the successive images of *Manhatta*. Although occasionally obtrusive, Whitman's lines serve not only to imply Strand's intuitive knowledge but also to underscore the film's affirmative mood. The quality of their photography, however, was hardly in need of verbal reinforcement.

Through the intensity of straight photography, *Manhatta* reveals the formal structure inherent in the urban environment. Sheeler and Strand occasionally employ a Cubist vocabulary in the film. For example, in one scene the camera, at an elevated vantage point, scans the Woolworth Building from top to bottom. Midway, it stops for a view of the lesser skyscrapers and then moves down to the street,

where the viewer sees the chaotic rooftops of the small buildings. The descent emphasizes the linear verticality of the Woolworth Building and other skyscrapers. But because of the camera's position, it is difficult to gauge the relative depths of the lowest buildings, and so the rooftops take on the guise of Cubist *passage*, with ambiguously interlocking forms.

The two filmmakers preferred to explore the geometric quality of the architecture. Thus, in the next to the last scene, they again look down from high upon the movement of crowds and traffic. The perspective results in a loss of spatial coordinates as the diagonal of the elevated train plays against the verticals of the skyscrapers in a flattened geometrical design.[31] In an earlier sequence the two photographers concentrate upon the construction of skyscrapers. Progressing from the excavation of the foundation by a large steamshovel (which swivels in a graceful arc that recalls Coady's "moving sculpture"), the camera takes an upward shot of the steel girders in geometric pattern. Gradually the camera moves backward to take in more girders, revealing two workers on a horizontal beam as they move in a maze of construction—a striking image of man in an abstract geometric field.[32]

Manhatta appeared in a Dada festival held at the Théâtre Michel in 1923. Reportedly accompanied by Eric Satie's music and Apollinaire's poetry, the film was part of an orchestrated spectacle of modern art, including what had become the obligatory scandal.[33] Whatever Sheeler's and Strand's affiliations with anti-art, the appearance of their film had little to do with things properly Dada except insofar as *Manhatta* satisfied the Dada craze for American modernity; yet even that mania had transcended Dada to become of general interest to the French.

Manhatta's distance from Dada can be determined by contrasting the film to Man Ray's *Retour à la raison*, which appeared on the same program, and *Entr'Acte*, directed by René Clair, with a script by Picabia, a 1924 film-short that had American sources. *Le Retour à la raison* was a makeshift affair, appearing at the Soirée only after Tzara jokingly had informed Ray the day before that he was expected to produce a film. Using his Rayograph technique along with the devices of conventional photography, Ray threw together a three-minute clip. While articulating a series of abstract forms, as *Manhatta* did, Ray also ran an irrational sequence of shots—hence the ironic

title, which indicates the film's divergence from *Manhatta*. *Entr'Acte*, a zany film, derived some of its action from Mack Sennet chases. Altogether nonrational, the film emphasizes the process of creation out of destruction.[34] In contrast, *Manhatta* is a somber film and peripheral to the nonsense of Dada.

Despite the clear affirmation of the urban-technological world depicted in *Manhatta*, Sheeler's paintings of the same subject from 1920 to around 1935 are uneven in statement and formal means. As a result, his canvases provoked confused and even hostile commentary from art critics, who maintained that the paintings articulated a cold if not negative industrial landscape. As late as 1946, Henry McBride, the astute critic from the Armory Show days, asserted, "I don't like the bleakness and bareness [of the paintings] and if Charles Sheeler has been holding the mirror up to nature and if half these things he says are true then he's got me worried."[35]

That these opinions and judgments ran counter to Sheeler's intentions should be obvious. Yet the critics' views cannot be dismissed entirely, for the underlying art/anti-art ambiguities of his painting create tensions between fact and value. By abdicating the artist's active role, by attempting to depict the "facts" of the landscape without interpretation, Sheeler left his work open to various social and moral judgments even though his intentions were affirmative. The facts of the actual landscape literally transcribed to the surface of the canvas simply did not result in an inevitable affirmation of those values which Sheeler thought he saw in the industrial scene.

Sheeler's paintings of New York skyscrapers in the early 1920's give evidence of an aesthetic vision by their distortion of perspective to create an illusion of environmental grandeur. At the same time, Sheeler stressed the geometry of the buildings to create an abstract design on the canvas. Another set of paintings, finished at the end of the decade, moved, however, toward a greater representational realism. Both *American Landscape* of 1930 and *River Rouge Plant* of two years later are extremely representational and singularly inert as a result of Sheeler's failure to assert himself as an artist. Indeed, both canvases fall under his own indictment of the realism which he claimed the Hudson River School espoused: "The Hudson River School largely sought to make a reduced replica of that part of nature which came within the angle of vision, both as to literalness of form and color."[36] Small in scale and unaided by compositional emphases, these indus-

trial landscapes are more impressive when reproduced with no indication of their actual size, for then the mind's eye tends to enlarge them.

Sheeler's representational art reached its peak with *City Interior* of 1935 and his *Power* series for *Fortune* magazine in 1939. Not until 1946 did he notably change his style, moving from his ambivalence toward art to a recognition of the informing efficacy of the artist's imagination. There were indications, however, that he would balance such tensions as early as 1929 with his painting of the *Upper Deck*. Given the smooth canvas and the hidden brushstroke, the painting on the one hand consciously renounces the painter's expressive use of medium. The predominant color is gray in muted shades and tonalities. While attention is thus focused upon the geometrical form of the machines, the painting is not Cubist. Depicted from a Renaissance perspective, the machine-forms are emphasized in their geometry simply because the machine is intrinsically geometrical. Yet, although these pictorial elements indicate a suppression of the artist, other elements recall his presence. In the composition Sheeler played line against mass. The powerful presence of the machines is offset by the sharp delineation of their forms. Cables break up the sky into planar areas which contrast with the complexity of the machinery in the lower half of the canvas and lend visual excitement through their diagonal motion. Unlike Schamberg, Sheeler did not hide the function of the machines in order to emphasize their formal aspects. Instead, he achieved tension by balancing the representational dimension of the machinery against their formal qualities. The result is a painting of machine-forms which exist in elegant repose.

Sheeler's presence as an artist emerges most forcefully in the later paintings such as *Ore into Iron* (1953) or *The Web* (1955). In the former, elegant configurations of shadows flatly painted in a single tone join with the linear complexities of catwalks to create an exciting formal design, balancing the abstract and the representational. In the latter, bright colors uniformly applied create repetitive masses that stand upward in an intricate composition involving industrial scaffolding. Through an awareness of the artist's conscious manipulation of form and color, Sheeler's intended affirmation of the industrial landscape is realized. Consequently, these paintings reveal a rationality and power that reside less in the subjects themselves than in his artistic treatment of the landscape.

Sheeler's necessary shift in attitudes is nowhere more dramatized

than in his final self-portrait of 1943, *The Artist Looks at Nature*, which offers an image of the painter in the landscape. His easel reveals a subject that has nothing to do with the surrounding milieu. Unlike the earlier *Self-Portrait*, the artist is now out in the open; whereas his instruments were once conceived in metaphorical terms as a machine, his paintbrush is now in full sight. Contrasts, however, do not neatly extend down the line. The work of 1943 still employs a meticulously hidden brushstroke, and a linear, precise articulation of nature prevails. Nevertheless the later painting suggests, as the earlier self-portrait did not, that Sheeler had finally come to accept the artist's unique ability to transform actuality into an imaginative vision in which aesthetic value, not fact, is predominant.

To assess the elements of Dada in the paintings of these Americans, one must first recognize the essential transformations that took place. Like the collagists, their feeling for landscape dissipated the Dada elements in their art. But even so, the landscapes of Demuth and Sheeler probably would not have been so predominantly industrial or urban had they not been influenced by the work of Picabia and Duchamp. Yet Demuth alone conceived the industrial scene in terms that approached Dada irony. And even though Schamberg concentrated upon machines, he did so for the purpose of exploring their formal rather than their symbolic or ironic possibilities.

Nonetheless, Dada served as a powerful catalyst. The linear style of Duchamp and Picabia was certainly a major source for these Americans' so-called "Precisionist" modifications of Cubism. The two Frenchmen also directed their American friends to the machine as subject matter for their paintings, although their success in this respect was more limited than that of the Dadaists. Schamberg, who, even on his deathbed, was still searching for a style and a pictorial point of view, achieved visual irony only in a few paintings. Demuth had more success, restricting his irony primarily to the titles of his paintings. In contrast, Sheeler was not at all ironical in his attitudes toward technology, but his absorption of Dada's anti-art attitudes led him on a long search in an attempt to resolve the conflict between formal and representational values.

All three Americans were young and still unsettled as artists when Duchamp and Picabia arrived in New York in 1915. Thus they were open, and in some respects vulnerable, to new ideas—a situation

not entirely salutary for their work. But in retrospect, without Dada, they might have developed into no more than second-rank Cubists, destined to decline, like so many American painters during the 1920s. Thanks to Dada, however, Schamberg, Demuth, and Sheeler broke away from Cubism to develop their own art, hazardous as the course may have been; for the significant anarchy of Dada moved them to discover, however haltingly, their own artistic sensibilities.

Aftermath and Conclusion

Associated with a particular time as an evanescent mood, Dada was proclaimed dead as early as 1922, making it inevitable that Dada in America also disintegrate, even though the controversy that had been generated continued until 1925. Clearly, New York Dada had been inspired by the intermittent presence of Picabia and Duchamp, so that when they left, a segment of the New York avant-garde lost its vital center, a center only briefly regained in 1924, when the young American expatriates of *Broom* and *Secession* returned home from their Dada odyssey in Europe.

Death, however, claimed not only Dada but some Americans who had been involved as well. Morton Schamberg was the victim of a flu epidemic in Philadelphia in 1918; and Robert Coady, who might have become a significant spokesman for American art, died in 1921, four years after the fifth and final issue of *The Soil* had been brought out. Long after the official death of Dada, but tragically premature, was the suicide of Hart Crane in 1932. And three years later Charles Demuth died of chronic diabetes.

The little magazines involved with Dada also came to untimely ends. Some of them, such as *The Soil* or *Contact*, had been given up for lack of funds. *Broom* and *Secession*, on the other hand, came to an end largely because of the combative energies of their editors. There were far too many conflicting personalities within that heterogeneous group of "aesthetes" to keep a concerted movement alive—a self-defeating situation that was only inadvertently Dadaist. Without a Breton to unite them, American artists were bound to move out in separate directions. Compounding the emotional tensions were the personal economic difficulties facing these expatriates upon their return from Europe. As a consequence, after *Aesthete 1925* Dada gestures were simply sporadic and ineffectual.

Another factor that contributed to Dada's decline can be found

in the implicit contradictions informing the views of the *Aesthete* group. In the final analysis, friends and enemies alike had been brought together by a general interest in the formal aspects of litera- ture—a preoccupation that eventually ran counter to the "life" stance of Dada anti-art, which was particularly strong in America. Thus by the time of *The Little Review*'s Exiles Number in 1926, Josephson had made a break with his Dadaist-turned-Surrealist friends, accusing them, in an open letter, of creating execrable literature, "tedious and tepid dreams," which he found doubly galling because they were capable of producing masterworks. In contrast, American artists, then living in a hostile environment, wanted desperately to create some- thing of value. Since the Surrealists were bent on revolution, he claimed, they should leave literature to the culture-starved American writer. "NO," concluded Josephson, with such strong emphasis that it subverted his ironic tone, "YOU HAVE NO RIGHT TO BE LITERARY. LEAVE THAT TO US. We wish to write immortal prose and verse."[1] Thus the *Aesthete* group forsook the polemics of anti-art to devote themselves to what the title of their pamphlet indicated, though without the original ironic intent. Just as Dada was being absorbed into other avant-garde movements in Europe, so too these American writers were absorbed into the literary worlds of journalism and aca- deme.

Discourse with Dada paradoxically encouraged both American painters and poets to come to grips with the dual problem of being an artist in America and being an American artist. Although the problem had existed since the seventeenth century, it was renewed with great intensity in the twentieth, and took on quite different di- mensions as well. Until the Armory Show American artists turned to Europe for their art forms, with the implicit but confident expectation of discovering and sharing common cultural norms. As a result, the art of both the American academy and its dissenters—Thomas Eakins most readily comes to mind—had its source in Europe during the latter part of the nineteenth century. The traumatic consequences of the Armory Show have overshadowed the fact that the event occurred within, and continued, the traditional patterns of cultural discourse between America and Europe. Converts to the new painting still had the satisfaction of knowing, however tentatively, that their experi-

ments strove for viable standards that were advanced by Europe, despite the disapproval of an American public narrowly conditioned by academic norms.

Subsequent events involving Dada were more ambiguous. Dada provided the first extensive opportunity for Americans to interact with an important segment of the European avant-garde in the twentieth century. But whereas the Armory Show had dramatically pointed up American provincialism, the internationalism of Dada fostered an atmosphere of mixed tensions, compounded by contradictory pressures.

Even though such painters as Schamberg, Demuth, and Sheeler were aware of European modernism prior to the Armory Show, their initial understanding was limited, as evidenced by their shocked response to the New York exhibition after they had returned to their own provincial milieu. They can be contrasted to older members of an emerging American avant-garde, such as Max Weber, John Marin, and Marsden Hartley—Stella and Dove among them—who were themselves establishing a modern idiom, having been prepared not only by earlier European experiences but also by Stieglitz and the exhibitions at his "291" gallery. It was, therefore, Stella and Dove who were most successful at assemblage, for they were already mature painters, capable of transforming Dada materials into another art form. Conversely, because the younger artists were less settled, more inexperienced as painters, they underwent the difficult revelations of 1913 only to have their sensibilities further assaulted by Picabia and Duchamp, whose arrival brought another set of radical assumptions and values, Dadaist in nature and opposed to much of European modernism. The young Americans were thus shifted violently in directions other than those that they had just begun to pursue.

In a typically subversive manner Dada encouraged American artists to turn back to their own culture. Although they consequently became aware of the possibilities of creating an American art out of indigenous materials, they also risked renewing a provincialism that might become all the more subtly entrenched because of its ostensible sanction by prestigious European artists. American discourse with Dada would have thus fulfilled Tzara's rather cryptic assertion that "Dada is not modern," had not subsequent developments been substantially different from what has become known as the American

Scene painting of the twenties and thirties. The latter, at its worst, was a sentimental retreat from modernism that had little to do with American Dada.

American problems were compounded by the fact that the Dadaists themselves were not particularly interested in America for its artistic possibilities. In rebelling against European art and culture, they extolled America precisely because it stood outside Europe and thus provided anti-art material that was considered shocking and lively. What the Dadaist conceived as a symbol of his own rebellion did not necessarily meet the needs of the American, who was urgently seeking cultural identity through the creation of an art of his own. Opposed to many, if not all of the European values that had previously provided norms for American artists, Dadaists cast off all standards, thereby disorienting Americans, who lacked a similar conviction and intensity born out of revolt and despair to sustain their own quest. Yet this disorientation forced them to seek an independent course in the arts, striking a profound chord in American culture.

Along with the hazardous movement of Americans away from Europe came another risk highlighted by Dada. Nineteenth-century distinctions between fine and popular art—Henry James on the one hand, and the dime novel, on the other—seemed secure until technology's alliance with the vernacular arts transformed the cultural environment to such an extent that artists could no longer ignore the changes of early twentieth-century America. It is in this context that Josephson's daring displacement of the fine arts by the mass media must be appreciated. To be sure, his eventual disapproval of American popular culture precluded the possibility of striking a needed balance, as exemplified by Duchamp's ironic detachment; yet Dada enabled Josephson (at a time when technology had radically entered daily life)[2] to stand as a prophet of our present day, anticipating many of McLuhan's ideas and boldly envisioning the new extensions of man that were to be henceforth available to the artist. Even though only a few American artists recognized the need to create an American art, not out of subject matter alone, but out of a range of formal means in keeping with this new world, the movement had begun, however haltingly, from Greenwich Village to the Global Village. New chaos would relentlessly characterize our lives and our art.

Notes

Preface

1. For one view of the avant-garde, see Renato Poggioli, *Theory of the Avant-Garde*, tr. Gerald Fitzgerald (Cambridge: Harvard University Press, 1968). Although historical studies and monographs on individual modern artists abound, more theoretical study of the avant-garde is necessary, particularly from a cross-cultural, anthropological perspective. Approaches may be garnered from a thought-provoking essay by Robert Redfield, *The Little Community: Viewpoints for the Study of a Human Whole* (Chicago: The University of Chicago Press, 1955). Another study, which, interestingly enough, draws upon some of the ideas of Marcel Duchamp, is Jacques Maquet, *Introduction to Aesthetic Anthropology* (Reading, Mass.: Addison-Wesley, 1971).

2. The basic study and source book of the little magazine remains Frederick J. Hoffman, Charles Allen, and Carolyn F. Ulrich, *The Little Magazine: A History and a Bibliography* (Princeton: Princeton University Press, 1946). For a brief discussion of the little magazine in relation to the avant-garde, see Frederick J. Hoffman, "Little Magazines and the Avant-Garde," *Arts in Society* (Fall 1960): 32–37. Aside from individual studies (most notably, Susan J. Turner, *History of "The Freeman": Literary Landmark of the Early Twenties* [New York: Columbia University Press, 1963], and William Wasserstrom, *Time of "The Dial"* [Syracuse: Syracuse University Press, 1963]), Gerardus A. M. Janssens, *The American Literary Review: A Critical History, 1920–1950* (The Hague: Mouton, 1968), considers such magazines as *The Dial* and *The Southern Review*, though distinct from the little magazine, in terms of literary tradition, and hence is instructive for an approach to little magazines. James B. Gilbert's study of the *Partisan Review* (*Writers and Partisans: A History of Literary Radicalism in America* [New York: John Wiley, 1968]) is germane for its overview of literature and politics during the 1920s, although the *Partisan Review* did not appear until a decade after the little magazines considered here.

Introduction

1. "Creative Dada," in Willie Verkauf, ed., *Dada: Monograph of a Movement* (Teufen, Switzerland: A. Niggli, 1957), p. 26.

2. Duchamp had originally paid "A Tribute to the Artist," Charles

Demuth: "His work is a living illustration of the disappearance of a 'Monroe Doctrine' applied to Art" (quoted in Andrew Carnduff Ritchie, *Charles Demuth* [New York: Museum of Modern Art, 1950], p. 17). While Duchamp and Picabia have been briefly mentioned in most standard histories of twentieth-century American art, little or nothing has been written that extensively studies their relationship with American artists, either from an overview or from the perspective of an individual American artist. A recent exception is John Tancock, "The Influence of Marcel Duchamp," in Anne d'Harnoncourt and Kynaston McShine, eds., *Marcel Duchamp*, pp. 159–178. The essay concentrates, however, on Duchamp's influence on American artists after World War II, though a brief survey of America's early modernists is also made. In the sort of criticism that has gone by the boards, Peyton Boswell, Jr., simply waved the flag to veil foreign influence for the sake of artistic chauvinism: "After the Armory Show came the World War, and its effect upon American art, as on so many other phases of American life, was disastrous. . . . It was the heyday of internationalism. . . . Our artists were sopping up cubism, futurism, dadism or any other stylish ism they could find except Americanism" (*Modern American Painting* [New York: Dodd, Mead, 1939], pp. 69–70).

3. *Dada à Paris* (Paris: Pauvert, 1965), pp. 25–26. For an account of American expatriates, see George Wickes, *Americans in Paris* (Garden City, New York: Doubleday, 1969); see, also, the reminiscences of Jimmie the Barman at the Dingo in Paris (James Charters, *This Must Be The Place*, ed. Morrill Cody [London: Herbert Joseph, 1934]).

4. See, for example, McLuhan's discussion in *The Mechanical Bride* (New York: Vanguard, 1951), pp. 68–69, 98–101.

5. There are two exceptions. The first is a brief article by John I. H. Baur, "The Machine and the Subconscious: Dada in America," *Magazine of Art* 44 (October 1951): 233–237; the second is by William Agee, "New York Dada, 1910–30," in *Avant-Garde Art*, ed. Thomas B. Hess and John Ashberry (London: Collier-Macmillan 1968), pp. 125–54. Although Agee mentions all of the appropriate painters, he ignores the writers involved and chooses to emphasize the Arensberg salon. This essay touches most of the bases, without offering significant detail.

6. See Milton H. Brown, *American Painting from the Armory Show to the Depression* (Princeton: Princeton University Press, 1955), which is the standard history, for a glaring omission of this sort.

7. *Dada: Art and Anti-Art* (New York: McGraw-Hill, 1966), p. 12. Richter's work is valuable both as a history and as a primary source, since he was active among the Dadaists.

8. Ibid., p. 32; Hugo Ball, "Dada Fragments," in Robert Motherwell, ed., *The Dada Painters and Poets* (New York: Wittenborn, Schultz, 1951), p. 52. Another collection is Lucy R. Lippard, ed., *Dadas on Art* (Englewood Cliffs, N. J.: Prentice-Hall, 1971).

9. Richter, *Dada: Art and Anti-Art*, p. 32; Tristan Tzara, "Seven Dada

Manifestos," in Motherwell, ed., *Dada Painters and Poets*, p. 77.

10. Tzara, "Manifestos," in Motherwell, ed., *Dada Painters and Poets*, pp. 81–95. For an excellent discussion of Futurist manifestos in similar terms as poetic documents, see Reyner Banham, *Theory and Design in the First Machine Age* (New York: Praeger, 1967), pp. 99–126.

11. Tzara, "Manifestos," in Motherwell, ed., *Dada Painters and Poets*, pp. 81–82.

12. Ibid., pp. 80, 76.

13. Ibid., p. 75; Richard Huelsenbeck, "En Avant Dada," in Motherwell, ed., *Dada Painters and Poets*, p. 43.

14. Tzara, "Manifestoes," in Motherwell, ed., *Dada Painters and Poets*, p. 75 ff.

15. Georges Hugnet speaks of Dada as a "state of mind," in his "Dada Spirit in Painting," in Motherwell, ed., *Dada Painters and Poets*, p. 125. Richard Huelsenbeck perhaps best articulated the "pure" anti-art position when he said, "The Dadaist considers it necessary to come out against art, because he has seen through its fraud as a moral safety valve. . . . Art (including culture, spirit, athletic club), regarded from a serious point of view, is a large-scale swindle" ("En Avant Dada," in Motherwell, ed., *Dada Painters and Poets*, p. 43).

16. Tzara, "Manifestoes," in Motherwell, ed., *Dada Painters and Poets*, p. 95. For an excellent survey of Dada work in the visual arts, see William S. Rubin, *Dada, Surrealism, and Their Heritage* (New York: The Museum of Modern Art, 1968).

17. Huelsenbeck, "En Avant Dada," in Motherwell, ed., *Dada Painters and Poets*, p. 28.

18. Georges Ribemont-Dessaignes, "Dada Painting or the Oil-Eye," *The Little Review* (Autumn-Winter 1923–24): 10–12.

19. Richter, *Dada: Art and Anti-Art*, p. 9.

20. The problem of distinction is a delicate one. As William C. Seitz has pointed out, these movements have to be viewed as an "interrelated sequence of currents" (*The Art of Assemblage* [New York: Museum of Modern Art, 1961], p. 37). But how does one distinguish between, say, Dada and Surrealism? One tendency among critics and participants has been to go with the movement in which one has the greatest intellectual or emotional investment. But this kind of favoritism obliterates those distinctions which were once historically viable. It seems to me that if the names exist, they must have had some working significance at the time of their use, which in turn would be helpful to us today for some insights into these movements.

21. *Dada à Paris*, p. 420.

22. Jane Heap, "Dada," *The Little Review* 8 (Spring 1922): 46.

23. Seitz, *The Art of Assemblage*, pp. 38–39.

24. Waldo Frank, "Seriousness and Dada," *1924*, No. 3 (September 1924): 71.

Chapter 1. *Camera Work* and the Anti-Art of Photography

1. "Picabia, Art Rebel, Here to Teach New Movement," *The New York Times* (February 16, 1913), Section V, p. 9.

2. According to William A. Camfield, "From 1912 onward he was familiar with the Italian Futurists who glorified the modern machine-dominated world in their manifestos and strove in their paintings (though they rarely depicted machines) to express emotions exacerbated by the simultaneous experience of the speed, power and noise of that machine era" ("The Machinist Style of Francis Picabia," *The Art Bulletin* 48 [September-December 1966]: 310).

3. Although he doesn't specify a particular period, Edward Dahlberg characterizes one aspect of the photographer: "Stieglitz has said many times that he did not like the word 'artist'—that if a man painted or wrote it was his own fault. He often fell into the most destructive nihilism about literature and painting, saying that he hated art and that he intended to burn all his photographs." (*Alms for Oblivion* [Minneapolis: University of Minnesota Press, 1964]: p. 7). For a compilation of Stieglitz' views, see Dorothy Norman, *Alfred Stieglitz: An American Seer* (New York: Random House, 1973).

4. Purely technical articles were scattered throughout the fourteen years of the magazine's existence, but such articles never dominated the text. A feature, usually entitled "Some New Things Worth Looking Into," recommending new photographic techniques and processes to the reader, ran only through the first twelve numbers. After 1906, technical material of this sort constituted a very minor aspect of the magazine. A similar trend occurred with articles devoted to individual photographers. The first eleven numbers usually contained at least one feature on such important photographers as Edouard Steichen, Clarence H. White, and David Octavius Hill. But around 1910 these articles thinned out and made sporadic appearances thereafter. For an impressionistic but interesting discussion of *Camera Work*, see Jerome Mellquist, *The Emergence of an American Art* (Port Washington, N. Y.: Kennikat Press, 1969), pp. 229–239. See, too, a recent collection by Jonathan Green, ed., *Camera Work: A Critical Anthology* (Millerton, N. Y.: Aperture, 1973).

5. Sam Hunter makes the point that *Camera Work* "printed perhaps the first sustained, serious criticism of American artistic life and culture, and the first tentative 'modern' art criticism" (*Modern American Painting and Sculpture* [New York: Dell, 1960], p. 54). Valid insofar as he goes, Hunter fails to recognize the fact that the magazine was grappling with aesthetics rather than criticism. So while the latter may have become dated, the former was extremely relevant in gauging the nature of the new art.

6. "Has the Painters' Judgment of Photographs Any Value?" *Camera Work*, No. 11 (July 1905): 42.

7. Charles Fitzgerald, "A Daniel Come to Judgment," *Camera Work*, No. 31 (July 1910): 52; Charles H. Caffin, "Some Impressions from the Inter-

national Photographic Exposition, Dresden," *Camera Work*, No. 28 (October 1909): 34. There were, of course, some writers who upheld pictorial photography, because the editors permitted a wide variety of opinions. Dallet Fuguet, for example, viewed straight photography as "bald naturalism" ("On Art and Originality Again," *Camera Work*, No. 11 [July 1905]: 25). Similarly, Robert Demachy asserted that "a straight print may be beautiful, and it may prove superabundantly that its author is an artist: but it can not be a work of art" ("On the Straight Print," *Camera Work*, No. 19 [July 1907]: 21). For a discussion of Stieglitz in relation to pictorial photography, see Robert Doty, *Photo-Secession: Photography as a Fine Art* (Rochester: George Eastman House, 1971).

8. Roland Rood, "The Origin of the Poetical Feeling in Landscape," *Camera Work*, No. 11 (July 1905): 25; Alvin Langdon Coburn, "The Relation of Time to Art," *Camera Work*, No. 36 (October 1911): 72. Four years earlier, Stieglitz had printed three photographs which he called snapshots. The editors insisted upon making the point: "The three snapshots by Mr. Alfred Stieglitz are snapshots, nothing more, nothing less; but carefully studied ones" ("Our Illustrations," *Camera Work*, No. 20 [October 1907]: 46). Coburn probably took his cue from Stieglitz in this matter.

9. Gabrielle Buffet, "Modern Art and the Public," *Camera Work*, Special Number (June 1913): 13.

10. "Water-Colors by John Marin," in "Notes on '291'," *Camera Work*, Nos. 42–43 (April-July 1913): 18.

11. "Photographs by Alfred Stieglitz," ibid., p. 19.

12. "If we grasp without difficulty the meaning and the logic of a musical work it is because this work is based on the laws of harmony and composition of which we have either the acquired knowledge or the inherited knowledge. These laws are the objectivity of painting up to the present time. The new form of painting puzzles the public only because it does not find in it the old objectivity and does not yet grasp the new objectivity. The laws of this new convention have as yet been hardly formulated but they will become gradually more defined just as musical laws have become more defined and they will very rapidly become as understandable as were the objective representations of nature" ("The Exhibition of New York Studies by Francis Picabia," ibid., p. 20).

13. "Picabia, Art Rebel, Here to Teach New Movement," *The New York Times* (February 16, 1913), Section V, p. 9.

14. Ibid.

15. "Vers L'Amorphisme," *Camera Work*, Special Number (June 1913): 57. The article was originally written by Victor Méric in *Les Hommes du Jour*, No. 276 (May 1913): 8–10.

16. Ibid.

17. John Weichsel, President of the People's Art Guild, took this article very seriously, indeed, and wrote a long and involved essay to demonstrate that modern painting was a healthy movement despite the offshoots

of "Amorphism" ("Cosmism or Amorphism," *Camera Work*, Nos. 42–43 [April-July 1913]: 69–82).

18. "The Art 'Puffer,'" *Camera Work*, No. 28 (October 1909): 31; "The Ironical in Art," *Camera Work*, No. 38 (April 1912): 18. Casseres' poetry is a polyglot of Emerson, Poe, and Whitman, with Nietzsche thrown in for good measure. See his first volume of poetry, *The Shadow Eater* (New York: Boni, 1915).

19. "The Unconscious in Art," *Camera Work*, No. 36 (October 1911): 17; "The Renaissance of the Irrational," *Camera Work*, Special Number (June 1913): 22.

20. "The Ironical in Art," *Camera Work*, No. 38 (April 1912): 17–18; "Insincerity: A New Vice," *Camera Work*, Nos. 42–43 (April-July 1913): 17.

21. Sadakichi Hartmann, "De Zayas," *Camera Work*, No. 31 (July 1910): 32; Marius De Zayas, "291," *Camera Work*, No. 47 (July 1914): 73.

22. De Zayas, "The New Art in Paris," *Camera Work*, Nos. 34–35 (April-July 1911): 29.

23. De Zayas said, "In no other artistic center of the world is there a greater liberality in making concessions to the thinking genius, nor are so many projects admitted to discussion, nor so many attempts and systems shown, without scandalizing the public, who do not listen to the outcry of the scholastic conventionalisms" (ibid., p. 34).

24. According to De Zayas, "art is free, it has never had, it has not, and will never have a legislature, in spite of the Academies; and every artist has the right to interpret nature as he pleases, or as he can, leaving to the public the liberty to applaud or condemn theoretically" ("Pablo Picasso," ibid., p. 65).

25. De Zayas, "The Sun Has Set," *Camera Work*, No. 39 (July 1912): 17–18.

26. Ibid., p. 21.

27. Ibid. In a letter to Tzara in Switzerland on 16 November 1916, De Zayas felt that he could work with the Dadaists to promote modern art, thereby implying his affirmative view of Dada: "Depuis quelque temps, je travaille à établir des relations artistiques entre l'Europe et l'Amérique, car je crois que le seul moyen d'arriver à maintenir le progres évolutif des idées modernes, c'est par le commerce d'idées entre tous les peuples" (in Sanouillet, *Dada à Paris*, p. 572).

28. De Zayas, "Photography," *Camera Work*, No. 41 (January 1913): 17.

29. Ibid., pp. 19–20.

30. Undated letter in the Alfred Stieglitz Archives, Beinecke Library, Yale University.

31. De Zayas, "Photography," *Camera Work*, No. 41 (January 1913): 19.

32. De Zayas, "Photography and Artistic-Photography," *Camera Work*, Nos. 42–43 (April-July 1913): 13.

33. De Zayas, "Modern Art: Theories and Representation," *Camera Work*, No. 44 (October 1913): 13–14.

34. Undated letter, ca. 1914 (Stieglitz Archives).

35. De Zayas, "Modern Art: Theories and Representation," *Camera Work*, No. 44 (October 1913): 14.

36. "'291' and The Modern Gallery," *Camera Work*, No. 48 (October 1916): 63.

Chapter 2. *291* and Francis Picabia

1. Letter dated June 3, 1914, from Stieglitz to De Zayas; letter dated July 9, 1914, from De Zayas to Stieglitz (Stieglitz Archives).

2. "The Magazine '291' and 'The Steerage,'" *Stieglitz Conversations*, p. 2. (Stieglitz Archives). For an account of activities at "291," see Chapter 4 in Edward Steichen, *A Life in Photography* (London: W. H. Allen, 1963). For an excellent facsimile reprint, see Dorothy Norman, ed., *291* (New York: Arno Press, 1972).

3. "'291'—A New Publication," *Camera Work*, No. 48 (October 1916): 62.

4. "The Magazine '291' and 'The Steerage,'" p. 1.

5. The most striking example of experimentation was the Special Number of *Camera Work* that appeared in August 1912 and published word-portraits by Gertrude Stein, along with reproductions of Matisse and Picasso. An isolated example of satire was an allegorical spoof on photography entitled "Past the Wit of Man to Say What Dream It Was," by Charles Caffin, *Camera Work*, No. 15 (July 1906): 17–23.

6. "The Magazine '291' and 'The Steerage,'" p. 2.

7. In particular, this phrase echoed that of Picabia, "291 arrange ses cheveux sur son front," in "Que Fais-Tu 291?" *Camera Work*, (July 1914): 72.

8. Steichen's back-page design, with its ominous turbulent forms and the rhetorical question, "What is rotten in the state of Denmark?" suggested the dark side of criticism which was exploited by *291* in its Dada machine phase.

9. The personae would suggest a split between the academic, represented by the Professor, and the creative, represented by "291" But such a split, latent at best, was not exploited in the dialogue.

10. *291*, No. 1 (March 1915): [4]. It is significant to note that Haviland phrased his avant-garde quest in almost the same terms as Hans Richter: "Our real motive force was not rowdiness for its own sake, or contradiction and revolt in themselves, but the question (basic then, as it is now), 'Where next?'" (*Dada: Art and Anti-Art*, p. 9).

11. *291*, No. 1 (March 1915): [2]. This essay gathered together many threads. Historically, it reacted against the fuzzy criticism of the late nineteenth and early twentieth century in its demands for rational objectivity, thereby foreshadowing the New Criticism. It also coincided with Imagism

in its desire to gain scientific prestige for literary criticism. But most important, it was imbued with an avant-garde spirit which welcomed experimentation in the arts with a tolerant yet critical eye.

12. *291*, No. 1 (March 1915): [3]. "Voyage" originally appeared in *Les Soirées de Paris*, No. 26–27 (July-August 1914): 386–87. By typographical arrangement, the visual elements add to the music of the poem, so that while words are scattered over the plane of the page in an apparently improvised random layout, suggesting free-form expression, they are actually designed in terms of the aural inflections ascribed to any particular word.

13. "The Magazine '291' and 'The Steerage,'" p. 1.

14. *291*, No. 1 (March 1915): [2].

15. *291*, No. 2 (April 1915): [2].

16. Ibid.

17. *291*, No. 4 (June 1915): [2].

18. Ibid. Although a very contemporaneous and ephemeral reference, the allusion to the "Flip-Flap" works poetically. Here is a description of the amusement ride at the Franco-British Exhibition: "This novel and ingenious contrivance—a modified kind of see-saw, with a strong family likeness to a builder's derrick-crane—consists of two latticed steel arms, each 150 feet in length and having at its extremity a car capable of holding abour fifty people. By means of an electric engine, each of these counter-weighted arms is slowly raised from a horizontal to a vertical position, and after enabling passengers to look around from this dizzy height, descends gently on the opposite side, completing a semi-circle, and depositing its occupants some 100 yards from where they started" (*A Pictorial and Descriptive Guide to London and the Franco-British Exhibition*, 1908 [London: Ward, Lock, 1908], [T]). Katherine N. Rhoades' use of this machine as a negative yet absurd metaphor for the motion of the soul or heart was unconsciously corroborated by the exhibitors themselves, who referred to this amusement ride as "that weird and fascinating monster" [E]. That Miss Rhoades was aware of this amusement ride is evident, because Joseph T. Keiley referred to a Coburn photograph of the machine in "Impressions of the Linked Ring Salon of 1908," *Camera Work*, No. 25 (January 1909): 29.

19. *291*, No. 4 (June 1915): [2]. According to Richter, "Laughter was the only guarantee of the seriousness with which, on our voyage of self-discovery, we practised anti-art" (*Dada: Art and Anti-Art*, p. 65).

20. *291*, No. 4 (June 1915): [3].

21. Michel Sanouillet, *Picabia* (Paris: Éditions du Temps, 1964), p. 30. According to Picabia's wife, "No sooner had we arrived than we became part of a motley international band which turned night into day, conscientious objectors of all nationalities and walks of life living in an inconceivable orgy of sexuality, jazz and alcohol. Scarcely escaped from the vise of martial law, we believed at first that we had returned to the blessed time of complete freedom of thought and action. This illusion was quickly dissipated. The famous

American neutrality was indeed nothing but sleething slag from the furnace that raged beyond the ocean. It was a brutal life, from which crime was not excluded" ("Some Memories of Pre-Dada: Picabia and Duchamp," in Mother-well, ed., *Dada Painters and Poets*, p. 259).

22. For an excellent interpretation of Picabia's machine *œuvre*, see Camfield, "The Machinist Style of Francis Picabia, "*The Art Bulletin* 48 (September-December 1966): 309–22. With few minor exceptions, Camfield and I basically agree about Picabia's work. We diverge somewhat, however, in terms of approach, because he is interested primarily in Picabia alone, whereas I am concerned with Picabia's "Machinist style" in relation to American pre-occupations with art at that time. For a general survey of Picabia's art, see William A. Camfield, *Francis Picabia* (New York: Solomon R. Guggenheim Museum, 1970).

23. *291*, No. 12 (February 1916): [2].

24. According to Camfield, "Given the preceding paintings, one suspects an intelligible content exists here, too, and is tempted to speculate about it. But the content is a private one that will continue to frustrate interpretation until all parts of the machine have been identified and properly associated with each other and the inscriptions" (*Art Bulletin* 48: 315). Camfield rightfully hesitates to make a doctrinaire interpretation here, but in my opinion, he mistakenly reads what I call an eye-viewer contraption as a spark plug, and thus throws himself off the path toward a reasonable, though speculative, interpretation.

25. Camfield claims that "Picabia merely selected an advertisement for a common portable electric lamp, copied it, eliminating a few unnecessary details and inscriptions, and submitted this simplified image as a symbolic portrait of his friend" (ibid., p. 314). Camfield has provided evidence that Picabia did indeed copy the copyists, as I later point out.

26. *291*, No. 12 (February 1916): [3]. Except for isolated instances, Camfield generally ignores the companion essay by De Zayas, but I am indebted to him for pointing out Picabia's interview in the *New York Tribune* in 1915. His statements to that newspaper corroborate my contention that the machine drawings were closely related to his views of American culture: "This visit to America . . . has brought about a complete revolution in my methods of work . . . [said Picabia]. Prior to leaving Europe I was engrossed in presenting psychological studies through the mediumship of forms which I created. Almost immediately upon coming to America it flashed on me that the genius of the modern world is in machinery and that through machinery art ought to find a most vivid expression" ("French Artists Spur On An American Art," *New York Tribune* [October 24, 1915], Section IV, p. 2). Camfield rightfully notes all the prior and contemporary influences on Picabia concerning his views toward the machine, but Picabia's statements in the *Tribune* underline my notion that he at least thought he was dealing with something close to America in treating the machine.

27. *291*, Nos. 5–6 (July-August 1915): [5].

28. Ibid.

29. Ibid.

30. Camfield claims that "Picabia's machinist paintings were no more anti-art than they were anti-machine" (*Art Bulletin* 48: 322). In a very broad sense he might be right, although only, I believe, in retrospect, much as Duchamp's *Bottlerack* is now considered art in some circles. In the historical context of De Zayas' essay, however, Picabia's work was intended as anti-art as I explain it.

31. *291*, Nos. 5–6 (July-August 1915): [5].

32. Ibid.

33. Ibid.

34. "Some Memories of Pre-Dada: Picabia and Duchamp," in Motherwell, ed., *Dada Painters and Poets*, p. 258.

35. *291*, Nos. 7–8 (September-October 1915): [1].

36. Ibid.

37. Ibid.

38. Camfield finds discernible machinery in this portrait: "The prominent forms in his machine consist of a mount support, a pistol, a target, and mechanical linkage connecting them" He sees the woman portrayed here as "an automatic love machine" (*Art Bulletin* 48: 315).

39. *291*, No. 9 (November 1915): [1].

40. Camfield places this drawing in the context of Picabia's machinist style. His excellent interpretation suggests a meaningful aspect of Picabia's mechanistic mythology (*Art Bulletin* 48: 315).

41. *291*, No. 12 (February 1916): [2].

42. In a letter dated November 16, 1916, to Tzara in Switzerland, De Zayas said, "Notre révue n'éxiste plus. Nous n'avons eu l'intention que de publier douze numéros. Elle ne fut qu'une expérience" (in Sanouillet, *Dada à Paris*, p. 572).

43. For a history of *391*, see Michel Sanouillet's introduction to the reprint of Picabia's magazine, *391*, Vol. I (Réédition intégrale, Paris: Le Terrain Vague, 1960) and Michel Sanouillet, *Francis Picabia et "391,"* Vol. II (Paris: Eric Losfeld, 1966).

Chapter 3. Marcel Duchamp and Man Ray

1. Duchamp's *Nude Descending a Staircase* so disturbed his fellow artists at the 1911 Salon that his brothers had the sad duty of requesting him to withdraw her from the exhibition. At the 1913 Armory Show in New York the conservative critics and the press reacted violently and virulently against the painting. For Duchamp's account of this period, see Pierre Cabanne, *Dialogues with Marcel Duchamp* (London: Thames and Hudson, 1971). For a description of critical response to the Armory Show in general, see Milton W. Brown, *The Story of the Armory Show* (Greenwich: New York Graphic Society, 1963).

2. "A Complete Reversal of Art Opinions by Marcel Duchamp, Iconoclast," *Arts and Decoration* 5 (September 1915): 427–28; Robert A. Parker, "America Discovers Marcel," *View*, Marcel Duchamp Number, Series 5 (March 1945): 32.

3. "French Artists Spur On An American Art," *New York Tribune* (October 24, 1915), Section 4, p. 2. Duchamp's statement on contradiction, appearing in several sources, can be found in Andrew Forge, "The Silence of Marcel Duchamp," *The Listener* (November 5, 1959), p. 776.

4. "The Iconoclastic Opinions of M. Marcel Duchamps concerning Art and America," *Current Opinion* 59 (November 1915): 346.

5. Ibid., p. 347.

6. "French Artists Spur On An American Art," *New York Tribune* (October 24, 1915), Section 4, p. 2.

7. Ibid.

8. Arensberg's two volumes of poetry, *Poems* (Boston: Houghton Mifflin, 1914) and *Idols* (Boston: Houghton Mifflin, 1916), are remarkable mainly because they appear untouched by any of the avant-garde activity in which he was immersed at the time. His poetry for Dada reviews was far superior to his published volumes. But even the Dada poetry was not particularly exceptional, very sparse, as though affected by Duchamp's asceticism. For a brief discussion of Arensberg's relation to French Symboliste poetry, see Haskell M. Block, "The Impact of French Symbolism on Modern American Poetry," Melvin J. Friedman and John B. Vickery, eds., *The Shaken Realist* (Baton Rouge: Louisiana State University Press, 1970), pp. 165–217. As a collector, Arensberg assumed a major position among Americans. Bequeathed to the Philadelphia Museum of Art, his collection is very important not only for its paintings but also for its archives, a magnificent collection of Dada ephemera. For a full description of the collection see *The Louise and Walter Arensberg Collection* (Philadelphia: Philadelphia Museum of Art, 1954).

9. Henri Pierre Roché, "Souvenirs of Marcel Duchamp," in Robert Lebel, *Marcel Duchamp* (London: Trianon Press, 1959), p. 80; Gabrielle Picabia, "Some Memories of Pre-Dada: Picabia and Duchamp," in Motherwell, ed., *Dada Painters and Poets*, pp. 255–67; Henri Waste [pseudonym for Ettie Stettheimer], *Love Days* (New York: Knopf, 1923); Alfred Kreymborg, *Troubadour* (New York: Boni and Liveright, 1925); Man Ray, *Self Portrait* (Boston: Little, Brown, 1963)—all have accounts, fictional and nonfictional, of the New York social life in which Duchamp participated upon his arrival. A recent single text, which contains a wealth of historical material along with some perceptive essays, is Anne d'Harnoncourt and Kynaston McShine, eds., *Marcel Duchamp* (New York and Philadelphia: Museum of Modern Art and Philadelphia Museum of Art, 1973).

10. "A Complete Reversal of Art Opinions by Marcel Duchamp, Iconoclast," *Arts and Decoration* 5 (September 1915): 428; Picabia's review "La Pomme de pins," in Motherwell, ed., *Dada Painters and Poets*, pp.

268–71; quoted in *Marchand du sel: Écrits de Marcel Duchamp* (Paris: Le Terrain Vague, 1958), ed. Michel Sanouillet, p. 111.

11. Duchamp's brother asked his artist friends for examples of their art to hang in his kitchen. Responding perfectly to the occasion, Duchamp produced his famous *Coffee Mill*. Andrew Forge incisively relates this early work to the readymades: "It looks at you with a terrific mechanical animation: it grinds and turns under your eye. You have the impression that you are using it" ("The Silence of Marcel Duchamp," *The Listener* [November 5, 1959], p. 775). Both the *Bicycle Wheel* and the painting possess an iconic presence. For a close consideration of the readymade, see Walter Hopps, Ulf Linde, and Arturo Schwarz, *Marcel Duchamp: Ready-mades, etc. (1913–1964)* (Paris: Le Terrain Vague, 1964).

12. For a brief account of the 1917 Independents, see Sam Hunter, *Modern American Painting and Sculpture*, pp. 77–78.

13. H. P. Roché, "The Blind Man," *The Blindman*, No. 1 (April 10, 1917): 3–4. Alfred Frueh had previously been exhibited at "291," from 20 November to 12 December, 1912 (Dorothy Norman, *Alfred Stieglitz*, p. 234).

14. Ibid., pp. 3–5. In the same essay, however, Roché advised that "every American who wished to be aware of America should read 'The Soil.'" Evidently, his desire for a contemporary American art cut across personalities, for Coady was to take issue with Duchamp in *The Soil*.

15. As Roché asked, "If a painter works passionately, patiently, and says, 'I am making experiments which may, perhaps, bring nothing for many years,' what can we have against him?" (ibid., p. 5).

16. Ibid., p. 6.

17. Marcel Duchamp, "The Richard Mutt Case," *The Blind Man*, No. 2 (May 1917): 5.

18. Louise Norton, "Buddha of the Bathroom," ibid., p. 6. Duchamp, a friend of Norton's, submitted a brief nonsense squib entitled "The Eye Test, Not a 'Nude Descending a Staircase'" to *Rogue* 2 (October 1914): 1.

19. Letter from Stieglitz, dated April 13, 1917, in *The Blind Man*, No. 2 (May 1917): 15. Charles Demuth, "For Richard Mutt," ibid., p. 6; "Letter from a Mother," ibid., p. 8.

20. *Rongwrong* contained, in the order of appearance, a letter signed by "Marcel Douxami"; "Plafonds creux," a poem by Picabia; "Une Nuit chinoise à New York," a poem by the "Marquis de la Torre"; a chess game between Picabia and Roché; "Ronde de printemps," a dialogue by Carl Van Vechten; "Pour Amuser Rich," a vignette also by Van Vechten; a small photoreproduction of John Covert's *Temptation of Saint Anthony*; "A Cette Heure là . . .," a poem by Allan Norton; "Portrait de M. et R. ensemble," a visual and verbal conglomerate signed by "H.F."; and a "Programme" on the final page. All in all, the material was neither distinguished nor inspiring and not even Dada, except in the sense that it really amounted to ephemera.

21. For a psychological and mythical interpretation of the *Large Glass*, see Arturo Schwarz, *The Complete Works of Marcel Duchamp* (New York:

Abrams, 1969). (Schwarz' work also provides a *catalogue raisonné* of Duchamp's work that supersedes Lebel's *Marcel Duchamp*.) Other detailed and perceptive analyses of the *Large Glass* are provided by André Breton in "Lighthouse of the Bride," *View*, Marcel Duchamp Number, Series 5 (March 1945): 6–9, 13; Marcel Jean, *The History of Surrealist Painting*, trans. Simon Watson Taylor (New York: Grove Press, 1959), esp. Chap. 4, "How the Bride was Stripped Bare by Her Bachelors, Even," pp. 94–114; and for an especially illuminating article on Duchamp's paintings, leading to the *Large Glass*, see Lawrence D. Steefel, Jr., "The Art of Marcel Duchamp," *The Art Journal* 22 (Winter 1962–63): 72–80.

22. Marcel Duchamp, *The Bride Stripped Bare by Her Bachelors, Even*, a typographic version by Richard Hamilton, trans. George Heard Hamilton (New York: George Wittenborn, 1960), n.p. A more complete version, with notes in somewhat different order, is *Marcel Duchamp: Notes and Projects for the Large Glass*, ed. Arturo Schwarz (New York: Abrams, 1969).

23. Schwarz reconstructs the *Large Glass* in autobiographical terms as Duchamp's working out of incestuous impulses, at the same time that it is fraught with Jungian archetypes. In my estimation, his interpretation, while full of valuable insights, is something of a *tour de force* which, in its wholeness, minimizes the disjunctive nature and opacities of this translucent work.

24. Gabrielle Buffet, "Magic Circles," *View*, Marcel Duchamp Number, Series 5 (March 1945): 23; Harriet and Sidney Janis, "Marcel Duchamp, Anti-Artist," ibid., p. 24.

25. "To Duchamp, the brush, the canvas and the artist's dexterity of hand are anathema. He thinks and works in terms of mechanics, natural forces, the ravages of time, the multiplex accidents of chance" (Harriet and Sidney Janis, "Marcel Duchamp," in *View*, Series 5, p. 18). For an analysis of Duchamp and the machine, see Lawrence D. Steefel, Jr., "Marcel Duchamp and the Machine," in Anne d'Harnoncourt and Kynaston McShine, eds., *Marcel Duchamp*, pp. 69–80

26. Quoted in Duchamp, *Marchand du sel*, p. 112; see also, Man Ray, *Self Portrait*, p. 101.

27. Identified as a portrait of Dorothy True (1919), photograph No. 29, in Doris Bry, *Alfred Stieglitz: Photographer* (Boston: Museum of Fine Arts, 1965).

28. *Marcel Duchamp: Notes and Projects for the Large Glass*, p.76. Since Duchamp had been a cartoonist in Paris between 1905 and 1910, and rarely associated with artists during that period (see Cabanne, *Dialogues with Marcel Duchamp*, pp. 21, 22), he would have appreciated, had he ever seen, Goldberg's prefatory "warning" to his early collection of cartoons in 1912: "This is not a work of art!" Recognizing the "artistic deficiencies" that separated him from fine art, he decided to embark on "a sea of foolishness," concluding: "A touch of art may nourish the soul, but a good laugh always aids the digestion" (*Chasing the Blues* [Garden City: Doubleday, Page, 1912], n.p.).

29. See Aline B. Saarinen, *The Proud Possessors*, pp. 238ff.

30. Société Anonyme, Inc., *Its Why & Its Wherefore* (New York: 1924), p. 4; *The Collection of the Société Anonyme*, (New York: 1920), p. 24.

31. *The Société Anonyme, Inc. Museum of Modern Art Report 1920–21*, a pamphlet which reported lectures, briefly announced this symposium. To be found in the files of the Yale University Art Gallery.

32. Letter from Hartley to Stieglitz, dated November 1, 1920 (Stieglitz Archives); letter dated January 18, 1917 (Stieglitz Archives); Marsden Hartley, *Adventures in the Arts* (New York: Boni and Liveright, 1921), p. 51.

33. "The Importance of Being 'Dada,'" in Hartley, *Adventures in the Arts*, pp. 254, 249.

34. Ibid., pp. 251 ff.

35. At his worst, Ray was a second rank imitator of Duchamp. Compare, for example, two photographs: one of Ray sitting before a chess board with a shaving cream beard and moustache; the other of Duchamp, head covered with shaving lather. Ray looks like a sheepish Santa Claus, while Duchamp, sleeves rolled up, hair twisted into two horns, moves demonically through a darkened space. The relationship between these two Dadaists cannot be simply resolved, however, partly because of Dada's casual attitude about what would ordinarily be called plagiarism in non-Dada circles. Man Ray himself has discounted the problem of influence: "All creators are influenced if they are aware of what has been done before" ("I Have Never Painted a Recent Picture," in Jules Langsner, *Man Ray* [Los Angeles: County Museum of Art, 1966], p. 31). More important is Ray's worth as an artist. He cannot be dismissed simply as a carbon copy of Duchamp, as one critic, Philip Leider, maintains: "It becomes clear that Man was never to become his own man" ("Man Ray, the Wandering Knight," *The New York Times* [November 6, 1966], Section II, p. 33). The more one studies Ray, the more difficult it is to deny his own integrity as an artist. Hence, my agreement with George Wickes, who claims that Man Ray "has always been a maker. His eyes are turned outward to the visible world, and his intelligence, as a French critic has said, is in his hands" (*Americans in Paris*, p. 131). Therein lies the basic difference between Ray and Duchamp.

36. *Self Portrait*, p. 99. In contrast, Duchamp has said, "The pieces aren't pretty in themselves, any more than is the form of the game, but what is pretty – if the word 'pretty' can be used – is the movement. . . . It's the imagining of the movement or of the gesture that makes the beauty, in this case. It's completely in one's gray matter" (Cabanne, *Dialogues with Marcel Duchamp*, pp. 18–19).

37. For an account of the process and its discovery, see Ray, *Self Portrait*, pp. 72–73.

38. Carl Belz, "Man Ray and New York Dada," *The Art Journal* 23 (Spring 1964): 207–08. Belz' article is one of the few critical appraisals of Man Ray's work that bypasses impressionistic appreciation for hard analysis. His discussion of the *Revolving Doors* and *The Rope Dancer* has been particularly helpful in my understanding of Ray.

39. In reference to *Dream*, Paul Wescher notes that "it was perhaps significant that the dream theme should occupy the young painter—the dream, the subconscious that later was to have such a share in the surrealist world of ideas" ("Man Ray as Painter," *Magazine of Art* 46 [January 1953]: 31).

40. Robert Melville notes of this painting "the profoundly satisfying symbolic act of making his mark on Cubism" ("Man Ray in London," *Arts* 33 [June 1959]: 46).

41. *The History of Surrealist Painting*, p. 60.

42. Man Ray had actually seen a rope dancer in a vaudeville show prior to painting the canvas (*Self Portrait*, p. 66).

43. Ibid., pp. 66–67.

44. William S. Rubin considers *The Rope Dancer* a trompe-l'œil collage (*Dada, Surrealism, and Their Heritage* [New York: Museum of Modern Art, 1968], p. 31).

45. *The Rope Dancer* also became an aerograph in 1918. As a final twist, the original *Rope Dancer* in oil became a virtual rope dancer when it was hung from the ceiling of Man Ray's small apartment in order to conserve space: "I had started a large canvas which I rigged up with ropes and pullies, to be drawn up into the skylight when not being worked on" (*Self Portrait*, p. 66).

46. Ibid., p. 68. With its characteristic wit, Ray's title refers to the collage's construction on a stand that allowed each to be viewed separately. Each collage becomes metaphorically, if not virtually, a revolving door. Five of the accompanying verbal texts ("The Meeting," "Shadows," "Mime," "Decanter," and "The Dragonfly") to the *Revolving Doors* appeared on what would be page 10 of *TNT*, a review put out in New York in March 1919. I am not certain that the remaining five texts for *Revolving Doors* were ever published or even written. Man Ray helped to print this issue of *TNT*, directed by the anarchist Adolf Wolff. Not particularly explosive, the review featured some poetry by Arensberg, a barn drawing by Sheeler, and a poem by the Dadaist Philippe Soupault. An anthology with some Dada contributors, the magazine had no concerted manifesto in the Dada genre, nor did it contribute any ideas about an indigenous American art. Not quite as Dadaist in feeling as the later *New York Dada*, yet not quite as inane and irrelevant as *Rongwrong*, this single-issue review was nonetheless an isolated collection of work by artists who in turn, probably felt isolated themselves.

47. That Man Ray considered the camera to be endowed with magical powers is clear from a delightful story he once told. "The other day I had come into the gallery to photograph a painting and set up my camera. There were people moving about who very considerately avoided passing between my instrument and the painting towards which it was directed. All except one person who ignored my presence and passed several times in front of the camera and even lingered a few moments in front of the painting I was copying. I said nothing, knowing that since I was giving a long exposure, anything that was in movement in front of my camera would not show on the

negative. However, when I developed my plate that night there was nothing on it—it was a failure. Perhaps I hadn't calculated my exposure properly, or it might have been the individual who stopped too long in front of the camera. I hung up the plate with some others, to dry. The next morning I examined the negative more carefully—there was something on it—it seemed to be entirely covered with fine writing. I made a print and read the text; it was an essay on modern art. The only explanation I could think of was that the visitor who had lingered in front of the camera had transmitted his thoughts to the sensitive negative—a sort of telepathy" (*Self Portrait*, pp. 97–98).

48. Strand's photographs appeared in *Camera Work*, No. 48 (October 1916) and Nos. 49–50 (June 1917). The latter issue also contained a brief essay by Strand on "Photography," pp. 3–4. Stieglitz began photographing his "equivalents" early in the 1920s and continued throughout the decade.

49. *Self Portrait*, pp. 128–29.

50. Tristan Tzara wrote a preface entitled "La Photographie à l'envers" for *Les Champs délicieux* (Paris: Société Générale d'Imprimerie et d'Édition, 1922).

Chapter 4. *The Soil* and *Contact*

1. That Williams was aware of Coady and *The Soil* is clear from his *Autobiography* (New York: Random House, 1951): "*The Seven Arts* was an important publication of the moment, as was *The Soil*—three issues [actually five]—of R. J. Coady, which came later. . . . Each was an unconscious collaborator in fostering the new spirit" (p. 147). In the fourth issue of *Contact* (Summer 1921) the editors included a brief note from Robert Alden Sanborn: "I have been pondering ever since his death of how we can give Bob Coady a fitting memorial. It strikes me that it would be best to publish the five numbers of his one volcanic outburst, *The Soil*, in a fine volume. But—" (p. 19). Although a good idea, it never materialized, even though Coady's best legacy was *Broom* and its concepts in the 1920s. One major difference between *The Soil* and *Contact* lies in the quality of the poetry published. Williams' magazine understandably published better.

2. Very little is known about Arthur Cravan, born Fabian Lloyd, in France, on May 22, 1887, of English parents. His claim to be the nephew of Oscar Wilde was probably a promotion stunt. He married the poetess Mina Loy, and in 1918 disappeared under unusual circumstances off the coast of Mexico, alone in a small boat that he was preparing for a voyage. Cravan's life was highlighted by the publication of *Maintenant*, his boxing match with Jack Johnson in 1916, and his appearance at the Independents in 1917. For a brief biographical sketch, see Bernard Delvaille's Preface to *Maintenant* (Paris: Erik Losfeld, 1956), a collection that contains all of Cravan's writings for *Maintenant* (which he himself peddled in a wheelbarrow through the streets of Paris), as well as scattered poems, with one exception, "Notes (Suite et fin)," which was published in the Surrealist magazine *VVV*, No. 2–3 (March 1943): 91–93. The only other account of Cravan is Gabrielle Buffet-

Picabia's brief but entertaining essay, "Arthur Cravan and American Dada," in Motherwell, ed., *The Dada Painters and Poets*, pp. 13–17.

3. "The spirit of Walt Whitman stands behind THE SEVEN ARTS. What we are seeking, is what he sought: that intense American nationality in which the spirit of the people is shared through its tasks and its arts, its undertakings and its songs" (*The Seven Arts* 2 [*May* 1917]: vii).

4. "America, Whitman, and The Art of Poetry," *The Poetry Journal* 8 (November 1917): 33; "Belly Music," *Others* 5 (July 1919), Supplement: p. 30.

5. For a sensitive understanding of these problems, see Sherman Paul, *The Music of Survival: A Biography of a Poem by William Carlos Williams* (Urbana: University of Illinois Press, 1968).

6. *The Soil* 1 (December 1916): 3.

7. Ibid.

8. Coady can be viewed as wanting "to seize life at its lowest levels, at its origins"—to use a definition of primitivism cited by Robert Goldwater, *Primitivism in Modern Painting* ([New York: Harper & Brothers, 1938], p. 52).

9. *The Soil* 1 (January 1917): 54.

10. Ibid.

11. Ibid., p. 55.

12. Ibid.

13. *The Soil* 1 (July 1917): 202.

14. Ibid., p. 204.

15. Ambroise Vollard, "Cézanne and Zola," *The Soil* 1 (December 1916): 14; Robert Coady, "Toto," ibid., p. 31. The desire for fictional characters to be "real" was reiterated in a short vignette by Enrique Cross entitled "Alice." The story deals with an invalid who yearns for freedom by cultivating a strong sense of reality. He rejects even Jack London's novels because he does not "want reality," presumably that which a naturalistic novel provides, but "something real," experience itself (*The Soil* 1 [April 1917]: 167). It is this tendency pushed to its extreme that distinguishes Coady from the Ashcan School. Although he probably approved of Ashcan realism, his rhetoric went beyond realism to incantation, beyond representation to the actual object unencumbered by art. In this respect, he was much like Williams.

16. *The Soil* 1 (December 1916): 30; *The Soil* 1 (March 1917): 138–39. The subsequent issue ran a series of children's work.

17. Gabrielle Buffet-Picabia, "Arthur Cravan and American Dada," in Motherwell, ed., *Dada Painters and Poets*, pp. 15–16.

18. Arthur Cravan, "Oscar Wilde is Alive!" *The Soil* 1 (April 1917): 146 (this essay originally appeared in *Maintenant*, No. 3 [October-November 1913]). Robert H. Sherard relates the Cravan hoax: "The legend as to his survival, as far as I have been able to trace its source, seems to have originated in the mind of an American newspaper reporter, probably a man writing on 'space rates,' who was anxious to get up a sensational article. It was just the kind of story which would appeal to the readers of the Sunday papers of the

American yellow press. The authority quoted was a Mr. Arthur Cravan Lloyd, who claims to be Oscar Wilde's nephew by marriage, and who combines the profession of poet with the craft of the pugilist. He is reported to have declared that his Uncle Oscar called on him in Paris, on 23rd March 1913, and had a drink with him. He added that Uncle Oscar had grown fat and was wearing a beard. Oscar seems to have told him nothing about himself beyond that he was writing his memoirs. This story was much quoted at the time, and evoked a number of quite unnecessary refutations" (*The Real Oscar Wilde* [London: T. W. Laurie, 1916], p. 328). Charles Sibleigh (translator of Fitzgerald's *Omar Khayyam* into French) had an interview with Cravan and came back supposedly convinced: "I now almost believe that some day we shall see Wilde back in Paris" ("No One Found Who Saw Wilde Dead," *The New York Times* [November 9, 1913], Section III, p. 4).

19.　*The Soil* 1 (December 1916): 4; originally appeared in "L'Exposition des Independants," *Maintenant*, No. 4 (March-April 1914); translated as "Exhibition at the Indépendents," in Motherwell, ed., *The Dada Painters and Poets*, pp. 3–13.

20.　*The Soil* 1 (April 1917): 162. That being a boxer was one of Cravan's poses can be substantiated by a comparison between his elaborate account and that of Johnson, who briefly mentions the incident in his autobiography: "I also arranged a ring contest with Arthur Craven who was an English heavyweight and had fled to Spain because of the war. A large crowd was attracted by the contest which lasted but a short time, for I knocked him out in the first round" *Jack Johnson—In the Ring—And Out* [Chicago: National Sports, 1927], p. 105). Although a commonplace event for Johnson, the contest symbolized Cravan's desire to be a man of action. That Cravan wanted to emulate Johnson out of the ring as well is evidenced by his lecture at the American Independents, when he, too, was surrounded by "a crowd of policemen." But again, he was ambivalent, not fully committed to this sort of behavior, because, according to Gabrielle Buffet-Picabia, "Cravan . . . never spoke of this exploit. . ." ("Arthur Cravan and American Dada," in Motherwell, ed., *The Dada Painters and Poets*, p. 16). The improbable Dada association has been perhaps surpassed by The Lampman, who, in an introductory preface, claims, "Strangely, my admiration and respect for Jack Johnson—not only as a world famous fighter, an outstanding boxer of all time, but as a man—is bound up with my passionate admiration for the great artist, Marcel Duchamp. Perhaps because they were both men of courage, style and imagination, in all ways inspirational, leaders in their respective fields" (*Jack Johnson Is a Dandy: An Autobiography*, introductory essays by Dick Schaap and The Lampman (New York: Chelsa House, 1969, p. 7). Although The Lampman sounds like Jack Armstrong with a mild case of Uplift, one would have to agree. Sanborn's articles on boxing include "Fight Nights at the Armory A.A.," *The Soil* 1 (March 1917): 130–34, and "Fight-Nights," *The Soil* 1 (July 1917): 214–18.

21.　See, for example, George W. Vos, "Art and Machinery," *The Soil* 1 (December 1916): 16–18; J.B., "Tugs," *The Soil* 1 (March 1917): 126–127.

22. *The Soil* 1 (December 1916): 36. The two poems were accompanied by a photograph of New York skyscrapers and an Abraham Walkowitz watercolor entitled *New York*. "Sifflet" originally appeared in *Maintenant*, No. 1 (April 1912). The second half of the poem was not included, probably because it was not particularly concerned with America.

23. America also symbolized for Cravan the exotic and the primitive. For example, in "L'Exposition des Indépendents," he rhapsodized, "Il y a aussi de jeunes Américains d'un mètre quatre-vingt-dix, heureux dans leurs épaules, qui savent boxer et qui viennent des pays arrosés par le Mississippi, où nagent les nègres avec mufles d'hippopotames; des contrées où les belles filles aux fesses dures montent à cheval; qui viennent de New-York plein de gratte-ciels, de New-York sur les bords de l'Hudson où dorment les torpilleurs chargés commes les nuages. Il y a également de fraîches Américaines, ô pauvres Gratteciella!!" (*Maintenant*, No. 4 [March-April 1914]).

24. Crotti maintained: "It is an absolute expression of my idea of Marcel Duchamp. Not my idea of how he looks, so much as my appreciation of the amiable character that he IS. How may such an appreciation be visualized without making it conventional and commonplace? I have used soft metal and fine wires for this characterization of Marcel Duchamp. To me, the character of my friend is most strikingly shown in the forehead and eyes, so I have carefully modeled these in detail, in the solid metal, and my likeness is already achieved. But as half a head, detached, would look odd and prejudice the portrait as a whole, I have completed the lower part of the face in bent wire outline. This is pure detached line drawing, in its way. Note how perfectly it conveys the expression of the mouth, harmonizing with that of the eyes" (*The Soil* 1 [December 1916]: 32). Coady may have been conservative about this sculpture, but to his credit he took the work seriously and insisted upon its aesthetic merits. The same cannot be said for the journalist who ridiculed Crotti: "The weird-looking wire and metal contrivance here photographed is neither a patent-applied-for mechanical device, nor a merry jest in a new kind of caricature. On the contrary, it is a serious and even idealized portrait of one distinguished artist by another. Jean Crotti, who made it, says so. His friend, Marcel Duchamp, who is the subject—ought we to say victim?—done in this gruesome medium, acknowledges as much" (*New York Magazine*, August 27, 1916, p. 8). Although, unfortunately, the sculpture is lost, a sketch of it exists at the Museum of Modern Art (Anne d'Harnoncourt and Kynaston McShine, eds., *Marcel Duchamp*, p. 193).

25. Mike Weaver, *William Carlos Williams: The American Background* (Cambridge: Cambridge University Press, 1971), p. 31; McAlmon's memoirs are entitled *Being Geniuses Together: 1920–1930*, revised and with supplementary chapters by Kay Boyle (Garden City: Doubleday, 1968). The only study of McAlmon is in *McAlmon and the Lost Generation: A Self-Portrait*, ed. with a commentary by Robert E. Knoll (Lincoln: University of Nebraska Press, 1962).

26. *Contact*, No. 1 (December 1920): 1.

27. Ibid.

28. Ibid.; "Further Announcements," ibid., p. 10.

29. Ibid.; John Rodker, "'Dada' and Else von Freytag von Loring-hoven," *The Little Review* 7 (July-August 1920): 36.

30. "Further Announcements," *Contact*, No. 1 (December 1920): 10.

31. *Contact*, No. 2 (January 1921): 8.

32. Ibid., pp. 9–10; Williams, *I Wanted to Write a Poem* (Boston: Beacon Press, 1958), p. 30.

33. *Contact*, No. 2 (January 1921): 11–12.

34. *Contact*, No. 3 (Spring 1921): 15. Williams reviewed *The Blind Man* in a short essay scanning little magazines: "Such things as *The Blind Man* are very useful, very 'purgative,' very nice decoration, even very true. It sponsors an art rather glad to be in a state of decay. It is rather naïve, I think. It prefers not to know when it is imitating the Chinese or the late French. It likes to reach out of the cabinet and grab whatever it touches and to imagine it has hit upon a new thing. In the dark all is in transition. It must be, for when nothing exists all must be changing from one thing to another. What else can there be? Oh, Chaos! Oh yes, but chaos is somewhat overdone" ("America, Whitman, and the Art of Poetry," *The Poetry Journal* 8 [November 1917]: 34).

35. *Contact*, No. 5 (June 1923): 1.

36. Ibid.

37. Ibid., p. 3.

38. Ibid.

39. Ibid.

40. For that reason, some criticism of Williams' poetry has been beside the point, or has covered the same ground much too often. J. Hillis Miller rightfully notes, "To accept the embrace Williams offers means the impossibility of 'criticizing' his work, if criticism means viewing with the cold eye of analysis and judgment" (*Poets of Reality* [Cambridge: Harvard University Press, 1966], p. 291). But it is not simply a matter of rational criticism being ineffective, as it might well be, but rather that of knowing what one is criticizing. At least within this early period, from 1919 to 1925, Williams was involved in art/anti-art ambiguities which modify, if not nullify, a New Critical approach. The standard criteria of poetry do not always apply, because Williams was not necessarily interested in the creation of "poetry."

Chapter 5. William Carlos Williams

1. Williams covered his Dada tracks quite effectively throughout his career. In a series of interviews he commented on his 1929 translation of Philippe Soupault's Dada novel *Last Nights of Paris*, disclaiming any understanding of the movement: "I had met Soupault in Paris. He was a very amusing person, really amusing, all wound up in Dadaism. I didn't understand what Dadaism was but I liked Soupault." Yet he could also say, "I didn't originate Dadaism but I had it in my soul to write it" (*I Wanted to Write a Poem*, pp. 47–48). Robert McAlmon has observed, "Bill was intent on meeting

young French writers [when he went to Paris in 1924], the Dadaists, Tristan Tzara, and the Surrealists, to get to the root of what they were driving at . . . They were frequently likable and bright and good conversationalists, but Bill would have it that they were profound and moved by significant impetus [as they indeed were]" (*Being Geniuses Together*, p. 186).

Williams also disclaimed that part of Wallace Stevens' Preface to his *Collected Poems 1921–1931* (New York: Objectivist Press, 1934), which pointed out the antipoetic element in his work. According to Stevens, "His passion for the anti-poetic is a blood passion and not a passion of the inkpot. The anti-poetic is his spirit's cure. He needs it as a naked man needs shelter or as an animal needs salt. To a man with a sentimental side the anti-poetic is that truth, that reality to which all of us are forever fleeing" (p. 2). Williams replied, "I was pleased when Wallace Stevens agreed to write the Preface but nettled when I read the part where he said I was interested in the anti-poetic. I had never thought consciously of such a thing. As a poet I was using a means of getting an effect. It's all one to me—the anti-poetic is not something to enhance the poetic—it's all one piece" (*I Wanted to Write a Poem*, p. 52). Williams rejected the concept of the antipoetic because it was, to his mind, simply part of the poetic spectrum. He realized that arbitrary distinctions between poetry, nonpoetry, and antipoetry were untenable—an insight that Duchamp had dramatized with his readymades about forty years earlier.

Williams' relationship to Dada has never been sufficiently explored. John C. Thirlwall makes only scattered references to Williams and Dada in "Two Cities: Paris and Paterson," *The Massachusetts Review* 3 (Winter 1962): 284–91. J. Hillis Miller insightfully, but briefly, relates Williams' use of language to Duchamp's readymades in *Poets of Reality*, p. 293. Although Bram Dijkstra offers a general history of the New York avant-garde during this period and mentions the relevance of Dada in passing, he goes on to consider other influences, as the title of his study indicates: *The Hieroglyphics of a New Speech: Cubism, Stieglitz, and the Early Poetry of William Carlos Williams* (Princeton: Princeton University Press, 1969). Richard A. Macksey plots the development of Williams' poetry during this period without considering its relationship to Dada, in his "'A Certainty of Music': Williams' Changes," in J. Hillis Miller, ed., *William Carlos Williams: A Collection of Critical Essays* (Englewood Cliffs, N.J.: Prentice-Hall, 1966), pp. 132–147. A longer and equally able treatment of Williams' development, but also omitting his Dada phase, is Thomas R. Whitaker's *William Carlos Williams* (New York: Twayne, 1968). Invaluable in providing an understanding of Williams' context, even though for the purposes of this study it primarily considers Williams' later relationship to Surrealism, is a more recent work, Mike Weaver's *William Carlos Williams: The American Background*.

2. *The Autobiography*, pp. 138, 148, 134. The French critic René Taupin has noted the influence of both French writers and painters on Williams. Taupin singles out Duchamp: "Enfin Marcel Duchamp qui état à New York en 1915 a eu une grande influence non seulement sur lui mais sur la

plupart de ceux qui l'ont fréquenté" (*L'Influence du Symbolisme* [Paris: H. Champion, 1929], p. 280). Williams may have respected Duchamp, but apparently the two did not get along. According to Williams, Duchamp snubbed him once at a party when Williams admired one of his paintings. "He had me beat all right, if that was the objective. I could have sunk through the floor, ground my teeth, turned my back on him and spat. I don't think I ever gave him that chance again. I realized then and there that there wasn't a possibility of my ever saying anything to anyone in that gang from that moment to eternity—but that one of them, by God, would come to me and give me the same chance one day and that I should not fail to lay him cold—if I could. Watch and wait. Meanwhile, work" (*The Autobiography*, p. 137).

3. *The Autobiography*, pp. 134, 229. Williams has also asserted that "'The Nude Descending a Staircase' is too hackneyed for me to remember anything clearly about it" (ibid., p. 134). His accurate assessment of the Nude parallels Duchamp's recent statement that the Nude is dead, thereby suggesting their restless avant-garde spirit.

4. Letter to Alva N. Turner, October 27, 1920, in John C. Thirwall, ed., *The Selected Letters* (New York: McDowell, Obolensky, 1957), p. 46.

5. "Belly Music," *Others* 5 (July 1919), Supplement: p. 25. It is significant to note that Arensberg financed *Others*, creating another connection between Williams and the Dada group in New York.

6. Ibid., p. 26.

7. Ibid., p. 28.

8. Some of *Kora in Hell* appeared in *The Little Review* prior to its publication in 1920 by the Four Seas Company in Boston, and at the time of the "Belly Music" essay. "Prologue: The Return of the Sun" appeared in Vol. 5 (April 1919): 1–10, and Vol. 6 (May 1919): 74–80. The Improvisations appeared in Vol. 4 (October 1917): 19; Vol. 4 (January 1918): 3–9; and Vol. 6 (June 1919): 52–59. For the best essay on *Kora*, see Sherman Paul, "A Sketchbook of the Artist in His Thirty-fourth Year: William Carlos Williams' *Kora in Hell: Improvisations*," in Melvin J. Friedman and John B. Vickery, eds., *The Shaken Realist*, pp. 21–44.

9. *I Wanted to Write a Poem*, pp. 28–29.

10. Ibid., p. 27; Williams, *Spring and All* (Paris: Contact, 1923), p. 44. In a letter dated February 27, 1921, to Alva N. Turner, Williams said, "You must know by this time that my liking is for an unimpeded thrust right through a poem from the beginning to the end, without regard for formal arrangements" (*The Selected Letters*, p. 50). *Les Champs magnétiques* was hailed as a revolutionary poem in "Briefer Mention," *The Dial* 69 (November 1920): 546–49. And so Williams might have at least known about this important work.

11. In a letter to Williams, Ezra Pound noted, "The thing that saves your work is *opacity* and don't you forget it. Opacity is NOT an American quality" (D. D. Paige, ed., *The Letters of Ezra Pound* [New York: Harcourt, Brace & World, 1950], p. 124). Williams reprinted part of the letter in the Prologue to *Kora in Hell* (Boston: The Four Seas, 1920), pp. 13–14. Pound

must have gained satisfaction from ascribing foreign qualities to Williams' poetry when Williams was trying to become "American."

12. *I Wanted to Write A Poem*, p. 29.

13. *Kora in Hell*, pp. 61, 60.

14. Ibid., pp. 49–50, 33.

15. Sanouillet notes that even *Les Champs magnétiques* was not purely automatic: "En d'autres termes, l'examen de ce manuscrit confirme notre confuse impression première: au départ le texte des *Champs magnétiques* n'est pas à proprement parler un pur produit de l'"écriture automatique' puisqu'on y peut encore déceler des éléments d'une structure logique" (*Dada à Paris*, p. 130).

16. *I Wanted to Write a Poem*, p. 30; *Kora in Hell*, p. 16. At the same time that he was writing *Kora*, Williams published three autobiographical vignettes which treat his role as a doctor in relation to his desire to write. He apparently had many self-doubts at the time, for he concludes, "I want to write, to write, to write. My meat is hard to find. What if I have not the courage?" ("Three Professional Studies," *The Little Review* 5 [February-March 1919]: 44). Less than a year later, he persisted in railing against American critics with a vituperation no less acerb than in "Belly Music." Once again he embraced the antipoetic and advised, "So let us take off our undershirt, my friends, and scratch our backs in good company. At least we will not be praised because of our loveliness" ("More Swill," *The Little Review* 6 [October 1919]: 30).

17. *Kora in Hell*, pp. 9–11.

18. Ibid., p. 11.

19. Ibid., p. 12.

20. Ibid., pp. 16–17.

21. Ibid., p. 19.

22. Ibid.

23. Ibid., p. 21.

24. Williams himself later noted that "their fault is their dislocation of sense, often complete" (*Spring and All*, p. 44); and the reviewer for *The Dial* made the acute observation, "One walks round and round the little well-born atrocities rubbing one's hands, though not precisely with pleasure" ("Briefer Mention," *The Dial* 70 [March 1921]: 351). Nevertheless, as René Taupin accurately noted, "Ce livre *Kora in Hell* qui contient les *Improvisations* est probablement le plus important dans l'évolution de la poésie de Williams, même si on pense qu'il n'est pas le mieux réussi" (*L'Influence du Symbolisme*, p. 284).

25. *The Autobiography*, pp. 164–65.

26. Here is how the Baroness made her entrance into the offices of *The Little Review*, according to Margaret Anderson: "She saluted Jane with a detached How do you do, but spoke no further and began strolling about the room, examining the contents of the bookshelves. She wore a red Scotch plaid suit with a kilt hanging just below the knees, a bolero jacket

with sleeves to the elbows and arms covered with a quantity of ten-cent-store bracelets – silver, gilt, bronze, green and yellow. She wore high white spats with a band of decorative furniture braid around the top. Hanging from her bust were two tea-balls from which the nickel had worn away. On her head was a black velvet tam o'shanter with a feather and several spoons – long ice-cream-soda spoons" (*My Thirty Years' War* [New York: Covici, Friede, 1930], p. 178). This attire was rather conservative, for she was reputed to have occasionally worn a coal bucket on her head.

27. *The Little Review* 7 (January-March 1921): 48–49.

28. Ibid., p. 49.

29. Ibid., pp. 49–50.

30. Ibid., pp. 53, 50; *The Little Review* 8 (Autumn 1921): 110. In the Prologue, Williams concludes, "An acrobat seldom learns really a new trick, but he must exercise continually to keep his joints free. When I made this discovery it started rings in my memory that keep following one after the other to this day" (*Kora in Hell*, p. 30).

31. *The Little Review* 8 (Autumn 1921): 109.

32. *Contact*, No. 4 (Summer 1921): 11. In a wonderfully surreal passage, Williams describes the Baroness: "High into the air the old lady bounced herself, turning and turning head over heels in the dawn and at noon as at night till dripping with holy nectar from the stars, naked as the all-holy sun himself, she mocked the dull Americans" (*Contact*, No. 4 [Summer 1921]: 12).

33. Ibid., pp. 12, 13.

34. *I Wanted to Write a Poem*, pp. 32–33.

35. *Sour Grapes* (Boston: The Four Seas, 1921), pp. 11–12, 15, 21.

36. Ibid., p. 69.

37. Ibid., pp. 75–76.

38. *I Wanted to Write a poem*, p. 48. Only recently have the poetry and prose of *Spring and All* been taken together. In his introduction, M. L. Rosenthal has accurately noted, "His prose matrix for the poems of *Spring and All*, dropped after the first publication of 1923, was already the work of a mature thinker with a good idea of what he was doing" (*The William Carlos Williams Reader* [New York: New Directions, 1966], p. xvii). This view is essentially repeated by J. Hillis Miller in his *Poets of Reality*, p. 309. James Guimond has written an excellent study entitled *The Art of William Carlos Williams* (Urbana: University of Illinois Press, 1968), which considers not only *Spring and All* in its entirety but takes up the important problems facing Williams during this period and later, as the subtitle indicates: "A Discovery and Possession of America." While Guimond does not consider Dada at all, an equally important flaw, dependent upon that omission, is the general impression that Williams' work and thought follow a coherent, rational pattern, which was clearly not true in the making, given Williams' temperament, and is thus merely a critical afterthought. For a general analysis, see Linda Wagner, "*Spring and All*: The Unity of Design," *Tennessee*

Studies in Literature 15 (1970): 61–73; and a provocative essay by J. Hillis Miller, "Williams' *Spring and All* and the Progress of Poetry," *Daedalus* 99: 405–34.

39. *I Wanted to Write a Poem*, pp. 36–37.

40. *Spring and All*, pp. 1–2.

41. Ibid., pp. 2–3.

42. Ibid., pp. 3–4.

43. Ibid., pp. 5–6.

44. Ibid., p. 7.

45. Ibid., p. 9.

46. Ibid., pp. 11–12.

47. Ibid., p. 22.

48. Ibid., pp. 50, 67.

49. Ibid., pp. 74, 93. Miller makes the excellent point: "This acceptance of words as things manifests itself in several ways in Williams' work. Sometimes words are taken as *objets trouvés*. A modern painter makes his collage of bits of newspaper or cigarette packages. Picasso creates a bull's head out of a bicycle seat and handle bars. Marcel Duchamp sets up a urinal as a 'ready-made' . . . Nonverbal things cannot be put into poetry, since poems are after all made of words, but words also are ready-made and may be taken out of their contexts and put into a poem just as they are found" (*Poets of Reality*, p. 293).

50. *The Great American Novel* (Paris, 1923), pp. 18, 62.

51. Ibid., p. 18. For a good analysis, see Hugh Kenner's essay, "A Note on *The Great American Novel*," in Miller, ed., *William Carlos Williams: A Collection of Critical Essays*, pp. 88–92.

52. *The Great American Novel*, p. 9.

53. Ibid., p. 10.

54. Ibid., pp. 10–11.

55. Ibid., pp. 19, 26.

56. Ibid., pp. 20–21.

57. Ibid., pp. 24–25.

58. Ibid., p. 26.

59. Ibid., pp. 27, 51–52.

60. Ibid., p. 61.

61. *In the American Grain*, p. 136.

62. Ibid., p. 109.

63. Ibid., pp. 189, 213.

Chapter 6. *Broom* and *Secession*

1. From November 1921 to September 1922, *Broom* was published in Rome; from October 1922 to March 1923, Berlin; then from August 1923 to January 1924, back in New York. There are very few secondary sources for *Broom* and *Secession*. Frederick J. Hoffman briefly discusses these two reviews in Chapter VI, "The *Tendenz* Magazine," of his *The Little Magazine*,

charting their development by geographical locale, a rather arbitrary if not superficial way of noting shifts and changes in editorial policy. Charles A. Allen unravels all the plots and counterplots surrounding *Secession* in his essay "Director Munson's *Secession,*" *The University Review* 5 (Autumn 1938): 95–102. Good on the shenanigans, Allen pays little attention, however, to the substantive issues between Munson and Josephson.

2. *Secession* ran for eight issues from Spring of 1922 to April 1924. It, too, was published all over Europe, from Vienna to Berlin and Paris.

3. *Broom* 2 (July 1922): 346–347.

4. *Broom* 1 (November 1921): 94.

5. Alfred Kreymborg, "Dada and the Dadas," *Shadowland* 7 (September 1922): 43, 70. Loeb was even more explicit than Kreymborg in his dismissal of Dada: "Although I was glad to run the Dadaists because there was life in them and a great earnestness, I thought of Dada as an expression of defeat, as a post-war disillusionment with French ideals and values, perhaps appropriate in France after centuries of intellectual and moral ferment, but largely irrelevant in America" (*The Way It Was* [New York: Criterion, 1959], p. 77).

6. *Broom* 1 (November 1921): 89–93; *The Way It Was*, p. 76.

7. *Broom* 1 (November 1921): 92.

8. Leon Bazalgette, "Notre Amérique," *Broom* 1 (December 1921): 154; Waldo Frank, *Our America* (New York: Boni and Liveright, 1919), pp. 10, 175, 181, 143, 147. For a discussion of Frank and the machine, see Thomas Reed West, *Flesh of Steel: Literature and the Machine in American Culture* (Nashville: Vanderbilt University Press, 1967), pp. 35–53.

9. *Broom* 1 (February 1922): 381–82.

10. Jean Epstein, "The New Conditions of Literary Phenomena," *Broom* 2 (April 1922): 10; *Our America*, p. 172.

11. *Broom* 2 (April 1922): 10, 6.

12. Letter dated December 6, 1921, from Gorham Munson to Malcolm Cowley (Malcolm Cowley Collection, Newberry Library, Chicago).

13. Malcolm Cowley, "This Youngest Generation," *The Literary Review of the New York Evening Post* (October 15, 1921), pp. 81–82; Gorham Munson, "The Fledgling Years, 1916–1924," *The Sewanee Review* 40 (January–March 1932): 28. Cowley fulfilled his role as generation historian in 1934 with *Exile's Return* (New York: W. W. Norton, 1934) and maintained his standing with *A Second Flowering: Works and Days of the Lost Generation* (New York: Viking Press, 1973).

14. Matthew Josephson, *Life among the Surrealists* (New York: Holt, Rinehart, and Winston, 1962), p. 100.

15. Gorham Munson, "The Fledgling Years, 1916–1924," *The Sewanee Review* 40 (January–March 1932): 31–32.

16. Ibid., pp. 28–29.

17. Kenneth Burke, "Dadaisme Is France's Latest Literary Fad," *New York Tribune* (February 6, 1921), Section VII, p. 6.

18. Josephson, *Life among the Surrealists*, p. 7.

19. Ibid., p. 116.

20. Letter dated December 5, 1921, from Matthew Josephson to Malcolm Cowley (Cowley Collection); see also, Josephson, *Life among the Surrealists*, p. 132.

21. *Le Cœur à Barbe* appeared on bilious pink stock in April 1922. In addition to Josephson, the lone American, Dadaists such as Paul Eluard, Vincent Huidobro, Benjamin Peret, Georges Ribemont-Dessaignes, Erik Satie, Rrose Sélavy, Philippe Soupault, and Tristan Tzara collaborated on what amounted to a conglomerate of one-liners. This "Bearded Heart" was a protest against the formalized Congress of Paris, a convention planned by Breton, to discuss all aspects of modern art. Josephson contributed some quotations from the New York Stock Exchange as well as some mild and brief diatribes against the American literary establishment that was promoting French literary naturalism. On the back page of the review appeared this announcement: "*Secession* a paru. Les excellents efforts de Munson et de Josephson mettront des fesses dans l'huile coagulée et parasite de Broom, Little Review, Dial et leurs morues d'aisance."

22. *Secession*, No. 1 (Spring 1922): 9.

23. Ibid., pp. 9–10.

24. Ibid., pp. 10–11.

25. Letter dated December 11, 1922, from Gorham Munson to Matthew Josephson (Harold Loeb Papers, Princeton University).

26. Philippe Soupault, *The American Influence in France* (Seattle: University of Washington Bookstore, 1930), pp. 20, 13; an earlier version entitled "The 'U.S.A.' Cinema" appeared in *Broom* 5 (September 1923): 65–69.

27. *Secession*, No. 1 (Spring 1922): 12–13.

28. Ibid., p. 13.

29. Josephson, *Life among the Surrealists*, p. 188.

30. *Broom* 2 (May 1922): 176–181.

31. *Broom* 2 (June 1922): 269.

32. Ibid.

33. Ibid., p. 270.

34. See Matthew Josephson, "After and Beyond Dada," *Broom* 2 (July 1922): 346–50; and Will Bray (pseudo. for Josephson), "Exordium to Ducasse," *Broom* 3 (August 1922): 3. *Broom* also presented a lengthy discussion of Dada by Jacques Rivière, "French Letters and the War," *Broom* 3 (August 1922): 18–28.

35. Loeb, *The Way It Was*, pp. 124, 135. Fourteen letters were exchanged between Robert Alden Sanborn and Loeb, discussing the implications of *Broom* and its relationship to *The Soil*. In the end, there were fewer differences between Loeb's position and Coady's than Loeb would admit (Harold Loeb Papers).

36. *Broom* 3 (September 1922): 115–30.

37. In the same issue Prampolini wrote an essay accepting the machine (in contrast to Frank). "Is not the machine today the most exuberant symbol of the mystery of human creation? Is it not the new mythical deity which weaves the legends and histories of the contemporary human drama?" he asked. *The Machine* in its practical and material function comes to have today in human concepts and thoughts the significance of an ideal and spiritual inspiration" ("The Aesthetic of the Machine and Mechanical Introspection in Art," *Broom* 3 [October 1922]: 236). See also, Gilbert Cannan, "Observations on Returning to the Remnants of Civilization," ibid., pp. 218–21; Robert Alden Sanborn, "A Champion in the Wilderness," ibid., pp. 175, 179.

38. *Broom* 3 (November 1922): 305.

39. Ibid., p. 309; letter dated December 13, 1922, from Waldo Frank to Harold Loeb (Harold Loeb Papers).

40. *Broom* 4 (December 1922): 57–60.

41. *Secession*, No. 1 (Spring 1922): 17–19.

42. Gorham Munson, "A Specimen of Demi-Dadaisme," *The New Republic* (April 18, 1923), p. 219.

43. "The New Patricians," *The New Republic* (December 6, 1922), p. 42.

44. Gorham Munson, *Waldo Frank: A Study* (New York: Boni and Liveright, 1923), pp. 23–25.

45. Ibid., p. 25; Gorham Munson, "The Skyscraper Primitives," *The Guardian* 1 (March 1925): 170. Note that the Italian Futurist Boccioni had called himself a primitive with reference to technology as early as 1912 (Banham, *Theory and Design in the First Machine Age*, p. 102).

46. Munson, *Waldo Frank*, p. 24; see, also, his "'291' A Creative Source of the Twenties," *Forum* 3 (1960): 9; "The Skyscraper Primitives," *The Guardian* 1 (March 1925): 164.

47. Matthew Josephson, "Henry Ford," *Broom* 5 (October 1923): 137, 139.

48. Ibid., p. 142.

49. Gorham Munson, "Tinkering with Words," *Secession*, No. 7 (Winter 1924): 31.

50. *Secession*, No. 7 (Winter 1924): 6, 8, 14.

51. Edmund Wilson, "The Aesthetic Upheaval in France," *Vanity Fair* 17 (February 1922): 100.

52. *Broom* 5 (August 1923): 49–51.

53. Edmund Wilson, "An Imaginary Conversation: Mr. Paul Rosenfeld and Mr. Matthew Josephson," *The New Republic* (April 9, 1924), p. 179. That same year, Gilbert Seldes published *The Seven Lively Arts* (New York: Harper and Bros., 1924). On the title page of the first edition appears a quotation by Walter Pater that informs Seldes' work: "*But, beside these great men, there is a certain number of artists who have a distinct faculty of their own by which they convey to us a peculiar quality of pleasure which we*

cannot get elsewhere; and these, too, have their place in general cul-ture. . . ." In 1929 Wilson wrote a novel, *I Thought of Daisy* (New York: Scribners, 1929), which dramatizes the artist's problems of creating fine art in a vulgar environment. For an excellent study of Wilson's novel, see Sher-man Paul, *Edmund Wilson: A Study of Literary Vocation in Our Time* (Ur-bana: University of Illinois Press, 1965), pp. 53–77.

54. Wilson, "An Imaginary Conversation," *The New Republic* (April 9, 1924), p. 179.

55. Ibid., p. 180.

56. Ibid., p. 182.

57. Waldo Frank, "Seriousness and Dada," *1924*, No. 3 (September 1924): 71.

58. Malcolm Cowley, "Communications on Seriousness and Dada," *1924*, No. 4 (November 1924): 140–41.

59. For accounts of this episode, see Loeb, *The Way It Was*, pp. 168–169; Gorham Munson, "The Fledgling Years, 1916–1924," *The Sewanee Review* 40 (January-March 1932): 46.

60. Quoted in Loeb, *The Way It Was*, p. 194.

61. For accounts of these episodes, see Munson, "The Fledgling Years," *The Sewanee Review* 40 (January-March 1932): 49; Josephson, *Life among the Surrealists*, p. 264.

62. Burton Rascoe, "'Aesthete: Model 1924'—Timeless and Univer-sal," in "A Bookman's Daybook," *New York Tribune* (December 30, 1923), Section IX, p. 3. In an essay entitled "On Being American," *Prejudices, Third Series* (New York: Knopf, 1922), pp. 9–64, Mencken himself castigated all the "young intellectuals" for leaving the American carnival to escape to Europe. In "A Modern Masterpiece" Mencken reviewed Josephson's trans-lation of Apollinaire's *The Poet Assassinated* and considered both the work and its translation a deliberate joke (*Prejudices, Fifth Series* [New York: Alfred Knopf, 1926], pp. 169–72). For all his championing of Dreiser and literary naturalism, Mencken was quite conservative when it came to litera-ture, particularly poetry, by the 1920s.

63. Ernest Boyd, "Aesthete: Model 1924," *The American Mercury* 1 (January 1924): 51, 53.

64. Josephson, *Life among the Surrealists*, p. 269; Burton Rascoe, "Ernest Boyd: Elegant Reading Machine," in "A Bookman's Daybook," *New York Tribune* (December 30, 1923), Section IV, p. 3.

65. *Aesthete 1925* (February 1925): 25, n. 2.

66. The magazine was also dedicated to Mencken as well as to William Jennings Bryan, Calvin Coolidge, and Cecil B. deMille, among others. Such company must have galled Mencken.

67. Jane Heap struck at the heart of the matter: "And—wasn't it rather a poverty of spirit to devote an entire magazine to Mr. Ernest Boyd? Mr. Boyd is, I believe, just a regular professional literary man. He may at any time write an article that no one likes . . . it is his business . . . don't interfere

with Business. And it was quaint of him to bring the word Aesthete back into the language when no one living today even knows what it means" ("Comments," *The Little Review* 11 [Spring 1925]: 19).

68. Other episodes limped into the Depression. Josephson collaborated with Cowley in publishing *Whither, Whither, or After Sex What?: A Symposium to End Symposiums* (New York: Macaulay, 1930). The collection was supposedly edited by Walter S. Hankel, the fictitious editor of *Aesthete 1925*, modeled after Munson. Containing essays by Kenneth Burke, Corey Ford, Slater Brown, John Wheelwright, E. E. Cummings, Josephson, and Cowley, the collection was probably a spoof on *Whither Mankind*, ed. Charles A. Beard (New York: Longmans, Green, 1928), with its pretentious subtitle, "A Panorama of Modern Civilization." The 1925 fiasco erupted all over again when Cowley began to publish his memoirs in the pages of *The New Republic* during the fall of 1931, later to be assembled as *Exile's Return* in 1934.

Chapter 7. Hart Crane and the Machine

1. For an account of Crane's participation in the *Aesthete* affair, see the definitive biography by John Unterecker, *Voyager: A Life of Hart Crane* (New York: Farrar, Strauss and Giroux, 1968), pp. 357–60.

2. Letter dated January 14, 1921, to Matthew Josephson, in Brom Weber, ed., *The Letters of Hart Crane* (New York: Heritage House, 1952), p. 52. As Philip Horton has described Crane's reactions to the Baroness: "Whatever her costume that particular day, Crane turned and fled at her invasion of his quarters, and thereafter vanished into alleys and doorways at the very sight of her brilliant approach along the street" (*Hart Crane: The Life of an American Poet* [New York: Norton, 1937], p. 65). While Horton's biography was the best before Unterecker's (and perhaps still the most readable), Horton exaggerates Crane's response to the Baroness.

3. Letter dated January 28, 1921, to Gorham Munson, in Brom Weber, ed., *The Letters of Hart Crane*, p. 52; letter dated January 23, 1922, to Gorham Munson, ibid., pp. 78–79. In a letter dated November 26, 1921, to Munson, Crane said, "Dada (maybe I am wrong, but you will correct me) is nothing more to me than the dying agonies of this movement [literary impressionism], maladie moderne" (ibid., p. 72). And later, on February 18, 1923, he told Munson that he had just sent a caricature of Rosenfeld off to *The Little Review* (ibid., p. 126). Quite clearly, he agreed with Josephson, Loeb, Munson, Cowley, *et al* on the need for aesthetic precision in poetry and criticism.

4. Letter dated April 19, 1922, to Gorham Munson; letter dated September 19, 1921, to Gorham Munson, ibid., pp. 84, 65.

5. Letter dated November 27, 1922, to Gorham Munson, ibid., pp. 105–06. Despite his personal anguish and his occasional inability to write poetry, Crane rarely directed his anger and frustration against art itself; nor did he ever develop an anti-art stance.

6. Letter dated March 2, 1923, to Gorham Munson, ibid., p. 129; Brom

Weber, ed., *The Complete Poems and Selected Letters* (New York: Doubleday-Anchor, 1966), pp. 144–46.

7. Letter dated December 13, 1919, to Gorham Munson, in Weber, ed., *Letters of Hart Crane*, p. 26; Weber, ed., *Complete Poems and Selected Letters*, p. 11.

8. In Weber, ed., *Complete Poems and Selected Letters*, pp. 27–33.

9. Letter dated February 18, 1923, to Gorham Munson, in Weber, ed., *Letters of Hart Crane*, p. 125.

10. Munson, *Waldo Frank*, p. 24. For an excellent study of Crane and Eliot, see Sister M. Bernetta Quinn, *The Metamorphic Tradition in Modern Poetry* (New Brunswick: Rutgers University Press, 1955). For a study of Crane and Whitman, see Hyatt H. Waggoner, *American Poets: From the Puritans to the Present* (Boston: Houghton Mifflin, 1968), pp. 493–511. And for a somewhat tentative study of Crane and Frank, see Robert L. Perry, *The Shared Vision of Waldo Frank and Hart Crane* (Lincoln: University of Nebraska Press, 1966).

11. T. S. Eliot, *The Waste Land and Other Poems* (New York: Harcourt, Brace and World, 1962), pp. 34, 37–39.

12. Letter dated March 2, 1923, to Gorham Munson, in Weber, ed., *Letters of Hart Crane*, p. 128; in a letter dated February 15, 1923, to Allen Tate, he mentioned that he had just read P. D. Ouspensky's *Tertium Organum* (ibid., p. 124).

13. Allen Tate, *The Man of Letters in the Modern World* (London: Meridian Books, 1957), p. 290. L. S. Dembo makes the point that "Crane did not share Whitman's 'measureless love,' that conception which invariably made it possible for Whitman to assert his identity with the world and engendered all his optimism" (*Hart Crane's Sanskrit Charge: A Study of The Bridge* [Ithaca: Cornell University Press, 1960], p. 6). Waggoner claims that Crane might have been "forced into a mystical tradition alien to him" (*American Poets*, p. 510). Eugene Paul Nassar, however, disclaims that Crane was a mystic, but believes, rather, that he embraced "a dualistic experience of life," expressed in *The Bridge* (*The Rape of Cinderella* [Bloomington: Indiana University Press, 1970], p. 144). While I do not entirely share Nassar's view, I agree with many of his other ideas, especially those in reference to the narrator's quest for meaning in *The Bridge*. For Cowley's rejection of Eliot, see his *Exile's Return* (New York: Viking-Compass, 1956), pp. 110–15; see also, Josephson, *Life among the Surrealists*, p. 157.

14. Hart Crane, *The Bridge*, in Weber, ed., *Complete Poems and Selected Letters*, p. 46. In a letter dated February 18, 1923, to Munson, Crane said, "History and fact, location, etc., all have to be transfigured into abstract form that would almost function independently of its subject matter" (in Weber, ed., *Letters of Hart Crane*, p. 124). Several critics simply have not understood Crane's use of history for mythical purposes. With their academic bent, they envision Crane (and find him lacking) as a professional historian turning out a monograph. Since Crane was heading in other directions,

naturally they were disappointed. For a refreshing view of Crane's use of myth, see Deena Posy Metzger, "Hart Crane's *Bridge*: The Myth Active," *Arizona Quarterly* 20 (Spring 1964): 34–36.

15. *Leaves of Grass and Selected Prose*, pp. 367–68, 234.

16. Ibid., pp. 147–57, 321–28.

17. Hart Crane, "Sherwood Anderson," *The Double-Dealer* 2 (July 1921): 43; Hart Crane, "General Aims and Theories," in the Appendix to Horton, *Hart Crane*, pp. 323–25.

18. Hart Crane, "General Aims and Theories," idem., pp. 324–27.

19. "Modern Poetry," in Weber, ed., *Complete Poems*, p. 260.

20. Ibid., p. 263.

21. Ibid., p. 261.

22. Ibid., pp. 261–62; Munson, *Waldo Frank*, p. 24.

23. "Modern Poetry," in Weber, ed., *Complete Poems*, p. 262.

24. Ibid.

25. Ibid.

26. For a cultural history of Brooklyn Bridge, see Alan Trachtenberg, *Brooklyn Bridge: Fact and Symbol* (New York: Oxford University Press, 1965).

27. In Weber, ed., *Complete Poems*, pp. 45–46.

28. Ibid., p. 46.

29. Ibid., pp. 60, 54.

30. Ibid., pp. 113–17. For an indictment of the "Atlantis" section, see Roy Harvey Pearce, *The Continuity of American Poetry* (Princeton University Press, 1961), pp. 103–09. The closest statement of my position has been expressed by Thomas A. Vogler: "The poem is a search or quest for a mythic vision, rather than the fixed, symbolic expression of a vision firmly held in the poet's mind" ("A New View of Hart Crane's Bridge," *The Sewanee Review* 73 Summer 1965 : 381).

31. In Weber, ed., *Complete Poems*, pp. 62, 66. For the identification of specific products, see John Baker, "Commercial Sources for Hart Crane's *The River*," *Wisconsin Studies in Contemporary Literature* VI (Winter-Spring 1965): 45–55.

32. In Weber, ed., *Complete Poems*, p. 63.

33. Ibid., pp. 107–12.

34. Ibid.

35. Ibid., p. 45.

36. Ibid., p. 56.

37. Ibid., p. 90.

38. Ibid.

39. Ibid., pp. 90, 91.

40. Ibid., pp. 89, 94.

41. Ibid., p. 41.

Chapter 8. E. E. Cummings and Dada Formalism

1. As a representative example, W. C. Blum (pseudo. for James Sibley Watson of *The Dial*) claimed that Cummings was only superficially modern,

that in actuality he was a lyricist ("The Perfumed Paraphrase of Death," *The Dial* 76 [January 1924]: 49). Very few critics at the time gave Cummings much credit for his experimentation. Indeed, most conceded its existence only as shallow and superficial. Waggoner makes a good case in Chapter 19 of his *American Poets* that Cummings was strongly influenced by Emerson. It seems to me that his gradually developing Emersonianism enabled him to be a radical and a conservative at the same time. Moreover, many of Cummings' Dada values were quite consistent with Emersonianism.

2. In *i six nonlectures* (New York: Atheneum, 1962), for example, Cummings does not mention Dada when citing poets that he had admired over the years. His silence is problematic, possibly indicating indifference. But the amount of evidence available would suggest that his values were rather close to Dada, even though he probably came upon them independently.

3. E. E. Cummings, "The New Art," in George J. Firmage, ed., *E. E. Cummings: A Miscellany Revised* (New York: October House, 1965), p. 5. Ribemont-Dessaignes, "Dada Painting or the Oil-Eye," *The Little Review* 9 (Autumn-Winter 1923–24): 11.

4. "The New Art," in Firmage, ed., *Cummings*, pp. 10–11.

5. "T. S. Eliot," ibid., p. 27. As early as 1923, Gorham Munson perceptively noted that "Cummings' criticism focuses flashlights upon his own work" ("Syrinx," *Secession*, No. 5 [July 1923]: 6).

6. Clement Wood, *The Poets of America* (New York: Dutton, 1925), p. 304; "The New Art," in Firmage, ed., *Cummings*, p. 9. Charles Norman tells how the reading of this poem at the Harvard Commencement lecture shocked all the little Cambridge ladies (*E. E. Cummings* [New York: Dutton, 1967], pp. 42–43).

7. Norman, *Cummings*, p. 54.

8. Rudolph Von Abele, "'Only To Grow': Change in the Poetry of E. E. Cummings," *PMLA* 70 (December 1955): 917n.

9. Slater Brown, "Book Reviews," *Broom* 6 (January 1924): 26.

10. H. L. C. Jaffe asserts, "The manifesto shows the influence of the Dada-movement, which had brought new life to Van Doesburg's literary experiments" (*De Stijl: 1917–1931* [Amsterdam: J. M. Meulenhoff, 1956], p. 19); see also, "Manifesto II" (1920), in Theo Van Doesburg, "The Literature of the Advance Guard in Holland," *The Little Review* 11 (Spring 1925): 56–59; E. E. Cummings, "Is 5," in his *Poems 1923-1954* (New York: Harcourt, Brace, 1954), p. 163. It must be noted, however, that Cummings expressed similar attitudes about the verb and the quality of being alive in his 1920 essay "Gaston Lachaise," *The Dial* 68 (February 1920): 194–204, reprinted in Firmage, ed., *Cummings*, pp. 12–24.

11. *The Little Review* 10 (Spring 1924): 20.

12. *Poems 1923-1954*, p. 76.

13. Hans Richter, *Dada: Art and Anti-Art*, p. 121.

14. *Poems 1923-1954*, p. 99.

15. Ibid., p. 78.

16. Ibid., p. 99. Charles Norman notes that this technique extends back

to the Greeks and is known as *Tmesis* (*Cummings*, p. 133n.). Once again Cummings looked both forward and backward in his poetry by rejuvenating a classic technique for contemporary purposes.

17. *Broom* 6 (January 1924): 27; E. E. Cummings, *The Enormous Room* (New York: Modern Library, 1934), p. 114.

18. The *Dial Award* to Cummings was announced in *The Dial* 80 (January 1926): 84–88. Malcolm Cowley and Slater Brown attacked the magazine as conservative, in "Comment," *Broom* 6 (January 1924): 30–31. Cummings, however, has described *The Dial* as "a firstrate magazine of the fine arts" (*i six nonlectures*, p. 50). He also made some contributions to other little magazines: "my love is building a building" and "O thou to whom the musical white springs," *The Liberator* 4 (July 1921): 24, 31; "Because / an obstreporous," "said John Roosevelt," and "listen / this dog barks," *The Little Review* 9 (Spring 1923): 22–24; "But observe" and "nobody loses all the time," *The Chapbook*, No. 36 (April 1923): 7–9; "impossibly," "voices to voices, lip to lip," "death is more than," and "weazened Irrefutable unastonished," *the transatlantic review* 1 (January 1924): 1–5; "it is winter a Moon," "why are these pipples," and "sunlight was over," *1924*, No. 2 (August 1924): 36–38. After October 1923, the publication date of *Tulips and Chimneys*, Cummings wrote new poems which appeared in *Broom*. Fifteen poems from *The Dial* were printed in *Tulips and Chimneys*, whereas only three poems from *Broom* were reprinted. This tally would suggest that Cummings was saving some of his newer poems for *Broom*, an indication that he was aware of its editorial inclinations. Such a count obviously does not indicate the experimental quality of the poems he submitted to the various magazines. It takes the kind of textual analysis as presented in the essay to reveal such qualities.

19. "Little tree" and "Buffalo Bill's" appeared in *The Dial* 68 (January 1920): 22–23; "Always before your voice my soul," in *The Dial* 71 (October 1921): 439–40. Cummings contributed a total of thirty-seven poems to *The Dial* in eleven issues, ranging from January 1920 to April 1926.

20. *The Dial* 72 (April 1922): 354–55; *The Dial* 76 (January 1924): 1–2. The seven poems were "suppose," "at dusk / just when," "before the fragile gradual throne of night," "Take for example this," "of this sunset (which is so," "Paris: this April sunset completely utters," and "will out of the kindness of their hearts a few philosophers tell me," *The Dial* 74 (January 1923): 25–30. These poems were all new, and had not been included in the original manuscript for *Tulips and Chimneys*. It is very difficult to determine exactly when Cummings wrote any particular poem. But a rough chronology can be established from the sequence of books that he published in correlation with the poems published in the little magazines, which provide a more precise date than the volumes of poetry.

21. *Broom* 2 (May 1922): 146–47.

22. *Broom* 2 (July 1922): 273, 306–08. Georges Ribemont-Dessaignes wrote an excellent minimal poem, "Le Singe et le Singe," *The Little Review* 10 (Autumn-Winter 1924–25): 42.

Fable
Je suis
Tu es
Il est
Nous sommes
Vous êtes
Ils sont
 Morale
Être.

23. "The Poems of Abel Sanders," *The Little Review* 8 (Autumn 1921): 111. Cummings was particularly interested in Krazy Kat. See "A Foreword to Krazy," in Firmage, ed., *Cummings*, pp. 323–28.

24. *Broom* 2 (July 1922): 346–47.

25. The five portraits were of Liz, Mame, Gert, Marj, and Fran, in *Broom* 5 (October 1923): 134–36.

26. "when the spent day begins to frail," "my smallhead pearshaped," "now that fierce few," and "the wind is a lady with," *Broom* 5 (November 1923): 204–07; "ohld song," "i'd think 'wonder,' " "if (you are i why certainly," and "Will i ever forget that precarious moment," *Broom* 6 (January 1924): 1–5; Brown, "Book Reviews," *Broom* 6 (January 1924): 27.

27. "workingman with hand so hairy-sturdy," "on the Madam's best April the," "(and i imagine," and "life hurl my," *Secession*, No. 2 (July 1922): 1–4; "a man who had fallen among thieves," "poets yeggs and thirsties," "the season' tis, my lovely lambs," and "this evangelist," *Secession*, No. 5 (July 1923): 13–17.

28. *Poems 1923–1954*, p. 104. For examples of his essays on the circus and burlesque, see "The Adult, the Artist and the Circus" and "You Aren't Mad, Am I?" in Firmage, ed., *Cummings*, pp. 109–14, 126–31.

29. *Poems 1923–1954*, pp. 189–90. The two exceptions are "her flesh" and the famous "she being Brand," in which sexual intercourse is satirically described in automotive terms (ibid., pp. 96, 178).

30. Ibid., p. 172.

31. Ibid., p. 172.

32. Cummings, *The Enormous Room*, p. 307.

33. "Parisian Epilogue," in *A Bookman's Daybook*, ed. C. Hartley Grattan (New York: Liveright, 1929), pp. 300–01; Francis Picabia, "Anticoq," *The Little Review* 8 (Spring 1922): 43.

34. Quoted in Burton Rascoe, "Parisian Epilogue," in *A Bookman's Daybook*, pp. 301–302; Cummings, *Poems 1923–1954*, p. 144. Recalling Robert Coady's tactic of parodying the jargon of modern art and aesthetics is a similar parody by Cummings in his essay on "Coney Island," where, like Coady, he appreciated the vitality of the amusement park over and above the pretensions of modern art (in Firmage, ed., *Cummings*, pp. 149–53).

35. Poems 1923–1954, p. 177; "Gaston Lachaise," in Firmage, ed., *Cummings*, p. 21.

36. See Eric Bentley's notes on *Him*, in which he relates the problems of mounting the play (Eric Bentley, ed., *From the Modern Repertoire*, Series Two [Denver: University of Denver Press, 1952], pp. 485–94). For Cummings' view of the play, see *i six nonlectures*, pp. 4, 79–82. For a sensitive reading of the play, see Robert Maurer, "E. E. Cummings' *Him*," *The Bucknell Review* 6 (May 1956): 1–27.

37. "*Him*," *The New Republic* 54 (May 2, 1928): 325–26; reprinted in S. V. Baum, ed., *E. E. Cummings and the Critics* (East Lansing: Michigan State University Press, 1962), pp. 47–49.

38. E. E. Cummings, *Him* (New York: Boni and Liveright, 1927), p. 12.

39. "An Imaginary Dialogue" is included in Bentley, ed., *From the Modern Repertoire*, p. 487; Maurer quotes George Jean Nathan as saying, "For utter guff, this Cummings exhibition has never been surpassed within the memory of the oldest play-reviewer in Manhattan. It is incoherent, illiterate, preposterous balderdash." The attitudes behind this evaluation were precisely those that Cummings warned against in his program notes ("E. E. Cummings' *Him*," *The Bucknell Review* 6 [May 1956]: 3). Bentley offers the interpretation of Theodore Hoffman, who traces the parallels of *Him* and the ideas of F. M. Cornford's *The Origins of Attic Comedy* (London: E. Arnold, 1914): Cummings "looks for survival of the rite in our own sterile civilization. He finds its imagery in the Circus and Burlesque, its ritual in psychoanalysis, which is itself a dramatized reenactment and resolution of a basic conflict" (Bentley, ed., *From the Modern Repertoire*, p. 493).

40. *Him*, p. 7.

41. Ibid., p. 19; for another reading of the play, see Norman Friedman, *E. E. Cummings: The Growth of a Writer* (Carbondale: Southern Illinois University Press, 1964), p. 63.

42. *Him*, p. 35; see Friedman, *Cummings*, p. 69.

43. *Him*, pp. 145, 130; Bentley, ed., *From the Modern Repertoire*, p. 494.

Chapter 9. The Art of Assemblage

1. For a dissenting opinion on Covert in general, see George Heard Hamilton, "John Covert: Early American Modern," *College Art Journal* 12 (Fall 1952): 37–42.

2. According to an unsigned explanatory text in the files of the Yale University Art Gallery, the title is supposed to suggest that the manikin constructions appear to have weight but actually do not, which is either a specious interpretation or part and parcel of Dada nonsense—hence specious in any case.

3. "The Brooklyn Bridge," *transition* No. 16–17 (June 1929): 87. For a discussion of the relationship between Crane and Stella, see Irma B. Jaffe, "Joseph Stella and Hart Crane: The Brooklyn Bridge," *The American Art Journal* 1 (Fall 1969): 98–107; George Knox, "Crane and Stella: Conjunction

of Painterly and Poetic Worlds," *Texas Studies in Literature and Language* 12: 689–707.

4. *Broom* 1 (December 1921): 119–23.

5. William H. Gerdts has perhaps phrased it best: Stella's "nature studies, decorative paintings and religious subjects have usually been looked upon as anti-climactic in the career of an artist who was one of the leaders in American modernism. Nevertheless, they reveal a poetic visionary no less than do his more purely Futurist paintings, a visionary who was able to adapt the new aesthetic vocabulary to the interpretations of his private dreams and fantasies until his death in 1946" (*Drawings of Joseph Stella* [Newark: Rabin and Krueger Gallery, 1962], p. 5).

6. *transition* No. 16–17 (June 1929): 88.

7. *Broom* 1 (December 1921): 123.

8. Schwitters exhibited in the galleries of the Société Anonyme from November 1 to December 15, 1920, and from March 15 to April 12, 1921, according to the *Société Anonyme, Inc. Museum of Modern Art Report, 1920–1921* (New York, 1921). Irma B. Jaffe does not agree with my comparison of Stella with Schwitters: "Stella more than Schwitters makes of collage a unique art. Schwitters' collages are extensions of paintings; many could actually have been painted without losing their brilliance or beauty, because these qualities are in the design, that is, in the interplay of shapes, of directions, and of movement. There is texture, to be sure, but the textual variations are not radically different from those used in painting. Stella's collages have an object quality that belongs entirely to that art form. It is the reality of the crumpled bit of paper or the torn, dirty cardboard as an object found and put into place as an artistic art that is asserted, rather than the act of picture-making. Schwitters' collages are over-all designs, many of which strongly resemble contemporary styles in painting; Stella's are like mounted reliefs and do not resemble contemporary painting" (*Joseph Stella* [Cambridge: Harvard University Press, 1970], p. 89). Ms. Jaffe's argument, of course, places Stella closer to Dada than I do, even though she recognizes his emphasis upon the "artistic act." In her major full-length study on Stella, which includes a checklist of his works, she discerns fundamental ambiguities in him and his work, particularly in his relationship to the urban milieu, thus capturing his complexities and dispelling an image of Stella as a naïve immigrant motivated by the Futurists and enthralled by American technology.

9. Dorothy Rylander Johnson adds a third category, "Dove's World," in her *Arthur Dove: The Years of Collage* (College Park: University of Maryland Art Gallery, 1967). Logically, this should encompass the other two categories, but it is difficult to place *Hand Sewing Machine* (1927) and a few other disparate pieces in the category either of portraiture or of nature.

10. Arthur G. Dove, "A Different One," in *America and Alfred Stieglitz*, ed. Waldo Frank, Lewis Mumford, Dorothy Norman, Paul Rosenfeld, and Harold Rugg (New York: The Literary Guild, 1934), pp. 243–45; Robert

Goldwater, "Arthur Dove," *Perspectives U.S.A.*, No. 2 (1953): 79–80.

11. "An Idea," a Statement for an exhibition at the Intimate Gallery, 1927.

12. "Notes by Arthur G. Dove," for an exhibition at the Intimate Gallery, April 1929.

13. Johnson, *Arthur Dove*, p. 15.

14. Quoted in Rudi Blesh, *Stuart Davis* (New York: Grove Press, 1960) p. 16. Davis has also related his 1928 series of paintings based on motifs provided by an eggbeater to Duchamp's anti-art. A direct visual source may have been Man Ray's *Man*, a 1928 photograph of an eggbeater, emphasizing its form, made intricate by the shadows cast. (See John Tancock, "The Influence of Marcel Duchamp," in Anne d'Harnoncourt and Kynaston McShine, eds., *Marcel Duchamp*, pp. 159–178.)

Chapter 10. Painting the Machine

1. Critics have generally glossed over the relationship between Duchamp and America's emerging modernist painters. One of the few exceptions has been Milton Brown, *American Painting from the Armory Show to the Depression*, pp. 103–19. But Brown is hostile to Duchamp and fallaciously attempts to separate Duchamp's Dadaism from his preoccupation with machine forms. In effect, he emasculates Duchamp and overlooks the complexities of his relationship with American artists during this post-War period. For a more sympathetic account, see Barbara Rose, *American Art since 1900* (New York: Praeger, 1967), pp. 84–113.

2. Ben Wolf, who has written the only critical-biographical monograph on this interesting artist, mentions only in passing the possible influence of Picabia and Duchamp upon Schamberg's work (*Morton Livingston Schamberg* [Philadelphia: University of Pennsylvania Press, 1963], p. 33).

3. "Statement by Morton Schamberg," Philadelphia *Inquirer*, Sunday Art Page (January 19, 1913); reprinted in Wolf, *Morton Livingston Schamberg*, pp. 26–28.

4. *Camera Flashlight* of 1916 and *Bowl of Flowers* of 1918, obviously disparate subjects, were both executed with soft, painterly forms. In comparing the two, one notices that the machine ironically takes on biomorphic qualities (although it is impossible to know whether or not Schamberg's irony was intentional). Yet the fact that both canvases were painted within two years suggests not a stylistic trend but a working out of plastic implications within a given painting. According to Milton Brown, "Schamberg, like the majority of Americans (one might almost call this typically American), lacked the complex esthetic mentality and was seemingly unaffected by the involuted philosophies of his European contemporaries. He was more simple and direct in his approach to the machine world" (*American Painting*, p. 117). I believe that here Brown is wrong about Schamberg, who is made to appear like a simple-minded provincial wandering among the decadent Europeans.

5. Quoted in Garnett McCoy, "Reaction and Revolution 1900–1930," *Art in America* 53 (August-September 1965): 81.

6. I would subscribe to James Thrall Soby's view of their relationship: "His [Duchamp's] influence on Demuth was immense. To it may partially be traced Demuth's use of provocative titles, his devotion to agility as opposed to weight, his choice of the alert over the solemn, the fugitive over the placid, his elegance and disdain." But Soby also claims, "Even without Duchamp's example, Demuth would almost certainly have found his own track" (*Contemporary Painters* [New York: Museum of Modern Art, 1948], p. 10). For the standard biography, see Emily Farnham, *Charles Demuth: Behind a Laughing Mask* (Norman: University of Oklahoma Press, 1971).

7. Letter dated February 5, 1929, from Demuth to Stieglitz (Stieglitz Archives). S. Lane Faison makes a perceptive comment about *Lancaster* (1920) in particular, but one which is true of many Demuth paintings: "For Demuth, a sky was not an empty continuum. It was a substance like glass, a fragile crown for an elegant substructure" ("Fact and Art in Charles Demuth," *Magazine of Art* 43 [April 1950]: 124).

8. "Belly Music," *Others* 5 (July 1919): Supplement, p. 30. Duchamp's choice of a ventilator for a readymade in 1915 — since lost — may have inspired Demuth's iconography in *Machinery* four years later (see Anne d'Harnoncourt and Kynaston McShine, eds., *Marcel Duchamp*, p. 315).

9. *Sour Grapes*, p. 78.

10. Letter dated December 12, 1929, from Demuth to Stieglitz (Stieglitz Archives). Two recent works which study the relationship between Williams and painting — in particular, the canvases of Demuth and Sheeler — are Bram Dijkstra, *The Hieroglyphics of a New Speech*, and James Guimond, *The Art of William Carlos Williams*.

11. Letter dated November 28, 1921, from Demuth to Stieglitz; letter dated October 10, 1921, from Demuth to Stieglitz (Stieglitz Archives).

12. To the contrary, however, Demuth claimed, "Colour and line can say quite a bit, unaided by words, when used by one for whom they are a means of expression. Words are not to me a means. I can only paint" ("Across a Greco Is Written," *Creative Art* 5 [September 1929]: 629).

13. Letter dated August 15, 1927, from Demuth to Stieglitz (Stieglitz Archives).

14. Lillian Dochterman has written one of the best studies of Sheeler, although she does not consider his anti-art ambiguities (*The Quest of Charles Sheeler* [Iowa City: The University of Iowa, 1963]). Constance Rourke has made a rather uncritical study, notable primarily for its abundance of statements by Sheeler (*Charles Sheeler: Artist in the American Tradition* [New York: Harcourt, Brace, 1938]).

15. *Charles Sheeler Papers*, Film NSH–1 (Detroit Archives of American Art). These papers include Sheeler's unfinished "Autobiography" of 1938, passed on to Constance Rourke.

16. Ibid., frame 65.

17. Ibid., frames 75, 93. For a discussion of this period, see Dochterman, *Charles Sheeler*, pp. 8–10.

18. *Sheeler Papers*, frame 8; quoted in Constance Rourke, *Charles Sheeler*, p. 185.

19. *Sheeler Papers*, frames 66, 94–96. For a discussion of Sheeler and photography, see Appendix C. in Dochterman, *Charles Sheeler*, and Charles Millard, "The Photography of Charles Sheeler," in *Charles Sheeler*, with essays by Martin Friedman, Bartlett Hayes, and Charles Millard (Washington: Smithsonian Institution Press, 1968), pp. 81–86.

20. *Sheeler Papers*, frames 93–94, 105–06.

21. Ibid., frames 113.

22. *Charles Sheeler*, with an introduction by William Carlos Williams (New York: Museum of Modern Art, 1939), p. 6; *Sheeler Papers*, frame 107.

23. *Sheeler Papers*, frames 72, 79, 106. Man Ray offers this vignette: "I also kept an old sign that hung on the wall [he was moving out of an apartment]: NOT RESPONSIBLE FOR GOODS LEFT OVER THIRTY DAYS—thinking to change the wording later, something like LEFT OVER GOODS NOT RESPONSIBLE FOR THIRTY DAYS. I never made the change, being satisfied with simply imagining the transformation" (*Self Portrait*, pp. 85–86). Sheeler contributed a series of photographs of modern art-work for Duchamp's loose-leaf tribute to Henry McBride, an anti-academic critic during the post-War years. Duchamp's tribute was entitled *Some French Moderns Says McBride* and reprinted the critic's essays in type-faces of varying size. The 1922 copy owned by the Museum of Modern Art is inscribed "Rrose cher Sheeler."

24. *Sheeler Papers*, frame 102.

25. Ibid., frame 92.

26. *Broom* 5 (October 1923), p. 128. Sheeler did another *Self-Portrait* the following year in 1924. This self-image, however, is representational, precisely drawn despite the use of pastel as a medium; reproduced in *Edith Halpert and the Downtown Gallery* (Storrs: University of Connecticut Museum of Art, 1968).

27. *Sheeler Papers*, frames 85–86.

28. Ibid., frame 28; statement in *The Forum Exhibition of Modern American Painters* (New York: Mitchell Kennerley, 1916), n.p.

29. *Broom* 3 (September 1922): *Sheeler Papers*, frame 101.

30. "Photography and the New God," *Broom* 3 (November 1922): 257. A photo-reproduction of Sheeler's painting *Skyscrapers of New York* appeared on the inside of the front cover of *Futurist Aristocracy*, No. 1 (April 1923). Edited by N. L. Castelli in New York for this single appearance, the magazine may have corresponded to Strand's idea of Futurism as "hysterical," but Sheeler's painting appeared as cool as ever. While Sheeler's affirmative attitudes toward the machine differed from Picabia's and Duchamp's, he derived his art/anti-art ambiguities from them and was closely associated with the *Broom* group, for whom he drew the cover of *Aesthete* 1925. It was

Josephson who arranged the first meeting of Sheeler and Williams (see his *Life among the Surrealists*, pp. 253–54.)

31. The composition of this shot closely approximated that of Sheeler's painting *Church Street El* (1921).

32. This film shot anticipates Sheeler's *Totems in Steel* (1935).

33. For an account of this episode, see Jane Heap, "Comments," *The Little Review* 9 (Spring 1923), Exiles Number, pp. 27–29.

34. For example, in one scene an Austrian shoots an egg which, upon shattering, releases a bird that flies away. Likewise, after a hilarious funeral cortege-cowboy chase, the coffin opens up and a magician is resurrected.

35. "Asceticism Pays" (March 9, 1946), undocumented clipping in the *Sheeler Papers*, frame 381. Frederick S. Wight has all sorts of personal reservations about industrialism. Although he senses the contradictions and ambiguities that animate Sheeler's work, he does not get at their source ("Charles Sheeler," *Art in America* 42 [October 1954]: 181–215).

36. *Sheeler Papers*, frame 125.

Aftermath and Conclusion

1. "A Letter To My Friends," *The Little Review* 12 (Spring-Summer 1926): 19.

2. For an excellent history of technology and its effects on modern culture, see Sigfried Giedion, *Mechanization Takes Command* (New York: Oxford University Press, 1948).

Selected Bibliography

Adams, Henry. *The Education of Henry Adams*. Boston: Houghton Mifflin, 1918.

Aesthete 1925, ed. Walter S. Hankel. New York, No. 1, February 1925.

Agee, William, "New York Dada, 1910–1930." In *Avant-Garde Art*, ed. Thomas B. Hess and John Ashberry. London: Collier-Macmillan, 1968.

Allen, Charles. "Director Munson's *Secession*." *The University Review* 5 (Winter 1938): 95–102.

Anderson, Margaret. *My Thirty Years' War*. New York: Covici, Friede, 1930.

Banham, Reyner. *Theory and Design in the First Machine Age*. 2d ed. New York: Frederick A. Praeger, 1967.

Baum, S. V., ed. *E. E. Cummings and the Critics*. East Lansing: Michigan State University Press, 1962.

Baur, John I. H. "The Machine and the Subconscious: Dada in America." *Magazine of Art* 44 (October 1951): 233–37.

Belz, Carl. "Man Ray and New York Dada." *The Art Journal* 23 (Spring 1964): 207–13.

Bentley, Eric. *From the Modern Repertoire*, Series 2. Denver: University of Denver Press, 1952.

The Blindman, ed. Marcel Duchamp. New York, Nos. 1–2 (1917).

Boyd, Ernest. "Aesthete: Model 1924." *The American Mercury* 1 (January 1924): 51–56.

Bry, Doris. *Alfred Stieglitz: Photographer*. Boston: Museum of Fine Arts, 1965.

Broom, ed. Harold Loeb. Rome, Berlin, New York, Vols. 1–5 (1921–24).

Cabanne, Pierre. *Dialogues with Marcel Duchamp*. London: Thames and Hudson, 1971.

Camera Work, ed. Alfred Stieglitz. New York, Nos. 1–49/50 (1903–17).

Camfield, William A. *Francis Picabia*. New York: Solomon R. Guggenheim Museum, 1970.

_____. "The Machinist Style of Francis Picabia," *The Art Bulletin* 48 (September-December 1966): 309–22.

Le Cœur à Barbe, ed. Tristan Tzara. Paris, No. 1, April 1922.

"A Complete Reversal of Art Opinions by Marcel Duchamp, Iconoclast," *Arts and Decoration* 5 (September 1915): 427–28, 442.

Contact, ed. Robert McAlmon and William Carlos Williams. New York, Nos. 1–5 (1920–23).

Cowley, Malcolm. *Exile's Return*. New York: Viking Press, Compass Books, 1956.

_____. "This Youngest Generation." *The Literary Review of The New York Evening Post* (October 15, 1921): 140–42.

_____ and Waldo Frank. "Communications on Seriousness and Dada." *1924*, No. 4 (November 1924): 140–42.

Crane, Hart. *The Complete Poems and Selected Letters*. Ed. Brom Weber. Garden City: Doubleday, Anchor Books, 1966.

_____. *The Letters of Hart Crane*. Ed. Brom Weber. New York: Heritage House, 1952.

Cravan, Arthur. *Maintenant*. Ed. Bernard Delvaille. Paris: Erik Losfeld, 1956.

Cummings, E. E. *E. E. Cummings: A Miscellany Revised*. Ed. George J. Firmage. New York: October House, 1965.

_____. *The Enormous Room*. New York: Modern Library, 1934.

_____. *Him*. New York: Boni and Liveright, 1927.

_____. *i six nonlectures*. New York: Atheneum, 1962.

_____. *Poems, 1923–1954*. New York: Harcourt, Brace, 1954.

Dijkstra, Bram. *The Hieroglyphics of a New Speech: Cubism, Stieglitz, and the Early Poetry of William Carlos Williams*. Princeton: Princeton University Press, 1969.

Dochterman, Lillian. *The Quest of Charles Sheeler*. Iowa City: University of Iowa Press, 1963.

Doty, Robert. *Photo Secession: Photography as a Fine Art*. Rochester: George Eastman House, 1971.

Duchamp, Marcel. *The Bride Stripped Bare by Her Bachelors, Even*. Trans. George Heard Hamilton. New York: George Wittenborn, 1960. A typographic version by Richard Hamilton of Duchamp's "Green Box."

_____. *Marcel Duchamp: Notes and Projects for the Large Glass*. Ed. Arturo Schwarz. New York: Abrams, 1969.

_____. *Marchand du sel: Écrits de Marcel Duchamp*. Ed. Michel Sanouillet. Paris: Le Terrain Vague, 1958.

Eliot, T. S. *The Waste Land and Other Poems*. New York: Harcourt, Brace and World, 1962.

Farnham, Emily. *Charles Demuth: Behind a Laughing Mask*. Norman: University of Oklahoma Press, 1971.

The Forum Exhibition of Modern American Painters. New York: Mitchell Kennerly, 1916.

Frank, Waldo, Lewis Mumford, Dorothy Norman, Paul Rosenfeld, and Harold Rugg, eds. *America and Alfred Stieglitz*. New York: The Literary Guild, 1934.

_____. *Our America*. New York: Boni and Liveright, 1919.

_____. "Seriousness and Dada." *1924*, No. 3 (September 1924): 70–73.

"French Artists Spur On An American Art." *New York Tribune* (October 24, 1915), Section IV, p. 2.

Freytag-Loringhoven, Elsa von. "Thee I Call 'Hamlet of Wedding-Ring.'" *The Little Review* 7 and 8 (January-March 1921, Autumn 1921): 48–55 and 108–11.

Giedion, Sigfried. *Mechanization Takes Command.* New York: Oxford University Press, 1948.

Guimond, James. *The Art of William Carlos Williams.* Urbana: University of Illinois Press, 1968.

Hartley, Marsden. *Adventures in the Arts.* New York: Boni and Liveright, 1921.

Hoffman, Frederick J., Charles Allen, and Carolyn F. Ulrich. *The Little Magazine: A History and a Bibliography.* Princeton: Princeton University Press, 1946.

Horton, Philip. *Hart Crane: The Life of an American Poet.* New York: W. W. Norton, 1937.

"The Iconoclastic Opinions of M. Marcel Duchamps Concerning Art and America." *Current Opinion* 59 (November 1915): 346–47.

Jaffe, Irma B. *Joseph Stella.* Cambridge: Harvard University Press, 1970.

Jean, Marcel. *The History of Surrealist Painting.* Trans. Simon Watson Taylor. New York: Grove Press, 1959.

Johnson, Dorothy Rylander. *Arthur Dove: The Years of Collage.* College Park: University of Maryland Art Gallery, 1967.

Johnson, Jack. *Jack Johnson Is a Dandy: An Autobiography.* Introductory essays by Dick Schaap and The Lampman. New York: Chelsea House, 1969.

Josephson, Matthew. "A Letter to My Friends." *The Little Review* 12 (Spring-Summer 1926): 17–19.

––––––. *Life among the Surrealists.* New York: Holt, Rinehart, and Winston, 1962.

Kreymborg, Alfred. *Troubadour.* New York: Boni and Liveright, 1925.

Langsner, Jules. *Man Ray.* Los Angeles: Los Angeles County Museum of Art, 1966.

Lebel, Robert. *Marcel Duchamp.* London: Trianon Press, 1959.

The Little Review, ed. Margaret Anderson and Jane Heap. Chicago, New York, Vols. 1–12 (1914–29).

Loeb, Harold. *The Way It Was.* New York: Criterion Books, 1959.

McAlmon, Robert. *Being Geniuses Together: 1920–1930.* Revised and with supplementary chapters by Kay Boyle. New York: Doubleday, 1968.

McLuhan, Marshall. *The Mechanical Bride.* New York: Vanguard Press, 1951.

––––––. *Understanding Media.* New York: McGraw-Hill, 1964.

Miller, J. Hillis. *Poets of Reality: Six Twentieth–Century Writers.* Cambridge: Harvard University Press, 1966.

Miller, J. Hillis, ed. *William Carlos Williams: A Collection of Critical Essays.* Englewood Cliffs, N. J.: Prentice-Hall, 1966.

Motherwell, Robert, ed. *The Dada Painters and Poets*. New York: Witten-
 born, Schultz, 1951.
Munson, Gorham. "The Fledgling Years, 1916–1924." *The Sewanee Re-
 view* 40 (January-March 1932): 24–54.
——. "The Skyscraper Primitives." *The Guardian* 1 (March 1925): 164–78.
——. "A Specimen of Demi-Dadaisme." *The New Republic* (April 18,
 1923), pp. 219–20.
——. *Waldo Frank: A Study*. New York: Boni and Liveright, 1923.
New York Dada, ed. Marcel Duchamp. New York, No. 1, April 1921.
Norman, Charles. *E. E. Cummings*. New York: Dutton, 1967.
Norman, Dorothy. *Alfred Stieglitz: American Seer*. New York: Random
 House, 1973.
Paul, Sherman. *The Music of Survival: A Biography of a Poem by William
 Carlos Williams*. Urbana: University of Illinois Press, 1968.
Picabia, Francis. *391*. Ed. Michel Sanouillet. Paris: Le Terrain Vague, 1965.
"Picabia, Art Rebel, Here to Teach New Movement." *The New York Times*
 (February 16, 1913), Section V, p. 9.
Rascoe, Burton. "A Parisian Epilogue." In *A Bookman's Daybook*. Ed. C.
 Hartley Grattan. New York: Horace Liveright, 1929.
Ray, Man. *Self Portrait*. Boston: Little, Brown, 1963.
Richter, Hans. *Dada: Art and Anti-Art*. New York: McGraw-Hill, 1966.
Rongwrong, ed. Marcel Duchamp. New York, No. 1 (1917).
Rose, Barbara. *American Art Since 1900*. New York: Frederick A. Praeger,
 1967.
Rubin, William S. *Dada, Surrealism, and Their Heritage*. New York: Mu-
 seum of Modern Art, 1968.
Sanouillet, Michel. *Dada à Paris*: Jean-Jacques Pauvert, 1965.
——. *Picabia*. Paris: Editions du Temps, 1964.
Schwarz, Arturo. *The Complete Works of Marcel Duchamp*. New York:
 Abrams, 1969.
Secession, ed. Gorham Munson. Vienna, Nos. 1–8 (1922–24).
Seitz, William C. *The Art of Assemblage*. New York: Museum of Modern
 Art, 1961.
Seldes, Gilbert. *The Seven Lively Arts*. New York: Harper and Bros., 1924.
Sheeler, Charles. *Papers*. Film NSH-1. Detroit: Archives of American Art.
The Soil, ed. Robert Coady. New York, Nos. 1–5 (1916–17).
Soupault, Philippe. *The American Influence in France*. University of Wash-
 ington Chapbooks, No. 88. Ed. G. Hughes. Seattle: University of
 Washington Bookstore, 1930.
Tate, Allen. *The Man of Letters in the Modern World*. London: Meridian
 Books, 1967.
Taupin, René. *L'Influence du Symbolisme*. Paris: H. Champion, 1929.
291, ed. Alfred Stieglitz. New York, Nos. 1–12 (1915–16).
Unterecker, John. *Voyager: A Life of Hart Crane*. New York: Farrar, Straus
 and Giroux, 1968.

Verkauf, Willie, ed. *Dada: Monograph of a Movement*. Teufen, Switzerland: A. Niggli, 1957.

View, ed. Charles Henri Ford. Marcel Duchamp Number. Series V, No. 1, March 1945.

Weaver, Mike. *William Carlos Williams: The American Background*. Cambridge: Cambridge University Press, 1971.

Williams, William Carlos. "America, Whitman, and The Art of Poetry." *The Poetry Journal* 8 (November 1917): 27–36.

––––––. *The Autobiography*. New York: Random House, 1951.

––––––. "Belly Music." *Others* 5 (July 1919), Supplement: pp. 25–31.

––––––. *Collected Poems, 1921–1931*. Preface by Wallace Stevens. New York: Objectivist Press, 1934.

––––––. *The Great American Novel*. Paris: Three Mountains Press, Contact Editions, 1923.

––––––. *In the American Grain*. New York: New Directions, 1956.

––––––. *I Wanted to Write a Poem: The Autobiography of the Works of a Poet*. Reported and edited by Edith Heal. Boston: Beacon Press, 1958.

––––––. *Kora in Hell: Improvisations*. Boston: The Four Seas, 1920.

––––––. "More Swill." *The Little Review* 6 (October 1919): 29–30.

––––––. *The Selected Letters*. Ed. John C. Thirlwall. New York: McDowell, Obolensky, 1957.

––––––. *Sour Grapes: A Book of Poems*. Boston: The Four Seas,1921.

––––––. *Spring and All*. Paris: Contact, 1923.

––––––. "Three Professional Studies." *The Little Review* 5 (February-March 1919): 36–44.

Wilson, Edmund. "An Imaginary Conversation: Mr. Paul Rosenfeld and Mr. Matthew Josephson." *The New Republic* (April 9, 1924), pp. 179-82.

Wolf, Ben. *Morton Livingston Schamberg*. Philadelphia: University of Pennsylvania Press, 1963.

Index